The Visual World of French Theory: Figurations

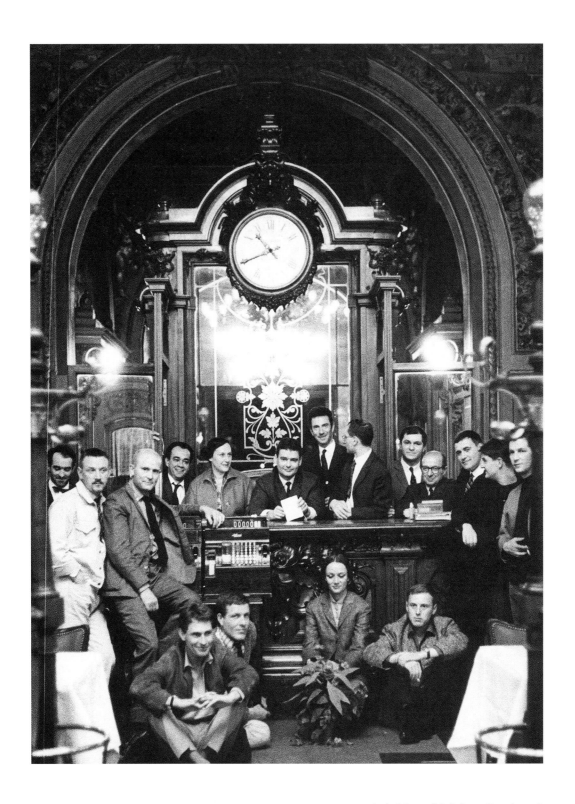

André Morain, 'Mythologies Quotidiennes',
exhibition dinner, Le Train bleu, Paris, 1964.

The Visual World of French Theory

Figurations

Sarah Wilson

Yale University Press

New Haven and London

Copyright © 2010 by **Sarah Wilson**

Designed by **Adrien Sina**

Library of Congress Cataloging-in-Publication Data

Wilson, Sarah, 1956–
 The visual world of French theory: figurations / Sarah Wilson.
 p. cm.
 Includes bibliographical references and index.
 ISBN 978-0-300-16281-3 (cloth: alk. paper)
 1. Figurative art—France–Paris–20th century. 2. Narrative art (Art
movement) 3. Philosophy, French–20th century. 4. Art and
philosophy–France. I. Title. II. Title: Figurations.
 N6848.5.F53W55 2010
 709.44'0904–dc22
 2010016378

A catalogue record for this book is available from
The British Library

Printed in China

Contents

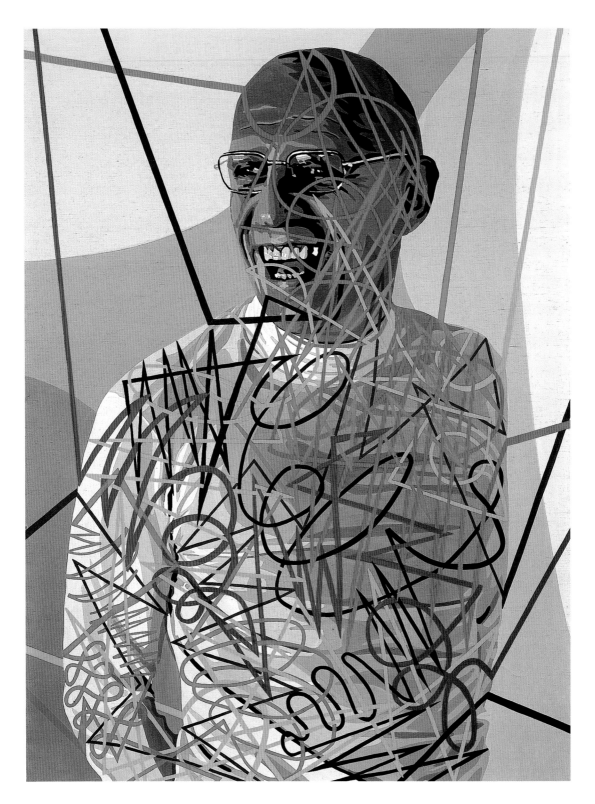

Fromanger: *Michel*, 1976

Preface and Acknowledgements

Res severa verum gaudium *

Valerio Adami inscribed these words by Seneca on the cover of the album-catalogue *Derrière le miroir*, which he created with Jacques Derrida in 1975. This book is the fruit of much joy; it was challenging and has evolved over more than a decade. My copy of Lyotard's *L'Assassinat de la peinture par l'expérience, Monory* was bought in 1985, when I visited his exhibition 'Les Immatériaux' at the Centre Georges Pompidou, Paris. In June 1994, I had the privilege of hosting Jacques Derrida at the Courtauld Institute in London for his lecture at the conference 'Memory: The Question of Archives', which led to his celebrated publication *Archive Fever* of 1996. My own work involving Derrida, inspired by Jean Genet's improbable trip to London, began around this time, including a first encounter with the two versions of *Glas*, important subsequently for understanding Derrida's collaborations with Adami and with Gérard Titus-Carmel.[1] In 1996, at the opening of Laurent Gervereau's exhibition 'Les Sixties en France et l'Angleterre', I met Jacques Monory and began to explore the link between French political artists of the older generation and their followers of the Pop era.[2] The exhibition 'Face à l'histoire', at the Pompidou the same year, juxtaposed this 1960s European generation with their American counterparts. Monory welcomed me and my students on several occasions to his remarkable blue and white studio in Cachan (with Ida the dog). There he showed us his films and his two superb *boîtes-en-valises*; there I discovered his catalogue of the *Mural Cuba Collectiva* which had far-reaching consequences.[3] With Duncan McCorquodale's support, the 'Revisions' series was conceived with Black Dog Publishing, and the translators associated with that series – Jeanne Bouniort, Rachel Bowlby, Sophie Mayoux and Dafydd Roberts – provoked many illuminating disucssions. In 'Revisions', Lyotard's complex and desire-driven texts on Monory were presented bilingually, and I was honoured to meet Lyotard and to clarify some points in telephone conversations with him, unaware that his last illness was far advanced.[4] Our second volume in the 'Revisions' series focused on Gérard Fromanger with texts by Gilles Deleuze and Michel Foucault, his friends. I well remember Gérard's amusement at our first meeting with a bevy of *filles du Courtauld* in his studio near the Place de la Bastille in Paris. A second Black Dog volume appeared in 1999, with Adrian Rifkin's splendid introduction; book launches took place in London and the

* A difficult thing is a true joy (Seneca)

Librairie-Galerie La Hune, in Saint-Germain-des-Prés. The friendship with Gérard has continued and has generated not only research work but wonderful shared moments in Paris, at La Seyne-sur-Mer, near Toulon, and in Havana, Cuba.[5] Gérard has spoken with charisma and passion to Courtauld students and to my students at the Sorbonne, and has visited London more than once, talking at Tate Modern on his relationship with Jean-Luc Godard for the comemmorative May 1968 anniversary celebrations in 2008.

In 1999 I was invited by Patrick Le Nouëne to Angers for the exhibition 'Monory/ Ex-Crime'.[6] Daniel Abadie's major Erró retrospective at the Galeries Nationales du Jeu de Paume in Paris that year involved another extraordinarily rich encounter, this time with a non-French artist, and a story ranging from Iceland to New York, work with Carolee Schneemann and with painters from Thailand. Erró's present to me of the precious catalogues *Forty-Seven Years* (Galleria Arturo Schwarz, 1967 – hilarious parodies of Soviet Socialist Realism) and the 'little red book' of his Mao series, 1974, set off important chains of thought.[7] The comic-strip misogyny of his exhibition 'Les Amazones en Proverbe' at the Galerie Louis Carré in 2004 was exasperating but engaging.[8] Erró's first London show, at the Mayor Gallery in 2008, also launched a definitive study of his life and work in English.[9] In 2002, as the principal curator of 'Paris Capital of the Arts, 1900–1968', I was able to reveal to a London public (and subsequently that of the Guggenheim in Bilbao) the work of revolutionary artists such as Jean-Jacques Lebel and the Narrative Figuration generation – Fromanger's newly rediscovered red *Bubble* sculpture (with its Jeff Koons-like shine), Rancillac's enamel *bleu-blanc-rouge* portrait of the assaulted student leader Daniel Cohn-Bendit, Monory's mirrored and bullet-shattered *Murder*, Erró's *Background of Jackson Pollock*, Henri Cueco's *Barricade, Vietnam 68* (as fresh as on the day it was shown in the Vietnam protest show of 1969) and, sensationally, in the Royal Academy rotunda, the unknown *Live and Let Die: The Tragic End of Marcel Duchamp*, the group work by Eduardo Arroyo, Antonio Recalcati and Gilles Aillaud which has since acquired much celebrity.[10] It did the job of representing Duchamp's *Fountain*, *Nude Descending a Staircase* and *The Large Glass* for our show – works not created in Paris (an essential criterion) – but crucial presences, whatever the roughed-up state of their progenitor. My thanks to the Arts and Humanities Research Council for the short period of leave that gave me time for this major project. Antonio Recalcati's retrospective was another wonderful occasion at the Villa Tamaris; Camille Aillaud has received me to talk about her late husband, whose work I have also appreciated in exhibitions at the Galerie de France and the Musée de la Chasse, Paris. While I had been introduced to Bernard Rancillac by my

friend Serge Fauchereau, the author of his monograph, my own work with Rancillac, his library and his archives came to fruition for his touring retrospective of 2003.[11] In Rancillac's acerbic and polemical account of the 1970s, *Le Regard idéologique* (2000), I was astonished to discover the chapter on Boris Taslitzky, the Socialist Realist artist and Buchenwald survivor – a dear friend and mentor; we three lunched together decades after Rancillac's studio visit to Taslitzky in the 1970s.[12] At this time, my friendship with Ruth Francken was becoming deeper; I went to see her exhibition in Hanover, when she was no longer able to travel, and was inspired for my own 'Song of Ruth' by her story, long after Lyotard's writings on this artist, which were crucial for his later work such as *Heidegger et 'les juifs'* of 1988.[13] Francken's 'Mirrorical Return' portraits of Lyotard and of Monory link her to the Narrative Figuration movement; my students remember her warm welcome in the rue Lepic, her adjoining studio in the spaces at the back of the Moulin Rouge and the strength of her work; her reputation will grow posthumously. The Leverhulme Foundation, which has been important at crucial stages of my life, granting me time at the Pompidou Centre at the beginning of my career, and in France in 1996–7, gave me another grant for research in Paris in 2004–5. I thank them for their continuing confidence in this project. It was following a meeting at the Musée de la Vie Romantique with Mme Madeleine Malraux and the distinguished curator of the Musée de la Ville de Paris, the late M. André Berne-Joffroy (we were all Fautrier lovers), that he told me of the link between the painter Leonardo Cremonini and Louis Althusser. This led to my discovery of Lucio Fanti, still painting in La Ruche – to a whole new bevy of visits with students, Fanti's visit to London, my text on his 'post-Soviet paintings' published in Russian and perhaps the most surprising chapter in this book.[14] Leonardo Cremonini, Roberto Alvarez-Rios and Fabio Rieti all received me in Paris at that time, Rieti lending me the catalogue which demonstrated the exchanges between European Figurative artists with those in Moscow: many thanks to all for their patience.

In 2006, at the invitation of Anne Dary, the curator of the Musée des Beaux-Arts in Dole, I joined the veteran critic Alain Jouffroy and the expert Jean-Luc Chalumeau to write in her catalogue *La Figuration narrative dans les collections publiques (1964–1977)*.[15] Dole (in the Jura mountains, near Besançon) is the place where many extraordinary large-scale paintings of the 1970s now have a permanent home – prior to their re-emergence, one trusts, on the international scene – notably the Malassis group's *Le Grand Méchoui*, discussed in my conclusion. This huge work was displayed for the opening in a barn adjoining the museum; the artist Henri Cueco gave a memorable peripatetic

talk, explaining its astonishing, aggressive iconography. Alas, the opportunity to show the work *in toto* for the 'Narrative Figuration' retrospective in 2008 was not seized at the Grand Palais, where it had ruled for a few hours only in 1972. Cueco and his wife Marinette (a superb artist whose work anticipates Andy Goldsworthy's) have also been warm and generous hosts and participated, as did Fanti, in my round-table discussions at the École Normale Supérieure des Beaux-Arts in 2007.[16] It was the Dole museum that hosted Lucien Fleury's retrospective in 2007, thus affording me the opportunity to meet Fleury's daughter Mathilde and to write about the history of the Malassis – including their great public *Raft of the Medusa* commission for Grenoble, visible for many years before consignment to an 'absestos cemetery' and recent destruction. The chance to show the Malassis's work in my conclusion will stimulate greater interest, I hope.[17]

I have been a guest of Robert Bonaccorsi at the Villa Tamaris, La Seyne-sur-Mer, for several of the figurative exhibitions and retrospectives that he has staged with great commitment. I must also thank Serge Lemoine for inviting me to teach at Paris-IV Sorbonne during the academic years 2002–4 and Henry-Claude Cousseau for his invitation to run a fifth-year seminar at the École des Beaux-Arts in 2007, thus offering me valuable extra research and interviewing time in Paris. Didier Schulmann is a special friend who, with his colleagues at the Bibliothèque Kandinsky at the Centre Georges Pompidou, now runs the modern and contemporary art history library *par excellence*; his colleague Jean-Paul Ameline invited me to write for 'Face à l'histoire' and curated the 'Figuration Narrative' retrospective at the Grand Palais, in 2008. Olivier Corpet welcomed me to the magnificent Abbaye de l'Ardenne, the home of the Institut Mémoires de l'Édition Contemporaine (IMEC). Pierre-Philippe Ruedin and recently Evelyne Taslitzky, have also been the most generous hosts, facilitating many stays in Paris. Peace and Provençal beauty has framed my work periodically thanks to the hospitality of Kamila Regent and Pierre Jaccaud at the 'Chambre de séjour avec vue', Saignon-en-Luberon. In Russia, Olga Zinoviev received me at Moscow University surrounded by her husband's paintings. She confirmed the friendship between Althusser and philosopher Alexandr Zinoviev, sparked in 1974.

Sander Gilman has sustained me throughout this enterprise and with Michael Corris offered indispensable support and pragmatic advice at a crucial stage. My colleagues in the Modern Department at the Courtauld Institute of Art, Mignon Nixon and Julian Stallabrass, have read and evaluated student research work in this area. The Courtauld Research Committee not only contributed to the financing of the Black Dog bilingual volumes on Monory and Fromanger but have also been more than generous in supporting

research work in Paris in the summers of 2006 and 2007 (with the Central Research Fund), with a final grant for visual material in 2009; thanks to the committee for their patience and faith as well as generosity. Karin Kyburz has been a sympathetic reader, efficient in procuring images; Elizaveta Butakova gave assistance in the final stages, prior to Katharine Ridler's excellent copy-editing, and Jane A. Horton's indexing. Throughout this period Adrien Sina has provided conceptual support, ideas, criticism and much more; his creative input is now visible in the exciting design of this book; so many thanks.

Together with the artists named above I must also thank AES (Tatiana Arzamasova, Lev Evzovitch, Evgeny Syvatsky), Eduardo Arroyo, Erik Bulatov, Guido Cegnani, Hans Haacke, Denis Masi, André Morain, Malcolm Morley, Jacques Pavlovsky, James Rosenquist, Richard Selby and artists' associates and families, many of whom have helped with images and fee waivers: Marie-Antoine and Roberte Alvarez-Rios, Sarah Bancroft, Jerôme Bourdieu, Natasha Bulatov, Elisa Farran, Lucie Fougeron, Emmanuelle Damaye, Marguerite Derrida, Christine and Jacques Dupin, Anna Kamp, Ivan Karp, Denise Klossowski, Christine and David Lapoujade, Dolores Lyotard, Florence Miailhe, Paule Monory, Christine and Jacques Dupin, Anouk Papiamandis, Nathalie Rancillac, Isabelle Rollin-Royer, Evelyne Taslitzky, Sylvie Zucca.

I am finally able to offer tribute to Gillian Malpass of Yale University Press for her belief in my work. Thanks also once more to Germain Viatte whose initial invitation to work at the Pompidou Centre has had inestimable consequences in my life, leading to so many friendships, such intellectual richness. *L'aventure continue.*

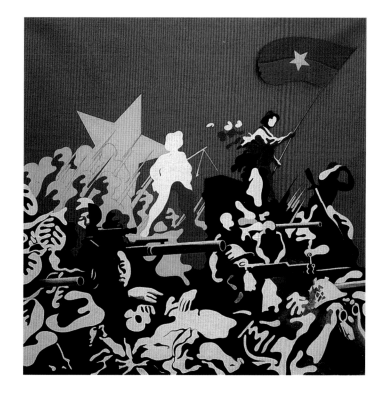

1. Cueco, *Barricade, Vietnam 68*, 1968

Witnesses of the Future
Painters of their Times

In 1974, Gérard Fromanger was the first French painter to visit Mao's China. His photograph-based history painting *In Huxian, China,* exhibited in 1975 with a catalogue by Michel Foucault, was rapidly acquired for France's national collections. Chinese peasant painters from Huxian, Shaanxi Province, were special guests at the Paris Biennale of 1975.[1] In 1976, Pontus Hulten, the director of the Musée national d'art moderne, sent the Icelandic painter Erró's *Nine Chinese Paintings* with contemporary French art to tour American university art galleries, for the United States bicentennial celebrations.[2] Erró's Chinese paintings had first been exhibited in 1975 in Lucerne and toured Europe, with a parody of Mao's *Little Red Book* as a catalogue. They appeared in New York in 1976, in the wake of Mao's death, before travelling to Berkeley, Houston and Purchase.[3] Erró subjected icons of Mao's revolution by Red Guard artists, such as Liu Chunhua's *Chairman Mao goes to Anyuan* (1967), to a deadpan *détournement*: the young Mao appeared in Venice (pl. 2), while Tang Xiaohe and Cheng Li's *Follow closely our Great Leader Chairman Mao, Ride the Wind, Cleave the Waves, Fearlessly forge ahead* (1972), appropriated by Erró became, simply, *In front of New York*.[4]

Following his discovery of Chinese propaganda posters during the shooting of Martial Raysse's film *Le Grand départ* (1970) and his visit to a show of Chinese Socialist Realist painters in Hong Kong, Erró began making collages which juxtaposed Socialist Realism with Western magazine images. These were found in American military bases in Thailand during his visit and it was with the aid of professional Thai poster painters that the collages were enlarged and transformed to smooth-finish paintings.[5] From 1996 to 2003, the Russian AES group used digital montage to achieve a parallel effect; see the remarkably similar series, 'Witnesses of the Future, the Islamic Project'. Rather than Mao in front of San Marco in Venice, a nomadic encampment is installed in front of St Peter's, Rome; in *Beaubourg* (the Pompidou Centre's nickname), Islamic architecture invades the museum's structure, now draped with rugs (pl. 3). Only the 'enemy' has changed; the critique – the political ambivalence – remain the same.[6]

2. Erró, *Mao at San Marco*, 1974

In Shanghai, Guangdong and Beijing in 2005, the official Centre Pompidou exhibition 'Nouvelles Vagues' emphasised New Wave cinema's connections with the Narrative Figuration movement to which Erró and Fromanger belonged. Painting and artists' films of the 1970s were set up to create a dialogue with contemporary Chinese figurative painting and video. The Narrative Figuration movement's politicised work had hitherto been suppressed at all costs: French painting was deliberately excluded from the showcase exhibition 'Premises', held at the Guggenheim Soho in New York in 1998. 'Nouvelles Vagues' was devised for a different public and a world which has radically changed.[7] The show celebrated France's long relationship with China. Under Mao's rule during the 1970s, an estimated 900 million copies of *Chairman Mao goes to Anyuan* were printed for propaganda purposes. In 2005, for millions of television viewers, and for an art public of 360,000 people in Beijing and 250,000 in Shanghai, Narrative Figuration became one of the most visible aspects of France's artistic self-representation. The link between the movement (whose images had long been plundered on the internet) and contemporary Chinese painting (like that of Zhang Xiogang's *Bloodline* series, now fetching millions of dollars) was not only suggested by the French, but explicitly avowed by the Chinese.[8] 'Nouvelles Vagues' followed the Chinese exhibition in Paris 'Alors la Chine?' held at the Pompidou Centre in 2003, the key exhibition of the 'Year of China in France'. The major diplomatic initiatives were lucrative, notably for France's involvement in Shanghai's metro contract and important programmed extensions planned for their Expo 2010. By coincidence, 2010 is the year that the celebratory 'Année France-Russie' will make similar political, cultural and economic gestures of friendship between France and Russia, again insisting upon a long history of mutual involvement.[9]

Today's new, then, is old. Contemporary Chinese and Russian artists who work with – and through – the Socialist Realism of their once terror-filled heritages in fact had their European precursors. 'Moscow conceptualism' (the work of Erik Bulatov or Ilya Kabakov, first shown in the Galerie Dina Vierny in 1973) continued a dialogue with European contemporaries in the aftermath of the revelations of Solzhenitsyn's *Gulag Archipelago*.[10] Modulated by a Europe-wide response to American hyperrealism, the high point of these exchanges was visible in Venice at the Biennale of 1976, and in 1977 when a show of Soviet non-conformist art accompanied a meeting of intellectuals from East and West. Communist ideology and Soviet repression were under intense international scrutiny. That crucial moment had a long history. Moreover, beneath

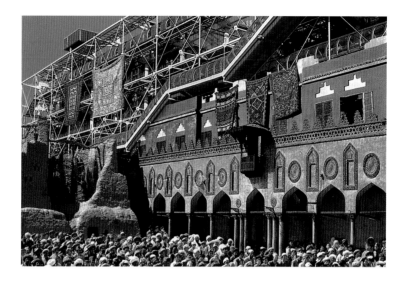

the painted surfaces of Narrative Figuration was concealed a repertoire of themes and practices linked back to France's own Communist histories and memories and its Socialist Realist painting: a story from the 'former West' which is gradually seeing the light.[11]

The exhibition 'Figuration Narrative, Paris 1960–1972', held in Paris's Grand Palais in the spring of 2008 – the fortieth anniversary of the May 1968 events – marked the culmination of the movement's new visibility.[12] The show ended symbolically in 1972, the year of the exhibition 'Douze ans d'art contemporain' at the Grand Palais itself, and Harald Szeeman's watershed Documenta 5 exhibition in Kassel – but before the publication of Bernard Lamarche-Vadel's *Figurations 1960–1973*, where Jean-François Lyotard's first writing on Monory appeared.[13] My own narrative continues to 1977 and the first group exhibition at the new Centre Georges Pompidou, which only now has taken on the responsibility for presenting the movement's history. Its contemporary 'look' has generated this renaissance – a spate of recent retrospectives, higher prices for historic pieces, museum displays and acquisitions. Narrative Figuration was positioned on the very cusp of postmodernism: it exemplified the last moment in France of grand history painting and the tradition of revolutionary romanticism. Its works are rich with critical satire, strategies of appropriation and a post-Situationist *détournement*. It contained not a trace of scepticism about the value of its own painterly and critical enterprise.

In a period in which an attempt to contextualise Marxist theory was seen as urgent, the Narrative Figuration movement sought to 'mirror' or reflect the society of its times.[14] Militantly figurative, its broken narratives anticipated Lyotard's very definition of postmodernism as based on narrative collapse and a critical analysis of the *grands*

3. AES group, *Beaubourg*, (Witnesses of the Future, *Islamic Project*), 1996

récits and the *petits récits* of the times.[15] Narrative Figuration was 'filmic', political and engaged with contemporary popular culture, including the issue of Americanisation. It was involved in dialogues with its contemporaries: not only the *dialogue de sourds* ('dialogue of the deaf') undertaken with the abstract Supports-Surfaces artists but also the more problematic engagement with the Americans, demonstrated, for example, in the exhibition 'Hyperréalistes américains et réalistes européens' held at the Centre National d'Art Contemporain in 1974. Narrative Figuration, then, as 'revolutionary romanticism' – innately French, a continuation of the tradition of Géricault and David – or a 'weak' French version of hyperrealism? It did not export well, yet at home could look too American; it was 'often interpreted as no more than an emanation of an imported culture, or of an aesthetic derived from Anglo-American culture and foreign to French "sensibility"'.[16] An extraordinary irony is in operation here. For it was precisely Narrative Figuration's close connection with May 1968 and its aftermath, its explicit political imagery, intransigent group practice and ultimate economic failure that led to its fall from grace. It became invisible because of a belief that politics could and should have a role in painting; that painting was indeed the arena in which to act and that a *praxis* of a political painting that could communicate with the 'people' was vitally contemporary. In today's climate of global political and economic crisis, this political engagement and wariness of the art market deserves a new look.

Only a few of the artists were affiliated members of specific Communist or Maoist groupings but all would have defined themselves as anti-fascist in this tense period of colonial wars and Cold War confrontations, extending from Cuba to Vietnam and China. The artist Jan Voss makes a crucial point: 'There was also that unbelievable brotherhood of all the émigré artists in Paris who originated from countries with fascist governments: Haiti, Spain, Portugal. Not to mention Eastern Europe, Christo for example.'[17] To which one might add Vladimir Velickovic from Yugoslavia (now Serbia) or Peter Klasen from a divided Germany. Paris and the French language offered an intellectual meeting place linked to the international exchanges of Western Marxism. Other outposts were also important, such as the Korcula summer school in Yugoslavia, which the artist Bernard Rancillac visited in the summer of 1965. Its Zagreb-based trilingual review *Praxis* (international edition 1965–73) demonstrates the depth and urgency of debates transmitted instantly back to France's own networks of colloquia – particularly those held in Royaumont and Cerisy – in discussion forums, universities, ateliers and publishing houses.[18] It was in Korcula that the Romanian Lucian Goldmann,

a disciple of György Lukács and the key theoretician of the Parisian *nouveau roman* met Herbert Marcuse, who himself became Lyotard's colleague at the University of San Diego, California.[19] The international mobility of philosophers mirrored that of artists and curators in the new era of air travel. These networks once again forcefully demonstrate the importance of German philosophy at the time, the renewed input of the Frankfurt School past and present, the presence of Eastern European Marxist thought and, above all, the retrospective misnomer of 'French Theory.'[20]

By definition, the artists linked to these currents of thought were anti-capitalist. The promotion of Narrative Figuration in an international arena confronted problems not merely of language or symbolic content (the politics and pictorial languages of large group projects such as *The Great Méchoui* of 1972 or *Guillotine and Painting* of 1977 now require patient elucidation) but of values: values not only political but also innately hostile to careerism and the commercial art market, which in France was in crisis.[21] Looking back at this period through the lens of the French minister Jack Lang's reforms and the cultural metamorphoses of the 1980s, the militant artist Henri Cueco and Pierre Gaudibert, a key critic and curator of the previous two decades, in 1988 came to grim conclusions: 'A certain self-criticism, neither contrition nor masochism, leads us to see that blaming the lack of economic support is not enough to explain a position of retreat: neither the artists nor their different partners travelled beyond France's frontiers or made visits abroad for professional reasons, nor were they good at languages, particularly English.'[22] A later passage evokes the suspicion, even repulsion, with which intellectuals of the left regarded commerce, money and profit. Cueco was a Communist, faithful to his home region of Corrèze and its idealised Resistance past; Gaudibert evoked a common Judaeo-Christian heritage and 'the cult of money experienced as something unclean' – at the very moment of Jean Baudrillard's anatomy of consumer society.[23] Astonishing as it may seem today, this refusal to collude with the art market (despite welcome state support and commissions from trade unions and municipalities) is one of the outstanding reasons for the intransigence and exceptional character of the movement in its early years.

Cueco and Gaudibert continued: 'The isolation of the generation that broke with the past, that of the years 1970 to 1975, was doubtless provoked, if not wished for, by the artists themselves. We were frequently aggressive and it required the persistence of certain curators, journalists, critics etc., to end this solitude'.[24] Yet the stirring conclusion to this passage underlines the artists' intimate relationship with both the intellectual

and the real encounters which gave a remarkable exhilaration to the period. 'With our "theory-based" radicalisations, born in a climate of structuralism, Tel Quel, the works of Althusser, Lacan, we contributed to the heating-up of the cultural field before and after 1968. Joining up with a movement exterior to art, participating in a seismic moment of history, we were living our times'.[25] The passions of the barricade (see pl. 1) were followed by the '"theory-based" radicalisations' (*radicalisations "théoricistes"*) and the intimate encounters between artists and philosophers at the heart of this book.

Yet the visibility of political messages and contexts in some of the work became retrospectively embarrassing. Beyond the euphoria of 1968, Communist ideology (in the aftermath of *The Gulag Archipelago* of 1974 and Maoism's political and cultural expressions in France) retrospectively signified a massive 'communal error' and an intensification of what was called, as early as 1950, *la guerre franco-française*.[26] This 'franco-french warfare' (renewed with the *épuration* purges following French war-time collaboration) meant an internecine pitting of left against right, class against class. The controversy is constantly reignited, never so intensely as when *Le Livre noir du communisme* (*The Black Book of Communism: Crimes, Terror, Repression*) was published for the eightieth anniversary of the Russian Revolution in 1997.[27] It re-emerges with each new obituary, notably that of Solzhenitsyn himself in August 2008, which appeared between the two stages of the Narrative Figuration retrospective. Paintings that evoked the political debates of the 1970s had associations which account for the French state's decades-long reluctance to promote them nationally or internationally. Indeed, Nicolas Sarkozy came to power with the mission to 'liquidate the heritage of May 68'; the May revolution was celebrated across France in 2008 in a muted way, nostalgically and peripherally.[28] Political work was present but rendered effectively silent and almost invisible in the 2008 Grand Palais retrospective, with its abrupt 1972 ending, multi-coloured walls and emphasis on a young 'French Pop'.

Philosophy of the Encounter

How did theory become 'theory' in America? An event of 1966 that had vast repercussions was a conference organised at The Johns Hopkins University, Baltimore: 'The Language of Criticism and the Sciences of Man'.[29] This precipitated the first encounters between thinkers such as Jacques Derrida, Jacques Lacan and Paul de Man. Freed from their native academic and ideological territories, the neutral ground

permitted an exchange of ideas constrained in Paris by the very success of structuralism: Hegelians and Marxists became more open to ideas about structure; Roland Barthes and Derrida, associated most closely with structuralism, for the first time took a critical distance from the movement.[30] François Cusset has described this generative moment of 'swerve', resulting in the metamorphosis of post-war French philosophy into 'post-structuralism' on American campuses in *French Theory: Foucault, Derrida, Deleuze et cie* (2003, English edition 2008). Cusset presented the 'mutations of intellectual life in the United States'. He noted how a 'veritable international political-theoretical arena… has gradually taken shape, enriched by French theoretical thought [*théorie française*] and centred in American universities', while in France he remarks upon the lack of translations or commentaries on analytic philosophy or any convergence between pragmatism and 'Continental philosophy' and the absence of post-colonial thought and gender theory, notions of multi-culturalism or deconstruction in literature.[31] However harsh his judgement, the 'mutations' he notes over a thirty-year period are irrefutable. More pertinently, America's power and creativity since 1945, as well as its domination of the art market, have been corroborated by a bias within the discipline of art history and wider critical discussion. The cultural division, the split in postmodernism itself between Europe and America, has a history still waiting to be written.

Lyotard's *La Condition postmoderne*, published in 1979, has a critical currency as far as European usage of the term 'postmodern' is concerned. Yet it was in the art magazine *Opus International*'s fiftieth issue of 1974 that the art critic Jean-Clarence Lambert, confronting the problem of critical practice with stylistic multiplicity, announced: '1967: the postmodern era has already begun'.[32] I argue both directly and implicitly that it was the confrontation with the explosion of the art world and its discourses – as well as events on the street and the barricades – that released a generation of philosophers from the ivory tower of the École Normale Supérieure and that their engagement with contemporary art played a crucial role in formulating the new postmodern mindset.

A paradox operates at the heart of this book: it is via the philosophers – names as familiar to an international academic public as the names of Impressionist or Cubist painters – that the art of 1970s France must be introduced to the wider audience it deserves. For despite the lessons of 'deconstruction', art history functions, mnemonically at least, via a series of heroic narratives. The problem was postulated by the critic Otto Hahn in the summer of 1964, when the exhibition 'Mythologies Quotidiennes', its title a homage to Roland Barthes, showed thirty-four Paris-based artists (including

Americans such as Peter Saul) in the wake of Robert Rauschenberg's triumph at the Venice Biennale. How could the range of identities and styles compete against the 'magnificent seven' of Warhol, Wesselmann, Rosenquist, Lichtenstein, Johns, Rauschenberg and Jim Dine?

What of the encounters themselves? Louis Althusser declared in 1982: 'Every encounter is aleatory, not only in its origins (nothing ever guarantees an encounter) but also in its effects. In other words, every encounter might not have taken place, although it did take place; but its possible non-existence sheds light on the meaning of its aleatory being.'[33] I focus on encounters which, as Althusser indicated, might never have happened: between Jean-Paul Sartre and his artists, between Althusser himself, Roberto Alvarez-Rios, Leonardo Cremonini and Lucio Fanti, between the sociologist Pierre Bourdieu and Bernard Rancillac, between Michel Foucault, Gilles Deleuze and the painter Gérard Fromanger, between Lyotard and the artist Jacques Monory, between Jacques Derrida and Valerio Adami. The body of writing produced bears witness to these encounters; it offers a contextual density to a certain moment of art and thought in the late 1960s and early 1970s in France, crystallised around Narrative Figuration.

Courbet after Duchamp: *Les rendez-vous manqués*

Following the Centre Pompidou's inaugural Duchamp retrospective, followed by 'Paris-New York', the Grand Palais staged the first major Gustave Courbet retrospective in the autumn of 1977. Rancillac attacked the catalogue which he claimed 'deliberately evacuates the political aspects of the work and the painter's engagement.'[34] In December, the conference 'Realism and Art History' was held in Besançon. A superb transatlantic marriage of minds was envisaged – French and German Marxist art historians in dialogue with the hottest young Anglo-American scholars, T. J. Clark and Linda Nochlin. Clark's *Image of the People: Gustave Courbet and the 1848 Revolution* (1973) had been conceived in Paris during the turmoil of May '68 and its aftermath; the Greek Marxist Nicolas Hadjinicolau (whose *Histoire de l'art et lutte de classes* had also been published in 1973) was also present. However, a trip to Ornans, Courbet's birthplace and an official lunch, drastically reduced time for debate on Socialist Realism and hyperrealism.[35] It seems that the 'New Art History', born in the politicised Paris I describe, remained apparently ill-informed of the problems of contemporary realist history painting.

When Norman Bryson, in *Calligram*, introduced 'New Art History from France' as late as 1988, the emphasis was entirely classical, bestowing on the authors themselves an old-master respectability: Foucault on *Las Meninas*, Baudrillard on *trompe l'œil*, Jean-Claude Lebensztejn on Alexander Cozens, Michel Serres on Turner and others. Cy Twombly, his work rich with classical references, acquired honorary old-master status when treated, finally by Roland Barthes.[36] The contemporary French art of the time was nowhere to be seen.

'1972: the international exhibition Documenta 5, held in Kassel, West Germany, marks the institutional acceptance of conceptual art in Europe' proclaims the 'user's guide' *Art since 1900: Modernism, Antimodernism, Postmodernism*. The authors point out 'the overarching condition of asynchronicity', mentioned as introducing the neo-avant-garde.[37] In fact, Documenta 5 marked both the apotheosis of conceptual art and of American hyperrealism, the movement which, in dialogue with its European counterparts such as Narrative Figuration, likewise accompanied the birth of postmodern theory. The Musée d'art moderne de la Ville de Paris showed 'Art conceptuel et hyperréaliste' from the Ludwig Collection, Aachen, from January to March 1974, followed immediately by 'Joseph Kosuth (Investigation on Art and Problematics (1963–73)'. The director Suzanne Pagé's policy mixed Narrative Figuration shows with both conceptual and women's art exhibitions from 1971 to 1977.

Nowhere is the dialogue so evident as in Cueco's contribution to *Five Romantic Painters of the Malassis Period – or Business as Usual*, exhibited as part of the Malassis group's offering to 'Mythologies II' held at the Musée in 1977. A grid of white squares overwhelms and blots out the painter with his paintbrush and photographic source in his hands, and the baying dogs with their animal passions: it is a literal assault on realism, on tradition, on painting as a practice (see the jacket to this book). While Narrative Figuration was overtly premised upon the photographic and on disjunctures of the image, the museum under Pagé engaged with photography's own experimental history (a John Heartfield retrospective in 1974, Rodchenko in 1977) together with its metamorphosis in terms of film and video ('Art/Vidéo Confrontation 74'). Indeed, the passage from painting to photography was the *leitmotif* of the critic Bernard Lamarche-Vadel's development. Yet the museum's retrospective devoted to his career, in the summer of 2009, completely omitted his pioneering engagement with French Narrative Figuration.[38] Cueco's morose self-portrait, then, was all too prophetic.

The 'user's guide' or 'theory as a toolbox' approach to late European art history empowers while disempowering its objects of study.[39] Unlike the situation in France in the 1970s – and unlike the mindset of the protagonists I describe – it is completely undialectical. Anglo-American 'French Theory' in translation involves a syncretic and anachronistic mixing of texts with varied dates of translation. By removing the immense pressure that the French Communist Party exerted on thought, art and politics, and the explosion of neo-Marxisms in the 1960s and 1970s – *against and with which* Barthes, Foucault, Lévi-Strauss and Deleuze proposed alternative forms of analysis – 'French Theory' offers, cumulatively, a travestied notion of collective thought. These disembodied texts offer no image at all of the period; compare the situation with the multitude of studies situating an intellectual such as Walter Benjamin within his time. 'Doing theory' was still the mantra at the symposium 'French Theory in America' at New York University in 1997, with the participation of many protagonists including Jacques Derrida, Julia Kristeva, Jean Baudrillard, Gilles Deleuze – a perfect loop.[40]

The 'strong reading', with its selectivity and narrative drive, can also mislead. Narrative Figuration as a movement does not exist in Rebecca J. De Roo's *The Museum Establishment and Contemporary Art: The Politics of Artistic Display in France after 1968* (2006).[41] Her study stems from work on Christian Boltanski and Annette Messager, who, with Yves Klein, Daniel Buren, Orlan and Sophie Calle, are arguably the most recognised names, outside France, of the post-1960s generations. Nor does De Roo's institutional history convey the energy and dedication of the younger curators and critics who frequented Pierre Gaudibert's experimental space at the Musée d'art moderne de la Ville de Paris and who moved from the period of the Centre National d'Art Contemporain (CNAC) founded in 1967, with its keynote retrospectives, to the huge experiment of the Beaubourg and its first exhibitions directed by Pontus Hulten.[42] Hulten's epoch-making team efforts included, as noted, not only 'Marcel Duchamp' and 'Paris-New York' in 1977 but also, in the same year, Narrative Figuration's apotheosis – the exhibition of contemporary history paintings called 'Guillotine et Peinture' ('Guillotine and Painting').

Other dialogues

Narrative Figuration nevertheless provided only one of many arenas for thinkers' involvement with the arts. Barthes was engaging with the painter and collagist Bernard

Requichot long before his 'photographic turn' with *Camera Lucida* in 1980. The birth of a psychoanalytic art criticism around the Tel Quel group, pioneered by Marcelin Pleynet, and the links with the Supports-Surfaces group which led to the involvement by the psychoanalyst Jacques Lacan with François Rouan, framed this notionally 'abstract' art, whose concerns embraced structuralism and revolutionary Maoism. There the formal heritages of Duchamp and Matisse competed with the revolutionary Malevich. Moreover, the philosophers themselves, once initiated into the realm of the visual arts, changed and developed their tastes: Lyotard published texts on both Duchamp and Jacques Monory in 1977, on Monory and Daniel Buren – another significant encounter – in 1981; he continued to write on art prolifically and curated 'Les Immatériaux' at the Centre Pompidou in 1985.

As photography and performance challenged the very premises of painting and sculpture, and as post-1968 concerns with personal freedom were explored by increasingly visible women artists – but also gay male artists such as Michel Journiac – new theoretical voices, in particular Julia Kristeva, Hélène Cixous and Guy Hocquenghem became prominent. These fascinating alternatives await a companion study, at this moment when the feminist context of 1970s Paris and artists ranging from Niki de Saint Phalle to rediscoveries such as Alina Szapocznikow are at last entering feminist art histories.[43] In George Pompidou's and Giscard d'Estaing's post-'68 France, the 'liberation' from Marxist frameworks of thinking offered by the turn to Nietzsche in the 1970s (thanks to the translations and thought of Pierre Klossowski) were crucial not only for Deleuze and Lyotard but also for art critics such as Catherine Millet.[44] It is impossible, of course, to give an overview of the 'visual culture' of the 1970s extending to film, television, opera, popular music and fashion, to international vogues and markets that go far beyond my scope.[45] The richness of the 1970s as a whole in France deserves a comprehensive retrospective and reappraisal.[46]

I return to the 'French theory' which operated within a certain field of high culture including the art world. Writing on art (and often philosophy) in the 1970s was based on the *essai*, specifically unacademic in character and utterly dissociated from university 'art history' prior to 1968. The project of the review *Derrière le miroir*, active from 1946 to 1982, was specifically to foster the pairing of artists with writers and this kind of writing. Later exhibition projects and new pairings continue the tradition, notably the philosopher Paul Virilio's 'Impact Inspections', written for Peter Klasen's monograph *Klasen Virilio* in 1999.[47] The enlightened members of the review *Macula* abhorred the

genre. Yve-Alain Bois, who left France for the United States – inspired by figures such as Meyer Shapiro and Clement Greenberg – retrospectively linked this writing with the blackmail of anti-formalism (see 'Resisting Blackmail' with which he introduced *Painting as Model* in 1990). He decried 'the Writer's or Philosopher's essay on art, more often than not an efflorescence of condescending words uttered by a complacent man of letters'.[48] It is the *essai*, however, that is at the heart of my investigation: the intersubjective encounter between writer and artist, the entry of the philosopher into the studio, the invitation to contemplate the practice of painting and its relationship to photography and, finally, the generation of a critical text – fruit of the encounter – as well as the tissue of exchanges between the worlds of art and philosophy and, in the broadest sense, the worlds of culture and politics at large.

So back to the 'philosophy of the encounter', a term used recently to introduce Althusser's later writings to an English-speaking public. Althusser's proposition qualifies the prescriptive and pedagogical nature of his earlier, theoretical writings. In 1982, re-hospitalised in Soisy, writing in the rain, in mourning, always, for his strangled wife Hélène, he describes the main thesis of his projected book: 'the existence of an almost completely unknown materialist tradition in the history of philosophy: the "materialism"… of the rain, the swerve, the encounter, the take [*prise*]… let us say, for now, a *materialism of the encounter*, and therefore of the aleatory and of contingency.'[49] This was repressed by philosophical tradition, he claimed, into an idealism of freedom; his task – to release the concept from this repression – introduced the Lucretian concept of the *clinamen* or 'swerve' of atoms as positing the origin of the world itself in contingency rather than Reason or Cause.[50] Later, having pitted Epicurus against Heidegger, he turned to his hero, Machiavelli, who created 'the conditions for a swerve' in the 'atomised' country of Italy: the Prince himself incarnated the encounter between *Fortuna* and *virtù*.[51] In short, Althusser's problem was the competition between materialist Marxist analyses – involving classic 'reflection theory' – and the conjunction of 'great men', chance and history: 'Hölderlins, Goethes and Hegels come into the world conjointly', Althusser argued. Napoleon rose and fell, specific encounters were catalysts for the Russian Revolution.[52] My focus on specific exchanges likewise avoids the pitfalls of reflection theory at its most vulgar, usefully narrowing the field; but its conjunctions of 'theory' and practice perforce exclude many artists, even within the Narrative Figuration arena (and Adrian Rifkin has warned of the 'wretched failures of recognition and over-demanding manipulations' as regards Zola on Cézanne or Proudhon on Courbet[53]).

It is not only many artists who receive scant attention: justice is not done to the late curator and writer Pierre Gaudibert, the founder of ARC (Animation, Recherche, Confrontation) at the Musée d'art moderne de la Ville de Paris; the critic Gérald Gassiot-Talabot, important for the early exhibitions; and the critics Alain Jouffroy and Jean Clair. Their roles were as crucial in creating an artistic and critical climate as Pierre Restany's role in promoting the Nouveaux Réalistes. Restany is at last acquiring the profile he deserves beyond France – alas, posthumously.[54] A magisterial unpublished thesis by Anabelle Ténèze situates Gaudibert's role as catalyst, his rise and fall, within the context of the decisions of the French ministry of culture and Parisian organisations, and the developing museography of the Musée d'art moderne de la Ville de Paris itself.[55] Jouffroy, the author of more than two hundred critical essays, rests untranslated; he has already deposited his extensive archives in two research venues in France.[56] As both a critic and a driving force behind the review *Opus International*, his name will appear several times in these pages, while his exhibition 'Guillotine et Peinture' at the Pompidou Centre in 1977 frames my conclusion. Jean Clair (the curator Gérard Regnier) promoted the Narrative Figuration artists as the editor of the Galerie Maeght's *Chroniques de l'art vivant* in the early 1970s, reshaping his essays in the panoptic publication *L'Art en France: une nouvelle génération* of 1972. He published Lyotard's first articles on hyperrealism and they collaborated on the Duchamp retrospective of 1977. While the dialectic between Duchamp's uncompromising conceptualism and a profoundly melancholic love of painting has structured Jean Clair's subsequent career as a highly controversial writer and curator, his rejection of the 1970s artists he once interviewed with brilliance and sensitivity is significant.[57] He became a member of the Académie Française in June 2009.

Almost twenty years passed before the first reappraisals of the Narrative Figuration movement. In 1992, 'Figurations Critiques' in Lyon looked back at eleven artists.[58] In 1996, the Centre Pompidou's catalogue *Face à l'histoire* contained an overview of strategies of political criticism and *détournement*, along with Gérald Gassiot-Talabot's text, which charted the development from Narrative Figuration to *Figuration critique* – a rival term. He claims paternity for *Figuration narrative* in 1964 (as opposed to the earlier *Nouvelle figuration*).[59] Jean-Louis Pradel's *La figuration narrative* (2000) was conceived for an exhibition at the Villa Tamaris, La Seyne-sur-Mer, and considered the artists Valerio Adami, Erró, the German Peter Klasen, Jacques Monory, Bernard Rancillac and Hervé Télémaque.[60] Gérard Fromanger was not included in this show,

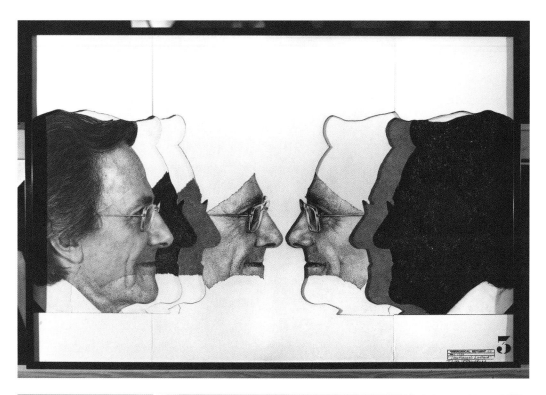

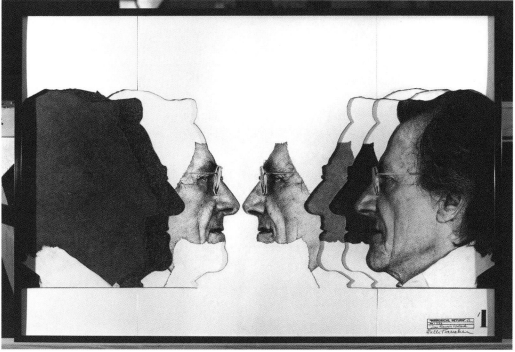

4. Francken, *Lyotard*, 1982-84

which travelled to Bergen and Reykjavik. The decade-based catalogue reprinted a selection of important critical writings and contained biographies of artists both in and excluded from the show. Jean-Luc Chalumeau's *La Nouvelle figuration: une histoire, de 1953 à nos jours* (2003) involves a whole spectrum of artists, artist groups (Les Malassis, Equipo Cronica), even the Italian Titiana Maselli. It offers a broad sweep in time and space and is superbly illustrated but its concerns are remote from my own.[61] In 2005, *La Figuration Narrative dans les collections publiques 1964–1977* demonstrated how Narrative Figuration immediately entered national museum collections.[62] That year, Raymond Perrot (a member of the DDP group of militant artists, with François Derivery and Michel Dupré, who have attempted to promote a critical art history since the mid-1970s) published *De la Narrativité en peinture: essai sur la Figuration Narrative et sur la figuration en général*, to be followed by his colleague Michel Dupré's *Réalisme(s): peinture et politique* in 2009.[63] One should also mention Fromanger's major touring retrospective which went from the Villa Tamaris in 2005 to Seoul in 2006 and Cuba in 2007, the Brasilia retrospective of 2009, his recent monograph by Serge July, the veteran director of *Libération*, and a comprehensive new Monory monograph edited by Paris-Musées.[64] The Galeries Nationales du Jeu de Paume followed the Erró retrospective in 1999 with Peter Stämpfli in 2002. In 2005, the Maison Européen de la Photographie exhibited Klasen's photographs from 1970 to 2003 (used for years as the source of his figurative paintings) in their own right – the artist significantly 'reinvented' for the era of photography.[65] The major Télémaque retrospective in Paris, held 'off-circuit' at the Musée de la Poste in 2005, demonstrated the power and complexity of this artist's work. He would be considered as a pioneer painter for a post-colonial art history, and a major precursor to Jean-Michel Basquiat, if he had stayed in New York after leaving his native Haïti in the early 1960s.[66]

The cultural history I offer via the conceit of the encounter, and my own encounters with certain artists, has no specific agenda of advocacy.[67] I would have liked to elaborate, in particular, on the struggles of women artists in the orbit of the Narrative Figuration movement such as Lourdes Castro, and the latecomers Sabine Monirys or Jacqueline Dauriac, whose work has been omitted from critical readings and group shows.[68] Indeed, the 'masculine' group ethos, inherited from earlier avant-gardes and their combative rhetorics, dates the Narrative Figuration enterprise. It remains alive and well: Erró's misogynistic 'Amazones' series in 2003–4 was succeeded by the exhibition 'Femmes' in 2008.[69] It is also poignant that I write after the tragic dispersion at auction

of Ruth Francken's life work.[70] Her 'Mirrorical Return' portraits, including those of Monory and of Lyotard (pl. 4) extends Narrative Figuration's intellectual world and world of friendships: 'Richard Lindner, Earle Brown, Maurizio Kagel, Jean Tinguely, Yannis Xenakis, Michel Butor, John Cage, Joseph Beuys, Jacques Monory, Bernard Heidseck… Luce Irigaray speaks of the "dark continent of woman"; I would like to examine the presumed clarity of man's continent', she declared.[71]

In 1975 at the Venice Biennale, Lyotard spoke of 'male writing' (*l'écriture mâle*) and a 'genre which is and which remains masculine, the genre of the *essai*… Masculine is… a body which can die …Men (in the West at least) love not to love but to conquer. Between them, there is irony and contempt for the sensual body, smell, touch, secretions… those who give in to these they call "artists". But artists are women'.[72] Paris, one knows, is also a woman… and thereby hangs a tale more complex than 'how New York stole the idea of modern art', of which France, since the 1970s, has been supremely aware.[73] To what extent, could one ask, did the engagement of the Narrative Figuration movement – its prickly politics, its Cold War hostilities – contribute to the situation in which France's primary intellectual export switched from paintings to a 'hard', masculine, decontextualised 'theory', purveyed abroad in the faculties of philosophy, sociology, literary criticism, even art history, with no engagement with the visual, sensual world of its time? Lyotard concluded his thoughts on *l'écriture mâle* with a jesting proposition around 'the primacy given to theoretical discourse' as 'male sexism'; he was already alerted to the 'sexing' of 'theory'.[74] While my continuing commitment to France's female artists cannot appear in this book, there is a transgressive element at the heart of its proposition; a conjunction of the female voice (my own) with an essentially male 'philosophy', recently explored by Françoise d'Eaubonne as a continuing 'historical allergy'. With her I shall continue to challenge what she calls *la fausse evidence universaliste*, France's exacerbated universalism and its *droits de l'homme*, where 'the rights of man' so often means man.[75]

The epistemological break signified by 'French Theory' has had inestimable repercussions in contemporary art practice, changing previous paradigms, conceptions, norms, the very parameters of creation and the definitions of art itself. I ask, then, what it might mean, today, to engage with Narrative Figuration in a hyper-capitalist, globalised and terrorised society, facing economic recession and the potential collapse of the narratives of both liberal capitalism and democracy; to mark the transition from painters of their times to witnesses of the future?

The Datcha
Painting as Manifesto

1969: Louis Althusser, hesitating to enter Claude Lévi-Strauss's datcha 'Triste Miels', where Jacques Lacan, Michel Foucault and Roland Barthes are together, just when the radio announces that the workers and students have decided, joyously, to abandon their past.

'A datcha is a Russian house in the country. Many Soviet intellectuals have been consigned to datchas for the main part of their lives, for diverse reasons. Considering them dubious without expressly condemning them, the powers that be kept them – and still keep them – away from public life to avoid them causing a nuisance by getting mixed up in what is none of their business.'

So a datcha is a secondary residence which risks becoming a principal residence.

Here too in the 'free' world the difficulties of life risk pushing each of us into what's none of our business. This is why intense publicity encourages each of us to pass the maximum amount of time in a calm retreat in nature.

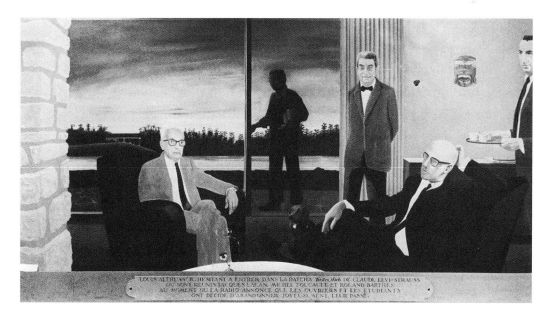

5. Aillaud, Biras, Fanti, Rieti, *The Datcha*, 1969

Intellectuals who at once have more time than others and always need more time for thought, rush to these secondary residences. It's there in the peace and quiet of meditation that they evidently court the greatest danger. They risk brusquely perceiving one day that no one asked their opinion to pass to action and get mixed up at last in what concerns us all.

Characters:

– Louis Althusser, *Marxist philosopher.*

– Claude Lévi-Strauss, *ethnologist. Professor, Collège de France. Candidate for the Académie Française.*

– Jacques Lacan, *psychoanalyst.*

– Michel Foucault, philosopher. *Professor, Collège de France.*

– Roland Barthes, *critic and essayist. Professor, École Pratique des Hautes Études.*

Gilles Aillaud[1]

A grandiose painting (two by four metres), *The Datcha*, was conceived by the Spanish painter in exile Eduardo Arroyo and executed by Gilles Aillaud, Francis Biras, Lucio Fanti and Fabio Rieti. It was created for the Salon de la Jeune Peinture's 'Police and Culture' exhibition at the Musée de la Ville de Paris in July 1969 (pl. 5). The description above, by Aillaud, a disciple of Louis Althusser, was not printed in the fifth *Bulletin de la jeune peinture*, which served as a catalogue to the exhibition; only an elliptical *résumé* was retained: 'a permanent and secondary residence, where, in a particularly well-appointed décor, plenitude of an exceptional nature favours the creation of structures'.[2]

Althusser's collaborative experiment in philosophy early in the 1960s had been unique. The 'liberating shock' of his desacralisation in *Pour Marx* and *Lire le Capital*, published in 1965, created a generation of fresh debate.[3] Its corollary was the import of 'Althusserian' procedures, as well as political stances, into painterly practice, particularly group practice. No work is more eloquent of this shift and the conjunctions of theory and practice in the immediate post-1968 period than *The Datcha*. As a realist work deliberately parodying academic history painting, it bore an ornately presented inscription at the base of its frame: 'Louis Althusser, hesitating to enter Claude Lévi-Strauss's datcha "Triste Miels", where Jacques Lacan, Michel Foucault and Roland Barthes are together, just when the radio announces that the workers and students have decided, joyously, to abandon their past.'

What was the meaning of this substantial painting? Rieti has retrospectively called Lévi-Strauss, Lacan, Foucault and Barthes *les quatre gens du régime*; it is significant that even Althusser was considered a 'structuralist' in a contemporary, popularising publication.[4] *The Datcha* (its name, *Tristes Miels*, 'Sad Honey', recalling Lévi-Strauss's book *Tristes tropiques*) signifies both the elevation and the enclosure of these philosophers, privileged *apparatchiks* of the educational elite.[5] It represented this elite as an ageing patriarchy, whose values and voice of authority were self-declared. Their remoteness from the real lives of the students and workers, from politics and action on the streets, is symbolised by the radio, which conveys joyous revolutionary experience only at second hand, subjected to state censorship.

Althusser hovers on the threshold. As institutionalised as any of his peers at fifty, he was nonetheless responsible for 'rescuing' Lacan from the world of medicine and bringing him into the École Normale Supérieure.[6] His seminar on Lacan and psychoanalysis in 1963–4 followed those on the young Marx (1961–2) and on the origins of structuralism (1962–3). *Dialectique marxiste et pensée structuraliste* had been published in his honour in 1967: the generational divide was clear.[7] Althusser, the smallest in size in the painting, standing outside a problematically invisible glass veranda door – a shadowy presence – was thus accorded the greatest critical distance. *The Datcha*, with its Soviet metaphor and atmosphere, clearly states a problem about the powerful intellectuals it depicts, who in 1969 were already deemed remote from contemporary concerns: revolutionary action took place outside the ivory tower. They were a new 'Holy Family', declared Raymond Aron from the right.[8]

From the far left point of view, Althusser's fidelity to the French Communist Party and his distance from the student protesters of 1968 is implicit in the critique. For orthodox Communists, *The Datcha* was highly problematic in its portrayal of figures of dissidence: it 'required all the moral and organisational force of Aillaud and Arroyo for it to be completed'.[9] *The Datcha* stands for the Collège de France, the École Pratique des Hautes Études, the École Normale Supérieure; for the cradles of what has been called, after Pierre Bourdieu, 'French intellectual nobility'. Bourdieu, Althusser's pupil and a mere sociologist, is absent. The attack, then, was on institutions, too, bastions of theory versus praxis, of the bureaucratisation of revolutionary thought and desire. This system of elites ruling France provided the catalyst for Bourdieu's investigative career; but not until 1989 did he study the link between the reproductive function of the *grandes écoles* and their practice of confinement and 'symbolic violence'.[10]

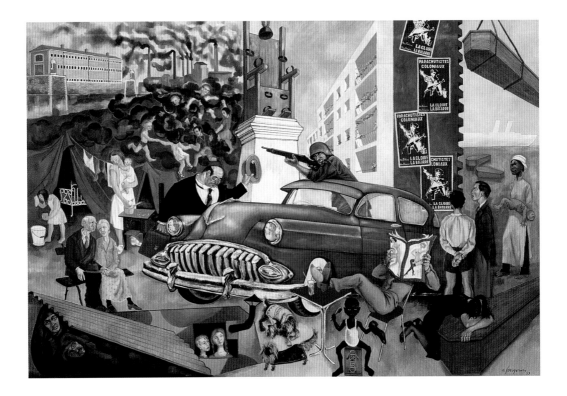

Niilo Kauppi's *French Intellectual Nobility* (1996), following Bourdieu, charted the mobility of subject boundaries and disciplinary models in a new media age that turned these professors into international stars – an evolution unforeseeable when the *Datcha* was painted.[11]

This, then, was a realist history painting in a Salon, hard versus the 'soft' of the prevailing *informel* – and designed to create a scandal. The continuation of the *grandes machines* of history painting in de Gaulle's France and afterwards is a well kept secret. A consensus view might be that an American scale was one of the distinguishing factors of a post-war turn to American painting. In fact, Picasso's *Guernica* in the Museum of Modern Art, New York, had informed not only Pollock but also the huge paintings that Roberto Matta, for example, brought back to Europe. The Salon paintings of the Socialist Realists, such as André Fougeron's *Atlantic Civilisation*, four by six metres, rivalled cinema-screen dimensions as early as 1953 (pl. 6). Even more significantly, James Rosenquist's room-sized *F-III* of 1964–5, was exhibited in Paris in 1967 as part of the Leo Castelli-Ileana Sonnabend contribution to the show 'Bande dessinée et figuration narrative' (pl. 7). Sheer size has been one factor explaining the reluctance of France's own museum structures to show major large-scale works; the other has been the critical

6. Fougeron, *Atlantic Civilisation*, 1953

content of a politicised figuration, conceived to challenge the very notion of a future cultural heritage. The result has been international ignorance based on sheer invisibility. By 1972, the Malassis group (Gérard Tisserand, Henri Cueco, Michel Parré, Lucien Fleury, Jean-Claude Latil) had surpassed Rosenquist in scale with their epic denunciation of the de Gaulle and Pompidou years, *The Grand Méchoui* (see pl. 116).[12]

The Datcha was a Salon painting and a manifesto. Grand Socialist Realist precursor paintings were uncannily evoked, memories of which had effectively been repressed in this period of unresolved de-Stalinisation. The 'shock-brigade' collective Soviet paintings, originating in the 1930s and promoted as late as 1952 by the still active Louis Aragon, the French Communist Party's cultural spokesman, were also precursors here.[13] The *travail de deuil* – the work of mourning still unfinished – is implicit, one could argue, in the frozen 'dead' postures. Ghostly in black and white reproduction, the colour was apparently garish, with asparagus-coloured trees and a red sunset: kitschy and very badly painted, Lucio Fanti recalls.[14] The Salon de la Jeune Peinture's 'Police and culture' show of May 1969 contained many other large-scale works with propagandistic, critical aims but in *The Datcha*, while speed of execution was paramount (hence the many hands involved), the Soviet ghost of collective authorship was countered by a post-Duchampian collective disdain.

The artists who painted the 'academic' *Datcha* cast themselves as the James Bonds of the art world: not only was 'French theory' itself contested by an emerging generation of political painters, as *The Datcha* makes clear, but the spectre of Duchamp was even more problematic. 'Better to paint and not to sign, than to sign and not to

7. Rosenquist, *F-III*, 1964-5

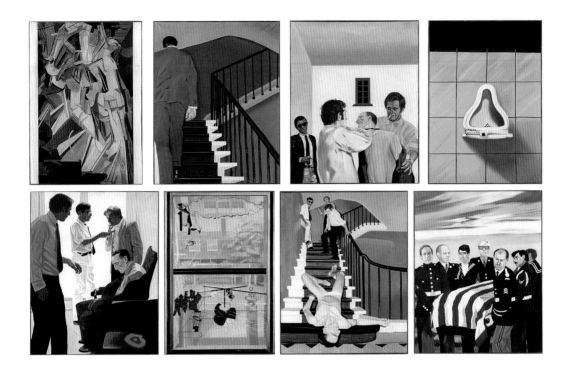

paint' had been the clarion call of the serial work *Live and let die: or the Tragic End of Marcel Duchamp* (pl. 8). It dominated the exhibition 'La Figuration narrative dans l'art contemporain' held at the Galerie Creuze in October 1965 (with no fewer than sixty-eight artists). Eight paintings in sequence were shown as a collective work by Eduardo Arroyo, Gilles Aillaud and the Italian Antonio Recalcati – although other artists may have been involved.[15] They comprised: 1) Duchamp's *Nude descending a staircase*, brilliantly copied; 2) a staircase with a suited figure, Duchamp, mounting the steps (a blue stair carpet); 3) an interrogation room with a parody of Duchamp's *Fresh Widow* as a window giving out onto the night; Duchamp severely treated by three ruffians; 4) a solitary urinal, Duchamp's *Fountain*; 5) the interrogation room with an exhausted Duchamp and a cushion – (the heart originally a *Verve* magazine cover); 6) *The Bride stripped bare by her bachelors, even*, another copied image; 7) a nude Duchamp cast down the staircase, his genital area unpainted canvas (a pleasing symmetry with his asexual *Nude descending* here), three tormentors mocking him from above; 8) a coffin draped with the stars and stripes borne by 'American Marines', recognisable as Robert Rauschenberg and Claes Oldenberg, Martial Raysse with the dark hair, Andy Warhol with the spectacles, Arman in the foreground and the art critic Pierre Restany on the right with the dapper moustache.

8. Arroyo, Aillaud, Recalcati, *Live and Let Die*, 1965

This aggressive collective work, made before *The Datcha,* suggests a second Oedipal history: the problem of Duchamp and the stifling of painting by pervasive Duchampiana. Nouveau Réalisme, Restany's spectacular and effective grouping of a range of artists using objects from the real world, was responsible. Duchamp's betrayal was double, not only of painting as a practice but also of France at the moment of political resistance to Vietnam (he had taken American nationality in 1955). The Nouveaux Réalistes are represented in *Live and let die* as uniformed, co-opted into the American military effort. They had in effect capitulated to the artistic and political enemy. Yet their fraternisation policy was doomed: the group show 'New Realism' at Sidney Janis's New York gallery in 1962, with Restany's text cut short, heralded the demise of the French group's specificity.

In *Live and let die* the artists are portrayed as troubleshooters – tough guys, men of action, not afraid to assassinate a celebrity if necessary. The James Bond cachet gives them an aura of bravado: it adds danger and humour to their critique and inscribes painting into the world of the contemporary Cold War spy story (*le polar*, pl. 9) and film. What a bravura performance! How extraordinary to paint the reflections of Mary Reynolds's garden through the *Large Glass* from the original photograph! What a contrast with the geriatric protagonists of the *Datcha* in their feminised, out-of-town space, their professorial easy chairs.[16]

I shall return to this realist, critical painting but now the 'rewind' must go back to the earlier 1960s. In 1963, British Pop dominated the Biennale de Paris with work that was sexy, funny, critical: Peter Blake's fanzine-based *Got a Girl* and *Wall of Love*, works by David Hockney, Derek Boshier, Alan Jones, Peter Phillips, Philip King. The *bonnardisme* and the weak *informel* of the Salon de la Jeune Peinture was tedious in comparison.[17] Arroyo and his band orchestrated the dynamic takeover of the sixteenth Salon de la Jeune Peinture in January 1965 and introduced a new figurative wave of painting. Here, the 'Green Room' ('la Salle verte') demonstrated the beginnings of change: the group advocated discussion and a satirical, political realism; they were against abstraction, against the monochrome. Arroyo's *Six Lettuces, a Knife and Three Peelings* was the most obvious metaphor for painting's turn from still life to political action.

9. Fleming, *Vivre et laisser Mourir*, 1964

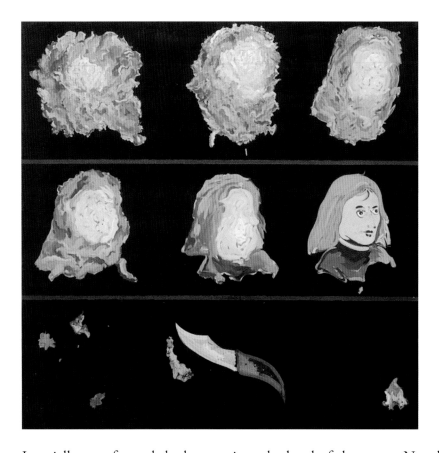

It serially transformed the lettuces into the head of the young Napoleon Bonaparte, reversing Charles Philipon's celebrated *topos* of King Louis-Philippe turning into a pear, while promoting the idea of military advance on the battlefield via camouflage (pl. 10). The London link was part of the 1965 Salon's agenda: Richard Hamilton, the sculptor Joe Tilson and Patrick Caulfield were invited, with the Spur group from Munich and Equipo Cronica from Madrid. (Caulfield's black contours, monochrome backgrounds and the uncanny sense of emptiness tempered with a deadpan humour had already ironised the mantra of 'Greenbergian flatness' and had a persuasive impact on painters such as Valerio Adami and the future 'Malassis' Lucien Fleury.[18]) The Salon coincided with the exhibition by Aillaud, Arroyo and Recalcati, 'Une passion dans le desert', a narrative sequence of paintings parodying Balzac's eponymous short story at the Galerie Saint Germain.[19] 'Figuration narrative' with *Live and let die* followed in October.[20] The Salon de la Jeune Peinture is central to Narrative Figuration's story, as are the curator Pierre Gaudibert's efforts to realise its objectives with major retrospectives in the ARC space of the 1930s-style Musée d'art moderne de la Ville de Paris.

10. Arroyo, *Six lettuces…* 1965

Two other *peintures-manifestes* take me back to the starting line. *Live and let die* pursued group authorship as a political objective: its stylistic homogeneity (given a beta grade by Marcel Duchamp) constituted part of the critique of capitalism and the art market.[21] This distinguished it from manifesto paintings marked by an aggressive cacophony of signature styles. The *Great Antifascist Collective Painting* of 1960 was the first (pl. 11). Antonio Recalcati is the transitional figure. He worked on this huge canvas with Erró, Jean-Jacques Lebel, Enrico Baj and two other Italians, Roberto Crippa and Gianni Dova.[22] Lebel had organised 'Anti-procès 1', an international exhibition and series of events (repeated in Venice) in May 1960 at the height of the Algerian war and its contested conscription policy: the *Great Antifascist Collective Painting* was shown in Milan in 1961 and promptly confiscated by the Italian police. Pasted onto the huge canvas was the immensely controversial *Manifeste des 121* signed by 121 intellectuals (drafted mainly by the writer Maurice Blanchot), which declared the right of young French men to refuse to bear arms against the Algerian people.[23] Here, each individual style was recognisable: Baj's screaming generals, Erró's choir of unholy cherubim, Lebel's aggressive swastika.

11. Recalcati, Erró, Lebel, Baj, Crippa, Dova, *The Great Antifascist Collective Painting*, 1960

This concept was repeated in 1967, the fiftieth anniversary of the Russian Revolution of 1917, with the manifesto painting created for Fidel Castro, the *Collective Cuban Mural* (*Mural Cuba Collectiva*). The painting formed part of an international collective event in Cuba, after the terror of the Cuban missile crisis: it demonstrated the divide into pro- and anti-Communist factions of the world's intellectual communities.[24] Deeply anti-American, it took place at the very moment when France's pavilion was eclipsed by the Americans' Buckminster Fuller dome at the Expo '67 world fair in Montreal. Major artists and writers, along with a selection of the contents of the Parisian Salon de Mai, were transported by air to Cuba in a pro-revolutionary propaganda move – a prelude to the 'anti-imperialist' Cultural Congress of Havana which took place in January 1968 (more than five hundred participants from eight countries, again involving artists and French intellectuals).[25] In a single night, 17 July 1967, in front of television cameras, the huge, target-like, spiralling pro-revolutionary *Collective Cuban Mural* – a worthy successor to the *Great Antifascist Collective Painting* – was created by a hundred artists. Again, personal style became signature, not only of artists but also of writers, from Maurice Nadeau to Juan Goytisolo. This largely expressionistic work, constituted from six separate panels, involved artists from the Surrealist Wifredo Lam to the Cobra group; it was visually punctuated by the silkscreen-effect work of Rancillac, the flat contours of Adami's *José Corti* and the blue dream-world of Jacques Monory: it exemplifies the transition from a 1950s inheritance to Narrative Figuration – and a moment of exhilaration before the compromise, for left-wing intellectuals, of the Cuban dream (following Castro's forced approval of the Soviet invasion of Prague in August 1968). The *Collective Cuban Mural* was exhibited in Paris in 1968, at the Salon de Mai (pl. 12, where its political force was dramatically eclipsed by events outside the gallery walls, on the streets.

This brief history of the 'painting-manifesto', originating with the 1950s generation of Cobra painters, brings me back to the point of departure and the figure of Jean-Paul Sartre. He is the significant absence – the Godfather – of the *Datcha* mafia.

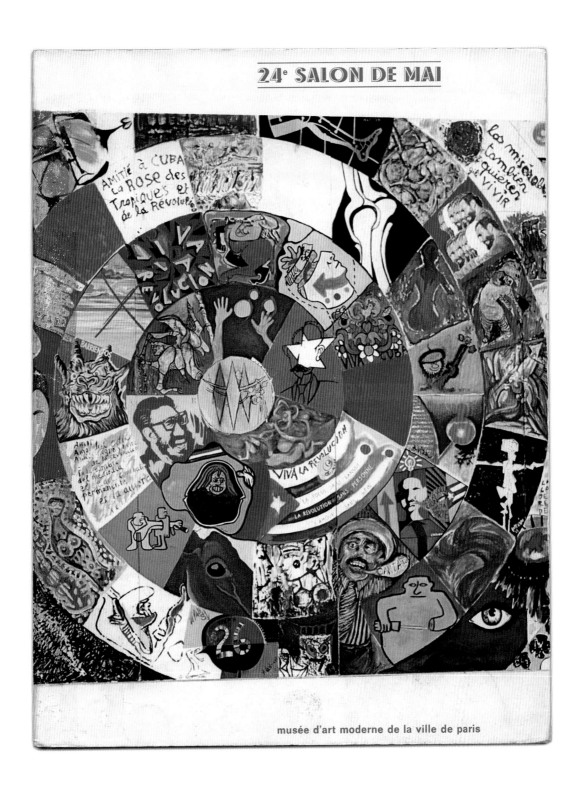

12. 24 Salon de Mai, Paris, 1968, (*Collective Cuban Mural*, 1967)

From Sartre to Althusser:
Lapoujade, Cremonini and the Turn to Anti-Humanism

> Victims, executioners: the painter makes our portrait. The portrait of the century, in fact. At the same time the object of his art is no longer the individual. Or the typical. It is the singularity of an epoch and its reality. How has Lapoujade succeeded, within the constraints of the 'abstract', what figurative art could never achieve?
> Jean-Paul Sartre on Lapoujade, 1961[1]

> I have begun the preface to these two volumes on *Capital*, and I have found myself engaged in a new enterprise, having discovered that it was indispensable for me, to explain how we have read *Capital*, to develop a whole 'theory of reading', for which naturally I had previous points of reference (what I suggested in the paper on Leonardo [Cremonini]... It will be a theory of 'symptomatic reading' within an epistemological domain.
> Louis Althusser, letter to Franca Madonia, 1965[2]

In March 1961, Jean-Paul Sartre prefaced the artist Robert Lapoujade's exhibition at the Galerie Pierre Domec in Paris: 'Paintings on the theme of Riots, *The Torture Triptych*, *Hiroshima*.' In May, the Galerie du Dragon showed figurative paintings by Leonardo Cremonini, prefaced by the critic Pierre Gaudibert; again the subject was torture and the Algerian war (pl. 13). It is probable that the philosopher Louis Althusser went to see this exhibition. Throughout the 1960s, Althusser developed his friendship with Gaudibert and Cremonini; while writing about painting as a practice, he became increasingly familiar with the French and Italian art worlds. Althusser's writing on art, compared with Sartre's, marks a change between two modes of representation and, indeed, two different epochs. Sartre's art writing continued within the mode of an existentialist humanism which embraced not only Giacometti's figurative painting and sculpture in the 1940s and 50s but also the semi-abstract *informel* work by Lapoujade and the politicised expressionism of Paul Rebeyrolle in 1970.

13. Cremonini, *La Torture*, 1961

Althusser, by contrast, moved from an early experiment with a 'colonial' late Surrealism to the advocacy of a 'critical' painting where the role of theory was important: Narrative Figuration. Here, his writings on Cremonini enjoyed a curious bridging role. Reciprocally, Cremonini's art became less painterly, with a sharper and more constructed realism during the later 1960s and after; he became the first artist to figure in the book edited by Bernard Lamarche-Vadel, *Figurations 1960–1973*.[3]

The magnificent Sartre retrospective of 2005, at the Bibliothèque Nationale de France in Paris, demonstrated the stature of this national figure. Extensive coverage was given to his novels, plays, political writings, letters, editing enterprises, political action on the street and engagement with contemporary media in hours of film and television. The exhibition demonstrated, quantitatively at least, the entirely subsidiary role that his writings on art had played in the constitution of 'Sartre as myth'.[4] These writings were by no means insignificant, but in status Sartre eclipses any contemporary artist on whom he wrote: Wols, André Masson, Lapoujade, arguably Giacometti. Nevertheless, it is the historical conjunction of Sartre with his artists that offers what Althusser described as a 'symptomatic reading' of the period and informs later readers' understanding of Cold War cultural politics. Sartre was a figure with whom all younger thinkers had to contend. Althusser's immense success in the 1960s as a political philosopher and charismatic figure, able to challenge and contest Sartre's universalism, is at stake here, as is his role in first supporting and finally attacking the power of the French Communist Party during its period of unsuccessful de-Stalinisation.

The 'epistemological break' symbolised by Althusser turns around the 'humanist controversy' which raged from 1963 to 1965. His writing on Cremonini clearly works through an unresolved situation at a tense moment of Communist Party politics: its art policies were not only involved with de-Stalinisation but also *rapprochement* strategies with the Catholics – competing with the Church's new modernist directives following the Second Vatican Council.[5] Althusser challenged the humanist concept of the artist – at the end of a development whose roots lay in Renaissance Italy – along with the concept of the work of art as a representation inviting empathic projection on the part of both artist and viewer. Concurrently, a change in visual and material culture was accelerating in France: Roland Barthes's *Mythologies* of 1957 examined the signifiers of increased prosperity such as plastics, advertisements and domestic television. In contrast, Guy Debord's *Society of the Spectacle* of 1967 signalled a loss of innocence, a complete break with the post-war culture of reconstruction. Its humanism had been

shattered by competitive consumerism set against the atrocities of colonial war and, internationally, the cynical and dangerous arena of Cold War geopolitics, guaranteed by the scientific achievements and the stockpiling of nuclear weapons in the atomic age.

For both Sartre and Althusser, the political engagement of the writer and the artist was crucial; writing about art was a display of cultural power and an act of leadership. Reciprocally, for both Lapoujade and Cremonini, the intellectual credentials of their work and its value were enhanced by philosophical or phenomenological interpretations. For Sartre, as for Hegel, aesthetics were integral to his philosophical project as a whole. His early publications such as *L'Imaginaire* and *L'Imagination*, along with Maurice Merleau-Ponty on Cézanne and André Malraux's *Musée imaginaire* project, offered key theoretical texts for a 1950s generation of painters. Sartre wrote on art in the tradition of a Baudelaire. Moreover, not only had he himself set the parameters for defining an *art engagé* in the 1940s but he also embodied the philosopher-writer whose domain extended to all aspects of contemporary thought and practice. The *travail du préfacier* – both the work of writing a preface and the conception of its function – went far beyond a simple act of friendship or the production of a commissioned introduction; it demonstrated a vision and consciously constituted a moment of the Zeitgeist.

In writing on artists from Wols to Giacometti, Sartre offered the paradigmatic encounters between philosopher and artist, between texts and artistic forms, both abstract and figurative, which could be said to typify the climate of existentialism.[6] As early as 1954, however, when Giacometti's exhibition was prefaced by Jean Genet at the Galerie Maeght, Sartre was visibly disassociated from 'his' artist because of his two-year-old allegiance with the French Communist Party, which lasted to late 1956. This period included his visits to both the Soviet Union and China; it extended over Stalin's death in 1953 and the beginnings of a cultural thaw. The year 1956 was traumatic for Communists worldwide and for Sartre: events unfolded in quick succession – the revelations of Stalin's crimes at the Twentieth Congress of the Communist Party of the Soviet Union, the Suez crisis and the Soviet invasion of Hungary. Against this backdrop, the Algerian question, accelerating into violence from 1952 onwards, remained unresolved until 1962.

Sartre's reflections on the torture of the colonised Other in his Lapoujade preface inevitably reverted to the moral dilemmas posed at the time of the Nazi Occupation of Paris, when torture techniques were practised that were later put to good use in Algeria.[7] Along with Sartre, many intellectuals (such as Georges Bataille) had at that

time reflected on the proximity between victim and torturer or executioner, *le bourreau*. In a more abstract way, Merleau-Ponty had posed the question of the means and the end in 1947, as the dialectic between humanism and terror, at a time when France's morality as a whole was rocked by purge killings and scandals: he focussed on the Soviet show trials of the late 1930s versus the 'greater good' of the revolution.[8] Sartre's 1948 text 'Black Orpheus' transposed the discourse of self and Other onto the colonial paradigm. 'Black Orpheus' prefaced the anthology of works by Aimé Césaire, the Communist political activist in Martinique, celebrated as the poet of *négritude*. Deeply affected both by Sartre and Césaire, Frantz Fanon, the Martinique-born psychiatrist and anti-colonialist militant, published *Peau noir, masques blancs* in 1952 (as *Black Skin, White Masks* in 1967 and after this became a cornerstone of post-colonial theory in the English-speaking world).[9] Fanon also spoke in situations that had a specifically cultural agenda, for example his speech 'Racisme et culture' for the first Congrès des écrivains et artistes noirs, held in Paris in September 1956.[10]

In 1957 Sartre's 'Portrait of the Colonised' in *Les Temps modernes* preceded his engagement with the issue of torture in Algeria. This appeared firstly in relation to Henri Alleg's *La Question* (1958), then with his own play *Les Sequestrés d'Altona* (*Loser Wins,* 1959, where the issue was transposed to Nazi Germany) and finally around the *Manifeste des 121* (as noted earlier, declaring the right to avoid conscription) which was destined to be published in *Les Temps modernes* of August-September 1960 but was immediately censored by the state.[11] These concerns frame Sartre's preface on Lapoujade's *Torture Triptych* of March 1961 and were intensified when Sartre met Fanon in Rome in July. He agreed to write a preface to *Les Damnés de la terre* (*The Wretched of the Earth*) for Fanon – one of his most violent texts – just before Fanon's death.[12] Sartre continued writing about the painting of Jacopo Tintoretto during that year, focusing on the incipient torture of a Christian slave miraculously prevented by the weighty Saint Mark, who plummets down from the sky to his rescue.[13]

The Algerian war was waged in a climate of censorship and provocation in Paris, which extended to dramas in the world of art. The French Communist Party had itself orchestrated a successful propaganda drive, taking colonised Algeria as the subject of a major art exhibition. Back in 1952, at the time of Sartre's *rapprochement* with the Party, it was still managing a bipartite arts policy, commissioning Socialist Realist projects yet profiting from the prestigious membership of Picasso and Fernand Léger. The Party's anti-colonial stance culminated in the exhibition of Socialist Realist paintings of Algeria

by Boris Taslitzky and Mireille Miailhe, 'Algérie '52', at the Galerie André Weil in January 1953 (the last exhibition of its kind before Stalin's death and great disarray in Party policy). Following police intervention at the Salon d'Automne of 1951 where Socialist Realist canvases attacking the war in Indochina were forcibly removed, paintings attacking 'national sentiment' which depicted politically contentious subjects were guaranteed to provoke another so-called *décrochage*, an official removal of works with well orchestrated press coverage.[14] Miailhe's *Group of Young Arabs in Rags* was accepted for the Salon des Tuileries in October 1952 but taken off the walls before the official opening.[15] By then, the theorising of Socialist

Realism, relating to Marx and Engel's writings and recapitulated by Stalin's spokesman Andrei Zhdanov after the war, was hardly relevant. The situation had become to all intents and purposes a question of power – Party sponsorship, ministerial decrees, police presence and the rhetorics of class protest, with maximum press coverage. While Miailhe saw herself as an epigone of Delacroix and Daumier (pl. 14), 'Algérie '52' demonstrated a deliberate *détournement* of the French Orientalist tradition (some years before the Situationists promoted this concept of critical appropriation in 1958).[16] Socialist Realism had been defined by her fellow-artist Taslitzky in 1952 as a two-way revelation: subject matter into art, art into the visual world of the proletariat.[17] The play of revelation and refusal, of sight and blindness, was repeated across the range of works in 'Algérie '52'. Fanon's 'Algeria unveiled', which opens his book *L'An V de la Révolution algérienne* (1960), offers a rich retrospective reading of the 1952 exhibition, from issues of stereotyping to the metaphor of the veil itself – lifted as a gesture of 'self-liberation' in Taslitzky's panoramic *Women of Oran* (pl. 15).[18]

Yet evidently Sartre, having promoted an 'existential' avant-garde – Alexander Calder, Wols, Giacometti, Masson, David Hare – could not support Socialist Realism despite his *rapprochement* with the Communist Party. Robert Lapoujade became his

14. Miailhe, *Barefoot in the snow*, 1952

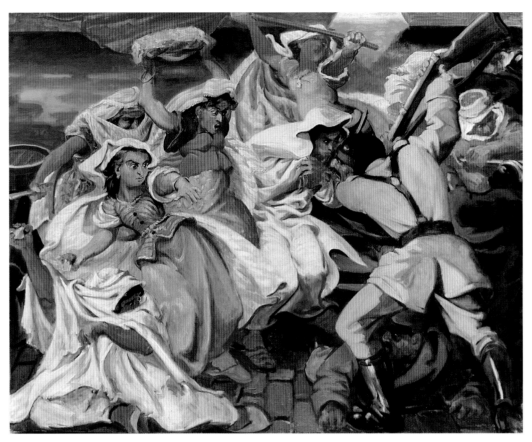

providential artist at a tense moment of de-Stalinisation. A humble 'unprivileged painter', *engagé* in Sartre's sense via his politicisation of the *informel*, Lapoujade had deliberately cast himself as the adversary of André Fougeron, the Communists' most prominent artist, whose Socialist Realist 'Mining Country' series continued to tour the capitals of the East European satellite countries during Lapoujade's 1952 show 'L'Enfer et la Mine'. There Lapoujade treated exactly the same subjects as Fougeron, such as *The Depths of the Mine* or *The Factory*, never mentioning his ideological enemy. Lapoujade's own preface distinguished between non-figurative, more or less geometric painting and his own *informe*, a term he took to be his own neologism, as his anxious footnotes reveal.[19]

Just as Fougeron's intellectual horizons had been constituted in the 1930s by prestigious Communist Party writers and artists, Lapoujade's self-fashioning involved the world of philosophical discourse. Born in Montauban, Lapoujade rose from the humblest of origins (a family of bakers) to become a veritable *peintre-philosophe*. At the École Alsacienne, where Lapoujade taught drawing, he became friends with Olivier

15. Taslitzky, *Women of Oran*, 1952

Revault d'Allonnes, the philosophy professor who recalled:

> one could see Robert Lapoujade sitting at tables in the Latin Quarter interviewing sometimes Gilles Deleuze, sometimes François Chatelet, Jean-François Lyotard... and others, hoping to find an answer to the question: what is meaning? Was he disappointed? Not entirely, because he perceived, in the shadow of the philosophy of Edmund Husserl, that if forms, particularly pictorial ones, are 'hollow moulds', one or several significations could *immediately* be cast in them.[20]

Lapoujade was an *informel* painter of the second generation; his treatise of 1951, *Le Mal à voir*, contained a whole chapter devoted to an *informe* that in its relationship to nature and the external world was deeply Sartrean: 'The *informe* is everywhere around us, renewed tranquilly over time. Walls, ceilings, old doors... mud, stains, the dry, the humid, the dirty, everything dispersed, cracked, coloured, in movement or static... unexpected and apparently useless chaos'.[21] This passage comes after a remark about 'intentional reality' using Sartrean vocabulary at its most complex (Sartre's idiosyncratic usage of Husserl's concept of intentionality has been described as a 'conversion module' with which to broach the art and artists of his time[22]). Lapoujade's *Mécanismes de fascination* of 1955 (following Lyotard's *La Phénoménologie* of 1954) insisted on Cézanne's role as a master thinker for the 1950s; here he follows Merleau-Ponty's famous reflections on 'Cézanne's doubt' and the interest in a contemporary phenomenology of painting.[23] The distinguished philosopher Jean Hyppolite, expert on Hegel and Marx, wrote the preface to Lapoujade's publication.[24]

16. Lapoujade, *The Riot*, 1961

Lapoujade's desire for theory and polemic in all his writing, which is steeped in quotations from French literature and philosophy, deliberately eschews any mention of his *informel* precursors of the 1940s (Dubuffet, Wols, Jean Fautrier), just as he avoids any mention of his gestural or semi-abstract contemporaries, the 'young' School of Paris, who were seen at the time as his immediate peer group.[25]

The *informel* was brought back into the political by Lapoujade: while Fautrier's *Otages* (hostage paintings) suggested with their thick impasto the violated, scarred and tortured bodies (often Communist or Jewish) of Nazi victims during the French Occupation, Lapoujade's visual roots may be traced to the left-wing, anarchist heritage of Impressionism, from Claude Monet to Paul Signac. From 1958, Lapoujade collaborated with the 'Jeanson network', sheltering militant Algerians attached to the F.L.N. (National Liberation Front). Works such as *The Charonne Métro* and *The Riot* (pl. 16) commemorate police brutality towards dozens of Algerian militants, thrown dead and alive into the Seine in October 1961. His semi-figurative representations, dark ink-blot *taches*, are thus differentiated from Henri Michaux's apolitical 'battling' ink marks (likewise called *tachiste* or *informel*).

Sartre's writing on Lapoujade embraces a range of concerns produced in the context of the Cold War, the liberation struggle in Algeria, the gaze of and from the colonised Other and, more crucially, the inter-subjective one-on-one of torture. His elaborate humanist rhetoric – evoking Henri Alleg, who wrote of his torture experiences in *La Question* (1958), and the female rape victim and *cause célèbre* Djamila Boupacha – continues to vibrate against the problem of the 'abstract' in Lapoujade's painting, as he focusses on the *Torture* triptych (pl. 17):[26]

> The painting cannot make us see anything. It allows horror to descend on it but only if it is beautiful; that's to say organised in the most complex, the richest way. The precision of the scenes evoked depends on the precision of the brush, to compress and group together this concert of stripes, these beautiful yet sinister colours – it is the only way of making us feel the meaning of what for Alleg and Djamila was their martyrdom…
>
> Nothing would appear unless, behind a radiant Beauty and thanks to it, appears a pitiless Destiny which men – ourselves – have inflicted on man.[27]

This grandiloquence manifestly fails Sartre's subject: is Lapoujade's vibrant colour and energetic mark-making commensurate with the task? Yet the conjunction of writer and artist was significant; and Sartre's pen could make, but also break, careers.

His monumental *Saint Genet* of 1952, appearing as the first volume of Genet's own *Œuvres complètes*, provoked a creative paralysis in the playwright.[28] Just so, Robert Lapoujade, a confident writer and theoretician as well as painter in the later 1950s, found new celebrity in the wake of Sartre's preface – but then emptiness. His style of painting became increasingly outdated after his 1961 exhibition (though his portrait show of 1965 included Sartre as a sitter and was prefaced at the same gallery by the writer Marguerite Duras). He turned to writing and making films. It was not only Lapoujade, however, who fell victim to the changes of a new era: Sartre's own undisputed intellectual dominance came to an end with his Communist alliance and its aftermath. No longer, as Anna Boschetti has argued, would his journal *Les Temps modernes* be 'the sensitive and faithful expression of the state of the field'. Boschetti abandoned her analysis at the moment of his 1952–3 turn to Communism, despite the fact that Sartre later demonstrated with the May 1968 students and actively espoused the Maoist cause.[29]

Sartre's rapprochement with Communism for anti-colonial reasons had deliberately avoided engagement with the French Communist Party's political, theoretical or indeed aesthetic bases. He was also ageing. Althusser, a younger, audacious figure, proposed a clean break: a new reading of Marx, a young Marx with no taint of the legacy of Stalinism. His collected articles in *Pour Marx* and *Lire le Capital* became handbooks for the student revolution of 1968, a symbol of generational revolt.

17. Lapoujade, *Torture Triptych*, 1961

A new and younger left sought revolution in the thought of Marx, Mao and the power of theory itself. Paradoxically, having joined the Communist Party in November 1948, Althusser remained faithful to its ideals for thirty years – another reason for his antipathy to Sartre, whose essay 'The Spectre of Stalin' in *Les Temps modernes* definitively broke with the Party after the Soviet invasion of Hungary.[30] Althusser had no sympathy with Sartre's later Maoism. Yet within and beyond the intense and competitive confines of the École Normale Supérieure (Sartre's *alma mater*) Althusser drove himself to write prolifically and to perform as a charismatic public figure, using Sartre as a model.

Althusser's writings on art are generally dismissed: François Matheron, the editor of his collected writings, declared 'More than any other, the sphere of painting for Althusser was in fact one of friendship, a network of friendships which he was careful not to mix too closely with his philosophical or political colleagues.'[31] Francis Mulhern saw the texts on Leonardo Cremonini, together with Althusser's theatre criticism, as 'moments of counter-ideological "recognition"… the more euphorically articulate for that, but the less instructive as adumbrations of a new theory and practice.'[32] Both statements contain some truth but ignore the visual worlds and political arenas in which Althusser was functioning: the Cremonini piece took more than a year to complete and was published, heavily illustrated, not in an exhibition catalogue but in the hard-line Communist periodical *Démocratie nouvelle*, in the aftermath of the Argenteuil Party congress on ideology, art and culture in 1966. After Althusser's discovery of Italy, the piece also followed his readings of Machiavelli, which finely honed his appreciation of political strategy.

Although Althusser's texts and prefaces were, indeed, occasional pieces, he was well aware of the immeasurable importance of the worlds of high art and of popular culture for the Communist Party in post-war France. Their Moscow-driven policies for the arts involved Party and personal prestige and the spectacle of power in action. Coverage in *L'Humanité* or *Les Lettres françaises* spread a distinct message to Soviet satellite countries, for whom Paris was still the capital of the arts.[33] At budget level alone, the PCF was successfully competing with American CIA cultural initiatives.[34] Communist Party politics had dominated the Parisian art world from 1945 to 1952, with the deployment of the 'stars' Picasso and Léger, together with scientists such as Pierre and Marie Joliot-Curie, poets such as Paul Eluard and Pablo Neruda and actors such as Gérard Philipe, all of whom officially visited Soviet satellite countries. Eluard's longstanding friendship with Picasso was the model for Aragon's relationship with Henri Matisse, a relationship

that, as Party spokesman and figurehead, he cultivated from the war years through the 1950s – concurrently with his promotion of hardline Socialist Realism in painting and sculpture. Not only was the Matisse relationship prestigious and a catalyst for writing on art and for luxury publications but it was also a prime channel of de-Stalinisation after 1956 (Aragon published the massive two-volume *Henri Matisse, roman* in 1970). Roger Garaudy, a senior Party figure, similarly promoted Léger as part of the 'new face' of the Party. Like Aragon, Garaudy was a self-fashioned 'all round' Communist intellectual, who displayed and transmitted cultural values, particularly in the fine arts, with unquestionable authority. He became Althusser's principal adversary in 1966.

Towards a Transfiguration: Althusser and Art

Althusser's encounter early in the 1960s with the Communist critic and curator Pierre Gaudibert was one with immense repercussions. Gaudibert introduced Althusser to Cremonini and his companion Giovanna Madonia in the spring of 1961 (hence his likely visit to Cremonini's exhibition at the Galerie du Dragon in May, for which Gaudibert wrote the preface). Cremonini, born in 1925 and educated in the art academies of Bologna and Milan, first exhibited in Paris in 1951, prior to a successful New York period of almost a decade.[35] Back in Paris, he exhibited at the Galerie du Dragon in 1960: a major work here, *Articulations and disarticulations* (1959–60), a mass of flesh, human and animal, dead and alive, was based on the sight of an open-air slaughterhouse on the island of Ischia (pl. 18). A year later, in 1961, his flayed carcasses were transfigured in response to the Algerian war; his May exhibition directly followed Lapoujade's. Competing, then, with Lapoujade's *Torture Triptych*, Cremonini showed fifteen paintings, including *Torture, Disarticulations of the Civil War, April 1961, Killing Machine* and *Tortured Head*. Gaudibert wrote of 'torture and eroticism, the violence of history and the problematics of the couple'.[36] The juxtaposition of torture and a dysfunctional eroticism, the interface between political and personal arenas in these paintings, surely struck Althusser, together with the extreme intensity of the images (red paint constantly doubling as blood and torn sinews).

Looking back in 2005, Cremonini remembered Althusser in the years of their first and most intense conversations: 'A young man who knew pain, not success, profoundly melancholic ... a man who had lost his skin and who had looked desperately for another one, which was not his ... I think that the skin Althusser lost was the skin of a Christian

[*la peau d'un chrétien*].'[37] This striking use of Cremonini's own metaphor of the flayed man, the painted *ecorché*, may suggest a circuit of empathy at play here regarding Cremonini's own interior state. The artist's youth had been marked by fascism and war; he had been forced to hide to escape military service. Yet the extraordinary optimism of the post-war years and his professional success in New York and London was followed by unexpected rejection and the ending of his friendship with the New York art-powerbroker William Rubin.[38] Back in Europe, Cremonini confronted challenges of another dimension: the shaming of France in Algeria, fascism and police brutality in the city he had chosen as his intellectual home.

It is crucial that Althusser later credited his initiation by Cremonini into the visual world of painting and its discourses as contributing to his evolution of 'a theory of *symptomatic reading* in the epistemological domain', elaborated in *Reading Capital*.[39] Evidently, beyond disciplinary constraints, there are differences between painting and a philosophical text. In painting, the problem of creativity, response, positioning, space and the material world of objects and their representation become far more explicit than in writing a chapter of *Reading Capital*. To take the 1961 exhibition: Cremonini's cultural heritage (Italian painting, peasant life, contemporary modernism) and questions of intention, transmission via perception, the position and receptivity of the spectator

18. Cremonini, Articulations *and disarticulations*, 1959-60

(Gaudibert and Althusser's vastly different subjective experiences), the *transposition d'art* (painting into writing) and writing's mediating role (involving Gaudibert's knowledge, intuition and creativity) were all in play. These issues also account for Althusser's future writing 'against' the increasing body of professional art criticism on Cremonini.

Another crucial estrangement took place as a result of the encounter between philosopher and artist. Thanks to Cremonini, Althusser's developing relationship with Italy changed his attitude to France, generating an understanding of France's 'provincialism', a term he elaborates in his Lacan seminar of 1963–4.[40] Giovanna Madonia invited Althusser to her family home in the village of Bertinoro, near Forli, not far from Ravenna, where, after Venice, he spent time in August 1961. The Madonia became Althusser's second family, initiating him into the intellectual life and social world of the Italian Communist Party – for whom he became a figure revered second only to Gramsci.[41] The passionate affair between Althusser and Franca Madonia, Giovanna's erudite sister, gave rise to an extensive and illuminating correspondence. It is here, above all, within a framework of personal intimacy and shared discoveries that Althusser speaks about art – rather than in the performative masculine arena of political philosophy.

In a letter of June 1962, Althusser mentions his desire to write an important article on Cremonini and modern painting 'which, uncultured oaf that I am, I naturally knew nothing about… But *it interests me*.'[42] The following month, he looked at Rembrandt and Malevich in Amsterdam and Mondrian in The Hague, all 'thanks to Leonardo'; also in July, he describes a Bonnard in the Musée d'art moderne 'which represents a man and a woman who have just made love, an admirable painting cut in half *à la* Leonardo'.[43] In turn, Franca's correspondence with Althusser speaks of her appreciation of individuals such as Odilon Redon, Paul Klee, Nicolas de Staël and the interconnection of art and literature.[44]

Althusser published his first article on an artist, Roberto Alvarez-Rios, in November 1962 in the influential Communist weekly *Les Lettres françaises*. The artist's exhibition at La Cour d'Ingres, run by Althusser's friend Inna Salomon, had a catalogue prefaced by the Surrealist doyen José Pierre, who evoked magic, eroticism, spirituality, and Alvaros-Rios's Cuban affiliations; the canvas *Towards a Transfiguration* was illustrated.[45] Althusser's review was deeply political, fired by the Cuban missile crisis of the previous month in which the world narrowly escaped nuclear catastrophe. While the Algerian situation was a 'French' affair, issues of colonisation and independence involving Cuba demonstrated Cold War geopolitics at their most intense and dangerous.

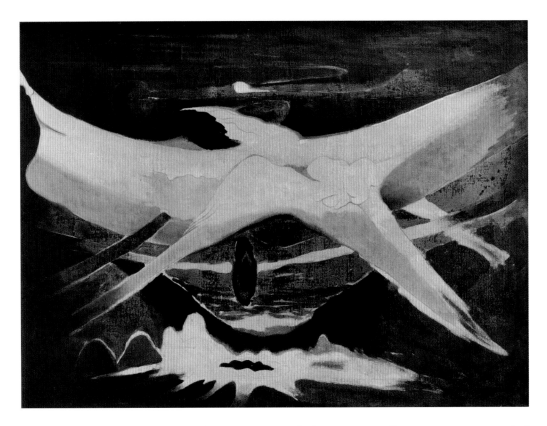

The Soviet Union's strategy of building missile bases in satellite countries extended to Latin American territory, dangerously close to the United States; Castro compared Kennedy's Bay of Pigs invasion of April 1961 with the invasion of Pearl Harbor. The cultural biography of a young Cuban painter, turning to Paris as an intellectual capital in this climate, is what fascinated Althusser; their encounter was warm and sustained.[46]

Althusser wrote:

> The devastating canvases of Alvarez-Rios, the young Cuban painter, once again pose for us *the question of Surrealism*... Thirty-one years old. Twenty-seven years of his life in Havana. Classic studies in the Beaux-Arts. Dreaming of Rembrandt, Cézanne, Van Gogh, Picasso. In *1950*, still in Havana, meets *Lam*, whose exhibition impresses him. In *1958*, Paris. Rios works in a basement at the Cité Universitaire, in his room (he's married) with no space, almost no light.[47]

He cites the relevant Surrealist masters – Max Ernst, Roberto Matta, Wifredo Lam – but above all the problem of Surrealism's status as a movement of the past, a church with 'its masses, its Latin, its syntax and vocabulary'.[48]

19. Alvarez-Rios, *Dove of Peace, 1960*

At ease in this new genre of art criticism, his text constantly uses the dialectical play of concepts. Why was the language, the 'liberty' of Surrealism chosen by Lam, Cardenas, Matta? It is a liberty which releases Alvarez-Rios from current figurative–abstract debates but also a liberty with political dimensions: the denunciation of slavery, the revolutionary tradition. (Late in 1977, in an unpublished text on Lam, Althusser recapitulated 'the mute cry of a people crushed by centuries of history' and posited the dialectic at the heart of Lam's identity: 'In humility such a refusal of humiliation, in peace the tension of such violence.'[49]) Althusser describes Alvarez-Rios's painting *David's Catapult* in the 1962 article: a huge crowd of men, fists raised against a monster bristling with canon who blocks the sky – Cubans against the American Goliath. In Latin America, the borrowed and transformed language of Surrealism has 'deep affinities with the living past of a world and the materiality of a close popular culture.' The 'discourse of a burgeoning history, speaking of men and of nature, of slavery and masters, of death and liberty' is posited against the operations of metropolitan Surrealism, the 'incantation of a lost and perverse history whose meaning had at all costs to be tamed.'[50]

20. Alvarez-Rios, Maison de Cuba, 1960

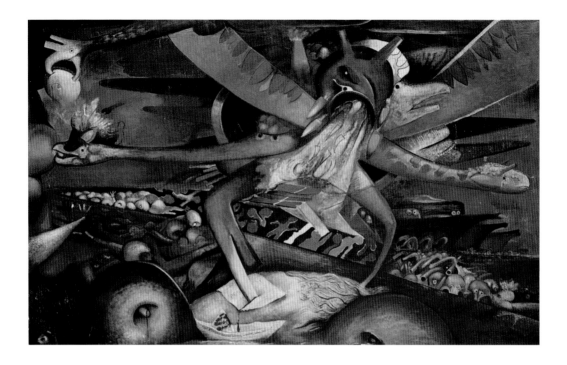

What grips Althusser is the notion of *two ways of speaking the same language* (his emphases reflect those used in the transcriptions of his spoken arguments). Rios 'speaks' Surrealism as he 'speaks' French; it is a question of displacement, estrangement and colonial 'lateness'; the new language is at once his 'liberty' and a means of self-liberation from this same language. Althusser's formal appreciation of diagonals, horizontals, opaque or transparent surfaces and the pictorial surface, *informe* or heavily worked, demonstrates his new critical competence. Yet his judgemental conclusion – 'Naivety, or the depth of this painting (one and the same thing) is *also* to speak of oneself, and of Rios's future, this painter who *could be great*'[51] – contains a coded ambiguity: 'to speak of oneself' may refer to the spectator or to the author as well as to the artist.

Alvarez-Rios's late Surrealist style now seems uncomfortably hybrid: his spiky peace-dove of 1960 has a touch of Lam's voodoo; *Human Beings, Wars, Invasions etc. Enough!* (1965), like much of his work, combines reminiscences of Hieronymus Bosch with contemporary politics (pls 19 and 21). In the same 'surrealising' style, *Homage to Patrice Lumumba* (1961) contained the face of the first president of the independent Congo, brutally murdered by the Belgian former rulers (in conjunction, it was instantly concluded, with America) who were fearful of the Communist-inspired liberation struggle. Yet certainly Alvarez-Rios's profile at the moment of his encounter with

21. Alvarez-Rios, *Human beings, Wars, Invasions etc. Enough!*, 1965

Althusser stood out from the 138 Latin American painters exhibited simultaneously at the Musée d'Art Moderne. This show was the sign of Paris's continuing importance as an art world centre, remarked the critic Michel Ragon in 1965, who distinguished *informel* and Surrealist tendencies from what he called the future mode of new figuration – *nouvelle figuration* – in the work of Hervé Télémaque.[52] The press for Alvarez-Rios's exhibition continued with major articles in Rome in January 1963 and in *Les Langues néo-latines* in March; that year too the French state purchased *Why are you killing me?* (1962). When the *Collective Cuban Mural* painting was made by Paris-based painters in Havana during their summer stay in 1967, it was Alvarez-Rios who independently held a solo exhibition at the Museo des Bellas Artes, with a preface by Pierre Gaudibert followed by a long extract from Althusser's piece on the 'language of liberty' in the modest catalogue. *David's Catapult*, now labelled *Mi Honda es la de David – octobre 1962*, was again exhibited, commemorating the most intense moment of the missile crisis.

Issues of colonial lateness and popular culture versus first-world, post-industrial models continued to preoccupy Althusser. They were the subject of his first joint venture with Cremonini, a series of edited, tape-recorded conversations. François Maspéro, the editor whose 'Théorie' series Althusser directed, created an international militant monthly, *Révolution*, in 1963. Its agenda was Communist, anti-colonial and third world (it appeared in French, English and Spanish editions). Althusser's dialogue with Cremonini on the need for the preservation of popular and colonised craft practices (*artisanat*) versus industrialisation in developing countries, particularly Africa, was published in November. Cremonini was selected for interview as 'one of the most fecund and original painters of the post-war Milanese school', an artist particularly preoccupied with the south of Italy where craft practices flourished. His 'engaged art reflecting the dialectic of the modern world' was corroborated by his Mediterranean culture and its ancient Greek heritage, which preceded the modern dissociation between art and technique. Here, Cremonini speaks of the 'colonisation of artistic conscience', praising the value of Sicilian peasant craft against Milanese industry; Althusser argues that local forms of culture have been encouraged by colonisers and that local crafts with no further utilitarian function are doomed to disappear; the discussion of relations among a future economic independence, ancient forms and religious practices then turns to the example of Kabyle society in Algeria and its artisans. It was an inconclusive conversation: the philosopher wisely preferred to appear as 'X' in the edited and published version.[53]

From Venice to Argenteuil: the Humanist Controversy

Althusser was already familiar with the international avant-gardes through the Paris Biennales, one may now assume.[54] At the 1964 Venice Biennale he saw Cremonini's solo show in the context of the artist's Italian contemporaries, including Enrico Baj and Pinot Gallizio. (Did Althusser see the American pavilion? He could not have remained unaware of the immense international controversy around the award of the Venice *grand prix* to Robert Rauschenberg.) Throughout the 1950s, the Venice Biennale had ratified the position of the 'masters of modernism', together with the new generation linked to post-war humanism and the spread of a European *informel*; Jean Fautrier and Hans Hartung won painting prizes in 1960, Giacometti and Alfred Manessier were laureats in 1962; in 1964, France showed Roger Bissière, Julio Gonzalez and Jean Ipousteguy, the realist sculptor to whom Cremonini felt the closest affinities. In the central Italian pavilion, besides an exhibition of contemporary art from European museums, major one-room retrospectives had been given to seventeen Italian artists. Cremonini was particularly privileged in terms of space; his room was juxtaposed with the *affichiste* artist Mimo Rotella's striking display including *Tender is the Night* (*Tenera e la notte*, 1963), a torn cinema poster for Henry King's 1962 film based on Scott Fitzgerald's novel (pl. 22).

Beneath a surface flashing with rips and tears, the stars were locked in a devouring kiss. Illustrated in the official Biennale catalogue, *Tender is the Night* precedes anguished illustrations by Cremonini, such as *Night Train* (1963–4), where limp and agonized limbs, bulging areas of flesh, drip against the rectilinear divisions of a train window (pl. 23). Cremonini versus Rotella: two night scenes, two techniques, two generations of work (though Rotella, born in 1918, was in fact seven years older than Cremonini). The Nouveau Réalisme critic Pierre Restany presented Rotella's 'anonymous lacerations… sprung directly from sociological reality.' This *Cinecitta*

22. Rotella, *Tender is the Night*, 1963

lacerta was an open city, *citta aperta*: here, contemporary film met Umberto Eco's concept of the porous 'open work'.[55] Restany, with a new conceptual vocabulary, promoted a new art and a new way of looking.[56] In contrast, Cremonini was linked to the rediscovery of archaic landscapes, furious animal couplings and a macabre refinement, where the night-time voyagers become prisoners of a Kafkaesque dream: an existentialist, humanist art of the past.[57]

'Finding myself in the room in the Venice Biennale where Cremonini was exhibiting admirable canvases, two French people entered, looked briefly around and headed for the door, one saying to the other "No interest at all; expressionism!"' Althusser's cutting recollection was maintained as the opening of his article on Cremonini published more than two years later.[58] The artist's humanism – obvious comparisons were with Henry Moore or Marino Marini – was also reflected in the article which the critic Michel Troche wrote on the 1964 show for *Les Lettres françaises*.[59]

Altogether different was Troche's article for the June-July issue of the official Communist monthly, *La Nouvelle Critique*. A Party discussion document, this demonstrated the review's understanding of the importance of the visual arts within a project of de-Stalinisation. With no reference to French Socialist Realism except for euphemisms ('cultural directives', 'summary manichaeanism'), Troche patiently worked through the rediscovered Karl Marx of the 1960s – *The German Ideology*, *The Holy Family* (with Engels), his early *Manuscripts* – and George Plekhanov's *Art and Social Life*, which raised the early Soviet theory of art as a 'reflection' of life: a perennial problem. Cultural heritage was proffered against the 'vulgar' theory of the disappearance of the superstructure along with its base; Picasso's *Déjeuner sur l'herbe* series was even cited with its precursors, Manet and Giorgione.[60] It is highly likely that Althusser, fired to write on 'his' artist, would have read Troche's polemic.[61]

Althusser's 'Leonardo Cremonini' was finally published in May 1965 in *Tendenzen*, a Munich-based, Communist-orientated review for politically committed art, in a version reduced to hardly more than five paragraphs.[62]

Cremonini's suspended blurred male figure, *The Swing* (1962; the artist at his most Bacon-like) appeared opposite Althusser's article, followed by *Night Train* and *The Dream* (1961; a sleeping male and sleepwalking female figure who does not correspond with her reflected mirror-image); the words *Mensch* and *menschlich* are used throughout with rhetorical insistence, while Althusser's investigation of Cremonini's use of mirrors reveals his reading of Lacan on the mirror stage.[63]

A more 'humanist' response to the artist could not be envisaged, framed as it was between illustrated articles on the Giacometti family and on the human figure in modern painting.

Yet humanism was increasingly contentious as a subject and was becoming a disguise for political power struggles.[64] Inevitably, the new *querelle du humanisme* took its place in the lineage of existentialist versus Marxist debates, dating back at least to Sartre's pronouncements of 1945.[65] 'Marxism and Humanism', Althusser's text dated October 1963, was aimed at the USSR's new thaw-period 'socialist humanism' under Khrushchev.[66] Althusser made the distinction between socialism as a 'scientific' concept and 'humanism' as an ideological one. Ideology he defined as a system of representations imposed in the form of *structures* on the majority and as the *lived* relationship between men and their world – contrasting with Marx's own 'anti-humanism'. The epigraph quoted Marx on Wagner: 'my analytic method starts not with man, but the social period framed economically'.[67] In March 1965, *La Nouvelle Critique* refocused attention on the 'humanist controversy' after the young writer Jorge Semprun's earlier challenge to Althusser, 'Socialist Humanism in Question' of January 1965.[68] (Perhaps this controversy explains the appearance of the 'humanist' Cremonini version in *Tendenzen*, not in Paris.) 'Marxisme et humanisme' was then republished in *Pour Marx*, which appeared with *Lire le Capital*, in November 1965.

Althusser's *Pour Marx* and *Lire le Capital* were the principal subjects of discussion for two 'study days' held for more than a hundred philosophers, intellectuals and economists at Choisy-le-Roi in January 1966 in preparation for the Central Committee meeting of the French Communist Party, held on 11–13 March 1966 in Argenteuil.[69] Roger Garaudy's *De l'anathème au dialogue* of 1965, regarding a new engagement with the Catholic Church in the wake of the Vatican II reforms, was the other contentious object of debate.[70]

Between the January and March meetings, however, the Sinyavsky-Daniel affair once more drew acute attention to the Communist Party's past and the Socialist Realism problem. The death of Stalin in 1953 and Aragon's humiliation over the Party's rejection of Picasso's portrait of Stalin had precipitated a change of Party policy in this area.[71] Yet Socialist Realism itself had not been denounced from within the USSR until 1959, with Andrei Sinyavsky's courageous article smuggled (at risk of the gulag) to the review *Esprit*. Sinyavsky characterised Socialist Realism as a production comprising 'millions of printed papers, kilometres of canvas and film, centuries of hours',

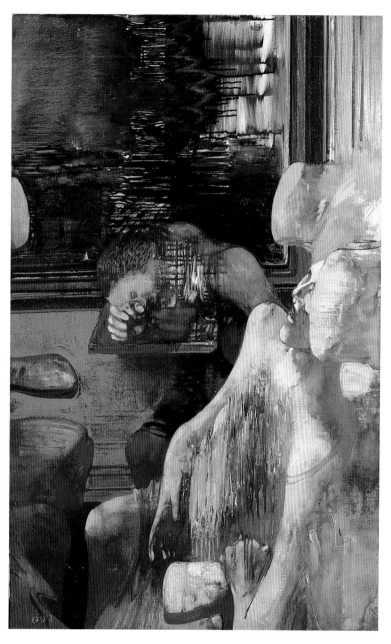

the very mask of Stalinist terror.[72] Almost immediately after Stalin's death, Picasso and Léger's 'humanism' was used to cover the previous excesses of the Socialist Realist campaign. Garaudy's monograph on Léger, *D'un réalisme sans rivages* (1963), emphasised Léger's humble roots, *bonhomie* and 'art for the people'.[73] The preface by Aragon used Matisse to turn the realism question – a human tragedy for Sinyavsky – to 'a tragic question of vocabulary'.[74]

23. Cremonini, *Night Train*, 1963

In February 1966, Aragon's tardy defence of Sinyavsky and Yuri Daniel (condemned to seven years' labour for anti-Soviet propaganda) provoked jeers in anti-Communist quarters: the Surrealists' brochure *Aragon au défi* recalled Aragon's approbation of the 1930s Moscow show trials, quoting Edgar Morin on the Party leader Maurice Thorez: 'Thorez leafs through a Fernand Léger album. The Stalinist concentration camps have become the object of sad elegies. Such is the humour of history: anti-Stalinism stolen from the anti-Stalinists by the Stalinists.'[75]

Alhough Althusser did not attend the Argenteuil meeting in March, readers of the May issue of *Les Cahiers du communisme* were well aware of the deliberate Althusser–Garaudy confrontation staged there. Its culmination was the Central Committee's resolution 'There is a Marxist humanism'.[76] The celebrated Argenteuil resolutions, notionally ending the French Party's artistic isolationism, approved the free distribution of cultural works, the separation of artistic and political spheres, the permission to criticise the USSR publicly and the independence of scientific research. Althusser's lengthy letter of objection to the Central Committee summarised his insistence on a 'theoretical anti-humanism'. He emphasised the 'implacable ideological struggle between *humanism* and *class struggle*.' What particularly exercised him was the resolution on 'artistic creation', whose proposition that 'in all works of art there is a part irreducible to its constituent parts, man himself' he attacked as 'epistemologically empty'. 'Man', Althusser argued, is a term used *'to mask class struggle.'* Paradoxically, the Argenteuil encounter and its aftermath governed his decision to stay with the Party; the rift with his increasingly Maoist acolytes deepened.[77]

Cremonini's summer exhibition of 1966 at the Galerie du Dragon again mixed the gentle Bonnard-like interiors with carcasses, child-voyeurs, the macabre.[78] Finally, in November 1966, Althusser's Cremonini text appeared in *Démocratie nouvelle*, well illustrated in black and white and with a modified conclusion. By this time the painter's 'radical anti-humanism' had to be demonstrated against the visual odds. The original ending had resonated with the word 'man': 'All man is there in the painting of Cremonini, precisely because *he is not there*, because this absence is his very existence… It is for us men, in front of these paintings, that this absence is addressed, as the highest appeal'.[79] In the new ending 'man' becomes a concept marked apart – '"men" that we are' (*les 'hommes' que nous sommes*). 'We cannot (ideologically) "recognise" [*reconnaître*] ourselves in these paintings… hence we can know [*connaître*] ourselves… Every work of art is born from a project at once aesthetic and ideological... Every work of art

produces *as a work of art* an ideological effect... but... a work of art may also become an *element* of the *ideological*.' Cremonini as an individual follows ways opened up by 'great revolutionary, theoretical and political thinkers, great materialist thinkers, who have understood that men's liberty passes not via complacent ideological *recognition* but *knowledge* of the laws of their servitude'. Althusser specifically engaged with current cultural debates in *Démocratie nouvelle* and sent his text to an Italian sister-journal.[80] This final version awkwardly traverses the distance between the Venice Biennale of 1964 and Argenteuil in 1966, between the initial fine descriptions of Cremonini's landscape and figure paintings, relating to the geological, the vegetal and the personal, the play of formal and representational qualities (abstract divisions, the position of the spectator, the exchange of subjectivities between spectator and artist, the mirror as metaphor), and the later 'anti-humanism' issue. By this time Foucault's *Les Mots et les choses*, with its magnificent and paradigmatic opening analysis of Velázquez's *Las Meninas*, had appeared; Cremonini's formal relationship with Velázquez (crucial for his representation of planes and mirrors), a Velázquez whom he conceived politically as decentring the established order, is a blind spot in Althusser's text.[81]

In January 1967, at the eighteenth congress of the Communist Party in Levallois, the concrete results of Argenteuil were to be seen in the confrontation of artistic styles at the official art exhibition: Cremonini's *Killed and Trussed Animals* would have resonated with Picasso's once highly controversial *Massacre in Korea*; Fougeron, the *doyen* of French Socialist Realism, exhibited his 1952 history painting of the funeral procession of Victor Hugo's son, *The February 13th Cortège*: what contrast, in both subject and technique, with Rancillac's apartheid protest in his *The Tragic End of an Apostle* (1966)! Tapestry figured: Victor Vasarely's abstractions played off against Jean Lurçat's Cluny-inspired medievalism; in the sculpture section, an Alexander Calder mobile was welcomed together with sculptures of the human figure by César and Ipousteguy.[82]

Althusser, however, returned to the more familiar nineteenth-century worlds of political confrontation between Marx and Feuerbach in *La Querelle de l'humanisme*, a recapitulative account of the 'humanist controversy' written – without reference to the visual arts – over the summer of 1967.[83] He will reappear in my narrative as a major player in 1969, after the May 1968 revolution.

Bourdieu, Rancillac
'The Image of the Image'

I believe our vision is totally photographic. That is why pictorial realism can only pass via photography... If asked why I don't simply do photography, I would reply that I am not a photographer and do not want to be one, but a painter. The direct transfer and enlarging of a photograph onto a sensitised canvas wouldn't interest me... Photography is convincing. The ad-men understand this. We believe in absolutely everything the moment a photo has been taken. Hence its force of persuasion... voluntarily or not, the photo always lies. It is passionately interesting to unmask the liar. Giving his image back to him, you can make him say the opposite. And putting together two or three images which exist naively as neighbours in the same magazine, you can explode the whole system...
Bernard Rancillac, 1971[1]

The comprehensive gaze of the ethnographer that I applied to Algeria, I was able to apply to myself, to the people of my region, to my parents, to my father's and mother's accent... I applied to people very similar to the Kabyles, the people with whom I spent my childhood, the necessary gaze of understanding which defines the discipline of ethnology... The practice of photography, first in Algeria, then in Béarn, doubtless contributed a lot to this conversion of the gaze...
Pierre Bourdieu, 2002[2]

Pierre Bourdieu's text, 'L'Image de l'image', for Bernard Rancillac's exhibition 'L'Année 1966' held in early January 1967 at the Galerie Mommaton in Paris, marks a fascinating encounter between intellectual and artist which traverses the cultural field of the period. There were similarities between the two men, linked initially to their upbringing and class ambiguities. Bourdieu was born in 1930 in the Béarn in Gascony, southwest France, near the Pyrenees. He rose to the status of 'intellectual' via the changing of his local accent and intensive schooling at the Lycée de Pau, the Lycée Louis-le-

Grand in Paris and, from 1951, the École Normale Supérieure, where he attended the lectures of Althusser and Foucault, the structuralist generation from which he set himself apart. The distinction between Parisians and provincials was part of the caste system of the École, while Bourdieu's stocky build also distinguished him from Parisian contemporaries. Other scholars, with Bourdieu's collaboration, have sketched a complete history of his early intellectual formation.[3] The compelling description of Bourdieu as 'an insider/outsider Frenchman' committed to what he himself called 'self-socio-analysis', is intimately related to the ethnographical perspective which he turned back onto his countrymen.[4]

The novels of Gustave Flaubert provided Bourdieu with a paradigm of upward social mobility: at stake, he recognised, was the relationship between individual aspirations and the wider 'field', as he expressed it, of society at large.[5] Later, Flaubert provided Bourdieu with a means of challenging Sartre; he criticised Sartre's performance as 'total intellectual' and the implications of this self-positioning for Sartre's mighty unfinished work on Flaubert, *The Family Idiot*.[6] For, as Bourdieu later argued, in terms of his structural position in bourgeois society, the intellectual himself is the 'family idiot'.[7]

Rancillac was born in Paris in 1931 but spent his first formative years, thanks to his father's teaching position, in El-Biar in Algeria. The family returned during the war years to their home in the Haute-Loire region amid the harsh volcanic landscapes of Yssingeaux (*ici cinq coqs*, its blason five cockerels).[8] In 1991, he offered a classically 'sociological' analysis of his access to art. His attention to eloquent detail recalls his encounter with Bourdieu:

> My childhood was not surrounded by art… At Yssingeaux in the family house, the walls were decorated with paintings (watercolours) of the so-called orientalist school, and skilfully handled landscapes by my grandfathers and great-uncles. Several generations of relatively (conventionally) enlightened bourgeois who indulged their leisure moments with the arts of good society: amateur dramatics, chamber music, *plein-air* painting, pottery. Up in the attic, small-scale unfinished canvases, boxes of pastels, outdoor easels, articles on the Paris 'salons'…[9]

Rancillac, not an academic achiever, rebelled against his father, an *agregé de lettres* in French, Latin and Greek who was also briefly his teacher at the prestigious Lycée Lakanal, in Sceaux on the outskirts of Paris. He was pressurised at first to train as a teacher of drawing at Guillaume Met de Penningham's preparatory design school.

Like Edouard Pignon in the 1930s or Robert Lapoujade a generation before him (both of humbler origin), Rancillac achieved intellectual status through the worlds of painting and theoretical writing. These worlds intersected with the new 'sociological' world of the 1960s, where Bourdieu achieved both high academic status and the acknowledgement of an extensive public, transcending his own peer group. During these years, the Sartrean dialectic between phenomenological philosophical traditions and the discourse of revolution gave way to new analytical disciplines, ratified by new university departments. Younger, more democratic ways of seeing emerged, affected by proliferating choices of life-styles and career paths – the very stuff of Bourdieu's later classic, *La Distinction* (1979, English 1984).

Both Bourdieu and Rancillac were initially politicised through their experience of military service, Rancillac in Meknes in Morocco, from 1951 to 1952, Bourdieu from 1956 to 1958 in Algeria as the Algerian war intensified. Whereas the ciné-anthropologist Jean Rouche's celebrated film *Les Maîtres fous* (*The Mad Masters*, 1955) used brutal juxtaposition to demonstrate the abrupt changes between rituals of Hauka masquerade and sacrifice and the banalities of immigrant city life in colonial Gold Coast Accra, Bourdieu sought to account for dimensions of the Algerian situation through searching sociological analysis. This involved taking more than two thousand small black and white photographs of his subjects and their environment. These photographs were sometimes neutral, sometimes witnesses of the violence of colonial practice: the forced 'regrouping' of Kabyle villagers in roped-off compounds, for example. He aimed to analyse disappearing tribes and the passage to new urban situations with their capitalist economies. After a year in Paris during which he attended Claude Lévi-Strauss's lectures, Bourdieu incorporated Lévi-Straussian analyses of myth and ritual into the second edition of his *Sociologie d'Algérie*, of 1961.[10] The position he specifically wanted to counter, however, was that of Frantz Fanon's *Wretched of the Earth*, with its Sartrean, revolutionary rhetoric that Bourdieu later characterised as 'speculation… false and dangerous'.[11]

Rancillac returned from Morocco to Paris and attended Stanley William Hayter's Atelier 17, where he acquired a certain technical and intellectual sophistication and worked with an experimental and international community. This included his friend the German artist Hans Haacke (Bourdieu's *regard*, his input and critical techniques such as the use of questionnaires, remain largely unacknowledged as influences on Haacke's early conceptual art and teaching career).[12] Rancillac's experiments resulted in

scribbly drawings in soft black crayon which embraced the *informel* ethos of the time and were shown in 'L'Infini turbulent' (its title from Henri Michaux) at the Galerie le Soleil dans la Tête in October 1961.[13] While Hayter's lessons in graphics and print-making about the play of black versus white, form versus void, were essential for his later work, Rancillac taught himself to paint, by looking at works in the Paris galleries. He moved from mentors such as Paul Rebeyrolle and Nicolas de Staël to Antoni Tàpies. *Moonstone* (1961), adopting Tàpies's earthy palette, won the painting prize at the second of André Malraux's international Biennale de Paris exhibitions. *Wall of Silence* (also 1961), similarly melancholic, took the picture surface as a metonym for repression and blockage, conflating intensely self-referential and political meanings (the erection of the Berlin wall). *The Dark Room* of 1962, a three-dimensional installation *avant la lettre* of a table with book and candle, wine bottle and egg, was a *vanitas,* an exorcism and a work of mourning (pl. 24). The drapes and wall-coverings were made of men's suits, sombre accoutrements of Baudelairean modernity which flattened the body of his bourgeois father into art. An anticipation of the explosion of psychoanalytic discourses in France in the 1970s, *The Dark Room* was also a lament for the traditions of painting and sculpture about to be displaced by the *camera obscura* of photography and cinema; it is to photography that this piece, subsequently destroyed, owes its own ghostly existence.

24. Rancillac, *The Dark Room* 1961

By 1962, artists of Rancillac's own generation such as his friend the monochrome painter Bernard Aubertin, felt themselves to be epigones of Yves Klein and Manzoni. However, the compelling entry of popular culture into Rancillac's art marked the passage to a new era, with *Fantômas leaps into the void* (a homage to Klein in the year of his death). An Ubu-like, phallic Fantômas/Rancillac figure is drawn over a hemmed fragment of bed linen collaged onto the creamy, monochrome surface. In *Fantômas received by the war veterans*, several grotesque figures may be deciphered amid blood-like smears and, in a balloon-like caption, the words *Je suis heureux* (I am happy). Fantômas, the master-criminal of penny novels and the hero of the Cubists, is overlaid by the *argot* and blasphemies of a Céline. The monochrome was struggling to survive.

Rancillac's contemporary *latrinogrammes*, a riot of obscene scribbles in coloured crayons, formed the basis of brilliantly coloured paintings such as *Carnaval at Canaveral* (1963).[14] Rather than Pollock or Pop at this juncture, the Cobra painters were in evidence, as was the impact of the American Peter Saul.[15] By the time of Rancillac's two solo shows in October 1963, his deliberate 'bad boy' image was emerging; Gassiot-Talabot dwelt on the schoolboy art which 'moons its arse and cocks a snook', sourced in popular culture (childhood memories, illustrated magazines and television serials as reflected in Rancillac's titles: *Mickey before Mickey, Voyage to Magieland*).[16] As the critic Michel Ragon remarked, cartoon humour (*l'esprit du comic-strip*) was becoming a feature in the work of many painters – Oyvind Fahlström, Erró, Hervé Télémaque and Peter Saul – during the years 1961–3.[17] These were the artists with the strongest American connections: Télémaque had spent the years 1957–61 in New York; Erró was introduced to the Pop world personalities by Fahlström during his stays there in 1962 and 1964; Peter Saul returned to America in 1963.

At issue was the response to the Amercanisation of popular culture. Virulent anti-Americanism had been the very theme of Fougeron's *Atlantic Civilisation* (see pl. 6), anathematised by Aragon in 1953, which marked the symbolic if not actual *terminus ad quem* of the French Socialist Realist movement. Nevertheless, by showing the NATO (North Atlantic Treaty Organisation) skyscraper in the Parc de Saint Cloud, the electric chair used to execute the Soviet spies Julius and Ethel Rosenberg, the great blue Ford, the leering American soldier with pornographic magazine 'occupying' France at the expense of its pensioners, by including immigrants and by its references to the Indochinese conflict and the re-armament of Germany, *Atlantic Civilisation* rehearsed all the elements of the new Western European order. Above all, the impact in France of

the Marshall Plan for reconstruction, instigated in 1948, led to the inevitable equation between modernisation and Americanisation.[18]

Irreversible processes of modernisation are implicit in Bourdieu's early analyses of the Algerian worker in transition between village and city, and the Béarnais peasant's similar relationship to modern France. Yet when it came to analyses of urban popular culture, references to Americanisation in Bourdieu's writing are almost entirely absent. Bourdieu was the intellectual protégé of Raymond Aron, France's most prominent anti-Communist and advocate of the NATO alliance: what Cold War distaste accounts for this significant repression? Barthes's *Mythologies* (1957) and Guy Debord's *La Société du Spectacle* (*The Society of the Spectacle* (published a decade later in 1967, with little understanding of the age of television) also, consciously or unconsciously, exclude America from their intellectual and theoretical horizons. Bourdieu's lifelong obsession with the French university and its relationship to culture and class, rather than the new world order, was still at the heart of his concerns. His 1967 translation and postscript to Erwin Panofsky's *Gothic Architecture and Scholasticism* (written by Panofsky in American exile) was crucial for the development of his concept of the 'habitus'. It offered the picture of an immensely learned medieval community focused on the French university and the transmission of its teaching methods. [19]

By the 1960s, the new generation of cadres (salaried bureaucrats), later to be analysed by Bourdieu's long-time disciple and collaborator Luc Boltanski (the brother of the artist Christian Boltanski), had been transforming France's industrial infrastructure.[20] The Blum-Byrnes agreement for French cinema had been overtly conceived as a tool of American cultural penetration from 1946: with the cancellation of France's war debts to the United States, it stipulated that for nine out of every thirteen weeks, France had to show American films.[21] The worlds of jazz music, fashion, novels and pulp novels acquired an American chic; from Boris Vian's 'fake' American thrillers to the B-movie inspiration for Nouvelle Vague cinema, the effects were obvious, co-existing with Sartre's existentialism and the lifestyle of Saint Germain des Prés.[22]

'Americanisation' had been far slower in the fine arts, primarily because of the French Communist Party dominance in the immediate Cold War period, commanding the allegiances of the 'giants of modernism' Picasso, Léger (paradoxically, given his American connections) and even Matisse. Party strategy was to promote them actively, at the same time as the Davidian 'tradition of revolution', which was enshrined in academically inspired Socialist Realist history painting.

With this two-pronged attack – late modernism and the revolutionary tradition – came finely tuned populist policies. Major architectural and decorative commissions were bestowed by the Communist municipalities encircling Paris with a 'red belt'; fêtes, celebrations and demonstrations demanded constant popular input; Moscow-backed Peace Movement processions with their Picasso doves were complemented by touring 'Batailles du Livre' (Battles of the Book), with celebrated authors reading from and signing their books against backdrops by Picasso or Léger. Exhibitions – notably of Fougeron's 'Mining Country' series – toured to industrial cities all over France; significant birthdays were celebrated, such as Stalin's or Maurice Thorez's, where the presence of artists or poets such as Paul Eluard on stage was crucial. The Fête de l'Humanité, on the outskirts of Paris, with its intellectual forums, art exhibitions, bookshops in tents, popular singers and regional specialities, marked an annual high point in the festivities. Above all, extensive cultural coverage and photographs of works of art, past and present, appeared in the Communist press during this period of great popularity: the daily *Humanité* and the weekly *Les Lettres françaises*. The French Party – its policy dictated by Moscow – was a 'national' party, which strategically deployed France's national heritage and left-wing traditions from Victor Hugo and Courbet to Picasso.

Just as Bourdieu's blind spot regarding Americanisation may be challenged, so may his general conclusions about 'access to culture' in the period. The analyses in *L'Amour de l'art* (1966), via their very technique of focused questions and statistical sampling on the museum threshold, based on taste relating to museum-visiting in Paris and the French regions (with some international comparisons), are far too specific; they deny twenty years of populist Communist Party successes in broadening the cultural base, together with trade union initiatives such as 'Travail et culture' and 'Peuple et culture'. Bourdieu's negative reactions to French intellectual life in all its Stalinist and Maoist intensities began with the anti-Stalinist Committee for the Defence of Freedom that he founded with Jacques Derrida and Louis Marin among others at the École Normale Supérieure (it was denounced by the École's own prestigious Communist cell).[23] In contrast with Bourdieu and his no-go areas (Americanisation and Communist Party practice), Rancillac emerges as the artist of the period whose work engages most emblematically with Americanisation, anti-American political engagement and Maoism. The move from a Bourdieu-inspired 'sociological' vision in his work to what Rancillac later characterised as an 'ideological' vision was played out over the decade of 1964–74.

Like French culture itself, Americanisation was also a question of 'high' and 'low'. In the fine arts, following milestones such as Jackson Pollock's first Paris show in 1951 and 'Véhémences Confrontées' travelling from Paris to London in 1952, came the major group exhibitions of 1953, 'Douze Peintres et sculpteurs américains contemporains' followed by 'L'Art mexicain du précolumbien à nos jours' (Fougeron's *Atlantic Civilisation* immediately adopted the Mexican muralists' colliding spaces). 'Cinquante Ans d'art aux États-Unis' was the watershed exhibition of 1955, comprising painting, sculpture, engraving, the decorative arts, typography and advertising. 'Jackson Pollock et la nouvelle peinture américaine', likewise spearheaded by the Museum of Modern Art in New York, toured major European capitals, arriving in Paris in January 1959.[24] An important statement at the beginning of the new Gaullist era, this heralded major changes.

Rancillac, denouncing 'powerful American imperialism, political, economic and cultural', retrospectively declared: 'The amiable M[me] Sonnabend did not disembark in 1963 in Paris for the simple pleasure of looking at the Seine.'[25] The story is now familiar: Jasper Johns first showed in Paris in 1959, Rauschenberg's 'Combine' paintings figured in the 1959 Paris Biennale with Raymond Hain's *Palissades*; his first show at

Galerie Daniel Cordier was held in 1961. Johns, Rauschenberg and Larry Rivers collaborated in Paris with Niki de Saint-Phalle and Jean Tinguely at this time; Arman, Christo, Martial Raysse and Daniel Spoerri were contemplating the move to New York.[26] By 1962, Galerie Lawrence (Lawrence Rubin), Galerie Anderson Meyer and Galerie Sonnabend run by the powerful Ileana (Leo Castelli's ex-wife) were established in Paris.[27] In 1963, Roy Lichtenstein's first solo show was held at Galerie Sonnabend.

25. Rancillac, *Mickey's return*, 1964

The manoeuvres of the duo Castelli and Sonnabend provoked endless bitterness in the 1960s generation of French painters; they were surely involved with Rauschenberg's Grand Prix for painting at the Venice Biennale in 1964, after highly contentious jury deliberations and Rauschenberg's late 'arrival' in the privately sponsored American Pavilion with its dazzling group show.[28] Alan Solomon's *obiter dicta*, 'The whole world recognises that the world art center has moved from Paris to New York', became a commonplace. The School of Paris was yesterday's news.[29]

Mythologies of the Everyday

Organised by Rancillac with Gassiot-Talabot and the Haïtian-born Télémaque, 'Mythologies Quotidiennes' (Mythologies of the Everyday) took place in July 1964 at the Musée d'art moderne de la Ville de Paris. Conceived long before the 1964 Biennale, it was interpreted, nonetheless, as a riposte. (It cohabited with a Franz Klein retrospective in spaces previously reserved for established individuals or prestigious group Salons; the Musée national d'art moderne was sedately showing Louis Marcoussis.) As a largely artist-curated show it was a first; the young in-house curator, Marie-Claude Dane, was subsequently punished for her audacity and banished to the Musée Galliera. Critics joyously emphasised Paris's liveliness and mythical unity.[30] Compared with the Pop artists, however, the Europeans were visually incoherent, with no story line or simple marketing strategy. (The same could be said for 'Un groupe 1965', an 'official' and expanded copy of the 'Mythologies' initiative the following year.[31])

By 1964, what the French call 'Anglo-Saxon' culture – the youth culture entirely invisible in Bourdieu's *L'Amour de l'art* (1966) – was two-pronged, British (such as the Beatles) and American. London's Carnaby Street style impacted on Courrèges,

26. Caulfield, *Greece Expiring on the Ruins of Missolonghi*,1963

while Patrick Caulfield's *Greece expiring on the Ruins of Missolonghi* (1963) reinvigorated Delacroix (pl. 26). Rancillac travelled to London's Whitechapel Art Gallery to see the new art.[32] Swinging London was a playground but not a threat; the impact of British gallerists in Paris was almost negligible at the time.

'Mythologies Quotidiennes' aimed to be as challenging as its title. This deliberately evoked Roland Barthes *Mythologies* and Henri Lefebvre's Marxist analyses of everyday life. Jean Baudrillard's *Le Système des objets* came only four years later, with its debt to Bourdieu's analyses of luxury reviews such as *Maison française* or *Mobilier et décoration,* and his semiotic analyses of the *briquet* (cigarette-lighter).[33] Baudrillard's Parisian analyses were indebted to American sociology: Lewis Mumford and Vance Packard subtend the obvious debts to Barthes, Bourdieu and contemporary writers such as Georges Perec (whose *Les Choses* (*Things*) was published in 1965, just after the 'Mythologies' show). Any contemporary references to Marcel Duchamp were thus conspicuous by their absence. It is more relevant to situate the 'object' dimension of 'Mythologies Quotidiennes' in the wake of François Mathey's imaginative exhibition 'Antagonismes II, l'Objet' at the Musée des Arts Décoratifs in 1962, where various commissioned objects linked the works of high art to contemporary design: here Yves Klein's air architecture and Bryan Gysin's dream machines shared spaces with a stately four-poster bed, a *lit d'apparat*, by Georges Mathieu – the most extravagant of his royalist fantasies.[34]

These exotica contrasted strikingly with the display of everyday items which acted as 'initiatory objects' in 'Mythologies Quotidiennes':

> For Raynaud, it is a red-coloured flowerpot and a little electric gadget as accessory, for Gironella, the sardine tin, for Niki de Saint-Phalle, plastic dolls, bits of old material, artificial flowers, for Rancillac, a guitar [electric], for Atila, a wheel, for Geissler, a magnifying glass, for Pistoletto, a mirror, for Bertholo, an electric iron, for Raysse, a sponge-wipe, for Kalinowski, quality leathers, for Arnal a blow-up mattress.[35]

Rancillac recalled:

> There was this notion of an everyday Mythology, which was a return, at the same time as American Pop art, to the domain of very ordinary themes, comprehensible by everyone, that were part of everyday life, and each person's daily life. These were not elitist, literary subjects… we were preoccupied by photography, advertising, cinema, comics… television, so-called 'popular' forms of culture.[36]

In the catalogue, Gassiot-Talabot emphasised the semiotics of the city environment as much as objects per se: 'city games, the sacred objects of a civilisation devoted to the cult of consumer society, the brutal actions of an order founded on force and subterfuge, the shock of signals, movements and customary demands which create daily traumas for modern man.'[37] German, Italian, Greek, Swiss, Spanish and Dutch artists were represented, artists from French-speaking Canada and Haiti; all had chosen Paris as their city at this time, including Leon Golub from Chicago and Peter Saul from San Fransisco.[38] The Galerie Lefebvre, Galerie Iolas and Galerie Daniel Cordier – all with New York outlets – advertised in the catalogue, as did Sonnabend herself (she was tactfully showing Michelangelo Pistoletto). This increasing globalisation of culture was another fact which Bourdieu's sociological statistics could not express.

Rancillac exhibited *Mickey's Return*, a huge canvas of three by two and a half metres (pl. 25). His 'hot' intrusion of a gesticulating Mickey Mouse into a riot of expressionist gesture and colour was ambiguous: it was 'not-too-American'. Titles such as the *Apparition of the Virgin to Cartoon Characters* (1964) offered a frisson of anachronism, sexuality and blasphemy (a naked inverted virgin sporting frothy white knickers), altogether alien to a Protestant mindset. The large format was repeated in

27. Rancillac, *Private Diary of a Kick,* 1965

his scandalous 'Walt Disney' exhibition at the Galerie Mathias Fels in 1965. Rancillac's first trip to New York, obligatory stay in the Chelsea Hotel and discovery of Duchamp in Philadelphia's Arensberg collection followed this show.[39] His cartoon style, closer to Warhol and Lichtenstein, developed later that year. He used the white grid of comic-strip cartoon frames and created effects of deliberate disarticulation and narrative collapse, symbolised by the aggressive blanks of white speech balloons and thought bubbles: *The Private Diary of a Kick* has evident parallels with Warhol's *Saturday's Popeye* (pls 27 and 28). The overriding sense of lack was counterpointed by the stridency of unmodulated flat colours intensified with the whites of hard reflections. Rancillac's forms zoomed and swerved like the crushed, phallic, missile trajectories of contemporary cartoon worlds, American or pseudo-American and their heroes, such as Salvator, the French space explorer.[40] 'A world of spasm, convulsions and panic', Gassiot-Talabot remarked.[41]

At the cutting edge of the avant-garde, Rancillac was using comic strips and photographic source material at the moment of his encounter with Bourdieu. Only in 1975, ten years later, was the 'cultural field' in which this work was produced retrospectively analysed by Bourdieu's collaborator Luc Boltanski in the first number of Bourdieu's *Actes de recherche en sciences sociales*. Boltanksi analysed a comic-strip 'field' essentially constituted after the Second World War 'on the model of erudite cultural fields', linked inevitably to American sources of production and distribution, with a culturally specific subset of artists – usually anonymous (they had repressed their failure to 'achieve' in the 'nobler' fields of the 'high' arts) – and a culturally specific though broad public (from children to university teachers). With wide-ranging analyses of styles (including the beatnik *style zizi)* Boltanski correlated in a chart the expansion of the 'field' of the comic strip with the 'intellectual field' and the 'university field'. The 'intellectual field' embraced negative articles by psychiatrists

28. Warhol, *Saturday's Popeye*, 1960

in *Les Temps modernes* (1955) to Umberto Eco's 'Myth of Superman and the Dissolution of Time' in *Giff-Wiff* (1964) and Situationist strategies of comic-strip *détournement* around 1968. Boltanksi juxtaposed the explosion of interest and availability of the comic strip, *BD* (*bande dessinée*), with the concurrent metamorphosis of French university literature faculties: 39,000 students, 177 teaching assistants in 1950; 67,000 students, 497 teaching assistants in 1960; 137,000 students, 1646 teaching assistants and *maître-assistants* in 1965. The

BD emerged as a taught course in 1970, as an academic subject in 1971 and as a subject for an international symposium in Paris in 1974.[42]

Boltanski dated the return to figurative painting to 1965 and mentioned 'Bande dessinée et figuration narrative' organised at François Mathey's Musée des Arts Décoratifs in 1967, yet he hardly understood its impact. This was a crucial show in its juxtaposition of the long history of the comic strip with works by contemporary Pop artists, notably Lichtenstein, and a range of Europeans. James Rosenquist's *F-111* (see pl. 7), then on its European tour, dominated all rivals; Rancillac helped to hang the enormous panels, along with Lichtensteins and other works provided by Castelli via Sonnabend.[43] With its epic size, quasi-narrative symbolic juxtapositions and political dimensions, *F-III* provided Paris-based artists with the biggest challenge since Pollock. The well illustrated *livre-catalogue* (a substantial book) offered a history and bibliography of the comic, with both American Pop Art and Narrative Figuration.[44]

For his *L'Amour de l'art*, Bourdieu used statistics – four thousand questionnaires – from the 1962 'Antagonismes' show at the Musée des Arts Décoratifs in his retrospective analyses, though most responses were based on later 1964 surveys; his two preliminary

29. Rancillac, *Ideal Homes*, 1965

articles were of 1964 and 1965.[45] Bourdieu's project had an official status; the surveys he directed for twenty-one museums in France were financed by the Study and Research Service of the French Ministry of Cultural Affairs. Rancillac recalls meeting Bourdieu for the first time at an artists' seminar in the Musée des Arts Décoratifs probably in 1965. At this historic seminar 'the Communists were still very powerful', Rancillac recalls; questions were still of the type 'should we paint for the people?', 'can a peasant like abstract art?' Bourdieu's quiet authority quashed the strident artists with simple statistics, proving the limitations of access to 'high' culture, though, Rancillac says, he was not taken seriously. 'He was not a philosopher… Sociologists were *les plombiers de l'université*' (the university's plumbers). Rancillac eagerly read Bourdieu's publications, exasperated with the clichés and lyrical effusions of art writing at the time. *Un art moyen*, on amateur photography and its social uses, had appeared in 1964, together with *Les Héritiers: les étudiants et la culture*, based on pilot surveys of the student population in Lille.[46] Rancillac attended several of Bourdieu's public lectures at the Collège de France, where, unconventionally, the master often acted as respondent to student exposés, for example by Luc Boltanksi. Bourdieu finally asked about the interloper; he and Rancillac became friends and dined together several times.[47]

Rancillac's 1965 series, in which Walt Disney cartoon-character transfers invade the lawns or staircases of stately mansions, are classic emblems of the Bourdieu–Rancillac encounter: see *Ideal Homes* (*Les Belles Demeures*), interventions in an article from *Paris-Match* (pl. 29). The children's stick-on transfers (*décalcomanies*) interrupt any desire-filled introjection into the images on the viewer's part. Cultural invasions, like rude gesticulations, they create an 'alienation effect'. They insist on the same critical distance that Bourdieu demanded of his readers, as he analysed the social codes of the same types of image from *Vogue* magazine or *Mobilier et décoration*. Baudrillard's 1968 analysis of the 'sublime' eighteenth-century house, part of the 'world of the unique', is also exemplified here: the aristocratic exemplar haunts the world of modern décor, where illustrated furnishings and objects serve, sociologically, as models.[48]

The year 1966

By late 1965, Rancillac had exhibited in Bochum, Tokyo, Geneva and Lund. The exhibition 'La Figuration narrative dans l'art contemporain', which baptised the Narrative Figuration movement (Rancillac and his peer group) travelled from the

Galerie Creuze in Paris to Prague in the same year. At some stage during 1965 Rancillac started using an epidiascope to project images onto his canvas, beginning with *Don't forget me*, which mingled an enlarged publicity image of a woman's face with a sports car. Rancillac carefully altered the projected image by hand to disguise its source. The epidiascope was brought back from New York by Hervé Télémaque, who later bequeathed it to his friend. Rancillac in turn took a small photography-based canvas to Bourdieu's home in the suburb of Antony as a gift; the inversion of the 'high' versus 'low', painting versus photography, became the catalyst for the text that Bourdieu agreed to write for the artist.

Yet, despite its sociological critique, Rancillac's work appeared apolitical. In June 1965, at the height of his success, a scathing open letter had appeared in *Les Lettres françaises* signed by the critic Raoul-Jean Moulin, 'Rancillac. Where are you? Where are you hiding yourself?' He spoke of 'alibi', 'puerile obstinacy in playing the Salon anarchists' and a cynical vision, when 'napalm is burning Vietnam.'[49]

The schizophrenia of a country where a burgeoning consumer society co-existed with a crescendo of protest against the Algerian war had been expressed in June 1961 by the work of Raymond Hains and Jacques de la Villeglé in 'La France déchirée' (France torn apart), their torn poster show. The advertisements which had turned Parisian streets into a huge capitalist comic strip were anonymously slashed in the work of these *affichistes*; on the surface of the posters, the slogans of politics and propaganda themselves became the mutilated signs of the presence of the Organisation Armée Secrète (OAS) in Paris and torture in Algeria. As Gaullist fought Communist, right fought left, Hains and Villeglé's 'anti-authorial' policy of non-intervention, as they lifted posters off the wall, was deeply imbued with neo-Dadaist strategies, reflecting the manichaean structures and the politics of disavowal of France at the time.

A different dialectic was posited in the works of the Narrative Figuration artists by 1966. With the end of the Algerian crisis and France's veto of British entry to the European Economic Community in 1963, a new self-confident, more self-centred era was heralded, culminating in France's withdrawal from NATO and the decision to develop unilateral defence forces in 1966. At this time, Bourdieu-inspired 'self-analyses' related class and privilege to culture within France. Outside, however, the deteriorating international situation again required immediate response from artists who prized political commitment and, in the era of Pop, the power of figurative art to respond.

The catalogue of the seventeenth Salon de la Jeune Peinture in January 1966 with its new militant committee and agenda (122 artists, almost 200 works) satirically represented its young artists with deliberately posed photographs: Arroyo seated as a troubled Spanish bourgeois, René Artouzoul in a suit outside the Chemical Bank (a New York Trust company), Jean-Claude Latil posing in a dinner jacket among tapestries and porcelain and Cueco's rustic riposte with its lavatorial humour. They parodied the display of stockpiled wealth in the world of global inequalities, war and day-to-day crises. In the same month, Rancillac resolved to paint the political events of the year (perhaps the first meditation on globalisation in paint), partly, he later claimed, to irritate those who liked to think that 'great' art was timeless.[50]

Throughout 1966, Bourdieu was painstakingly translating Erwin Panofksy's *Gothic Architecture and Scholasticism* with its focus on the medieval cathedral. This was the year his influential article on the 'intellectual field and creative project' appeared in the special number on structuralism of Sartre's *Les Temps modernes*.[51] 'He spoke about Panofksy all the time', Rancillac recalls. Bourdieu's decision to translate two lengthy illustrated texts and to embark on extensive research into medieval art history involving correspondence with Panofsky himself demands explanation. While still steeped in Marx, Bourdieu had attempted to clarify the Marxist notion of relative autonomy through reading Max Raphael's *Proudhon, Marx, Picasso* of 1933.[52] There Raphael had attempted to update the earlier reflection theory of Georges Plekhanov and the Soviets: he had analysed the spectrum of painting styles, including abstraction and Surrealism, as equally representative of bourgeois aspirations, corroborated by the contemporary art market. The situation of abstract versus figurative movements, driven by conflicting ideologies, was as pertinent as ever in Bourdieu's 1960s.

Panofsky, however, fielding the charge of Hegelianism (the pre-Marxist simplicity of Hegel's theory of a *Zeitgeist*), established a parallel between Gothic architecture (with its complex hierarchies and the spread of its styles, regionally and over time) and the evolution and transmission of scholastic thought (with its compartmentalisation, rationality of structure and rhetorical and pedagogical forms). Focusing on Paris as a centre of theological discussion with its new university structures, Panofksy proposed that collective 'mental habits' led to supra-personal 'habit-forming forces'. Collective intellectual formations and a *modus operandi* could account for connections between material artistic achievements – cathedrals – and theological texts. Bourdieu's postscript makes a contemporary analogy with Chomsky's generational grammar to explain the

1 • la bande dorsale élas-
tique arrondit la taille enca-
dre mieux qu'un conture
et beaucoup plus confor-
tablement

2 • les côtés et le dos en
élastique assouplissent les
hanches en diminuant
l'une aux hustiers ou aux
combinés qui comprimient
toute la poitrine

3 • la coupe des bonnets
met en valeur la poitrine
grâce à se parfaite adap-
tation et talles à profon-
deurs de bonnets à la
sous-armature

4 • le double élastique
élastique séparé élégam-
ment la poitrine mais
tient fermement

5 • les bretelles élastique
très réglables ne roulent
plus et gardent leur élas-
ticité même après de
nombreux lavages

idea of a system with its individual variations. What was original in Bourdieu's strategy was to counter an essentially structural model with Panofsky's earlier preface on Abbot Suger of Saint Denis. Suger, an upwardly mobile, exceptional and paradigm-changing individual, demonstrated the possibility of agency in an era of transition.[53] Bourdieu's conclusion on methodological self-consciousness sidestepped both the question of his personal investment as a Suger-like individual in a 'university field' and his use of Panofsky as 'ennobling' in terms of both art history as a discipline and his individual pedigree. However, this new endeavour established a methodology of correspondences together with 'agency in action' which helped Bourdieu to keep a crucial distance from Marx, Marxists and reflection theory, all intensely topical issues.

Bourdieu's year as a medievalist art-historian, 1966, saw Rancillac engage with the world of Cold War geopolitics – imperialism, totalitarian regimes, colonial liberation struggles and terrorism. His painting, increasingly manichaean in its themes, used harsh acrylic colours and print-inspired techniques. The imitation of a silk-screened effect through the use of masking offered technical equivalents for his uncompromising stance, his sense of urgency. Eighteen works were shown at the Galerie Mommaton in February 1967, treating subjects such as Vietnam, war between Israel and the Arab states, the assassination of Che Guevara in Bolivia, the Red Guards in China or apartheid in South Africa; another highlighted the struggle for women's emancipation in the privileged West: legalised abortion and the contraceptive pill were hot issues. Most of the material for the exhibition had sources in journals such as *Paris-Match*; these were the images through which France perceived 1960s world events in colour.

The exhibition 'L'Année '66' was prefaced by Bourdieu's 'L'Image de l'image':

> A strange project. An art which uses the everyday language of comic strips, posters or photographs. Frank colours which say frankly what they have to say, blue for sky, green for grass and red for blood. Themes as familiar as the poster you read in a flash in the metro corridor, a symbolism as transparent as in nursery tales or bad westerns, a revolver, crime, a wolf, violence. Intentions which are declared: to denounce racism, oppression, smug consciences. In short an art which wants to reach out to the most art-deprived public.... But this intention hides another which contradicts it. If *By Watt's Wall* or *The Indian Clock* expressed nothing other than the will to go to the people with nice sentiments, these works would not demonstrate so strikingly how the intention to be populist is self-destructive.[54]

Rancillac's procedure, making an 'image of a [photographic] image', is like a pleonasm, Bourdieu says: it is a superfluous doubling which nonetheless denounces the original image's claim to 'double' the world. He warns of the banalising of subject matter as it is conveyed in the saccharine tone of television announcers, as 'photographic realism' becomes in itself a sign of the redundancy of thought and the gross error, *bévue* (a word playing with *vu* and vision), of the photographer who does not understand what he allows to be seen, of the photographed subjects who do not perceive that they are being seen – the gross error inherent in everyday looking.[55]

Using the topsy-turvy device of the picture which could be hung either way up, devised in 1965 for *Melody beneath the Palms* (Hawaiian beach-girl versus American fighter plane), Rancillac's political canvases were increasingly brutal in their message: in *At last, a Silhouette slimmed to the Waist* (1966), a South Vietnamese soldier plunging a Vietcong prisoner head-first up to the waist in a cauldron of water, was contrasted, through inversion, with five different images of a waist-length, stretch-nylon bra (pl. 30). While Lichtenstein's reds, blues and yellows kept rigorously to comic-strip primaries, Rancillac's sugar-pink damsels and the acidic brilliance of his jungle shades produced a bilious effect. The spectator (the potential owner who must hang the picture) was forced to choose between two readings, 'Comfort over here, torture over there'.[56] In *Holy Mother Cow*, Rancillac replaced the desert sun with a cheese-spread label, *La Vache qui rit* (the Laughing Cow): above a blinding desert of yellow acrylic, a veiled woman struggles with her son, mule and water-pot (an image from a tourist brochure) – the Hindu cult of the sacred cow co-exists with starvation. At home, post-colonial problems took a new twist with the mysterious disappearance and assassination of the Moroccan leader Medhi Ben Barka. In *The Ben Barka Affair*, a separate panel contained the victim's face, behind which was the mirror to catch the beholder which fascinated Bourdieu.

With *Dinner-party of the Head-hunters*, the 'image of the image' encountered serious legal difficulties (pl. 31). If the three shutters were opened, Patrice Lumumba, Malcolm X and Frantz Fanon in black and white erupted into the virulently coloured orange glare of a bourgeois dinner party, at which art-loving guests posed sporting African masks. Which scene was the off-scene, the ob-scene, Rancillac demanded? The source was a photograph taken by Tony Saulnier, a professional photographer, African art collector and amateur ethnologist, first published in *Paris-Match* in a report on the exhibition 'Art Nègre, Sources, Evolution, Expansion' (part of the first World Festival of Black Arts in Dakar) which travelled to the Musée de l'Homme in Paris for the summer

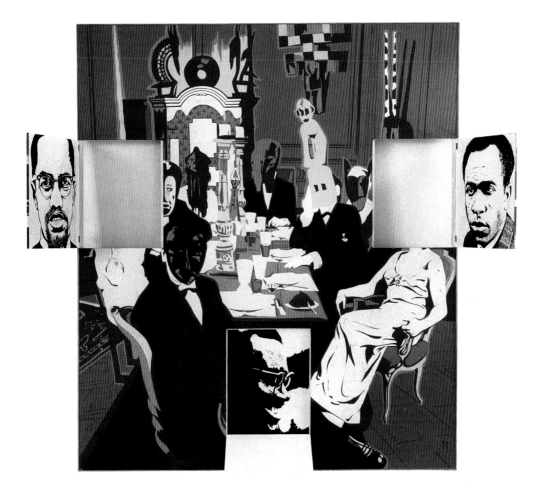

of 1966.[57] Saulnier sued; this was possibly the first court case in the contemporary art world where a photographer claimed his image as intellectual property.[58] Bourdieu himself singled out the *Tragic End of an Apostle of Apartheid* (1966) and the *Ben Barka Affair* for comment: he wrote of the inability of the viewer to 'see' reaching a paroxystic *mise en abîme* when the viewer is caught in the mirror placed behind the portrait of Ben Barka: 'the image of the image of another himself – other than himself', declared Bourdieu.[59] The work became a message of transference, in which the bourgeois spectator's position is mirrored as that of the colonised Other.

At the official Communist Party exhibition at Levallois, in January 1967, Rancillac showed *The Tragic End...* along with the Socialist Realist generation, Fougeron and Taslitzky, but also with his contemporaries Erró, Arroyo and the newly condoned abstractionists.[60] This fiftieth anniversary of the Russian Revolution of 1917 was celebrated in Paris by Communists and neo-Marxists alike.

31. Rancillac, *Dinner-party of the head-hunters*, 1966

In April, the Sino-Soviet split released Mao's China as an alternative 'territory for the imagination' for anti-Stalinist French intellectuals, offering a brighter palette and a pastoral theatre for artists as yet unaware of Peking's (Beijing's) Potemkin strategies. Rancillac's *Red Guard on Parade* shown in 'L'Année 1966' thus anticipated a theme which was developed with the 1967 series of four canvases, 'The Word': *General Assembly*, *Truth comes from the Mouth of Children*, *The Interview* and *The Gospel according to Mao*.

Rancillac had become an established star; the Bourdieu preface added to his prestige.[61] The press positioned him not only as *primus inter pares* in his own peer group but also in contrast with Bernard Buffet, his exact contemporary (by then the portraitist of a Parisian elite from de Gaulle to Yves Saint-Laurent), or against Michel Tapié and his well promoted *tachistes*.[62] An artistic right wing (together with milder shades of conservatism) existed in counterpoint to artists of the left, Communists, Maoists or fellow travellers, often attached to the increasingly militant Salon de la Jeune Peinture. During America's 1967 'summer of love' the counter-proposition was Cuba. Rancillac joined Erró, Monory, Adami and other Salon de Mai artists in Havana for the creation of the *Collective Cuban Mural* (pl.12).[63] It was an exhilarating foretaste of revolution in Paris when the mural's presence at the Salon de Mai in 1968 was eclipsed by Cuban-inspired French revolutionary posters – and blood and barricades on the streets.

32. Rancillac, *Bris/Collage/K* 1967

Consumerism, Americanisation, the 'world of television' and the urgency of political situations (not yet qualified as 'simulacral' by Baudrillard) haunted Rancillac. The 'Warhol effect' in his subsequent work contains all these ambiguities. Warhol was well known in Paris (he showed the 'Death in America' series in 1964 and the 'Flower' series in 1965 at Sonnabend's). Rancillac produced Warhol-based décors for the outrageous theatrical event *Bris/Collage/K* (for Kennedy), which was performed in October 1967, with a deliriously critical script by the poet Jean-Clarence Lambert. As a backdrop, Rancillac repeated

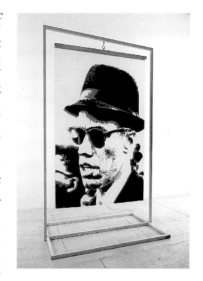

the Warhol-like covers of *Le Nouvel Observateur*, and the magazines *Adam* and *001*, with headlines booming 'WAR,' 'RUSSIANS TODAY,' 'NASSER AND THE ISRAELIS', 'THE LAST DAYS OF SAINT TROPEZ', 'BRAINWASHING', 'SPY MONTHLY' (pl. 32) arranged in bland, repetitive rows like Warhol's *200 Campbell's Soup Cans* (1962).[64] The 'Warhol effect' resurfaced vividly after May 1968 in Rancillac's silkscreen on plexiglass sculptures shown at the exhibition 'Les Américains' held in October 1968 at the Galerie Mommaton (while Rauschenberg was showing at the Musée d'art moderne de la Ville de Paris). Rancillac celebrated the recently assassinated Malcolm X (pl. 33), together with Jack Kerouac and Allen Ginsberg, who were heroes of the American underground in Paris (especially at the vibrant American Center on the Boulevard Raspail).[65] The

mug-shot silkscreened photographs used for the 'Les Américains' recalls Warhol's 'Thirteen Most Wanted Men' series shown in Paris the previous year. Confronting Warhol's blandness, in which the American dream is confounded by its own simulacral nature, the Warhol–Rancillac dialogue creates another *mise en abîme*. While Rancillac's appropriation of Warhol's style is premised on critical *détournement*, a denunciation of 'imperialist' violence on the world stage, it paradoxically involves forms of desire and visual pleasure: his anti-Americanism acquiesces within the parameters of the new world order.

34. Rancillac, *Nous sommes tous des juifs et des allemands,* 1968 33. Rancillac, *Malcolm X*, 1968

After May 1968: Pornography and Kitsch

Rancillac produced arguably the most iconic poster of May 1968: *Nous sommes tous des juifs et des allemands* (*We are all Jews and Germans*, pl. 34). The face of the student leader, the 'German-Jew' Daniel Cohn-Bendit, laughs at the forces of order who demanded his extradition from France.[66] Despite the overnight modification of his poster title to *Nous sommes tous 'indésirables'* at the insistence of the committees of the Atelier des Beaux-Arts, Rancillac still hears the provocative chanting of the modified, even more powerful slogan in the streets: *Nous sommes tous des juifs allemands.* The watershed of 1968 in various artists' careers will be explored in later chapters.

The final collaboration between Bourdieu and Rancillac surely comes as a surprise to the philosopher's followers today: the 'Pornography' exhibition at the new Galerie Templon in April 1969 ('the last major fallout of May '68 for Rancillac', claimed Serge Fauchereau).[67] Issues of taste, public versus private, 'art' versus photography and amateur photography were again on the agenda, as were voyeurism and censorship. Rancillac took about six months to collect pornographic photographs (from 'normal guys – most of them had some') which he enlarged on photographic paper. Specialist material such as *Sacristy Mice* (adolescent girls caressing themselves in front of a prurient curate) came from an Italian collection. *Pornography censured by Eroticism* was one of Rancillac's large works, later retouched with acrylic and objects (a zipped purse to cover the sex, electric bells to cover the nipples, were added in 1984; pl. 36). The arrondissement's police demanded discretion: the show had to be in the basement, by invitation only and inspected each day by two gendarmes who were bewildered to find no trafficking. Above all, pubic hair had to be masked: Rancillac used adhesive strips of white vinyl cut to shape. Bourdieu devised a survey, left optimistically in the

35. Rancillac, *Sailor boy,* 1969

gallery: 'Seeing this exhibition, do you think that art can have a liberating effect? Among the works presented in this exhibition, are there any which you think are beautiful? Would the same subjects seem more acceptable if treated pictorially?'[68] The exhibits were defaced, the vinyl strips picked and ripped by the exclusive public. Alas, there were insufficient replies to Bourdieu's questionnaire to proceed to publication; his scientific project was stymied by ribaldry and humour – or anxiety?

Another work, *Sailor Boy* (pl. 35), showing two men in provocative sailor outfits practising fellatio, also received violent treatment from the public: the genital area was later ripped away. While the explosion of homosexual culture in Paris came later in the 1970s, it is significant that the posters of the Comité d'Action Pédérastique had been the only ones torn up and censored by those who occupied the Sorbonne in 1968. At the Galerie Templon, Rancillac's 'Pornography' show followed the gay Catholic artist Michel Journiac's 'Great Wash' series of March 1969 and preceded his 'Mass for a Body', celebrated on 6 November with the assistance of the critics Pierre Restany and Catherine Millet. (Rancillac, in the audience, did not partake of the 'host', made of Journiac's own blood.) Journiac's later transvestite photographic series '24 Hours in the Life of an Ordinary Woman' (November 1974) parodied the magazine material used as raw sociological data by Bourdieu or Luc Boltanski. Like Rancillac's exposure of pornography, Journiac introduced awkward questions of sexuality, desire and fetishism into the typical bourgeois or petit-bourgeois universes that the sociologists claimed triumphantly to decode.[69]

36. Rancillac, *Pornography censured by eroticism*, 1969

By November 1969, art was entering what the *Chroniques de l'art vivant* called the 'time of kitsch', an era noted for the blurring of the boundaries and criteria of good and bad taste. Pascal Rossini's article seems to echo Bourdieu – 'for the masses submerged by cheap cultural products art is seemingly also an image of its images' – while his etymological discussion of the word itself (he offered as equivalents *le frelaté* or *camelote*) suggest that 'kitsch' was indeed a new concept (Bourdieu never used it in his contemporary analyses). 'Through posters, magazine and advertising photos, films and TV, the "solitary crowd" confronts the phantom of itself, which it has been responsible for imagining, elaborating, creating. So that, once and for all, it can perfectly conform to it.' The proximity of kitsch contaminates artists and intellectuals, Rossini continued: 'They become shamefully bound to dealers and the gigantic culture industry which devours everything including art itself under the weight of its innumerable products.' Hence, the recent phenomenon of the *artiste honteux* and the *intellectuel honteux*.[70]

Rancillac, disgusted with the atmosphere of compromise in Paris, left the metropolis for a large studio by the river at Boran-sur-Oise. In a vastly changed and recriminating post-1968 atmosphere, a major Andy Warhol retrospective was held in 1970 at the Musée d'art moderne de la Ville de Paris, organised by John Coplans from Pasadena. It coincided with the end of Warhol-fever in New York against the backdrop of the Vietnam War. Paris was again lamentably late. Pop was giving way to its successor.[71] While Gassiot-Talabot had praised Rancillac's *hyper-réalisme* in terms of his equation of light, shadows and colour to lit, photographic spaces in the 'L'Année 1966' catalogue, hyperrealism as such – anticipated since the mid-1960s by the Narrative Figuration group – finally arrived at the seventh Paris Biennale in 1971.

I would argue that Bourdieu's analyses of the variants of petit-bourgeois – even new petit-bourgeois – taste in *Distinction* (1979), though recognising a France in transition, are threatened by notions such as 'kitsch' which relate to a more fluid, Americanised, sophisticated society. With the Edward Kienholz show at the new Centre National d'Art Contemporain (CNAC) shared with Dusseldorf, Antwerp, London, Stockholm and Italy in 1970 and the impact of American hyperrealism all over Europe later in the decade, one should surely argue against Bourdieu's proposition that the university is the 'unconscious' of society. Evidently relating to his own brilliant generation of philosophers and sociologists (and ratified by Panofksy), this claim eschewed the increasingly rapid transmissions and absorption of visual culture in Paris. As the museum replaced the cathedral, and the Beaubourg project focused energies once concentrated on Notre

Dame and the Sorbonne, exhibitions could function as symptoms of change, as shifters of paradigms; this is a notion I shall explore in later chapters.

After Bourdieu: The Ideological Seventies

The *eminence grise* of the Maoist left, Gilbert Mury, succeeded Bourdieu as a figure of authority for Rancillac. The artist had thought about asking for a preface from the writer Michel Leiris whom he had met in Cuba; it was Mury, however, whom he approached in 1971. As Rancillac's political position hardened, his art became more aggressive. Mao's 'wind of class struggle' was rushing through France. It was a political coup for Rancillac, after his prestigious contacts with Bourdieu, to have Mury preface his exhibition 'Le Vent' at the CNAC in 1971. This was a controversial show which toured to the Hamburg Kunsthalle and Wuppertal (where Rancillac had been included in 'Kunst und Politik' in 1970) and the Aktions Galerie in Bern.[72]

37. Rancillac, *Kennedy, Johnson, Nixon and Lieutenant Calley on the road to My-Lai*, 1971

A painter asks a political militant to present his work; that is really unusual
– vaguely scandalous for today. Has not the French 'Communist' Party just
given the very example of a break between art and politics in this month
of September 1971, when it used the Fête de l'*Humanité* to put a 'national
museum-quality show' on the walls of the baraques at La Courneuve?

Mury referred with contempt to the Communist Party's updated 'modernist'
image and its new Parisian headquarters by the Communist architect Oscar Niemeyer.
The conflation of praise for Rancillac's 'photographic painting' and for Socialist Realism
in his text recalls Louis Aragon's classic eulogy of John Heartfield's photomontage in
1935. Here, however, Mao's advocacy of a Chinese Socialist Realism pronounced in
spring 1942 is the touchstone. Rancillac's photographic painting 'engages political
debate', Mury wrote, while his political formulas are pitched against the future: 'the
probable visit of Nixon to Peking, the certain arrival in Paris of a Chinese government
delegation, the diplomatic rapprochement between Tirana and Peking on the one hand
and Belgrade and Bucharest on the other'.[73] While 'Le Vent' marked the apotheosis
of a figurative, Maoist painting in France, a critical distance generated by the 'image
of an image' was always involved. The state-sanctioned exhibition caused a scandal at
the highest government levels (Mury's text had passed straight to the printers, unread

38. Rancillac, *The Red Detachment of Women*, 1971

by the CNAC curator Blaise Gauthier). Rancillac then cancelled the *vernissage*, in the face of curators and government officials as well as the public, because of the 'Mathelin affair' (government censorship of two canvases by Luc Mathelin at the Musée d'art moderne de la Ville de Paris).[74]

The installation of 'Le Vent' was crucial: *Long Live the People's Republic of China* – nine panels with painted Chinese slogans – together with *The Red Detachment of Women*; *Chinese Leaders salute the Procession for the 20th Anniversary of the Revolution*; *Make Revolution, Promote Production* (six canvases, each with Chinese slogans) were confronted by works about America, linked by those treating the Israel–Palestine conflict. Rancillac's Israeli triptych, *Israel and her Judges* (showing Israel's occupation of Jerusalem), was countered with a slogan painted in Arabic, *Long live the Palestinian Revolution*, together with New Albania: a flag-waving procession (illustrated Communist journals such as *La Chine nouvelle* and *L'Albanie nouvelle* provided the source material). Among the American paintings was the *American Suite*, which showed Vietnam as a sordid Mafia story (later purchased by the state) and the viciously topical *Kennedy, Johnson, Nixon and Lieutenant Calley on the Road to My-Lai* (pl. 37), based on the photograph by Sgt Ronald Haeberle used for the celebrated Art Workers' Coalition poster 'Q. And babies? A. And babies'. Serial assassinations invited renewed bloodshed; killers were to be killed in their turn.[75]

Among documents collaged on *The Red Detachment of Women* was Mao's 'Let a hundred flowers bloom' speech and extracts from the 1942 talks on Socialist Realism: dismembered pages are scattered over the canvas (pl. 38).[76] (The extraordinary Red Detachment 'opéra-ballet' performed for Nixon in China, then in Paris, was released as a film.[77] It became a point of reference not only for other painters such as Erró but also for the psychoanalyst Jacques Lacan.) Despite China's importation of Soviet mentors to its art schools from 1949, when Socialist Realism became official doctrine, its academic chiaroscuro – a sign of 'high' art, visually incomprehensible in China – was substituted by a brighter more indigenous palette.[78] This corresponded with Rancillac's own use of pale, flat colours, in particular the powder blues he often contrasted with a dark, blood-coloured maroon. These works were shown again at his major retrospective at the Musée d'art et d'industrie de Saint-Étienne later in the year; both Rancillac and the hard-left curator, Bernard Ceysson, referred here to Bourdieu's 'Image of the Image'; works from the 'Pornography' show listed in the catalogue were again censored (through political caution) but shown for a price to the public by museum guards.

Ceysson referred to the 'median, systematic and conventional' vision of photography, quoting Bourdieu's *Un Art moyen*, and justified Rancillac's move from using comic strip to using photography as source material – a move, he said, from the aesthetic to the sociological plane, at the confluence of art history with history.[79]

The 'Pornography' pictures were censored again when Rancillac exhibited fifty canvases in the working-class Communist conurbation of Villeparisis, twenty kilometres from Paris in 1973. Protests by the town-hall concierges against the pornographic images led to censorship of the show (evidently, the real cause was its Maoist content) and an order to remove the work by the departing Communist mayor. The coincidence that very day of the address on 'Freedom and Culture' by the Communist Party bureau member Roland Leroy to Samuel Maurice Druon, the minister of cultural affairs, added piquancy to Rancillac's threat to expose the situation to the press. He returned with officials from the Artists' Front (the Front des Artistes Plasticiens, FAP) to find a hasty rehanging of the show and a Communist champagne *vernissage*. Patrick Elme's description of the clash of the right and the far left, 'The *fleur de lys* and the Little Red Book', forms a chapter in *Peinture et politique* (1974), a treatise exemplary in its deliberately 'sociological' descriptions of the working and lower middle-class 'habitus' which framed such art-world strategies.[80]

Rancillac was by no means in retreat. During the 1970s, powerful political work alternated with charismatic images of jazz players. From 'Mythologies Quotidiennes' onwards, when Rancillac and the jazz drummer Daniel Humair became friends, jazz had provided not only a pleasure but also the possibility of a metaphorical transposition of his art into music. 'Mythologic Blues' (including the piece 'Rancillac'), performed in September 1964, had been the 'first experiment in collective improvisation translating

39. Rancillac, *BB King*, 1972

a pictorial emotion'[81]; 'Royal Garden Blues', the first French Pop lithograph album, involved all his painter friends. 'L'Age du Jazz' at the Musée Galliera in April 1967 was the first of several museum exhibitions on the subject in France, while summer jazz festivals at Antibes and the Fondation Maeght in Saint Paul de Vence became increasingly ambitious. The new 1970s art magazine *Chroniques de l'art vivant*, which had outstanding musical coverage, published Rancillac's sources, including Philippe Gras's dark, grainy, black and white photographs which were often put together in syncopated arrangements: see Rancillac's *BB King* (1972; pl. 39).[82] From Cecil Taylor to Noel McGhee, Janis Joplin or the sultry, psychedelic Diana Ross with her Afro hairstyle, the subject for Rancillac was always already politicised. Bourdieu's later analysis, in *Distinction*, of *Rhapsody in Blue* as the 'middle brow' position between lovers of Bach and of the *Blue Danube* (the 'worker's choice') seems an astonishingly crude measure of taste by 1979 in the context of these new (undoubtedly age and class-specific) audiences, with their new forms of specialised leisure and pleasure, circuits of sponsorship, public events, production and reproduction.[83]

Contrapuntally with the jazz pieces, political subjects continued, such as *Belfast* or *Bloody Comics* (both 1977) which brought Donald Duck and Pluto back to pillory the Chilean military junta. Rancillac's more ambitious suite of thirteen large-scale acrylic panels, *In Memory of Ulrike Meinhof* (1978, pl. 40), was ten years ahead of Gerhard Richter's 1988 series *18 October 1977* (pl. 41)[84] The furore in spring 2002 surrounding the display of some of these pieces in Richter's retrospective at the Museum of Modern Art in New York after the 11 September 2001 terrorist attack, together with renewed interest in Red Army Faction terrorism and its world-wide networks in the 1970s, gives a contemporary topicality and resonance to Rancillac's work.[85] His Meinhof suite depends, like Richter's, on the epistemology of the blurred image; striated depictions of high-speed racing cars on the Le Mans circuit alternate with Stuttgart's Stammheim prison corridors, where the Red Army Faction terrorists were held. The case had saturation coverage in France, where the terrorist question was far from neutral.[86] Sartre visited Baader in prison late in 1974 and *Les Temps modernes* published an article on torture by sensory deprivation. Rancillac's series was undertaken in 1977, before the discovery of the dramatic mass suicide of 18 October.[87] As a spectator, whose attention has initially been captured by the speed of the cars, one is 'arrested', then brutally plunged into the deep perspectives of the prison corridors, spaces in which perspective functions as a metaphor of control, surveillance and solitude, with all its topical

Foucauldian resonances. The metallic prison environment is represented as a steely harmony of greys, modulated with browns and lilacs. Richter used grey as 'the epitome of non-statement'. His works, blurred, desultory, 'non-judgmental' with their calculated delay and the patina of photographic memory, evoke the problematics of retrospective martyrdom; his black and white photographic sources from the Stuttgart prosecutor's office were generally personality-based. In contrast, it is the death-like impersonality of Rancillac's images which still disturb. Again he presents the spectator with a nominal choice, yet both sets of images – cars and prisons – approach blankness. Paradoxically, the racing-driver is equally a prisoner of his space-capsule, dicing with death. The cars (*bolides*, 'meteors' in French) pass across the lens at 250–300 kilometres per hour; the image is compressed via the camera shutter speed. Based on slide-projections of these on-the-spot photographs (again, the stuff of popular magazines), Rancillac's coloured streaks become increasingly painterly, non-referential: 'you arrive at swept forms which approach almost pure whiteness', Rancillac said.[88] 'Bolide Design', François Mathey's pioneering show at the Musée des Arts Décoratifs in 1970 – racing cars in the museum – was yet another imaginative gesture designed to cross cultural barriers; it was too fast again for the Bourdieu formed by the convictions of *L'Amour de l'art*.

40. Rancillac, *In memory of Ulrike Meinhof*, 1978

Rancillac exhibited his 'Ulrike Meinhof' suite when other Narrative Figuration artists were also involved with protest exhibitions and when various groups close to Michel Foucault were clamouring for prison reform.[89] The series finally reached a Parisian public in the Musée d'art moderne de la Ville de Paris late in 1979 and was shown in January 1980 at the Maison de la Culture in Grenoble, one of the most militant cultural venues in France at the time.[90]

Postscript

In Rancillac's words, *Il n'y pas de vrai artiste sans cocktail* ('there's no

true artist without a [Molotov] cocktail').[91] Rancillac continued to throw explosive cocktails at the art establishment. A sharp eye and knowledge of art history, combined with his technical flair, illuminate his manual of acrylic painting *Peindre à l'acrylique* (1987) and *Voir et comprendre la peinture* (1991), a book which aims, one could argue, to activate Bourdieu's proposals for a 'levelling-up' of cultural and artistic know-how for a wide public. Only in 2000 was Rancillac able to publish *Le Regard idéologique* (the ideological gaze), his excoriating analysis of the French art scene written in the mid-1970s, which is remarkable for its acerbic style and the transparency of the author's self-examination.[92] Rancillac repositions his figurative generation within a history of realisms stretching back to Courbet. The ideological gaze triumphed, then, over the sociological viewpoint. In the next chapter – indebted to Rancillac's own account of the 1970s – I shall investigate an era of depression and the collapse of the Marxist dream – in more photography-based work.

The paradoxes of the 'image of the image' continue to structure and haunt Rancillac's art. His 'Women of Algiers' series – with its deliberate nod to the tradition

41. Richter, *October 18, 1977, Cell,* 1988

of Delacroix and Picasso – continued the story of decolonialisation and political tragedy which precipitated the writings of Fanon and Bourdieu in the 1960s. *Bar Codes* (1999) evoked brilliantly striped Oriental textiles (each woven with their own ancestral meaning) and simultaneously the transactions of capital that maintain the first-world versus third-world dichotomies – and finance war and terrorism (pl. 43). Onto these striped backgrounds were projected newsreel images of victims (mostly female) of the continuing Algerian tragedy. Several hundred Algerians, notably women, came to see his 'Algeria' exhibition in Lyons in 2000–1 and later in Paris.[93] Pierre Bourdieu's Algerian photographs were discovered in their astonishing quantity and investigated just before his death; they were shown for the first time posthumously in Paris in 2003 (pl. 42).[94] It is remarkable that the great sociologist never mentioned his photographic activity to Rancillac.

42. Bourdieu, *Untitled*, nd.

In 1964, the year of 'Mythologies Quotidiennes', 'L'Art et la Révolution Algérienne' was shown in Paris, then in the Ibn Khaldoun exhibition space in Algiers. There, Arroyo, Cremonini, Lapoujade, Ferro (Erró), Monory and Rancillac, artists linked with Narrative Figuration, joined the older Surrealists André Masson and Roberto Matta and Communist artists such as Jean Lurçat and Boris Taslitzky. Forty four years later, in the spring of 2008, the Musée national d'art moderne et Contemporain in Algiers opened with 'Les Artistes Internationaux et la Révolution d'Algérie', showing Taslitzky's *Women of Oran* (see pl. 15), works by Mireille Miailhe (who was present and who had toured Algeria with the artist Taslitzky in 1952) and Rancillac's *Woman of Algiers*, 2 (1998), which he gave to the museum: it represented an Algerian woman almost camouflaged with lattices of wood and thorny branches.[95] The engagement continues.

43. Rancillac, Bar-Codes, Algeria, 1999

44. Fanti, *Soviet Garden*, 1972

Althusser, Fanti:
The USSR as Phantom

> All that is solid melts into air, all that is holy is profaned.
> Karl Marx and Friedrich Engels, 1848
> Fanti would say: the USSR is a necessary detour for me to speak of us, of myself.
> Louis Althusser, March 1977

Lucio Fanti's paintings exhibited in France, Germany and Italy in the 1970s are extraordinary in their proximity to Moscow Conceptualist art in both romantic and critical modes, yet significant in their difference.[1] Produced as early as 1969, Fanti's work traverses the period shaken by the revelations of Solzhenitsyn's *Gulag Archipelago*. He collapses the heroic epic of the USSR, creating a collision between dream and kitsch, a Marxian uncanny extending from the cult of personality to a dystopic sublime.[2] Fanti was one of the least prolific of the Narrative Figuration artists, though he extended his work to murals for mass housing projects and theatre design during the 1970s.[3] Yet his paintings operate as a Barthesian *punctum* (a point where meaning is deconstructed; simultaneously a focus of mourning) for belief in leftist politics and the revolutionary power of art, not only in terms of his own work but also of the Narrative Figuration movement as a whole. In *Loss: The Politics of Mourning*, Judith Butler has written of 'the loss defrayed through mania, disavowed loss and its textual and visual effects; the redemption that animates loss; the longing to which loss gives rise' and, 'perhaps most difficult, the loss of loss itself'.[4] Fanti's sublime quotes the skies of Russian nineteenth-century Romantic painters, floating above a Soviet mausoleum. He addresses questions of loss, located in a past and present history where 'the time is out of joint'.[5] What in the 1930s Walter Benjamin called 'left melancholy', defined as a post-revolutionary bad faith mixed with nostalgia, resurfaced in the 1970s in a context of disavowal – disavowal of the gulags, where contemporary 'dream kitsch', to transpose another Benjamin term, expressed a profound sickness.[6]

Louis Althusser's 1977 catalogue preface for Fanti's elegaic exhibition on the theme of Mayakovsky's suicide mirrored the artist's melancholy. It anticipated Althusser's public declaration of the 'crisis of Marxism', his denunciation of the French Communist Party and his final tragedy: the murder of his wife (Butler's 'loss defrayed through mania'?). The encounters between philosopher and artist, both working on a Franco–Italian axis, raise questions which go beyond the Parisian worlds of painting and academe. They were framed by the *anni di piombi* (years of lead) when political action, particularly in Italy and Germany, involved urban guerrilla warfare, terrorist murders and the larger geopolitical confrontations of the late Cold War.

Fanti grew up under the influence of his father, Giorgio Fanti, an Italian intellectual and correspondent for the Communist *Paese Sera* newspaper, a job which took him from Rome to the USSR, as well as to London and Paris.[7] Giorgio Fanti became a close friend of Althusser and other prestigious intellectuals in the Communist 'family' who later appreciated Lucio Fanti's work; these included the writers Italo Calvino and Jorge Semprun, the Buchenwald survivor who became engaged with Althusser in the so-called 'humanist controversy' (as described in Chapter 1).[8] Arroyo, the Spanish anti-fascist artist in exile, became Fanti's friend and mentor; Arroyo lived in Montparnasse's La Ruche, the 'beehive' of artists once frequented by Alexandra Exter, Marc Chagall, Chaim Soutine and Fernand Léger and where Roberto Alvarez-Rios, Francis Biras and Lucio Fanti live and work today.

The godfather of La Ruche when Fanti arrived in Paris was Paul Rebeyrolle, a figurative expressionist and the respected contemporary of Picasso and Edouard Pignon in the 1950s, all Communist Party painters. Rebeyrolle had emerged from the Salon des moins de trente ans, founded in Paris during the Occupation in the Second World War; it became the Salon de la Jeune Peinture in which he was a prominent figure. He left the Party in 1956 and was marketed by Galerie Maeght; Sartre wrote about Rebeyrolle's work in 1970, Foucault in 1973.

45. Buraglio, *Camouflage Mondrian*, 1968

In Jean Clair's *Art en France: une nouvelle génération* (1972), Rebeyrolle was given the status of a founder-figure for contemporary developments, along with Léger, Matisse, Duchamp and Bonnard.[9] Yet, later his style and position were overthrown by the generation of Arroyo and Gilles Aillaud. The generational conflict, insistently present, is at its most explicit, most acute, with Fanti, the benjamin of the group.

At the age of fourteen, Fanti was sent on holiday with a small group of Italian boys to Arthek, the model Soviet pioneer camp in Crimea. On his return, his father was moved abruptly to London: the young Lucio, speaking neither English nor French, was dispatched to London's Lycée Française in 1959. It was in London that the satirical and critical works of artists such as Hogarth and George Grosz first made their impact: Fanti began drawing at this time. In 1962, Arroyo's first London exhibition,

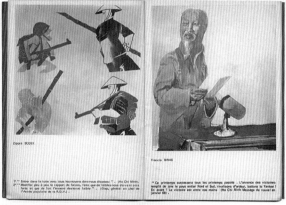
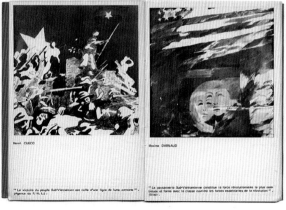

reviewed by Giorgio Fanti for *Paese Sera*, strengthened links which developed when Lucio became an art student in Paris shortly afterwards.[10] Here, he gravitated towards the militant painters who had seized and reformed the Salon de la Jeune Peinture in 1965, particularly Arroyo, Gilles Aillaud (Althusser's disciple, as noted earlier) and the Italian Antonio Recalcati – the three artists whose *Live and let die: or the Tragic End of Marcel Duchamp* (see pl. 8), drew up the lines of battle already discussed.

46. Buraglio, Cane, Bodek, Biras, Cueco, Darnaud, *La salle rouge*, 1969

Key moments of the Salon's history after the 1965 takeover with the 'Green Room' show include the anti-bourgeois theme of 'Luxury' (*Le Luxe*) at the 17th Salon in 1966, with its committee photographed as rich *arrivistes*, and the intervention of the BMPT group (Buren, Mosset, Parmentier, Toroni) in 1967. By this time, however, a response to the escalating situation in Vietnam seemed urgent.[11] A form of transference was also at stake. As Kristin Ross has pointed out, 'a new political subjectivity passed by way of the Other... it was the North Vietnamese peasant and not the auto worker at Billancourt, who had become, for many French militants, the figure of the working class'.[12] Fanti first exhibited in the 'Salle Rouge pour le Vietnam' (Red Room for Vietnam) show, planned initially for 1968, a project led by the artist Pierre Buraglio, who was by then a dogmatic Maoist. While the 'Green Room' paintings such as Arroyo's lettuces (see pl. 10) had deliberately banalised both content and formalist positions, in the 'Red Room' show, content was crucial. The works, each two metres square, were elaborated from February to April 1968: each project and its preliminary drawings were submitted to group interrogation. The subject, legibility and political impact of each picture was examined in the context of the 'Vietnamese people's victorious struggle against American imperialism'; progress was documented in the *Bulletin de la Jeune Peinture*.[13] Vietnamese propaganda material was produced both for study and inclusion: posters featured in the final exhibition. Not only graphic design but also,

47. Rieti, *Courrier de Vietnam*, 1968

crucially, Vietnamese photographs formed the basis of paintings. A political, photography-based painting, then, brought images produced through photojournalism (notably, syndicated images from Vietnamese newspapers distributed in France such as *Le Courrier du Vietnam*) into the powerful 'arena of art'. The catalogue was a 'little red book', rich with Maoist symbolism. Revolution on the streets of Paris in May forced the postponement of the exhibition but not the artists' growing concern.[14] On 20 July 1968, Ho Chi Minh's call for peace was met by a vicious American riposte; the Cambodian government's condemnation of America's genocidal policies in Vietnam was echoed worldwide.

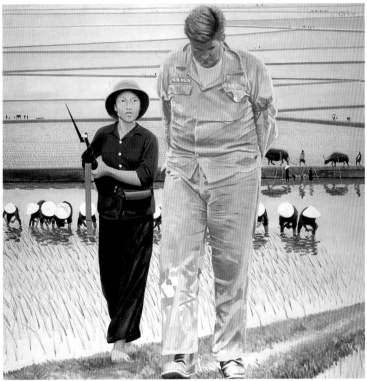

48. a. Fanti, *Vietnamese Family,* 1969
b. Aillaud, *The Battle for Rice,* 1968

The 'Red Room for Vietnam' show finally took place the following year, from 12 January to 23 February 1969 in Gaudibert's ARC space in the Musée d'art moderne de la Ville de Paris; it was a political gesture that instantly jeopardised his budget.[15] Following the May 1968 imperatives of art on the street and art for the people, the exhibition was restaged in Paris's Cité Universitaire in March and then toured factories, youth clubs and other popular venues in the provinces (just as Fougeron's 'Mining Country' series had toured in 1951).[16] Its explicitly Maoist line alienated support in Communist municipalities, except in Bagnolet where three of the painters lived.[17]

With this show an apotheosis of political painting was reached. Henri Cueco's *Barricade, Vietnam 68* (see pl. 1) subconsciously evoked Delacroix's famous barricade with a flat, bright, Pop technique. Buraglio, the purest of Maoist activists, was closer to the BMPT group. His parodic, highly critical *Camouflage Mondrian* (1968) was entirely abstract (pl. 45). Yet for the 'Salle Rouge' in the context of militant work, he created a poster-like portrait of Nyguyen Huu Tho, the President of the National Liberation Front (pl. 46). Among the more aggressive works was that by Zipora Bodek, a Hungarian-born Israeli and survivor of Belsen (also Buraglio's companion); beneath her image of conflict and impalement was a quotation by Giap, the General-in-Chief of the People's Army of the Democratic Republic of Vietnam (pl. 46): 'Enter into battle with all the means at your disposal (Ho Chi Minh) / Little by little change the balance of power, so that from weaklings we become strong and from strong men the enemy becomes weak'.[18]

A reverse dialectic between strength and weakness eloquently represented the power of Vietnamese resistance strategies linked to craft skills and a rural economy.[19] Gilles Aillaud's *The Battle for Rice* (pl. 48b) showed a tiny woman frogmarching a huge American pilot at gunpoint against a background of paddy fields – a celebrated image repeated in Fabio Rieti's photograph-based painting which used the *Courrier de Vietnam* of 16 September 1968 (pl. 47).[20] Fanti's quietist *Vietnamese Family*, depicting peasants in a rice field, typically elevated the theme of peaceful resistance (pl. 48a). His painting, with its doubled space, sky and water reflections, anticipated much of his future œuvre, yet the recessive perspective, with harmonious labour in the background and family unity in the foreground, suggested an overall tranquillity, in conflict with his developing sense of critical irony.

Fanti subsequently exhibited with various collective projects for 'Police and Culture' at the Salon de la Jeune Peinture of 1969, including *The Datcha*'s satire on

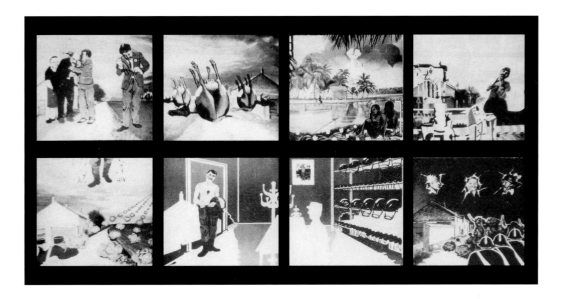

French intellectuals (see pl. 5). Gaudibert wisely offered the lower spaces of the Musée d'art moderne de la Ville de Paris in July, when most Parisians were on holiday. With the abolition of the official jury, each group of artists constituted a *jury de base*, a 'people's jury from the base'. Politically inspired restrictions (including no catalogue or reproductions) were such that exhibiting numbers fell drastically, to a mere fifteen or so artists. Althusser himself attended the show and was involved in a surprisingly virulent radio interview with several painters, in which he criticised the Communist Party.[21]

The collective *Datcha* therefore took its place within a range of works in which new group procedures were linked to the concept of critical practice inspired by Althusser. *Painting on the Question of the Minor Peasantry*, later called *Story of a Poor Peasant*, consisted of eight canvases. Here, Gérard Tisserand, Latil and Michel Parré were joined by Hans Erni, Claude Rutault and Roméro (pl. 49). In this parable of blistering irony, the 'prodigal' younger son enlists for a military sojourn in a Gauguinesque colonial paradise and then returns, soon abandons factory work for the police force and finally confronts his brother across the barricades at a peasant protest. With floating, topsy-turvy cows and flying cabbages, its humour was acerbic – an elegy for the depopulated countryside and the collapse of biblical morality. It embodied the *guerre franco-française* (permanent internal conflict in France) in which state police recruitment among the peasants or working-classes was part of an orchestrated strategy.[22]

Henri Cueco, Marinette Cueco, Lucien Fleury, Gérard Schlosser, Edgard Naccache and Jacky Schnee painted the propaganda wall, *School Book, Class Book* (pl. 50).

49. Latil, Parré, Rutault, Tisserand, *Story of a poor peasant*, 1969

A massive panel containing photograph-based painting, cartoon strips, writing and parodies of French schoolbooks (hence 'class' society) was emblazoned 'Schoolbooks, propaganda instrument of the bourgeoisie'. The ill-defined humanism of the school books that had formed the generation of the 1950s and 60s was attacked: 'psychologism, paternalism – Progress, the University, Man ... profoundly idealist.'[23]

Gaudibert's publication *Action culturelle: intégration et/ou subversion* of 1972 cites Althusser's roneotyped course notes of 1967–8 on schooling as the ideological indoctrination of the masses, linked to that of church, state and political parties. Later in the book Gaudibert elucidates the concept of the AIE (*Appareils Idéologiques de l'État;* Ideological State Apparatuses), again first elaborated in Althusser's lectures of 1967–8.[24] Following sections on Althusser and Wilhelm Reich, he turns to Paul Nizan, whose *Les Chiens de garde* (*The Watchdogs*), the celebrated 1932 attack on the state co-option of intellectuals, was first re-edited in 1960.[25] Nizan was explicitly fêted in the 'Police and Culture' Salon. *Intellectuals, Watchdogs*, a huge panel of four by four metres by Sergio Birga, Zipora Bodek, Gian Marco Montesano and Frodlich, treated the same theme as *The Datcha*. It attacked 'the role of the intellectual in the service of the bourgeoisie, the philosopher, the scientist, the artist, the ideologue, the politico, who are the watchdogs of capitalism'.[26] (Fanti's own portrait of Nizan was later published in the new hard-line left review *Rebelote*, on 3 October 1973).

Gaudibert also contrasts contemporary cultural rhetoric with media brainwashing, particularly the state radio monopoly ORTF (the target of many 1968 posters).[27] Hence the meaning of *The Datcha*'s inscription: 'just when the radio announces that the workers and students have decided, joyously, to abandon their past'.[28] Do the intellectuals, depicted rigid in their armchairs, believe their ears? Out on the street, the militants know that a new struggle has begun.

50. Cueco, Marinette Cueco, Fleury, Schlosser, Naccache, Schnee, *School book, Class book*, 1969

Fanti participated in another Arroyo-inspired group work, *Boxing*, made for the show. Other works deserve further investigation: *Television, Merchandise*, which showed the police detention centre set up at Beaujon to house the rebels of 1968, and the *Country Party*, a forty-minute political video; or *Repression, Italian Style* (an installation of images of the police transferred onto suspended transparent plastic strips) by Paolo Baratella, Giampaolo de Filippi, Marcello Mariani, Giangiacomo Spadari and Gobbi. For the Italians who were linked to a new critical figuration, Althusser joined Antonio Gramsci as a theoretical beacon. The Italian protagonists of the movement were well known and promoted in France.[29]

Lenin, Fanti and the Soviet Dream

In the late summer of 1969, Fanti left the tempestuous politics of the Parisian scene behind to join Arroyo in the Italian resort of Positano on the Amalfi coast. It is here that his first deeply personal works were created: *Grandchildren of the Revolution* and *Statue*. These figured in the militant 'Kunst und Politik' exhibition in Karlsruhe, held to celebrate the centenary of Lenin's birth in 1970. For Marxists worldwide, 1970 was 'Lenin year'. The Paris 1969–70 season culminated in May and June with the official 'Vladimir Ilitch Lénine' exhibition held at the Grand Palais, where Soviet Socialist Realism, including Gerasimov's iconic *Lenin on the Tribune* and a small version of Isaak Brodzki's *Lenin at Smolny* (1930; pl. 51), was on show for the first time since 1937, in the Soviet Pavilion at the Paris World Fair.[30] Althusser's *Lénine et la philosophie* had been published in 1969.[31]

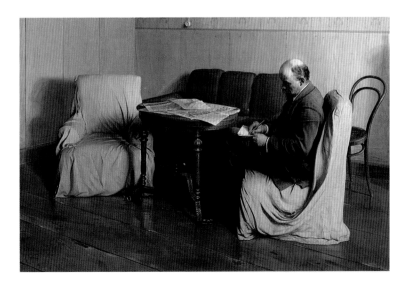

51. Brodzki, *Lenin at Smolny*, 1930

More work was appearing on Lenin, including Jean Fréville's *Lénine à Paris* and paperback editions of Lenin's writings, together with new publications through the 1970s on theoretical figures such as Plekhanov and Alexander Bogdanov – and on creators in poetry and theatre such as Mayakovsky and Vsevolod Meyerhold.[32] Four decades after the 1930s publications by or on these figures, many of the critical authors such as Fréville were still active.[33] In parallel with these new editions, France's own left-wing struggles and Popular Front cultural policies had their first histories written by former participants.[34] A veritable mirror-reflection between 1930s and 1970s France appeared at this time, including a revival of the Frankfurt school. Intellectual battles against right-wing monopolies and government policies raged, while – as in the later 1930s – state-financed cultural initiatives expanded.

In May 1970, Fanti accompanied *The Datcha* to the Karlsruhe Kunstverein for 'Kunst und Politik', the most significant exhibition of European critical realism conceived for Lenin's anniversary year (it toured later to Wuppertal, Frankfurt and Basel).[35] Here, Fanti exhibited his two key paintings and met German artists such as Johannes Grüztke, who figured in the special number of *Tendenzen*, 'Was Tun?' (Lenin's 'What is to be done?'), that coincided with the opening. With a Paris-based, French contingent of works organised for the show by Gassiot-Talabot, the affinities between these European 'children of Karl Marx and Coca-Cola' were demonstrated.[36] Herbert Marcuse's 1967 text on the position of art in a one-dimensional society was translated for the catalogue.[37]

Like his fellow members of the Narrative Figuration group, Fanti used photographic documents; but while Rancillac or Gérard Fromanger worked with contemporary advertising or photographs of Parisian streets, projecting images onto canvas with an epidiascope or slide projector, Fanti initially squared up his canvas, like an Italian master. His images were neither of France nor Italy; they came from the sepia mythologies of the Soviet Union, from commemorative volumes given by Soviet officials to his father. In *The History Lesson*, Fanti had depicted himself as a young child, eyes unhealthily red-rimmed, transfixed by the stories and images in a huge album devoted to Lenin's life and exploits: Lenin at the Finland station, Lenin with his wife, Nadejda Kroupskaya, and so on. A book on Kiev celebrating the 300th anniversary of Ukraine's accession to Russia, published in 1954, served for the Positano paintings and later works such as *Soviet Garden* (1972; pl. 44) with its grand Lenin sculpture. Here were city vistas and civic monuments photographed using conventions inherited from

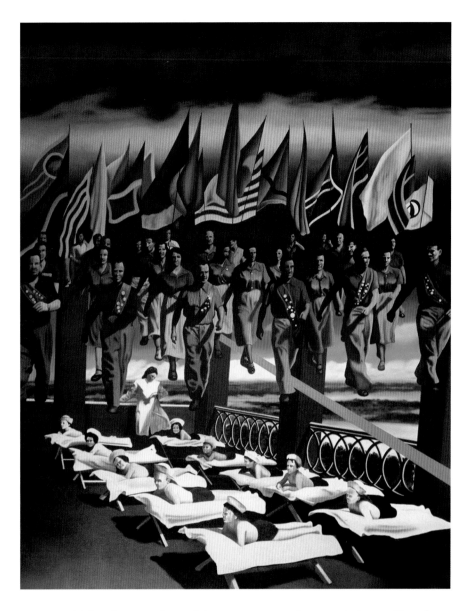

nineteenth-century guidebooks together with more recent views and the smiling faces of Soviet propaganda.

A photographed parade of bemedalled officials is the source for the generation who march in the sky over *Grandchildren of the Revolution* (1969; pl. 52). The 'grandchildren' are the young pioneers, like Fanti himself, sunbathing to a stopwatch in the sanatorium at Arthek. Weightless, the dark spectres march above the boys towards a brave new world now lost in a distant past.[38] The lack of gravity extends to their ideals and beliefs. Fanti's painting invites reflection on the confusions of ideology plunged into

52. Fanti, *Grandchildren of the Revolution*, 1969

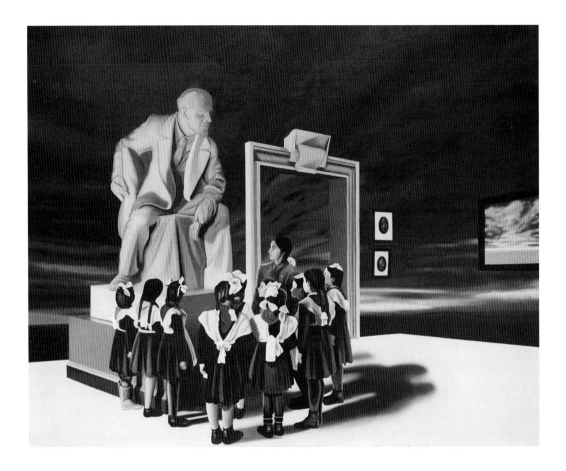

a generational chasm – absurdity encounters a dark nostalgia. Paternal *gravitas* versus gravity defied is a constant in all Fanti's works of this period; one recalls Althusser at his most congenial on the 'comic fall' of philosophy and the 'philosophical theory of the fall'.[39] The image is transparent in terms of memory, fantasy and what it belies. Paul Thorez, the privileged son of the French Communist leader Maurice Thorez, recalled: 'Arthek – that mirage which deceived me, also anchored in me the passionate need for a fraternal world'. As an adult, Paul Thorez finally saw through his own recollections of Arthek, concluding that the youth camp was a 'microcosm of Sovietism, similarly founded on social inequality, the hierarchical ranking of privileges, a frankly military-type organisation, the lie of stereotyped jargon'.[40]

Fanti's *Statue* of 1969 also derives from the 1954 album (pl. 54). In the Ukraine state museum, Sergei Merkhurov's huge Lenin statue looms above a young schoolteacher and her pinafored students: 'You could not go through these museum rooms without a deep impression of the image of the great proletarian leader', the caption declares.

53. Fanti, *Statue*, 1969

Squared-up, folded, scored, Fanti's working document for the painting – a torn-out page – betrays a disturbing private rage. *Statue* translates this photograph, already rich with Oedipal bathos, into a painted mirage. Lenin is dead, yet arrested in a turning movement on his seat like Michelangelo's patriarchal *Moses* (doubtless this was in Merkhurov's mind). Obsolete, his remains have moved from the mausoleum to the museum. A *revenant* in marble, he is the focus of living adoration, a promise of redemption – or punishment? Fanti's painted sculpture occupies a terrifying interval, a red chasm of time between historical past and future. In the very convergence of painting and photography, Rosalind Krauss has remarked, can be seen 'the relationship between obsolescence and the redemptive possibilities enfolded within the outmoded itself'; conversely, Paul Virilio, for whom the 'interval' lies between the moment of hyperrealism and the virtual, sees hyperrealism in its relationship to photography as pictorialism was to painting, 'the symptom of the arrival of the end'.[41]

The claustrophobia of the original photograph, where Merkhurov's Lenin statue is constrained by its corner setting and the bevy of schoolgirls, is doubled by the seascape on the museum wall. Nature is trapped in the past, museumised. In Fanti's painting, the seascape hangs from an invisible wall, while its skies are repeated in the sky at large; the *mise en abîme* signals no escape: one sees the 'museum without walls' of classic Communism. The red sky streaked with purple spreads like blood across the scene, surrounding Lenin with a glow that confirms his presence as a spectre. This dystopic sublime is signalled with its mix of emotions, of terror and love.

Rather than a biographical statement, Fanti chose a quotation from Lenin's *The State and Revolution* (1917) for the 'Kunst

54. Kiev Museum of Russian Art, c. 1954

und Politik' catalogue. Here the device of *mise en abîme* becomes textual, for Lenin himself had the same premonition of posthumous longevity:

> The oppressing classes have constantly rewarded great revolutionaries during their lifetime with continual persecution. After their deaths, they are canonised, turned into harmless deities, aureoled in glory... The bourgeoisie and working-class opportunists collude together in this appeasement of Marxism, which represses the revolutionary dimensions, the revolutionary soul of the doctrine...

Rather than simply an attack on the 'appeasement of Marxism', Fanti's painting could be read as a more complex proposal for a dialectics of the image. In 1970, *Statue* was a painting of premonition and of warning: its painted threshold demarcated the interval between generations, between past and future.[42] It was also made in Italy: Fanti, the living 'prodigal son,' was attacking the father-as-statue. De Chirico's classical bearded sculptures and empty chairs together with the myth of Don Giovanni (as well as Freud's Moses and Hamlet's ghostly father) haunt Lenin's apparition.[43] Sartre's banished 'spectre of Stalin' was also present, as was Althusser's own desire to banish the 'phantom of Hegel'. A 'hauntology' was established, then, in philosophical thought as well as representation long before Derrida's definition of the concept in his extremely late *Spectres of Marx* (1993).[44]

Committed to the principles of revolutionary violence, Italy's Red Brigades came together in 1970, following the formation of powerful proletarian groups in Italy in 1968–9 (Lotta Continua, Potere Operaio, Collectivo Politica Metropolitana). Fanti's first paintings were shown again in Rome for his solo show in 1972 at Galleria Il Fante di Spade (Ace of Spades), in this political context. The full panoply of the Italian Communist elite attended the opening. Lenin's words again prefaced the catalogue, which was introduced in both French and Italian by Gassiot-Talabot. Socialist Realism was ritually invoked here, only to emphasise Fanti's reversals of meaning, his 'cruel delicacy' and his 'strange skies, vast as regret, open as hope, tenacious as memories'.[45] The exhibition placed Fanti with an excellent gallery, frequented by the Cremonini generation. Pierre Gaudibert then arranged for the show to travel to Paris.

A lengthy illustrated article in *Opus International* of June 1972 introduced Fanti's work to a Parisian public. It appeared, however, at a moment which Gassiot-Talabot described as one of general malaise, of government censorship and of extraordinary splits and jealousies in the Parisian art world, provoked by the official exhibition at the Grand

Palais, 'Douze ans d'art contemporain' or '72 pour 72' (seventy-two artists for 1972): artists rioted, police intervened, rivalries intensified into hatreds, the militant artists' front, the FAP (Front des Artistes Plasticiens), was born. Internationally these events were framed by the Venice Biennale and the build up to Harald Szeemann's Documenta 5 at Kassel, where France, apart from Daniel Buren, was all but invisible.[46]

Fanti's sense of the uncanny sat well with this malaise. Less auspiciously, Gaudibert, too militant as both curator and state employee, left ARC under a cloud.[47] The Salon-connected *Bulletin de la Jeune Peinture* was substituted by *Rebelote,* whose first number, of February 1973, contained a double-page composite collage by Arroyo devoted to Fanti.[48] Gaudibert's young commandant, Suzanne Pagé, became responsible for a 'new' ARC 2, inheriting Gaudibert's show for April 1973. There three artists came together: Fanti, the Hungarians László Méhes, who had arrived in Paris in 1972 with his 1960s hyperrealist canvases, and Istvan Sandorfi, resident in Paris since the Hungarian uprising of 1956.[49] By 1973, a comparison with American hyperrealism

55. Fanti, *Lenin's armchair at Smolny, 1917,* 1975

was *de rigeur*: Sandorfi's *Five Self-Portraits in a State of Alienation* were contrasted in the catalogue with Chuck Close; Méhes was at pains, retrospectively, to distinguish 'a flowering of the new European realist painting… developed in parallel to American hyperrealism… transmitting European doubts.'[50] Gassiot-Talabot's lyrical Rome article on Fanti appeared here after a didactic, 'theory'-style exposition by Aillaud and Buraglio.[51] Fanti's works toured in late 1973 with those of Gilles Aillaud and Gérard Schlosser to the Maison de la Culture in Rennes; more 'Soviet' canvases were included in a group exhibition prepared for the end of the year.[52]

Althusser's own position during this period was less promising. His 'Reply to John Lewis (Self-Criticism)', written in mid-1972, published in French in late 1973 with its postscript 'On the cult of personality', restates a certain orthodoxy.[53] A parodic dialogue in defence of the 'Reply to John Lewis' appeared in *Rebelote* in February 1974.[54] However, Althusser could not remain aloof from the impact of Solzhenitsyn's *Gulag Archipelago*, which appeared first in Russian in December 1973 and in French during 1974, the year of his own trip to Moscow.[55] Despite an extensive debate in the 1950s – notably the denunciations of the former concentration-camp deportee David Rousset – earlier proofs of the existence of the gulags, backed by statistics and witness accounts, had become submerged in intense propaganda wars.[56] In this period of notional de-Stalinisation, Solzhenitsyn's revelations profoundly shocked a new generation. The new union of the left, a carefully brokered deal of June 1972 between the Socialists and the French Communist Party under Georges Marchais, was threatened. Following President Georges Pompidou's unanticipated death on 2 April 1974, the closest fought elections in French history saw the left union candidate, François Mitterrand, defeated by Valéry Giscard d'Estaing in May. An anti-Communist 'Solzhenitsyn effect' was a strong possibility. France voted for a right-wing government that lasted through to the late 1970s.

With *Lenin's Armchair at Smolny* (1975; pl. 55), Fanti offered an oblique and melancholic response. The spectral space of the Father returns. It is a *reprise* of Brodzki's famous Lenin portrait of 1930, already a posthumous, photograph-based representation, where the significant emptiness of the white chair (Stalin, the coming man?) confronts the great leader engrossed in his paperwork (pl. 51). In Fanti's painting, the spectral presence-in-absence of the Father – Stalin's empty chair – is made more uncanny as the 'museum without walls', with its black and white Socialist Realist reproductions and municipal plant-pots, falls away into an idyllic seascape at sunset.

The striped carpet stretching into the background suggests rails leading to a camp, perhaps the trope of deportation? Fanti's paintings necessarily invite over-determined readings, analyses both terminable and interminable.

Indeed, Althusser chose the title 'Histoire terminée, histoire interminable' to preface his disciple Dominique Lecourt's first retrospective analysis of the 'Lysenko affair' in the spring of 1976. The reference to Freud's article on 'Psychoanalysis terminable and interminable' (of about 1937) was explicit. In the 1950s the Lysenko debate had erupted at the high moment of French Stalinism; the entire scientific establishment debated the possibility of inheriting acquired characteristics.[57] The Soviet miracle, Trofim Denisovich Lysenko argued, could breed not only giant harvests but also the Soviet 'new man'; all was possible. There was a 'proletarian' science to be pitted against a 'bourgeois' science. The tomatoes in Fanti's *Anaït Anian* or the huge maize leaves in *Kukuruza* (both 1971 and shown in 1973; pls. 56 a and b) – deadpan in their humour, devastating in their critique – had their sources in Lysenko-inspired, triumphalist Soviet publications.

For Althusser, the notion of a 'symptomatic reading' was again in play. By using the past itself as a critical probe, he spelled out his distance from the Communist Party and its ideological orthodoxies. His preface for Lecourt recalled facts which *crèvent*

56. Fanti, a. Anaït Anian, 1971–2
b. *Kukuruza* (maize), 1971

les yeux et la mémoire, literally, 'put out the eyes and memory'. The shameful Lysenko story does not exist, he claims, because it is buried in the silence of Soviet archives but also in the silence of French Communists who are 'impotent, as Marxists, to account for their own history, especially when it is a failure.' The Soviet leadership refused and still refuses, he says, to offer a Marxist analysis of the 'gigantic error, buried, after its millions of victims, in the silence of the State.'[58] This unimaginable history had not been terminated: it had interminable, unresolved implications. Althusser was also, clearly, implying that the French Communist Party's compulsive repression of the truth had psychoanalytic dimensions.

This denunciation was repeated in public when, on 16 December 1976, at a talk to Communist students at the Sorbonne, Althusser violently attacked the recent decision at the 22nd Congress of the French Communist Party to abandon the principle of the dictatorship of the proletariat. With elections in mind, the Party had a new anti-class war slogan: 'the union of the people of France'. Althusser responded by reminding the Party that their use of examples of dictatorship (Hitler, Mussolini, Pinochet) had deliberately avoided Stalin:

> not just the individual Stalin as such, but the structure and the confusion of the Soviet Party and state; the line, 'theory' and practices imposed by Stalin for forty years, not just in the USSR but on Communist Parties the world over…Yes, there were the Red Army, the Partisans and Stalingrad, unforgettable. But there were also the trials, the confessions, the massacres and the camps. And there is what still goes on.[59]

It was in the climate of response to this attack (published as *22ème Congrès* in May 1977), a sombre climate for Althusser, that the studio visit to Fanti finally took place. His preface was written for an exhibition of Fanti's new work at the Galerie Krief-Raymond from 21 April to 21 May. Gone were Fanti's picture-postcard evocations of a Soviet Union proud of its achievements, its powerful father figures. The imagined territory shifts to more desolate wastes, to steppe and to snowscape, in this era of a post-gulag imagination. Hagiography retreats, just as, having created his monumental poem, 'Vladimir Ilyich Lenin', Mayakovsy himself faced despair, blankness.[60] Fanti (surely as self-referential as the poet) offered a meditation on Mayakovsky, retrospection, suicide. Mayakovsky's 'twenty years of work' (the title of his self-staged retrospective) had been celebrated over the winter of 1975 in Paris.[61] It was one of the most richly documented exhibitions at the CNAC and was followed by the first major show of

Soviet non-conformist art held at the Porte Maillot in 1976 and Dina Vierny's show of Lydia Masterkova's collages in January 1977, which occasioned a passionate plea for the liberty of Soviet artists.[62] In his own show Fanti exhibited 'Useless Poems' I–III, two called *My poem flies like a telegram* (pl. 57a), the third *The Sea is not always Calm in the Crimea*; and a series of five works 'Young Man in a State of Nostalgia' I-V (pl. 57b). These works were subtitled with Mayakovsky's final adieu, his suicide note: 'the bark of poetry [love] has smashed against the everyday'.[63]

57. a. Fanti, '*My poem flies like a telegram*',1976
b. Fanti, *Young man in a state of nostalgia*, 1977

Fanti's exhibition preceded the major official retrospective of sixty years of Soviet painting at the Grand Palais in July 1977 which celebrated the sixtieth anniversary of the 1917 Revolution.[64] Preparations were also under way for the 1978 Malevich retrospective and 'Paris-Moscou 1900–1929', an immense feat of political negotiation for the new Pompidou Centre.[65] 'Paris-Moscou' diplomatically avoided the year 1930 precisely because it signalled the Kharkov congress of writers, the beginning of artistic repression and Mayakovsky's suicide. Interpreted as a renunciation of the shining revolutionary future, his death caused shockwaves around the world.[66]

Althusser visited Fanti's studio to discuss his paintings; immediately he perceived the play of memory, ideology, truth and silence:

> Lucio Fanti is a painter who 'announces his colours'. When you ask what he is painting, he replies (and besides it is enough to look at his canvases) 'the Soviet Union'. No less. And if you ask why, he replies with his own life: he was brought up by Communist parents enthusiastic about the USSR which he got to know when he was fifteen, a whole summer in a pioneer camp, where the 'new man' is forged; the 'new man' whose existence Soviet ideology needs to believe in, to justify the idea it creates of socialism, and to keep teachers and pupils well in hand…
>
> A good Hegelian would say 'Fanti paints the conscience of the Soviet Union'. A Marxist would say 'Fanti paints the official Soviet ideology of the USSR: the type of identity the Soviet Union needs to give itself to ensure the official unity of its "citizens" and its "peoples".'
>
> And if one asks: but what is one to do to paint ideology? Lucio Fanti replies by painting official Soviet photographs composed by photographers attentive to their ideological duties… the ideology 'exists' in these images, in the treatment of the 'subject', in the symbolism of the figures, the framing, the type of landscape, the statues, the statues, the statues that people the gardens, in the statues and the pictures that inhabit their dwellings.[67]

As opposed to Bourdieu's fascination with the 'image of the image', the resonances of high painterly or low photographic culture, Althusser's reaction is more complex: 'an image charged with ideology never presents itself to be seen as ideology in the image'. At the moment when Duchamp's concept of the *infra-mince* – infinitesimal proximity – filtered through the Beaubourg (and Fanti was not the only painter to eschew a visit to this major retrospective), Althusser wrote of the 'miniscule interior distance' that throws the image off balance, identifies it for what it is, denounces it.

In the silence of his various procedures, Fanti practises this implacable *décalage*: either the insistence on the uncanny in the ordinary, colour as violence or mourning, the strangeness of certain papers flying loose across an immense plain crushed by a stormy sky, or men who read in the snow while pages escape from their books, or even absence, witness these gigantic electrifying pylons of a Communism lacking only Soviets! But forest trees have taken the place of men.[68]

Althusser, who identifies the dreamy adolescent on the riverbank with the 'tormented' painter driven to repetition, avoids the deeper psychoanalytic exploration that these works, with their declamatory nihilism, seem to invite. Yet he offers a hidden clue to his first-hand knowledge of a Soviet non-conformist absurd, astonishingly resonant with Fanti's images. It was an absurd, one could argue, which he had anticipated with his 'public question' text, a deconstruction of dialectics – a pure, self-parodic conceptual piece, created in 1972 at the very moment of the dogmatic 'Reply to John Lewis'.[69]

58. Fanti, *Forgotten books: Lenin in Siberia*, 1978

Later, his first autobiography, *Les Faits* (*The Facts*, written in 1976, after his 1974 encounters in Moscow), allowed the 'truth' of recollection to make unexpected detours: he inserted deadpan, fictitious encounters with the Pope and de Gaulle into his writing (in fact, he had met them both).[70] Surely, Althusser, like Fanti, is permitted black humour as well as black bile ? Yet his absurdist twist provided ammunition for his future detractors.

Althusser immediately grasped the link between photography and ideology: 'Is the Soviet Union just a detour? Yes, says Fanti… The one-thousandth of a second click [*cliché*] of the camera follows the ideological clichés, despite a certain poetry in the platitudes.' Althusser continued: 'Fanti would say the USSR is a necessary detour, in order to speak of you, of me'. Recalling the words of an unidentified Soviet friend (the Georgian philosopher Merab Mamardashvili), he went on: '"I would never leave this country, incomparable in terms of understanding, for here things can be *seen naked,* the truth as truth, the false as false, and each word bears a consequence. Playing with words prohibited." Playing with images prohibited'. Fanti knows this as he 'plays' with these *clichés*, not for the sake of playing but so they reveal the naked truth. Only naked kings reign.'[71]

In *L'Avenir dure longtemps* (*The Future Lasts a Long Time*) of 1992, Althusser described his 1974 visit to Moscow University for an international Hegel conference. There he played truant, thanks to Mamardashvili, to meet and discuss life in the USSR with 'hundreds' of Soviet citizens. Here, the metaphor based on the emperor's new clothes for the Soviet body politic ('Only naked kings reign') was revealed as lived reality (one might compare Simon Leys's 1971 exposé of Communist China, *Les Habits neufs du président Mao*). The Fanti preface also mentions 'Zinoviev' – another philosopher colleague from Moscow University, the logician and writer Alexander Zinoviev, whose book *The Yawning Heights* (first published in Switzerland in 1976) counterpointed Solzhenitsyn's exhaustive account of convict life in the Gulag archipelago with an equally mighty, Swiftian dystopia.[72]

I argue that Althusser's Moscow experience in 1974 (ignored by his exegetes) demonstrates his encounter with a 'philosophical absurd'; hence his intuitive recognition of the haunted premonitions of Fanti's paintings (today's understanding of the philsophical environment of early Moscow conceptualism – in the work of Ilya Kabakov, for example – reinforces my claim).[73] Moreover, Althusser'self-investment in the Fanti preface may be read as an oblique *détournement* of the Communist genre of

confessional 'self-criticism' (originating in the first Moscow show trials). At an acute moment of political crisis and personal dismay, apprehending the possible disintegration of the global Communist system, Althusser was, indeed, using the USSR as a 'necessary detour' to speak of himself. Appearance, then, was the mask: naked truth was exposed as inherent in the *cliché*. Self-inscription, for Althusser, involved not only a parodic absurd but also intimations of the tragic.[74]

Following Fanti's spring exhibition, the summer of 1977 was catastrophic for Italy. Violent protests against the *compromesso storico* – the compromise between the Christian Democrats and the PCI (Italian Communist Party) – led to a state of siege with tanks on the streets and police repression in Fanti's native Bologna, where his uncle, Guido Fanti, had been a powerful mayor who promoted a reforming Eurocommunism.[75] France was not only a spectator: her intellectuals were active voices and presences in the struggle. Sartre, Barthes, Deleuze, Guattari and Foucault among others signed the 'Appeal by French Intellectuals' of 5 July against repression in Italy, linking it to concurrent anti-Soviet human rights protests at the East–West security summit in Belgrade.[76] The Communist newspapers *Lotta continua* and *L'Unita* continued the protests; Guattari published 'L'Italie enchaînée' with Alberto Moravia in Milan at the end of July and 'La Grande illusion' later in *Nuovi argumenti*.[77]

59. Boulatov, *Red Horizon*, 1971–2

At the September convention in Bologna 70,000 people united against oppression, the mass demonstrations inevitably leading to violence and the question of armed struggle. Coinciding with the tempestuous 'German autumn', this provided the blueprint for the 'Tunix' congress in West Berlin in January 1978 (again involving Foucault and Deleuze), which confirmed the perception of links between Italy's Red Brigades and the Red Army Faction terrorists.

60. Pavlovsky, *Althusser*, 19 May 1978

In November 1977, Althusser travelled to Venice for a meeting of intellectuals from East and West dominated by the aftermath of the political protests of the summer and the world's focus on Soviet human rights abuses. The dilemmas of Western Communist parties and of theoretical Marxism were at the core of the impassioned debates. Following the 1976 Venice Biennale, a 1977 'Biennale of Dissent' accompanied the international conference: it staged the major exhibition 'La Nuova Arte Sovietica', an extraordinary international *première*. Soviet non-conformist art from the late 1950s to 1977 was on display; it represented a culmination of encounters and the daring export of underground works that had extended over the previous few years from Prague to Paris, Germany to New York (several artists had already emigrated) and involved important Italian collectors.[78] Pierre Gaudibert's catalogue essay, 'From Protest to Dissidence', and his presence at several of the conference debates suggest that Althusser visited the exhibition with his friend and mentor.[79] Works by Erik Bulatov, such as *Horizon* (1971–2; pl. 59), shown in Venice, proclaimed the existence of a parallel Soviet figurative art, while the circulation of European Narrative Figuration and images of American hyperrealism in Moscow raises wider questions.[80] The dimension of the absurd in what had not yet been baptised 'Moscow Romantic Conceptualism' looked strangely familiar.[81] The critical take on both everyday life and the collapse of utopias in a society with no market was declared to an international public. For once, the Soviet 'reflection theory' that underpinned Socialist Realism, worked against itself: the chasm between Communist and capitalist systems – and the proximities in terms of dissimulation and control – were at stake. Leonid Brezhnev's USSR lived, then, in all its schizophrenic relationship to cliché, and official discourse was pictured in Venice by its own artists as 'naked truth': a truth indeed in contrast with the overdressed Communist parties of the West, which accommodated themselves to capitalism, prevaricating with tortuous arguments, and repressing accumulated 'errors' of their Stalinist pasts.

Althusser's Venice speech, 'Finally something vital has come out of the crisis and the crisis of Marxism', was a much awaited moment, immediately published and translated.[82] Yet he retrospectively described this speech as improvised and 'masked', a kind of Machiavellian operation to dam up overflowing waters, needing to find a *terra firma* in a torrent of shit (*merde*). 'How many times I have thought of what you said, how many times', he repeated in a letter of January 1978, again to Merab Mamardashvili, quoting his friend's words: '"I'm staying because it is here that you see the depth of things, bare [*nu*]."'[83]

In April 1978, in the wake of the defeat of the 'union of the left' and the French Communist Party's subsequent break with the socialists, Althusser published four excoriating articles. 'What can no longer go on in the Communist Party' appeared in *Le Monde* newspaper at the very moment of the Party's plenary session. Again he attacked the sclerosis, secrecy, the personality cult, the disclaimers, the notorious 'affairs' and expulsions. The published version was significantly 'corrected' at the insistence of Giorgio Fanti (Lucio's father), who titled his interview with Althusser in May for *Paese sera* 'Theory "degree zero"' (*pace* Barthes).[84] Perhaps Althusser had already inscribed the fateful words *l'avenir dure longtemps* above the strange abstract drawing he chalked on a blackboard in his bureau at the École Normale Supérieure (pl. 60).[85] Confronting an illimitable future, the potential waste of twenty years of work ('certain papers flying loose across an immense plain crushed by a stormy sky'), Althusser wrote through the summer; his prolonged adieu, 'Marx dans ses limites', remained unpublished within his lifetime.[86]

Postscript: Silence

On 16 November 1980, Althusser strangled his wife, Hélène Rytman, in his rooms at the École Normale Supérieure. An astonishing juridical verdict of *non-lieu* (no case to answer) released him from prosecution and from the legal imbroglios of any accusation of a 'crime of passion'. He retreated from public life. 'Althusser's silence: is it comparable to Hölderlin, Nietzsche's or Artaud's silences, those "absences of an *œuvre*" which fascinated Foucault?' asked Etienne Balibar in 1988, prior to the appearance of Althusser's devastating autobiography of 1992, which took its title from his premonitions of 1978, *L'Avenir dure longtemps*.[87] 'In killing his wife, Louis Althusser ceased to exist as a philosophical subject' claimed his editors subsequently, as they distinguished late philosophical works from those of a purely 'clinical' value.[88] This seemed to be the principal preoccupation of his exegetes, rather than any reflection on the collapse of the meaning of his life's work, the Soviet dream, the Communist project. I would argue that the position of Althusser at 'the degree zero of theory' challenged the very notion of a disembodied 'philosophical subject'.

Beyond quantities of press speculation and the critical reception of his biography, more sensitive textual readings have interrogated notions such as the repeated void at the core of Althusser's work.[89] A correspondence could be visualised here, in terms of

Fanti's equally persistent figurations of loss: the sad and infinite skies, stretches of blank water and snowscapes; the illusory depths of reflection, the pylons which themselves become spectral signs of redundancy and lost hope. *Electrification plus the Sentiment of Nature* (1977; pl. 61) combines the romantic landscapes beloved by Fanti – sourced in romantic paintings such as the luminous moonscapes of Arkhip Kuindzhi (State Russian Museum, St Petersburg) – with Lenin's famous dictum, 'the Soviets plus electrification', symbolised by the pylon. The piercing light shining here through the pine trees surely figures a divine

presence, revelation: to name the Leader would be sacrilege. These zones of piercing iridescence might well be compared to the 'zone of light' that the young Althusser once figured as a dazzling wake in his first poetic, autobiographical writings.[90]

Althusser wrote of Fanti's paintings in 1977 that *Le souffle coupé d'un poète est encore un poème*:

> The breath of a poet cut short remains a poem, which explains why he accepted life. Writings fly away; words remain and the passing of time renders them harder than metal. Lenin, Mayakovsky: their statues… are like phantoms, surging with a surprising lightness through the winter sky, abandoned in the mourning branches of naked trees. Words of a dead man, dead, always alive in what he denounced…[91]

Lucio Fanti held solo shows at the Galerie Krieff-Raymond with catalogues prefaced by the eminent writers Italo Calvino in 1980 and Jorge Semprun in 1983. Twenty years later, his early Soviet works were exhibited together with contemporary Camargue landscapes of an exemplary melancholy at the Galerie Lavignes-Bastille in 2004. He is celebrated across Europe for his theatre design, a passion and commitment that began in 1973, shared with the Narrative Figuration artists Arroyo and Aillaud.[92] Fanti's décors for Iouri Olecha's *Le Mendiant ou la mort de Zand*, performed in Strasbourg and Paris in 2007, were faithful to the mirage of the Soviet past.

61. Fanti, *Electrification plus the sentiment of nature*, 1977

Deleuze, Foucault, Guattari Periodisations: Fromanger

> What does it mean to paint today? What can such a practice signify after
> the collapse of the systems of representation which supported individual and
> collective subjectivities right up to the great sweep of mass-media images and
> the great deterritorialisation of traditional codings and overcodings our epoch
> has known? This is the question that Fromanger has decided to paint.
>
> Félix Guattari, 'Fromanger: la nuit, le jour', *Eighty Magazine*, 1984[1]

Félix Guattari was writing about Gérard Fromanger during what he called the
années d'hiver, the 'winter years' of the early 1980s, years marked by a certain
retreat for Guattari himself and for the painter, whose successive changes of style
had flouted critical expectations. In 1980, Fromanger's series 'Tout est allumée'
(everything's alight) was presented at the Centre Pompidou, with a catalogue prefaced
enthusiastically by the director Pontus Hulten. Fromanger's peers were envious, yet
for this prestigious show he abandoned his Narrative Figuration mode. By 1984,
after a twenty-year career, Fromanger faced a double bind: Guattari situated what he
called Fromanger's 'painting act' (using the analogy of J. R. Searle's 'speech act'[2]) as
an enunciation taking place at a historical moment – the moment of the *impasse* of
abstraction and minimalism, or the asceticism of Supports-Surfaces, and, conversely,
at the very moment of what he called 'a conservative figuration'. Fromanger, who had
not participated in 'Mythologies Quotidiennes' (1964), was always the newcomer
for the older generation of artists; yet his prominent role in 1968 and his privileged
encounters – with Jean-Luc Godard and Guattari, as well as Gilles Deleuze and Michel
Foucault – account for his particular profile.

A politically conservative 'bad painting' emerged early in the 1980s: the
international taste for the figurative included the expressionist realisms of Sandro Chia
in Italy, Julian Schnabel and David Salle in America and, in France, Gérard Garouste,

who was commissioned to paint a mythological ceiling for President Mitterand's private apartments in 1983. Responding to the populism of Jack Lang's socialist reforms, a media-wise younger generation, dubbed Figuration Libre, emerged, including artists such as Jean-Charles Blais.[3] Guattari mentioned no names or movements; instead, his earlier reference to 'deterrorialisations' in his Fromanger essay confronts 'the gigantic carnival... which has managed to respond, even in the most debilitating ways, to an authentic desire for subjective reterritorialisation.'[4] Fromanger, then, abandoned his Narrative Figuration style only to confront the sensual, painterly figurations of the 1980s – when the left, elected to power for the first time since the Popular Front, became increasingly compromised.

Whether painting was deterritorialised or reterritorialised and whatever Fromanger's splendours or vicissitudes, the language of Deleuze and Guattari's *L'Anti-Œdipe* (the first volume of *Capitalisme et schizophrénie*, 1972) acts as a reminder of the intensity of the previous decade. Fromanger's intellectual credentials are signified via this critical language, together with the specific context of militant politics and protest.[5] In 1978, for example, the artist was delegated by Guattari to organise French participation in the 'Tunix' festival in West Berlin (following the autumn of militant protest in Bologna), an initiative which saw thousands of citizens out on the streets for the first time since

62. Fromanger, *Bubble*, 1968

the war, protesting against housing shortages and police surveillance. Foucault, Deleuze and Guattari spoke on revolution and their role in the increasingly popular, liberationist 'anti-psychiatry' movement. It was the last mass protest of the European left.[6]

Guattari's article for *Eighty Magazine* celebrated Fromanger's eight-metre canvas *Night and Day*; his words were used again for Fromanger's show in Tokyo the following year (where the critic Alain Jouffroy, then the cultural attaché, organised Franco-Japanese cultural summits from 1983 to 1985). Recapitulating Fromanger's 'painter's progress' since the 1970s, with an accent on series, Guattari's is a generous piece of writing, imitating the painting it describes via the profusion of its own enunciations, its rhythm, its energy and displacing, perhaps deliberately, any description of content. The two components of the artist's work, colour and the human form as monochrome silhouette, are described as a Deleuzian 'body-colour-without organs' (*corps-couleur-sans-organes*), formally engaged in a debate of form versus content. Now, Guattari argued, the triangular topos of 'a-signifier, significative, and enunciation loses its hold and, with it, that of the Id, the Ego and the Superego', in contrast to the 'joyous narcissism' of 'The Painter and the Model' series of 1972.[7] As he wrote:

> He who paints, the 'actor' who happens to be this painter, has thus been drawn into an irreversible deterritorialisation of bodies and codes, operating as well within as beyond personological limitations. The originality of this transformation as directed by Fromanger, is that it does not result in a decomposition, in the Soutine-Bacon sense, or a desexualisation as in the case of American formalists. One witnesses on the contrary a bodily recomposition and a refoundation of a pictorial enunciation...[8]

The mention of Francis Bacon evokes Deleuze's *Francis Bacon: logique de la sensation* (*Francis Bacon: The Logic of Sensation*, 2003), a commissioned text based on a year's seminars (1979–80), which was written without contact with Bacon himself and published in French in 1981.[9] Evidently, Guattari was writing on Fromanger after both

63. Fromanger, *Self-portrait with Test-Tube*, 1963-4

Deleuze and Foucault's catalogue prefaces for the artist of 1972 and 1975, the subject of this chapter. I shall explore what relationship these writings bear to Foucault's previous interest in painting, particularly Manet, or to Deleuze's work on Bacon, and argue that, for all protagonists, the contemporary artistic and political scene was paramount, framing their responses to the older or modern masters.

Gilles Deleuze 'Cold and Hot': The Painter and the Model

The Painter and the Model exhibition proclaimed Fromanger as an epigone of Deleuze – particularly so to the crowd of disciples, *deleuziens*, who came to the opening at Galerie 9 early in 1973. The painter, baptised 'Red Fromanger' by his older friend and the 'people's poet', Jacques Prévert, had enjoyed a steady rise to prominence since the mid-1960s. To situate Deleuze's preface 'Le Froid et le chaud' ('Cold and Hot') and Foucault's later text 'La Peinture photogénique' ('Photogenic Painting') for the show 'Le Désir est Partout' ('Desire is Everywhere') at Galerie Jeanne Bucher in 1975, it is important to understand Fromanger's position in the Parisian art world.[10]

Having trained at the École des Beaux-Arts (for a mere eighteen days), Fromanger was schooled at the Académie de la Grande Chaumière and City of Paris evening classes. He encountered his hero, Alberto Giacometti, at the Salon de Mai in 1964 and was introduced as 'young blood' to the sculptor's own Galerie Maeght, the most powerful gallery in Paris and perhaps in Europe. How could Fromanger's Narrative Figuration style – by 1971 the counterpart to American hyperrealism – have originated with Giacometti and the sculptor César, who also gave him frequent counsel? Fromanger's 'Grey' series provides the answer: the works are Giacometti-esque in their elongation and raking perspective, the way that the viewer's gaze reconstitutes the painted stare of grey faces, in particular in Fromanger's intense, recognisable self-portrait. His subject was traditional: the female nude, the naked model in the studio, the women he loved. These were reduced later to the names with which he titled his *Bubble* sculptures (*Souffles*): concave, transparent, coloured altuglass bubbles, mounted on metal stems, they were used in the jubilatory street performances of October 1968; the *Bubbles* were utopian ripostes to the convex plastic shields of the riot police (pl. 62).[11] While women later featured as mere merchandise in the 'Painter and Model' series of 1972, Fromanger's romanticism in the era of critical theory and the machismo of hyperrealism remain a constant subtext to his work.

Fromanger's *Self-Portrait with Test Tube* (1963–4, in the 'Petrified' series) combines the tender painterliness of the artist's head – quasi-sculptural, grey, with Giacometti-like features – and the hard, flat surfaces of the red and green ground (pl. 63). Maeght showed the grey paintings with Fromanger's lithographs in 1965. In the accompanying *Derrière le miroir* review, Jacques Prévert described the arrival of the fire brigade: Fromanger's atelier was in flames, his work reduced to ashes.[12] Yet both Maeght and the Salon de la Jeune Peinture refused to show the 'Petrified' series: Maeght was apprehensive about his new departure and the militant Salon derided his links with the 'bourgeois' Maeght.[13] The series climaxed with the multiplied figures of the *Prince of Homburg*, a portrait of Gérard Philipe. This veritable prince among actors, a Communist celebrity who took the hero's role in Heinrich von Kleist's eponymous play, was represented as a coloured phantom, illuminated with the green of limelight, doubled and redoubled, receding on a black ground.[14] (Fromanger had performed as an extra at the Théâtre Nationale Populaire with Philipe). The change in style relates to the time he was spending with his neighbouring painters Arroyo and Antonio Recalcati.[15] Fromanger joined the Salon de la Jeune Peinture in 1965, the year of the Narrative Figuration takeover. In riposte

to the Maeght and Salon de la Jeune Peinture refusals, Fromanger created a series of multi-coloured, three-dimensional, acrylic-painted wood reliefs, 'The Picture in Question', such as *My Picture is dripping* (pl. 64), with its red-painted, fretted wooden 'splashes' (it was nevertheless shown under Maeght's auspices in Grenoble prior to the ending of Fromanger's contract).

May 1968 erupted: Fromanger took on an organising role in the Atelier Populaire at Paris's École des Beaux-Arts with the artist Merri Jolivet, making posters and participating in militant debates. It has been estimated that with the silkscreen technique brought from New York by Guy de Rougement, Eric Seydoux and David Woolworth, from one to three thousand posters could be printed per

64. Fromanger, *My picture is dripping*, 1966

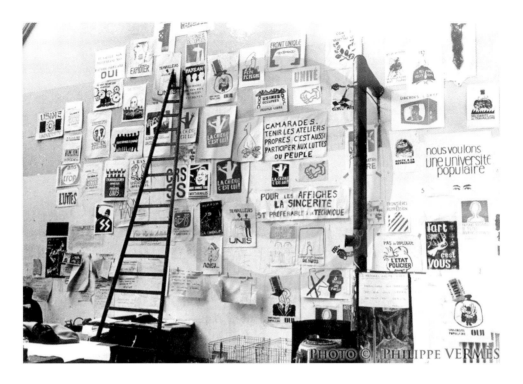

day; 800,000 posters were created based on 800 original designs (pl. 65).[16] Respecting the politics of anonymity, Fromanger nonetheless created two of the more important posters of May 1968. Once expelled by the police from the Beaux-Arts, Fromanger and Jolivet made *La Police s'affiche aux Beaux-Arts, les Beaux-Arts affichent dans la rue* (The Police appear at the Beaux-Arts, the Beaux-Arts poster the streets) with the protection of the politician Michel Rocard in the PSU (Socialist Party) headquarters.[17] A precursor, however, was far more contentious: the French national tricolour flag was shown with the red section 'bleeding' (there is an evident analogy with *My Picture is dripping*). This poster design provoked an eight-hour debate and Fromanger's final condemnation for 'counter-revolutionary provocation'. Condemned, the poster was in fact printed in an edition of 20,000 by the student leader Daniel Cohn-Bendit, who promptly fled the country (the works were abandoned at the printers). The image inspired the film-maker Jean-Luc Godard to meet Fromanger, who, as he frequently recounts, 'taught Godard to paint'; Godard in turn encouraged Fromanger to make films. Their collaboration on the 'film-tract' *Red* – the filmed three-minute 'event' of poured red paint on a tricolour ground – has retrospectively been classified as a pioneering anticipation of video art.[18] It has been estimated that Fromanger made more than thirty *ciné-tracts* with Godard through the summer of 1968, in London and later in Stockholm;

65. Philippe Vermèse, Atelier des Beaux-Arts, Paris, 1968.

this moment of collaboration should by no means be underestimated when considering the atmospheres – utopian or dystopian – of everyday Paris in Fromanger's later works.

Fromanger's lithograph album *Le Rouge*, edited in 1970, combined images of bleeding flags, multiplied to represent all nations, with 1968 street demonstrations photographed by the intrepid press photographer Elie Kagan. Blown up in blue and punctuated with red silhouettes, the tricolour *bleu blanc rouge* effect of the street scenes claimed the protests of the *gauchistes* for the nation as a whole (pl. 66a). These blow-ups, animated and with a different soundtrack, were used to create a more complex film, also called *Red*. This was shown in the militant film festival, 'La Peinture qui bouge' (Painting on the move), in 1970, with works by the Dziga-Vertov group, the Medvedkin group, Chris Marker and films from Latin America, Ireland and Palestine.[19] In the same year, Pierre Gaudibert arranged an exhibition of artists' films at the Musée d'art moderne de la Ville de Paris, also featuring Christian Boltanski, Erró, the Nouveaux Réaliste Martial Raysse, and the sculptor Ipoustéguy (two pioneering nine-screen artists' film installations were later shown in 'Douze ans d'art contemporain' in 1972).[20]

The bleeding flags with the street scenes – everyman on the march – created a powerful backdrop for the performance *Hymnen*, created by the Amiens ballet company with five choreographers led by Michel Descombey, which also had its premiere in 1970. Karl-Heinz Stockhausen's multi-sourced, electronic soundtracks mixed cacophonous street noise with discussion and fragments of national anthems. A message of hope existed in dialogue with ineradicable memories of Fascism, its resurgence in contemporary dictatorships and in a context of imperialist violence. Echoing Stockhausen's political textures, the images by Fromanger and Elie Kagan were used for the ballet décor. The street scenes arranged in contrapuntal rectangles contained the recollection, surely, of John Heartfield's militant photomontage *Platz dem Arbeiter*! ('Make way for the Worker!'), used as the cover for an almanac of 1924 (pl. 66c). Fromanger's flag-based costumes brought the images alive: dancers grouped and regrouped, their gestures expressing combat or hope.[21] The production toured France, southern Europe and then South America, while Fromanger's album *Le Rouge* won the prize at the Tokyo graphics biennale during Expo 1970 (outclassing Warhol and Rauschenberg).[22] The visual energy, clash of primary colours and the denunciation of war and oppression on an international scale gave these works symbolic status; emanating from the heart of revolutionary France, they embraced the 1968 revolutions across the globe.

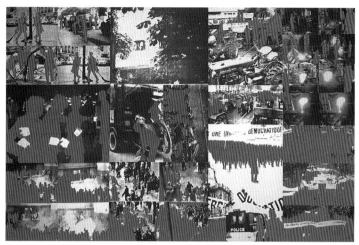

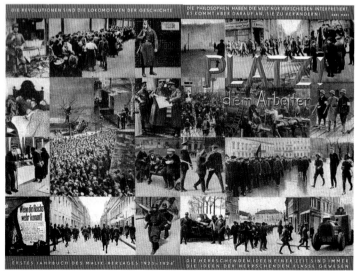

66. a, b, Fromanger, *Red*, 1970
c. Heartfield, *Platz! dem Arbeiter*, 1924

It was an expansion of the *Red* project, based on an extended collaboration with Kagan, that gave rise to the series 'Le Boulevard des Italiens' (1971; pl. 67). Twenty-five paintings were exhibited at Gaudibert's invitation in the ARC space at the Musée d'art moderne de la Ville de Paris. The overall colour scheme progressed from a deep violet blue through green, orange, yellow, red – the colours of the spectrum – to brown, purple and grey-black. Kagan's realist street-scene photographs were taken over a half-hour period with Fromanger at lunchtime on 5 February 1971; there is a sense of the uncanny both in their enlargement (each canvas was one metre square) and in the red silhouettes that represent everyman – warm clusters of human action, energy, purpose – but are disturbing in their blankness: they are ciphers, potential targets. Their random disposition fuses a memory of Giacometti's alienated city-walkers with the anonymous worker of Heartfield and the 'disappeared' identities of those picked up by the police. The street environment is engulfed by advertising slogans and cinema posters: the visual apparatus of capitalism creates the insistent vulgarity of the present.

All the while, the sharp colour contrasts – red and acid green, red and purplish blue – and hard-edged outlines support the 'hard' political message. Slogans within the painting, such as *Tout doit disparaître* (everything must go) are doubly coded: the shopping-street sales' publicity is elided with a contemporary *vanitas*. Fromanger's political positioning was enhanced by Jouffroy's analyses in the catalogue, where each painting was accompanied by the original Kagan photograph, given a status of *aide-mémoire*.[23] The 'reality' of the scene as photographed was thus made explicit; Fromanger's enlargement (via projection) and the artificial progression of colours through the series was made totally transparent. Elie Kagan was arguably the most important political photographer at the time, his credentials forever connected to the police brutalities that he recorded (at considerable personal risk) in Paris on 17 October 1961, where the repression of peaceful Algerian demonstrations against an evening curfew – and the bodies washed up subsequently in the Seine – marked the domestic climax of the Algerian crisis.[24] (The downplaying of Kagan's role in Fromanger's work persists in current literature on the artist.[25]) Fromanger's exhibition in February 1971 preceded the first major showing in force of American hyperrealism in Paris, at the autumn Paris Biennale.

In the context of hyperrealism, nothing could have been more French than Fromanger's 'Boulevard des Italiens' subject matter. Acting dialectically against the insistence of the present in his work is the conscious sense of history inscribed in the

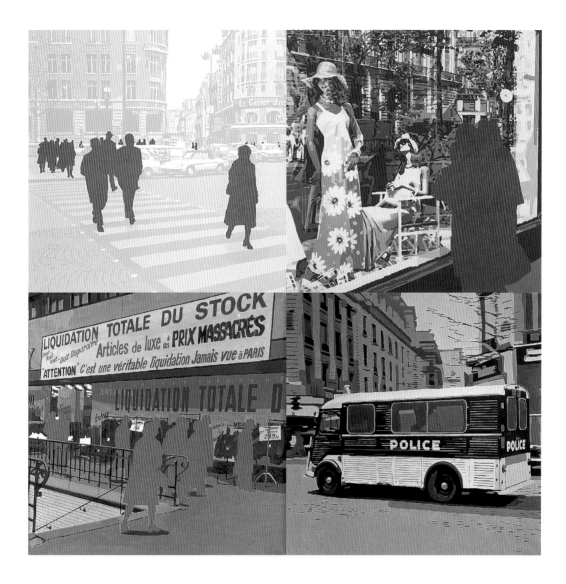

images, the *longue durée* of Parisians' relationship with the streets. This links Fromanger directly back to the traditions of the Impressionist painters at their most political and more specifically to the tension between power and revolution – the Hausmannisation of Paris versus the 1871 Commune, the burning of the Tuileries, the first barricades. There was an evident continuity with May 1968, where rhetoric, photography and the choreography of the people on the streets were, to some extent, self-consciously staging a ritual reeenactment. This was an art of the streets, for those on the street: taking his cue from the rue des Beaux-Arts, Prévert supposed that, for Fromanger, all streets should be called the *rue des Arts pour la rue*, street of Arts for the street.[26]

67. Gérard Fromanger, '*Boulevard des Italiens*' series, 1971

The Paris Biennale – André Malraux's initiative and a showcase for international talent – had celebrated its tenth anniversary in 1969. Internationalist from the start, it showed the best of the avant-garde: the German Zero group in 1965, Italian Arte Povera and American minimalism between 1967 and 1969. In the autumn of 1971, its aim was to remodel itself on the Kassel Documenta exhibitions. Moving from a museum setting to the Parc Floral de Vincennes, the Biennale orchestrated a major confrontation between conceptual art and hyperrealism, preceding the same confrontation at Szeeman's Documenta 5 in Kassel in 1972.[27] Hyperrealist works ranged from the Fine Arts Squad from Los Angeles to European equivalents such as the Spanish Equipo Realidad: the look was international. Louis Aragon was photographed, rapt, in front of Beny von Moos's six-metre-long *Agony and Ecstasy*.[28] Aragon, the former Surrealist poet, then hardline promoter of Stalinist Socialist Realism in France and Eastern Europe, was again re-inventing himself: he pleaded unsuccessfully with Fromanger, the up-and-coming *gauchiste*, to write for his 'Boulevard des Italiens' catalogue; Fromanger chose Prévert.[29]

Deleuze and Guattari's *L'Anti-Œdipe*, illustrated with Richard Lindner's *Boy with Machine* of 1954 (pl. 68), was undoubtedly the most significant publication of 1972. By this time, the German-American Lindner had become a close friend of Arroyo and other artists of the Narrative Figuration grouping.[30] One may only speculate on the excitement that might have been generated by an *Anti-Œdipe* coming after Documenta 5 in Kassel, with a Deleuze already initiated into contemporary visual culture by Fromanger. His responses would in this case have been focussed

on the juxtapositions of 'overcoded' American hyperrealism, cold conceptualism (Daniel Buren) and the uncontrollable flows of authentic 'schizophrenic' art.[31] Instead, the stout, potentially menacing little *Boy with a Machine* sets *L'Anti-Œdipe* visually in a pre-adult, though sexually perverse, realm, consonant with the anti-Oedipal attack on 'Daddy-Mommy-me'.[32]

In fact, *L'Anti-Oedipus* is a highly literary creation, driven in large part by the energy of its writing and the repetitive impact of its innovative vocabulary. Apart from the central position of Antonin Artaud (the source of the concept of the 'body-colour-without-organs') and of van Gogh as the paradigm of the mad genius, there is a brief, if dramatic, Oedipal reading of the Holy Family in Venetian painting and an unexpected encounter with Turner in London.[33] The status of the visual arts and representation is entirely supplementary. However, Deleuze's subsequent review, 'Appréciation', of Lyotard's *Discours, figure* in May 1972, plunged him into the problematics of what he called, rightly, a *schizo-livre*, where the paradox of *figures-images* and an 'anti-dialectic' of reversals between the figure and the *signifiant* anticipate his writing on Fromanger's serial images.[34]

The encounter between Deleuze and Fromanger was entirely serendipitous and happened when the gallerist Karl Flinker, scared by the artist's firebrand reputation, reneged on a promise to show Fromanger's work; his assistant, Fanny Deleuze, was sympathetic.[35] The small Galerie 9 on the rue des Beaux-Arts stepped into the breach, agreeing to exhibit the 'Painter and the Model' suite. Deleuze finally proposed five long brainstorming sessions about the meaning of the pictures, before writing his catalogue preface 'Le Froid et le chaud'. The title was an acknowledged play on Claude Lévi-Straus's antithesis between 'raw' and 'cooked' (*Le cru et le cuit*, 1964); cold and heat were likewise empirical categories, aiming to 'be used as conceptual tools with which to elaborate abstract ideas and combine them in the form of propositions'.[36] The writing on Fromanger was essentially dialogue-based, just like the process of conversation, recording notes, writing drafts, corrections and rewriting with Guattari for *L'Anti-Œdipe*.[37] *On va faire des séances, je vais te poser des questions cons* ('We'll have some sessions together. I'll ask you some really stupid questions'), Deleuze said.[38] He recorded his exchanges with the artist in his notebooks – concepts and whole phrases, evidently verbatim.

Deleuze's ease and authority in his later writing on Francis Bacon was based on this initiation with Fromanger. In the French artist's studio he witnessed the paraphernalia of

production, the lived relationship of photograph, image (model), projection and canvas, the relationship of complementary colours, balance and tone. Beyond the studio, he learned of the place of painting within the network of exchanges that make up the art world: galleries, contracts, money – the relationships between métier and merchandise – and the model again as 'living money'. While there is no trace in these exchanges of Deleuze's contemporary interest in the writer and artist Pierre Klossowski, the latter's *La Monnaie vivante* (Living Currency) of 1970 was surely present in his mind, in terms of the dialectical relationship between desire and the capitalist infrastructure.[39] Hence his inclusion of 'nuptial' and 'erotic' merchandise in the catalogue preface's opening volley:

> Fromanger's model is the commodity. Every kind of commodity: vestimentiary, seaside, nuptial, erotic, alimentary. The painter is always present, a black silhouette: he seems to be looking. The painter and love, the painter and death, the painter and food, the painter and the car: but moving on from one model to the other, everything is rendered in terms of a single model, the commodity, which circulates with the painter. The paintings, each constructed around a dominant colour, form a series. One could start the series with the painting *Cadmium Red*, and end with *Veronese Green* [pl. 69], which represents the same picture but this time hanging at the dealer's, the painter and his painting now commodities themselves. Or one can imagine other beginnings and other ends.[40]

Following Fromanger's colour chart aesthetic, Deleuze insists on the neutrality and indeed the materiality of colour (the conceptual slippage from the political discourse of dialectical materialism to a 'materialism' in art practice was commonplace at the time): 'green is not hope; neither is yellow the colour of sadness, nor red the colour of cheerfulness. Nothing but hot or cold, hot and cold. The material in art: Fromanger paints, that is to say he gets a painting to work. The painting-machine of an artist-mechanic, the artist-mechanic of a civilisation – how does he get the painting to work?'[41]

Fromanger's black silhouette (for Guattari a sign of his 'joyous narcissism') is, of course, the reproduction of his shadow cast onto the canvas, as his body intervened between the slide projector and the projected photographic source for his painting. A sign of both presence and absence, the author and his anonymous double, it also signals an archaic, pre-photographic process, the tracing of a contour, at the origins of a myth of depiction itself.[42]

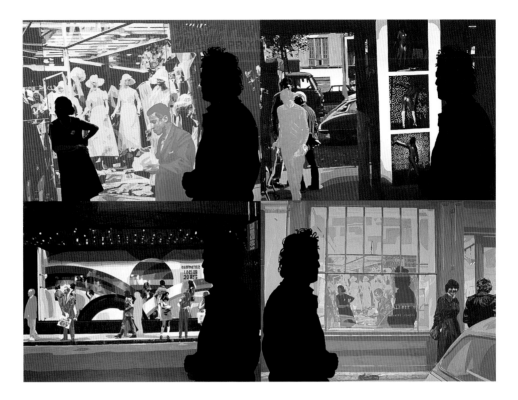

Even today, Fromanger recalls Deleuze posing him the question of the artist's fear of the blank white canvas and his own riposte: the canvas is not white but black, black with the density of the great paintings created throughout history, black with his own previous works, black with the memory of subjects and unrealised visions.[43] The task is to make it white. Materially speaking, with a photograph projected at the outset of the session, the canvas is likewise never white. Here is Deleuze's transcription of Fromanger's conversation:

> The painter paints *in the dark*, for hours. His nocturnal activity reveals an eternal truth of painting: that the painter has never painted on the white surface of the canvas to reproduce an object that acts as a model, but has always painted on an image, a simulacrum, a shadow of the object, to produce a canvas whose very operation reverses the relationship of model and copy, and which means that there is no longer a copy, *nor is there a model*.[44]

Unlike Fromanger, Bacon painted not from projections but from hand-held photographs, coloured reproductions and his own sketches; he worked not in the dark but in the light. Given the egregious contrasts in generations, status and techniques, and despite the contrast in the depth and breadth of Deleuze's texts on

69. Fromanger, *'The Painter and the model'* series, 1972.

Bacon and Fromanger (his crucial engagement with the tortured work of Antonin Artaud intervened), one may still compare Deleuze on Bacon in 1981 – a flashback, or rather 'reterritorialisation', of conversations of 1971–2, following Bacon's Grand Palais retrospective in the autumn of 1971:

> It is a mistake to think that the painter works on a white surface. The figurative belief follows from this mistake. If the painter were before a white surface, he could reproduce on it an external object functioning as a model. But such is not the case. The painter has many things in his head or around him, or in his studio. Now, everything he has in his head or around him is already in the canvas, more or les virtually, more or less actually, before he begins his work. They are all present in the canvas as so many images, actual or virtual. So that the painter does not have to cover a blank canvas, but rather would have to empty it out, clear it, clean it. He does not paint in order to reproduce on the canvas an object functioning as a model; he paints on images that are already there, in order to produce a canvas whose functioning will reverse the relations between model and copy...[45]

Fromanger's process of adding zinc white within the contours of his images, beginning with the lightest areas – perceptual highlights, glare, reflections – and working, as it were, backwards to saturated colour straight out of the tube was, one could argue, both a quasi-Brechtian technique of critical distancing and an emphasis on painting as primarily a 'material practice'. It was surely not the commonplace of hyperrealism. Yet, 'The Picture in Question' series, with its dripping, 'angry' painted surfaces breaking away from their supports, and the very liquidity of paint itself evidently relate to the Deleuzian concept of 'flows'. Later series such as the pastel 'Rhizomes' (1999) or the energised topographies of 'Bastilles' (2007–8) demonstrate a continuity of explicit engagement with Deleuze's thought – as does his portrait of the philosopher of 1993 (Deleuze proposed, more than once, to write a monograph on Fromanger, sub-titled *Périodisations*, around that time; it was never realised).[46] The reciprocity of their vocabularies and expressions is reflected constantly in Deleuze's writing, for example in the description of 'how the painting works': 'hot or cold in its turn may cool or heat the dominant colour', 'black, like a double potential which is actualised in both directions can "tend towards" the cold blue or the hot violet', a simple colour lesson. Yet it is language from *Anti-Œdipe* that traces the painter's dark shadow from canvas to canvas through the series:

two functions in two different circuits: a heavy immobile paranoid silhouette which fixes the commodity as much as it is fixed by it; but also a mobile schizoid shadow in perpetual displacement in relation to itself, running the whole gamut of cold and hot, so as to heat the cold and to cool the hot, in incessant travelling on the spot.[47]

Deleuze's meditation on what he called circuits of respective indifferences, disconnection and death are also contrasted dialectically with an energising, reorganising circuit of life.

The cinematic dimensions of these images in series were also intuited by Deleuze, such as a boulevard stroll fraught with impending interruption (many of the cold images are reminiscent, if not direct quotations, of Godard's 1965 film *Alphaville*). For Fromanger, their conversations anticipated Deleuze's publications on cinema: they deconstructed the painting together as an active *démontage*, the sense of thrust and direction heralding Deleuze's concept of the 'time-image' (*image-temps*). For his writing on cinema, Deleuze, too, would be 'working in the dark'.[48] He had made the connection between philosophy and cinema as a student, comparing the brain to a screen and recalling that 'it was not a question of applying philosophy to cinema, but one went straight from philosophy to cinema. And inversely, one went straight from the cinema to philosophy.'[49]

To move from philosophy to politics, politically speaking, 'Red Fromanger' as 1968 revolutionary had surely embodied with his street posters and street actions, his *Bubble* sculptures, his mobility and militancy, 'the action of decoded flows' against the 'overcoded' despotic state. 'The Painter and the Model' series, in which paintings, clothes, women, shop windows, mannequins and amusement parlours are indifferently subsumed as 'merchandise', provides a contemporary vision of 'the civilised capitalist machine' in *Anti-Œdipe*.[50] The 'circulation of exchange value' evident in the series becomes commensurate, medium-wise, with 'the voyage, the circulation of tones' in the images, while the deathliness that Deleuze notes – the black silhouette, the frozen figures, the coldness of several images – relates directly to the 'cold' of post-1968 melancholy. Indeed, Fromanger has described the initial dialectical contrary that inspired his vision: 'a dream of happiness for the people' (*un rêve de bonheur populaire*), exemplified by the bridal shop on the rue de Clichy, illuminated like a beacon in the night-time blackness, contrasts implicitly with the underlying reality of workers' struggle under Pompidou's short-lived government (rosy happiness, *Clear Cadmium*

Red, can be seen, then, as travesty).[51] Finally, Deleuze's 'cold and hot' acknowledges Marshall McLuhan – the third party in this text – whose *Understanding Media* had been published in French in 1968, while the polemic *McLuhan hot and cool* followed in 1969.[52] McLuhan's *War and Peace in the Global Village* (published in French in 1970) has even greater resonances, recalling Deleuze's idea of Fromanger on the street with his photographer in a mood of 'suspended imminence' or his thought that 'a new Kennedy assassination may emerge anywhere'.[53]

The art world had also become a global village. From 1972 to 1975, American hyperrealism swept the commercial scene in Europe and affected museum programming in Paris, though its prominence was always contested by conceptualism, and the older School of Paris in 1970s mode continued to occupy much of the artistic landscape. 'Hyperréalistes américains' at Galerie Arditti was followed by 'Grands Maîtres Hyperréalistes américains' at Galerie des 4 Mouvements, both in 1972; in 1974, 'Art conceptuel et hyperréaliste: Collection Ludwig, Neue Galerie, Aix-La Chapelle', was shown at ARC, in the Musée d'art moderne de la Ville de Paris, following both Fromanger and Fanti's exhibitions there. *Chroniques de l'art vivant* in February 1973 described the great impact of the movement on the art market, including new interest in pre-war Precisonism, magic realism and Neue Sachlichkeit and related exhibitions.[54] Indeed, each country seemed to find its own precursors to appropriate the style as in some sense 'national' – de Chirico for Italy, Christian Schaad for Germany, even

70. Estes, *Cafeteria*, 1972.

Salvador Dalí for France – his 'realist'-paranoiac imagination of the 1930s encountering the Lacanian potentials of current trends.[55] This led to what one might call an 'anxiety of differentiation', nowhere more evident than in Alain Jouffroy's attempts to separate the European *visionneurs*, as he called them, from the hyperrealists and to claim their historical priority as projectors of images.[56] From February to March 1974, the Centre National d'Art Contemporain showed 'Hyperréalistes Américains – Réalistes Européens', a major exhibition organised in conjunction with Hanover and Rotterdam; an expanding bibliography reflected both French and international interest in the movement.[57] It was at this CNAC exhibition that Fromanger first saw hyperrealism, he claims (perhaps disingenuously), visiting the show in support of his friends who were exhibiting. He concluded retrospectively that it was *très démagogique et objectivement faux* ('demagogic and historically false').[58] Yet Linda Chase's catalogue introduction, discussing contemporary alienation within the urban landscape, the fetishistic nature of sexualised objects, the distance from the object established by technique and the insistence on the image's status as reproduction, surely sound uncannily familiar.[59] Alternatively, her description of Richard Estes cleaning dirty surfaces, and eliminating photographed passers-by as 'distractions' from his paintings, positions him as the ultimate 'counter-Fromanger'. The reflective plate-glass windows and oblique neon signs of an Estes work such as *Cafeteria* (pl. 70), or a painting by Robert Cottingham, seem far sharper and more aggressive than those on Fromanger's streets; far more

71. Mahaffey, St. Louis, Missouri, 1971,

menacing and anonymous than his views of Pigalle nightlife with their lyrical French titles such as *Violet de Bayeux* (*Bayeux Violet*). Yet in each of Fromanger's images, the spectator, likewise, looks through invisible glass.

Hyperrealism in Europe, it is arguable, enjoyed the same response as Rosenquist's *F-III*: despite its own double codings, the use of deadpan representation as critique, it confirmed the fantasies and expectations that fuelled an exacerbated anti-Americanism in the wake of Vietnam. Above all, it produced confused emotions, a mixture of desire and fear. Estes's images of New York, or Noel Mahaffey's aerial views of St Louis Missouri, with its serried ranks of skyscrapers (pl. 71), or Portland, Oregon, with mountains on the horizon, certainly proclaimed the supremacy of America's huge spaces and its power in terms of natural and human resources. While works by Duane Hansen shown in Paris, such as *Riot* (1968), denounced police brutality as did his European counterparts, his obese American supermarket shopper or kitschy *Baton Twirler* (1971) confirmed the alienating strangeness of these facsimiles of American 'reality'. Moreover, these paintings and sculptures demonstrated for militants such as Fromanger a political equation he has reiterated, that between American capitalist realism (hyperrealism) and Soviet Socialist Realism – the art of the two oppressive superpower regimes. Like France's independent nuclear deterrent, however, its 'third way' in painting was, for the time being, excluded from competition on the world stage.

Fromanger, like Godard or Alain Robbe-Grillet, was distinctively a man of his own territory. Paris was both actor and backdrop in his complex explorations of contemporary life, just as it was for Nouvelle Vague cinema (whose *film noir* genre looked with a critical irony at the clichés of Hollywood 'B' movies) or for the literature of the *nouveau roman*. The titles of paintings in the 'Painter and the Model' series, which refer to the poetic names of paints of the colour chart or *nuancier* (such as Aubusson Green), were analogous to the *nouveau roman*'s self-reflexive writing practices.

Michel Foucault 'Desire is everywhere' Photogenic Painting?

The autumn of 1971 was crowned not, in fact, by the Paris Biennale but the Francis Bacon exhibition at the Grand Palais, a Bacon of magnificent recent triptychs with searingly bright, monochrome backgrounds, orange, yellow or violet. These constituted, arguably, the last great statement of the humanist tradition in art before an irrevocable

change in the intellectual climate.[60] The impact of Bacon on European artists was considerable, nowhere more visible than in the work of the former Communist and senior member of La Ruche and the Salon de la Jeune Peinture, Paul Rebeyrolle. He had received major commissions from the Maeght family and from 1952 onwards had been promoted by Bacon's Marlborough gallery in England; he had exhibited successfully in New York in 1964. His work was always figurative and expressionist (though in contrast to Bacon he also identified with Courbet and with Millet's peasant paintings). Sartre wrote the catalogue preface to Rebeyrolle's show at Galerie Maeght in 1970, juxtaposing the horrors of Cuba and Vietnam with the Soviet invasion of Prague (reasserting his changed anti-Communist, pro-Maoist position). He also wrote 'Coexistences' in 1970 for Maeght's review *Derrière le miroir*.[61] The baton was then passed to his charismatic rival, Michel Foucault, who accepted a commission from the review to write on Rebeyrolle for his exhibition in 1973. Its theme was the prison. Foucault's development from writing on Rebeyrolle, through Magritte, Velázquez and Manet to Fromanger's work is my focus here.

In 1970, Foucault was elected to the prestigious Collège de France. On 8 February 1971, he founded the Groupe d'Information sur les Prisons (GIP). Just like the expanding university, which both demographically and intellectually could no longer

72. Godard, *La Chinoise*, 1967

be contained within nineteenth-century structures, the prison system was exploding and monstrously obsolete.[62] In May that year, Foucault published an article in *Combat* called 'La Prison partout' (the prison everywhere).[63] Two men were guillotined in 1972; the prison issue dominated national headlines for the next few years, hence the topicality of Rebeyrolle's torture series and a work such as *Enragé* (1972), where a furious dog-like being is trapped, abjectly, within the material world of his confinement: wood, straw, chicken wire. In this case, Foucault's eloquence engaged more with the subject of prison and freedom than the pictorial.[64] Two years later, his preface on Fromanger, in contrast, demonstrated how Narrative Figuration offered coherent links with his fascinations: Manet, mirrors, the very *topoi* of representation, and hyperrealism.

Foucault's engagement with the fine arts and with visual culture was an essential dimension of his 'archaeology of knowledge'. It has long been underestimated.[65] To recapitulate: as early as 1954, in *Maladie mentale et psychologie*, he engaged with Hieronymus Bosch's *Garden of Earthly Delights*. Foucault's *Madness and Civilisation* (first published as *Folie et déraison: histoire de la folie à l'âge classique* in 1961) begins with the Ship of Fools portrayed by Bosch and Dürer and moves from Dieric Bouts, Stephan Lochner and Mathias Grünewald to Sade, Goya, Nietzsche, van Gogh and Antonin Artaud at the end of the book – his doctoral thesis.[66] Impassioned evocation rather than pictorial analysis rules. Foucault was always the essayist; and though he was meticulous as regards citing primary sources relating to the main body of his text, for his painting references he rarely noted locations or visual sources, far less the world of art-historical scholarship. He looked at Bosch in Lisbon in November 1963 and compared Manet with Flaubert as early as 1964 while working on Flaubert's *Tentation de Saint Antoine*: both broke with the past, while their new self-referentiality signalled the beginnings of the modern.[67]

In 1966 *Les Mots et les choses* (*The Order of Things*, 1994) was first submitted without the sequence on Velázquez's *Las Meninas*.[68] This appeared, however, as a virtuoso overture when the book came out in April: it was a publishing sensation that secured Foucault's celebrity.[69] The Velázquez passage has, on the one hand, a function similar to the Ship of Fools in *Madness and Civilisation*: it is a memorable trope which can act as a *mise en abîme,* subsuming the meaning of a book as a whole. The painting questions the geometries, reflections, light, spectator position, the way we as spectators are regarded; it reverses hierarchies, interrogates categories, traverses time, speaks always to the present.[70] On the other hand, the Velázquez piece serves as the ultimate

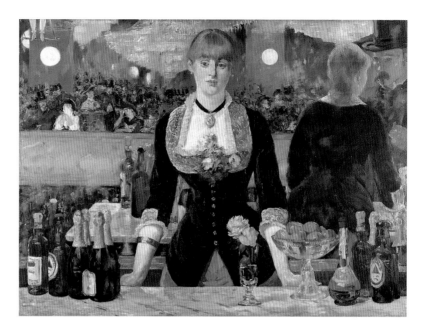

critique of Foucault's analyses: for his comprehensive treatment of the taxonomies of thought since antiquity omits the visual world of representation. The highly complex descriptions of the painting once again entirely eschew the reasoned scholarship of the rest of his enterprise. Hence Foucault's constant reticence about art, with which, he later declared, despite his pleasure in writing, he had no 'tactical or strategic relation'.[71] Paradoxically, the reticence persisted despite the importance of sight in the act of scrutiny (the symptom as sign of malady) in *Naissance de la clinique* (*Birth of the Clinic*, 1963) or vision and power in terms of the panopticon model prison in *Surveiller et punir* (*Discipline and Punish*, 1975) – and despite the eulogies of Michel de Certeau regarding Foucault's own 'visual character' and 'optical style'.[72]

It was *The Order of Things* which precipitated the letter to Foucault by Magritte, the veteran Surrealist, in May 1966. Magritte's pictorial universe seemed to be a discovery. Foucault's *Ceci n'est pas une pipe* (*This is not a pipe*), first published as a posthumous tribute to the artist in 1968, is a semantic rather than a visual study, a moment of 'high' structuralism, including the chapter on 'Klee, Kandinski, Magritte' (sic).[73] Magritte's second letter to the philosopher in June 1966 addresses the substitution of coffins for figures in *Perspective, le Balcon de Manet*.[74] At this very period, Foucault was signing a contract for *Le noir et le couleur*, a book on Manet.[75] He continued to insist, however, that he was not an art historian, notably when reviewing Panofsky's *Essais d'iconologie* and *Architecture gothique et pensée scholastique* (translated by Pierre Bourdieu) in 1967.[76]

73. Manet, *A Bar at the Folies-Bergère*, 1882

The non-existent Manet book, which leads me to Fromanger and the contemporary, seems as ill-fated as Jean Genet's *Rembrandt* (published only in 1995).[77] Yet it was a constant preoccupation, indeed, an element of Foucault's public reception: he lectured on Manet with slides in Milan in 1967, in Buffalo, Tokyo and Florence in 1970 and in Algeria in 1971. It is thanks to Rachida Triki, who established the text of the 1971 lecture, that one can catch a glimpse of Foucault's Manet. It may be that he destroyed a manuscript.[78] What counts is that Foucault set up a history of art and aesthetics course in Tunis, based on the Renaissance construction of space and the human body, as references to Giotto and to Masaccio in his Manet lecture testify.[79] His largely formalist approach has obvious art-historical sources, notably Pierre Francastel's classic, equally lecture-based, *Peinture et societé* of 1951, sub-titled 'birth and destruction of pictorial space from the Renaissance to Cubism'.[80] One wonders how these Western visual regimes would have appeared to the largely Marxist and Maoist Tunisian students oppressed by the national government and engaged with the situations in both Vietnam and Palestine. Any awareness of a 'colonial' dimension pertaining to Foucault's lecture series goes unrecorded. Yet, thanks to discussions in this context, Foucault became a passionate militant.[81] The question, then, was how to reconcile art and politics, two separate spheres of existence. While writing on art in the 1960s, Foucault could not look to a contemporary equivalent of Velázquez; when explicitly challenged, he offered only Klee.[82] The progress to an apolitical contemporary, to Mark Tobey (he bought a Tobey painting in 1974), is evident here.[83] Rebeyrolle's art indeed provided a passage. Suddenly, however, figurative painting – including the *pompiers* and artists like Clovis Trouille – became sexy again (Foucault says 'the current passed bodily, sexually').[84] In the era of a politicised, photography-based Narrative Figuration, Foucault met his artist.

Fromanger and Foucault first encountered each other in political, not artistic circles: the milieu of the GIP. Foucault had acquired his own post-'68 credentials, participating in the occupation of the University of Vincennes, where he later taught for two years, in early 1969: he took the podium with Sartre in an atmosphere of unrest, missiles and tear–gas, to denounce the calculated repression at the Mutualité in February.[85] As the director of the philosophy department at Vincennes, during the academic year 1969–70 Foucault sanctioned extraordinarily hard-line political courses (which finally provoked government intervention): Jacques Rancière's 'Theory of the Second Stage of Marxism-Leninism: Stalinism', Henri Weber's 'Introduction

to Twentieth-Century Marxism: Lenin, Trotsky and the Current of Bolshevism' and Judith Miller's 'Third Stage of Marxism-Leninism: Maoism', for example.[86]

With the Sino-Soviet split, Mao's China had become a new territory of the imagination for anti-Stalinist intellectuals of the West. France was the only Western democracy to have established diplomatic relations with the People's Republic of China in 1964; the relationship had ancient roots. The extraordinary Maoist phenomenon among French intellectuals can merely be hinted at here, with all its paraphernalia: from *dazibaos* (wall newspapers) on the streets of Paris to little red books and posters in the Bibliothèque Asiatique parodied in Godard's *La Chinoise* of 1967 (pl. 72), to the peasant orientalisms of the Supports-Surfaces artists and the bitter ideological confrontation between the Tel Quel group who supported Maria Antoinetta Macchiocchi's eulogistic *De la Chine* (1971) and the sinologist Simon Leys, whose attempt to lift the 'ideological smokescreen' covering China encountered passionate and critical responses.[87]

In February 1972, thanks to negotiations in Paris, Richard Nixon went to China; Pompidou followed in September 1973. In April 1974, the Tel Quel intellectuals (Philippe Sollers, Julia Kristeva and Roland Barthes), with the art critic Marcelin Pleynet and the editor François Wahl, undertook their own symbolic voyage to China.

74. Fromanger, *In Huxian, China* 1974

Their retrospective accounts and subsequent tergiversations are now well known.[88] In June of the same year, the celebrated Belgian Communist film-maker Joris Ivens was invited back. The gift of his 35mm camera to the Eighth Route Army on the Long March had generated China's documentary film tradition. He travelled under the auspices of the Association Amitiés Franco-Chinoises, to make a twelve-hour long television documentary, *Comment Yukong déplaça les Montagnes*.[89] He invited Fromanger to join a group of artists, engineers and doctors. It was the paintings based on Chinese experiences that dominated the series 'Desire is everywhere' which was shown at Galerie Jeanne Bucher in February 1975; Foucault prefaceed the little red catalogue for Fromanger, with his text 'Photogenic Painting'.[90] 'Desire is everywhere' played dialectical ping-pong with Foucault's 'prison everywhere' theme.[91] The period was indeed Deleuzian – one of circulation, exchange, encounters and short–circuits; but in the context of Mao's China, the slippage from expectations to illusions, to delusions and to disillusions strongly marked the desires from the West, while the classic 'Potemkin strategy' of controlled tourism disguised poverty, disfunctionality and tragedy in the East.

Fromanger's *In Huxian, China* was the most grandiose of the works he created using his own photographs on his return (pl. 74). His elaborate sub-title reads: 'Peasants and amateur peasant painters in Huxian province of Shaanxi, People's Republic of China, 20 June, 1974, in front of the door to their painting exhibition, at the moment we left', and the Chinese inscription reads 'Serve the People'.[92] The work is a *constat*, a statement of a moment allied to the 'truth' of photography, but the ambiguity of the posed session raises questions which Fromanger's critique takes care to leave open. Against the dark background of the building that houses an exhibition of peasant painting, rows of individuals are carefully differentiated; the rainbow colour contrasts which flood them are joyous – yet ambiguous in this closed country of unknown multitudes. The peasants' own art is signified – like the interior behind Manet's *Balcony* – only by blackness. Perhaps Fromanger's literal *mise en abîme* signifies the abyss where the preservation of local traditions encountered state strategies, the control of tourist visits and cultural exports. When filmed by the artist Jean-Noël Delamarre, in the process of portrait-painting with the peasant painter Liu-Tchi-Tei, Fromanger's provocative questions – 'It never rains in your village? You are never unhappy?' – were evidently designed to disrupt preordained responses. He broadcast five hours of conversation live for the radio channel France-Culture on his return.[93]

Foucault, however, never mentions *In Huxian, China* in his preface. It is unclear how he regarded the Chinese content of the show. He was supremely aware of the issues at stake, as witnessed by his questions when interviewing the author K. S. Karol for *Libération*, on the subject of the so-called second cultural revolution which arose in the aftermath of the disappearance of Mao's rival Lin Biao and the Gang of Four's 'Criticise Lin, Criticise Confucius' campaign. 'Is there now a regime so repressive that the people no longer have the right to the free, spontaneous, savage expression of the cultural revolution?' Foucault asked. The masking of contradictions at a time of widening disparities raised questions, he suggested, about the unifying role of ideology.[94]

Instead, Foucault considers the masking exercise of photography. He begins and ends with an androgyne – Ingres's 'androgynous image' (the hermaphrodite marriage of photograph and canvas) and, finally, Fromanger's androgynous, photograph-based painting of Michel Bulteau, the long-haried 'electric' beat poet and 1970s-style Manet bar-girl: a century of images which embrace photography as travesty. Some two weeks' research in the Bibliothèque Nationale were preferred to Deleuze's long visits to the artist's studio. It was the unscrupulousness, the fakery (*truquage*), the travesty (*travestissement*) of the new processes that delighted Foucault – the delirious multiplication of hybrid, turn-of-the-century practices – just as he called some of Manet's ruses 'vicious', 'wicked', 'perverse'.[95] While Gisèle Freund's *Photographie et societé* with its detailed technical and sociological history of photography was republished in 1974, this does not seem to have been Foucault's prime source.[96] His accelerating prose conveys his reading with excited

75. Rejlander, *Two ways of life*, 1857

lists: for example, the photographs which faked paintings in a recognisable painting style, 'what Reijlander did with Raphael's *Madonna*, what Julia Margaret Cameron did for Perugino, what Richard Pollack did for Peter de Hooch, Paul Richier for Böcklin, Fred Boissonas for Rembrandt, and Lejaren and Hiller for all the *Depositions from the Cross* to be found.'[97] He marvels that it took six weeks and thirty negatives to produce the biggest photograph in the world: Oscar Gustav Reijlander's *Two Ways of Life* (1857, pl. 75) – the contemporary equivalent of Raphael's *School of Athens* or Couture's *Romans of the Decadence*. Indeed, many of Foucault's 'art-photographers' are contemporaries of Manet. Through the gamut of good and bad taste, chemical experiments, amateur family practices, he sees 'Desire for the image everywhere, and by every means, pleasure in the image'.[98] Yet despite the dialectic of 'desire is everywhere' versus 'the prison everywhere', Foucault does not pursue the challenge; he does not discuss the immediate co-option of the invention of photography for police files, scenes of crime or anthropometric profiles – the *système Bertillon*.[99] On a contemporary axis he mentions neither police photography and new surveillance systems – the dangerous obverse of Elie Kagan's *photo-reportages* – nor the co-opting of photography for political propaganda.[100] In fact, Foucault's preface is strangely a-political, when in this very show Fromanger's diptych, *Revolt at the Toul Prison,* I and II, recalled the shared activism of artist and philosopher:

> A prisoners' revolt on a rooftop: a press photo reproduced everywhere. But who has seen what is happening? What commentary has ever conveyed the unique and multiple event which circulates in it? By throwing a confetti of multicoloured marks onto the canvas, whose position and colours are calculated with no relationship to the painting, Fromanger draws countless celebrations from the photograph…[101]

Indeed, Foucault is not even describing a photograph of Toul but a 1972 image of the Charles III prison in Nancy. The photograph, 'reproduced everywhere', is shown again as a projected image in the artist's darkened studio in *The Artist's Life* (1972–5; pl. 76). The revolt triggered Foucault's failed attempt to organise a press conference in the Ministry of Justice, where he was beaten back by the CRS riot police – a less than celebratory experience.[102] Within the dynamic of his text, Foucault himself seems more taken, however, with Fromanger's strange slide-projector method, in particular the moment when the projector is turned off. Specifically, he is interested precisely in the differentiation of Fromanger's work – through its content – from hyperrealism.

Richard Estes, Robert Cottingham, John Salt, Ralph Goings used a pictorial composition whose virtual presence is immanent in the photographs they deployed to create paintings. Yet Fromanger was looking for something else:

> Not so much what might have taken place at the moment the photo was taken, but the event which takes place and continues ceaselessly to take place on the image, by virtue of the image… to create through the colour photograph short-circuit, not the faked identity of the older photo-painting, but a source exploding with myriads of images.[103]

As with the Manet lecture, process wins strangely over content, in this case political content, even as regards Fromanger's sixteen variations on an immigrant street-sweeper, where the titles, *Rue de la savane, Rue de mon peuple, Rue de la saison des pluies (*Street of the Savannah, Street of My People, Street of the Rainy Season), create a poetry of Prévert-like poignancy. The sweeper's reverie and displacement are energised by the different colours that contradict the monotony of the one repeated image (low-skilled invisible labour sweeping the boulevards clean, perhaps in the aftermath of a demonstration).

Foucault's writing culminates, however, in the shattering of Manet's paradigm of Western modernism:

76. Fromanger, *The Artist's Life*, 1972-75

Two paintings end today's exhibition. Two thresholds of desire. In Versailles: a chandelier, light, glitter, disguise, reflection, mirror; at this symbolic centre, where forms were necessarily ritualised in the sumptuousness of power, everything decomposes in the very glitter of pomp and the image liberates a flight of colours. Royal fireworks, Handel falling in rain; the Bar of the Folies Royales, Manet's mirror shatters; the Prince in drag, the courtier is a courtesan. The greatest poet in the world officiates, and the regulated images of etiquette flee at a gallop, leaving behind them only the event of their passage, the calvacade of colours elsewhere, departed.

At the furthest reaches of the steppes, in Huxian, the amateur peasant painter gets to work. No mirror, nor chandelier. His window opens onto no landscape, but onto four planes of colour which are transposed into the light which bathes him. From Court back to discipline, from the greatest poet in the world to the seven-hundred millionth humble amateur, a multitude of images escape, and this is the short circuit of painting.[104]

The greatest poet in the world? Michel Bulteau, performing and partying in Versailles, becomes the Manet bar-girl of 1975 (pls. 73 and 77).[105] This is a *travestissement* framed by the ultimate pomp and circumstance of Old Europe: the Galerie des Glaces in Versailles, witness to France's humiliation in 1871 and the victory treaty of 1919 with its Pyrrhic consequences: the Second World War.

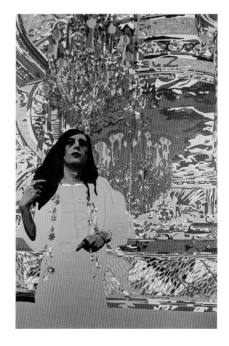

Here, at the climax of a *son et lumière* extravaganza – to the music of Handel's *Fireworks* suite – the mirrors and chandelier drops refract and magnify light into a blinding dazzle: personhood, identity, place, reflection itself are lost. Countering this image is that of the amateur peasant painter Liu Chi-tei (pl. 78). East versus West; democracy versus despotism; decadence versus humility – yet the circulation of images, merchandise, desires is everywhere. Foucault's brilliant, ambiguous conclusion responded to Fromanger's lived experiences and his premonitions. It anticipated none other than new archeologies of knowledge, a new world order.

77. Fromanger, *Michel Bulteau, at the Versailles Opera.* 1974

One month after Fromanger's show, ARC staged 'Images du Peuples Chinois', including posters, comics and toys at ARC in the Musée d'art moderne de la Ville de Paris. The peasant painters from 'Houhsien' (Huxian) were the guests at the Biennale de Paris in September: the circulation of images and ubiquity of desires reached an apogee.[106] Pontus Hulten, the director of art for the Beaubourg, in *gauchiste* mode, purchased *In Huxian, China* for the national collections in 1975. Fromanger's portrait of the laughing Foucault, *Michel*, in photographic black and white, electrified

with jagged, coloured force-lines, was created as part of the 'Splendours' series (see p. 6), along with photograph-based portraits of Sartre and Prévert in 1976.

The 1970s Chinese adventure, at the height of French Maoism, was a prelude: Fromanger exhibited in the Centre Culturel Français in Beijing in 1984, in the still anti-capitalist People's Republic of China, prior to his success in the official French touring exhibition, 'Nouvelle Vagues', in 2005. After meeting Karl-Heinz Stockhausen in London, the artist was granted permission to restage the ballet *Hymnen,* with a new choreography, set and costume designs in 2007. It was performed in Nancy and Paris.[107] A retrospective of Fromanger's work in the Communist centenarian Oscar Niemeyer's modernist capital Brasilia, moving to Rio de Janeiro, celebrated the *année France-Brésil* in 2009.

78. Fromanger, *Liu-Chi Tei, amateur peasant-painter*, 1974

Lyotard, Monory
Postmodern Romantics

'Lyotard is not a theorist' declared Bill Readings, in *Introducing Lyotard: Art and Politics* (1991), a book which devoted a few lines to Cézanne, fewer to Jacques Monory as a 'hyperrealist' and none at all to Daniel Buren. 'Just as his postmodernity claims to make no temporal breaks, so his thought ceaselessly denies the pretensions of theoretical distancing, of epistemological breaks.'[1] Yet in 1971, Jean-François Lyotard attempted the first extended psychoanalytic critique of Cézanne; his lengthy encyclopaedia article was republished in *Les Dispositifs pulsionnels* (1973). He enjoyed an extended friendship with the senior painter of the Narrative Figuration group, Jacques Monory, during a period in which he also wrote on Marcel Duchamp and the highly structuralist, conceptual world of Daniel Buren. No epistemological break could be more striking than that between Monory's figurative, emotionally invested dreamscapes and Buren's striped interventions in the spaces of the museum or the street, where the 'work' itself becomes a debate between sign and signifier. Until very recently, scholarship outside France on Jean-François Lyotard's aesthetics, melancholy and even the 'pictorial' turn mentioned not one of the contemporary French artists with whom he engaged.[2] However, new interest in Lyotard's 1985 'Les Immatériaux' exhibition is now producing more exploratory approaches.[3]

The Lyotard-Monory relationship signals the philosopher's move from an engagement with art of the past into the contemporary and a specific style of writing that informed not one but two of the major essays in Bernard Lamarche-Vadel's collection *Figurations 1960–1973*. Lyotard's own daughter Corinne espoused the language of the father – her father – to write a substantial critical essay on the artist Henri Cueco, using the trope of *jouissance rouge* (red ecstasy). Cueco's *Barricade, Vietnam 68*, in the 'Red Room for Vietnam' show in 1969, had reworked Delacroix's *Massacre at Scios* with primary colours and a 'silkscreen-style' flatnesss, to denounce American war atrocities (see pl. 1). Corinne Lyotard wrote: 'Cueco's canvases are assassinations... Cueco sees red... the red of *jouissance*'.[4] Whereas Cueco's subjects were intensely linked to the politics of the time, along with their basis in history painting, Monory's subject matter

was more distanced. Whereas Cueco's *jouissance* was red, Monory's was blue – according to Lyotard himself, the blue *jouissance* of an abject and prostituted capitalism. Just as Pierre Bourdieu engaged with Panofsky, Lyotard took on Anton Ehrenzweig and the theoretical problems of 'applied psychoanalysis' and its relationship to art writing; yet, as a writer, his relationship with Monory was more libidinal, more literary. For Lyotard, Monory became (under the sign of Baudelaire) the contemporary 'painter of modern life'.

79. Monory, *For all that we See or Seem is a Dream within a Dream,* 1967

The Painter of Modern Life

Lyotard, writing on Monory, examined new relationships among modernity, capital, the mass public, prostitution, dandyism, painting, photography and film. He mapped not only 1970s Paris but also, significantly, Los Angeles over Baudelaire's own universe and, like the poet, cited authors such as Thomas de Quincey and Edgar Allen Poe. Yet these writers were no longer contemporaries but exotic anachronisms. The implications of this fold in time for Lyotard in the 1970s are in question. It was with irony, rather than with arrogance or perversity, that Lyotard cast himself as a second Baudelaire and Monory as the Manet of his times. With a highly selective reading of the contemporary art world, Lyotard set up a wager. Looking backwards as he looked forwards, he situated his texts as liminal, on a threshold between the past and a new era. Lyotard's later writings addressed American painters such as Barnett Newman and Sam Francis and conceptual artists such as Joseph Kosuth. Here he added a philosophical and poetic dimension to an established critical language. Monory's art claims priority, however, as the painting that initiated Lyotard into the present. His texts on Monory mirror his private and psychoanalytical concerns over the course of a decade, while the encounter of both philosopher and painter with the work of Duchamp adds an additional dimension to the Narrative Figuration story.

From the first thoughts of Monory as dandy in 1972, to the 'sublime aesthetics' of 1981, written for the series 'Skies, Nebulae and Galaxies', both philosopher and artist were aware that Paris was in decline; new centres were arising on both Atlantic and Pacific horizons. As Baudelaire himself proclaimed: 'Dandyism is a setting sun; like the declining star, it is magnificent, without heat and full of melancholy'.[5] The shift to Los Angeles rather than New York was significant, as both men discovered a land whose scales of time and space were totally other, where ancient rocks and deserts confronted young civilisations with an immediate grasp of the future – the latest computer chip developments. Death Valley encountered Silicon Valley, named only in 1971. Monory's knight errant in *Death Valley no. 1* (1974) – a citation of Albrecht Dürer – is already vanquished, a museum piece, like the dry skulls he encounters (pl. 80). The technological prowess of the United States, leaving Europe 'magnificent and full of melancholy', frames this encounter and collaboration.

Monory's melancholy was confirmed as early as 1966 with *Impossible Revolution*, exhibited at Expo '67, the Montreal World Fair, in a French pavilion dominated by

the School of Paris. He had shown in 'Mythologies Quotidiennes' in July 1964 and in the 'Green Room' at the Salon de la Jeune Peinture in 1965 with *Green, the Assassin*. Oedipally violent and full of derision, the work, later destroyed, showed the colour green obliterating and 'assassinating' the subject of painting itself (significantly, the half-apparent body of a female victim). For Monory, the 'assassination of painting' had important autobiographical dimensions: with the abrupt onset of success, he had destroyed most of his earlier work. He had trained in applied arts, continuing to paint privately for himself, yet in his day-to-day job as a layout artist and designer for the publisher Robert Delpire, he was confronted with hundreds of photographs and reproduced images. The capitalist conception of the catalogue and its principle of 'substitutability' – the interchangeability of products and desires elaborated by Lyotard in his Monory texts – were surely anticipated here. Monory's own painting, increasingly anxious, moved from images of interiors and photocollages in the late 1950s to monstrous, virally proliferating abstract forms in nauseous colours.[6] By 1963, murder and suicide doubled his destructive act by appearing as motifs in his new work. *Memories of a Dead Woman: Russian Roulette* introduced a real pistol into an assemblage. The fissured painting of the blue car with a self-portrait, *For All that we see or seem is a Dream within a Dream* (1967), takes a line from Edgar Allan Poe for its title (pl. 79). It figures Monory as hero or villain in shades next to his white Cadillac. Speeding in a mirage through the palm-fringed roads of Cuba later that year, the Cadillac reappears in his first film *Ex* (1968; see pl. 88), made long before he met Lyotard. Already his art was about photography, film, memory and erasure, love and loss, the 'romantic space-time of nostalgia'.[7]

Did Monory himself invent the mighty *fin-de-siècle* Baudelaire–Manet jest with Lyotard? *Toxic no. 1, Melancholy* (1982) reworks Manet's 1868 *Portrait of Émile Zola*

80. Monory, *Death Valley no. 1*, 1974

(pls. 81 and 82). In place of Zola the writer and connoisseur surrounded by books, lithographs, Japanese prints and photographs in his study, Monory paints a woman of his times, conflating Zola with Dürer's celebrated figure of Melancolia. He surrounds her not only with books and reproductions but also the reproductive technology of her age: radio, tape recorder, headphones. Monory embraced popular culture, kitsch, the erotic and, above all, the fictional with an ease and a profusion that constantly seemed to amaze Lyotard. Ironically, the philosopher's own burden of civilisation, art history,

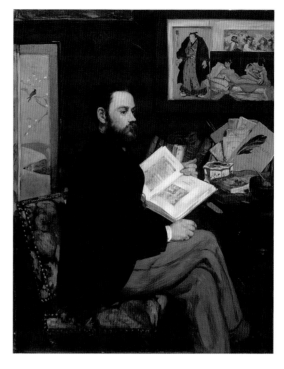

literature and political and psychoanalytic theory marked him, rather than Monory, as the *monstre-dandy*, the dandified monster. His own work beat a path through intertwining disciplines, from which the libidinal, constantly striving for freedom, was doomed, through the decorum of theory, to repression. One senses Lyotard's relish in Monory's *Document bleu* (1970), a novel of lust and murder; one senses that Lyotard's literary allusions function not only as triggers but as restraining devices, to keep the contemporary artist within Baudelairean confines.

It is the reciprocity of the relationship that was exceptional. Both men were fascinated by the power of tradition and desired to break with it; both were sensual, emotional, aggressive in their appetite for experience. The Lyotard of *Économie libidinale* (1973; *Libidinal Economy*, 1993) remains theoretical, opaque, without the illuminations of Monory's painted narratives, which serve as parables. As a critic and spectator of Monory's painting, Lyotard's role was fused with the theories of dreamwork he had explored in psychoanalytical criticism, and with the death drive he saw operating in Monory's blue. Extending the topological metaphor of the Moebius strip (derived, one may assume, from Jacques Lacan's 1963 seminar on anguish), he contended that, like the outside and the inside of the body and the scene of writing, desire and its inscription on a surface – the skin, canvas, film or, more provocatively, a bank account

81. Manet, *Émile Zola*, 1868

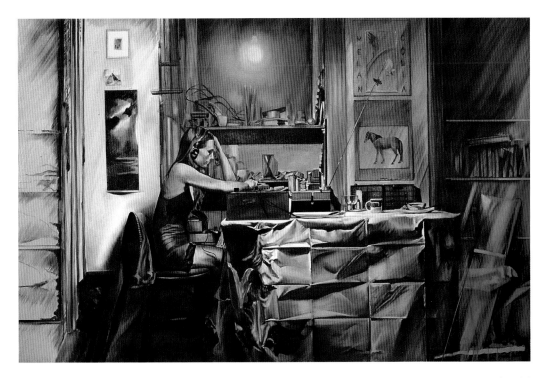

or a cheque book – become a continuous whole.[8] Lyotard's characterisations of cold 'male writing' and Monory's procedures with second-hand, processed images are both negative modes of distancing and displacement, while Monory's use of real mirrors on his canvases, together with his own mirror-image as a hysterical, fugitive double, are especially close to Lacan. These modes conceal inadmissible longings for a wholeness and truth, perhaps irrecoverable, in a fragmented and artificial society.

When Lyotard and Monory finally met in 1972, they were at the most productive and exciting points in their careers. Lyotard, born in 1924, was, at forty-eight, a recognised philosopher and political essayist.[9] He had published *Discours, figure* earlier in 1971. This was followed by two anthologies, *Dérive à partir de Marx et Freud* and *Des Dispositifs pulsionnels* in 1973, as well as his first substantial essay on Monory in *Figurations, 1960–1973*. Monory, Lyotard's exact contemporary, had established an international career. By 1966, when he was invited to show in Arturo Schwarz's influential Milan gallery, he had achieved his signature style of the monochrome canvas, the doubled and fissured image, the use of mirrors and plexiglass. His 'Velvet Jungle' series, shown at Gaudibert's ARC space in Paris in 1971, established his reputation (the exhibition toured to Brussels, Amsterdam, Saint-Étienne and Aachen). He featured in the definitive and highly controversial survey of contemporary art in France,

82. Monory, *Toxic no 1, Melancholy*, 1982

'Douze ans d'art contemporain', in 1972 at the Grand Palais. The most brilliant young critics and curators, such as Jean Clair, the editor of the magazine *Chroniques de l'art vivant* which was linked to the powerful Galerie Maeght, were reviewing Monory's work.[10] Lyotard sought the artist in 1972 and 'timidly' sent him a first, unsolicited and 'rather crazy' piece of writing.[11]

In his youth, Lyotard had contemplated becoming a painter – or a monk or a historian. An 'unfortunate absence of talent' dissuaded him from a career in art.[12] Subsequent to his experiences as a teacher in Algeria under the French regime, he had become passionately involved with politics and the reformulation of Marxism within the group Socialisme ou Barbarie led by Cornelius Castoriadis. Just as Lenin or Trotsky adapted Marx's doctrines and principles for their own times, so Lyotard in 1973 characterised his political engagement, and his first *dérive* (he uses the Situationist term for 'drifting'), as a purposeful turning away from the recent orthodoxies of Louis Althusser. Lyotard viewed Althusser's attempt to reread Marx as the 'carbon copy of the former nightmare', preserving hierarchies, practices and the moral righteousness of the French Communist Party at the height of its Stalin cult. At the same time, he said, the *dérive* of desire meant that for millions of young people the capitalist machine, with its equation of exchange between labour and consumption, was no longer adequate as the Marxist paradigm of society. With his students at the University of Nanterre, Lyotard in July 1968 charted the *désirévolution* which modified political analyses.[13] The desires were not new in themselves but new as focuses of attention: 'The desire which forms and sustains institutions is maintained by investments of energy in the body, language, the earth, cities, sexual and generational differences etc. Capitalism is one of these investments.'[14]

The Monory essay appeared as Lyotard's first substantial piece of writing on contemporary art following *Discours, figure*, published in 1971. This had been his doctorate, worked through with his students in the revolutionary years 1967–9. Time, space and colour were transposed in his seminars from the investigations of art and society – the medieval, the Renaissance and the modern – to those of the formal investments in both language (*discours*) and art (*figure*) of emotion, anguish and the unconscious.[15] Working at the University of Nanterre with Louis Marin and the philosopher Mikel Dufrenne, Lyotard attempted to bring a philosophy of the senses to a modernised art history.[16] 'The eye listens… reflection comes at the crossroads of two experiences, to speak and to see.'[17] His engagement with current psychoanalytic

texts on art and literature was complemented in *Discours, figure* by his close textual reading of Freud and a range of examples, from medieval manuscripts and Cézanne ('Cézanne psychoanalyses Masaccio', he claimed) to El Lissitzky, Paul Klee, Picasso and Jackson Pollock. Most important was Freud's analysis of libidinal drives – the pleasure principle and the death drive as they were related to representation in general. However, Freud had not substantially addressed the issue of representation through time, the changing styles of art, as presented in Henri Focillon's classic *Vie des formes* of 1934.[18] The problem had haunted Malraux's magisterial *Musée imaginaire* of 1947 (the imaginary museum of art from around the world available through reproduction); it continued to haunt Lyotard throughout his life.[19] The alternative, phenomenological model for *Discours, figure* had been provided by Maurice Merleau-Ponty in his famous essay 'Le Doute de Cézanne' (Cézanne's doubt) of 1945.[20] Lyotard's first book, *La Phénoménologie*, was published in 1954. He proceeded to extend Merleau-Ponty's reflections from visual and phenomenological to psychoanalytical realms; his example, 'Freud selon Cézanne' (Freud according to Cézanne; 1971), demonstrated the insights of his developing approach.[21]

A compendium of decades of reading and reflection, *Discours, figure* nevertheless looks forward to the encounter with Monory.[22] There are passages on Freud and dreamwork, on America, on Galileo and on the colour blue.[23] Different analyses of narrative and its components, such as Claude Lévi-Strauss on myth, Vladimir Propp on folk-tale morphologies, and the structuralists' concern with generative grammar may be seen as particularly relevant for Monory. They offer methodologies through which to approach the repeated elements of his subject matter: artist/protagonist, revolver, crime scene, woman, victim, glaciers, deserts, stars. Similarly, the ambiguity in *Discours, figure* regarding the writer's, the reader's or the spectator's response – emotional empathy or cold, dispassionate analysis – mirrors the spectator's unease in front of Monory's work.

Despite Lyotard's energy as a teacher, the positive in his writings was constantly countered by melancholy, that of the anguish of Cézanne's doubt, the retrospective, ruined and fragmented time of Malraux's imaginary museum and, despite the encyclopaedic ambitions of *Discours, figure*, the impossibility of reconciling strong voices of the present with those of the past. Moreover, Lyotard and his fellow the activists of May 1968 never relived the rapture, the anxieties or the 'true anti-art' (Lyotard's phrase) of the first barricades, the revolutionary moment that marked a watershed in French history.[24]

The 1970s were experienced with a profound sense of aftermath and, for Lyotard, guilt – despite his analyses – at abandoning the dominant Marxian narrative in France.[25]

An alternative ideological debate subtended the reception of American art in Europe at this time, reflected in Lyotard's chameleon embrace of the new: 'The most modern currents, American abstractionists, Pop and hyper-realist artists in painting and sculpture, poor and concrete music (especially Cage), free choreographies (those of Cunningham), theatres of intensity (do they exist?) pose a considerable challenge to critical thought and negative dialectics; they are producing works which are affirmative and not critical'.[26] American artists did not experience the intensity of Parisian post-'68 blues; therein lies the conflict between the 'affirmative' options of Herbert Marcuse and the melancholic conclusions of Theodor Adorno, the scourge of the 'culture industry'.[27] As early as 1955, Marcuse had attempted to fuse Marx and Freud in *Eros and Civilisation*, with its vision of free sexuality, non-alienated labour and play in a non-repressive society: it could have been a blueprint for student revolution and Lyotard's *dérive* of desire. However, in 1961, visiting a Paris rendered schizophrenic in the midst of the Algerian conflict, Marcuse wrote: 'the events of the last years refute all optimism... All talk about the abolition of repression, about life against death etc., has to place itself into the natural framework of enslavement and destruction. Within this framework, even the liberties and gratifications of the individual partake of general suppression. Their liberation, instinctual as well as intellectual, is a political matter.'[28] The years of the return of the Frankfurt School's critical theory to Paris coincided, then, with a period of post-'68 reassessment.[29] The Marcusian vocabulary on Lyotard's lips of *désirévolution* and 'affirmative culture' soon succumbed to Adorno's more acerbic reflections.[30] While Marcuse became a colleague of Lyotard's at the University of California, La Jolla, San Diego in the 1970s, and the two men certainly knew each other, Lyotard retained a certain scepticism towards him and towards the Frankfurt School in general.[31] Lyotard defined his position, which required its own 'eye and ear, mouth and hand', as 'the end of criticism' – just two months before finishing his first essay on Monory.[32]

Irony, however, as well as melancholy constituted the '1970's turn' in Paris and a new Nietzscheanism in philosophy mirrored the turn away from revolution to 'decadence' – a symbolist revival in the arts and more ambiguous sexualities expressed in music and fashion. Simultaneously with Lyotard's growing involvement with the 'devilry' of Adorno, he encountered hyperrealism and Pierre Klossowski. Klossowski's critique of neo-Marxism in a context of photography and film was crucial for Lyotard's

concept of the narrative in Monory's painting. Klossowski, France's most prominent Germanist, the translator of Benjamin, Nietzsche and Saint Augustine, turned from novels to drawing in the 1950s, later taking a veteran acting role in his own *tableaux-vivants* and films.[33] Lyotard's 'Freud selon Cézanne', an apparently anachronistic positioning of two familiar names (two mutually resonating, deconstructing, bodies of work) may have found its catalyst, I suggest, in Klossowski's pre-war article 'Don Juan selon Kierkegaard' (Don Juan according to Kierkegaard; 1937).[34]

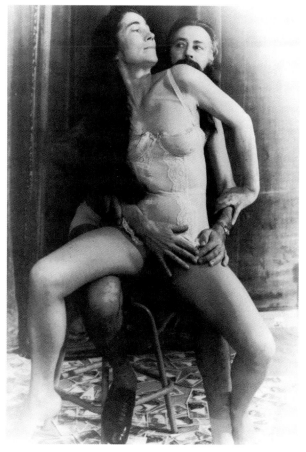

Klossowski's *La Monnaie vivante* (living currency) was published in 1970 with a purple cover, illustrated with autobiographical, quasi-pornographic parodies of contemporary cinema stills, taken by the photographer Pierre Zucca (pl. 83). The text challenged the Marxist schema of the superstructure and infrastructure by introducing desire – and a certain Nietzschean hilarity.[35]

In 'L'Acinéma' of 1973, dedicated to Klossowski, Lyotard sees the cinema screen as he later saw Monory's paintings, as a *paroi spéculaire* (screen-mirror). The material practices of film-making, including the 'visual sound-field' composed of rhythms, sounds and movements, relate to the spectator's perceiving body and desires. While sexual activity as 'productive' *jouissance* results in procreation, its *détournement* into pure expenditure (which could be as simple as striking a match to watch the flare) demonstrates 'sterile' (perverse) consumption. Lyotard makes the link here to Klossowski's concept of the simulacrum, not a problematic of representation but the 'kinetic problematic' produced by chaotic drives.

83. Zucca, (Klossowski, *La Monnaie vivante*) 1970

The cinema – and 'narrative-representative art in general', Lyotard declares – cannot be a mere 'superstructural' product of the cinema industry but must be linked to the sexed body of the active or passive spectator.[36] Klossowski's thought and the new Nietzcheanism subtend the whole of Lyotard's *Économie libidinale* of 1973.[37] Just as, for Ehrenzweig, psychoanalysis transformed Gestalt theories of perception in *The Hidden Order of Art* (1967), so Lyotard's synthesis of current desire-led theories provided a thoroughgoing critique of 'applied psychoanalysis' – a misnomer, he later argued as he engaged extensively again with Ehrenzweig in 1974, whom he found superseded as a theorist.[38]

It is in this context of chaotic libidinal energies countered with retrospection and melancholy that the construct of the dandy must be understood. Bernard Lamarche-Vadel took Lyotard to Monory's studio. He was also the editor of Lyotard's first two anthologies, in the popularising 10/18 paperback format; Lamarche-Vadel's *Figurations, 1960–1973* appeared in the same series.[39] Seven artists (Arroyo, Cremonini, Télémaque,

84. Monory, *Dreamtiger* 5, 1972

Peter Klasen, Joël Kermarrec, Monory and Cueco) were treated by Gassiot-Talabot, Gaudibert, Lamarche-Vadel himself, Gilbert Lascault, the art historian Marc le Bot, Lyotard and Corinne Lyotard (she also retranslated the Communist manifesto in 1973) with Catherine Masson respectively. The genre of the *essai* was given a new agenda of serious and sustained writing on art. A few black and white photographs redeemed the unillustrated body of the text – including the most sexually explicit of all Monory's paintings, *Dreamtiger 5* (a woman, legs splayed apart, in a dreamscape of tigers and glaciers; pl. 84) and *Measure 12*, a scenario based on Monory's film *Brighton Belle*. Compared with the mounting challenges of conceptual and performance art, these artists enjoyed a status which if not *officiel*, 'official' in an art world sense, was already *consensuel*, relating to a consensus of taste.[40]

Lyotard titled his essay with a deliberate preciosity: 'Contribution of the paintings of Jacques Monory to the understanding of the libidinal political economy of capitalism in its relationship to the pictorial set-up and conversely'. It was dated December 1972.[41] A psychomachia, a struggle in the soul, it was tense with the very impossibility of the *transposition de l'art* (the transposing of painting to writing). Mutual recognition and seduction were played out in the spaces of rage, desire and fear: Lyotard the dandy and Monory the hysteric, writing and painting against the Prostitute, inscribed their own intellectual capital on her body.

The dilemma for Baudelaire's painter of modern life was the challenge of photography and reproduction ('Cézanne versus Niépce' is Lyotard's formulation). This challenge was reactivated as Monory's own sources in photographic contact sheets, separated chemical colours and slide-projected, virtual images were explored at the moment of the exhaustion of realism and his ironic 'toxifying' of the modernist tradition. Lyotard compares Manet's *Déjeuner sur l'herbe* with a work from Monory's 'Velvet Jungle' series, with its polluted undergrowth and women-victims, a comparison the contemporary artist continued to pursue through the 1970s and beyond.

While Baudelaire is pitted against Marx in Lyotard's text, another essentially *fin-de-siècle* figure must be added as a phantom presence: the exemplary dandy Marcel Duchamp, who confronted the great Prostitute, capital, with strategies of sterility and delay.[42] Duchamp's renunciation of painting added its own nuances to the melancholy of the Parisian intellectual and artist. Dandyism, as a posture to counter the excesses of the libidinal economy, was an expression not only of distance but also of impotence, at a moment when the loss of authenticity became a symptom of the loss of centre.

Monory's *Claude* (1972), in the version where her multiple photographed profiles are projected onto light-sensitised canvas, was his gift to Lyotard (pl. 87b). Based on Monory's own photograph of Claude Vaujanis (pl. 86), the dark woman approaches two other women, Micha Venaille and Marie-Hélène Règne, both of whom featured in Monory's Sapphic-erotic *photo-roman* of 1973, *Deux*.[43] An act takes place between these two women; it is more violent when Monory's own 'touch' is more involved, in the larger second version of *Claude* in oils. Within a libidinal economy, desire's primary

position in the circuit of transactions, is dependent, then, on the position of the Female.[44] An obsession for both Monory and Lyotard, the Female's function as symbol, as exchange, or as impossibility, prevails. In the 1970s, women remained a territory, a question, or a lack. Claude, Sabine or Adriana – whose smouldering face is surrounded by a tiger menagerie – have hallucinatory presences in Monory's painting. Lyotard's focus on the *dispositif* – the apparatus of projection and image-making – in his texts on Monory and the hyperrealists, itself acts as both screen and shield. The *dispositif* separates his intellectual field and the competitive scene of 'male writing' from female 'trouble' and writing (*écriture féminine*).[45] Compare the gridded perspective device through which Dürer peers at a woman's sex (pl. 85), an image

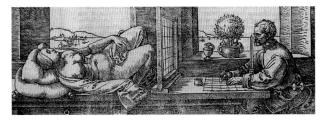

much reproduced at the time and a precursor of Duchamp's recently revealed *Etants Donnés*.[46] Female artists close to Narrative Figuration, such as Sabine Monirys, Monory's first wife and often his model, or Jacqueline Dauriac, another intimate associate, could elaborate. Radical personal dramas as well as the fictional and filmic generated Monory's emotional subjects and titles; while separation, 'the American experience', was not merely geographic but psychic and libidinal in his work.

85. Monory, *Photo of Claude*, 1972 86. Dürer, *Perspective Drawing of a Woman*, 1538

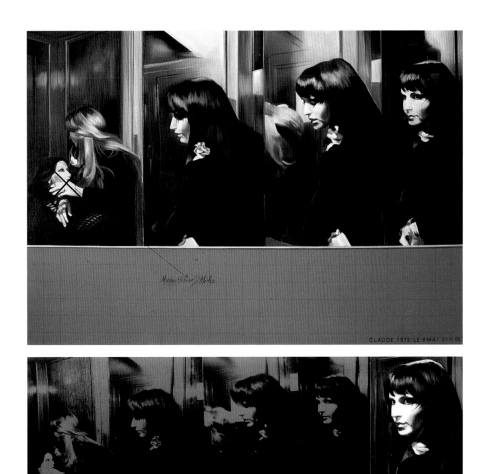

The *femme fatale*, the *femme-enfant,* the investigations of love, recall the debts of both Lyotard and Monory to Surrealism. Lyotard acknowledged Surrealism's pioneering work on psychoanalysis and the image, the linguistic experiments, Dadaist jokes, automatic writing, and the Surrealist leader André Breton's pronouncement, 'the eye exists in a savage state', all of which are encountered in *Discours, figure*.[47] Alain Jouffroy, writing on Monory's first exhibition in 1955, compared his 'strangely sumptuous' paintings with their crepuscular colours to forgotten memories of Max Ernst and de Chirico.[48] René Magritte, whose *Infinite Gratitude* Lyotard used as an example of Freudian dreamwork metamorphosing language, also comes to mind.[49]

87. a Monory, *Claude*, 1972
b. *Claude*, 1972

Magritte's rapport with the detective story established another link to Monory, with strange murders, abandoned crime scenes, a climate of fear and apprehension, pictorial framing as both a narrative device and a system of clues. In this first analysis Lyotard is at his sharpest on the paintings themselves, when he writes of space leaning to the left in Monory's 'Murder' series (in *Murder no. 10/2* of 1968, the killer exits as the viewer reads the crime across the canvas; pl. 89) and of the 'eroticisation of duration', the 'sensuality of the brushwork' and 'the metrical marks on canvas which add to the intensity of pleasure/death'.[50] Stanislas Rodanski, a writer who embraced the Surrealist heritage with a startling, contemporary twist, was rendered homage in Monory's first *livre-objet*. This gangster's briefcase pierced with bullet holes contained a map, a pistol, Monory's silkscreen prints and Rodanski's novel of 1975, *La Victoire à l'ombre des ailes* (victory under the shadow of wings, a post-atomic thriller set in Honolulu) as a blueprint for action.[51] The old Surrealist

fascination with crimes of passion and the *faits divers*, the daily horror stories of the newspaper, resurfaces in Monory's popular universe, already processed, as Lyotard wrote in 1981, for the 'cinema-goers, tele-audiences, all of average humanity who, in the morning metro, the station café, the Saturday cinema, in short whenever they are not working, look through illustrated magazines'.[52] The 'everyday', not as in Henri Lefebvre's Marxist material world but as an imaginary repertoire of clichés, is ironically snapped shut in this briefcase, where Duchamp's *Boîte en valise* meets James Bond.

Unlike many of his fellow artists, Monory was not a Communist, yet he was involved in Marxist debates around realism, later in the 1970s. His cool blue style, both poetic and laconic, addressed issues such as Maoism in the *Ho Chih Minh* paintings and Holocaust memory in the 'Caspar David Friedrich' series exhibited in Hamburg in 1977.[53] How could one paint landscapes and flowers after Auschwitz? asked Monory, who proceeded to paint the very subjects he deemed impossible – the poisoned landscapes and flowers of the 'Velvet Jungle' series – while simultaneously inverting Duchampian aesthetics via retinality and the sensual, paint surfaces that Duchamp most despised.

88. Monory, *EX*, 1968

As acts of assassination of realism, the School of Paris, colour, the subject and the author (Monory as artist, perpetrator and victim), his works were created in a climate of violence where assassination had an established discourse. Gaudibert's 1972 monograph study revealed that Monory's Argentinian father, a dedicated revolutionary, had fought in the International Brigades in the Spanish Civil War and that Monory witnessed traumatising violence on the streets of northern Paris and the Saint-Ouen suburbs as a child.[54] Moreover, when writing on Monory, Lyotard's allusions to Thomas de Quincey's essay 'On murder considered as one of the fine arts' had its own textual precedent: de Quincey's text had been key to Sartre's writing on Jean Genet in the 1950s.[55] De Quincey's 'On murder' both ratifies and shifts Lyotard's device of a textual palimpsest underlying his criticism; Sartre therefore joins Baudelaire (whose 'existential' biography Sartre had published in 1947) as another major figure with whom Lyotard was competing as a writer on art. Intertextual references, then, constituted a parallel universe of phantom presences to assassinate.

Of all the Narrative Figuration artists, Monory was the first to experience hyperrealism: he saw 'Twenty Two Realists' at the Whitney Museum of American Art on his first New York trip in 1970, before the seventh Biennale des Jeunes Peintures in 1971 and the Kassel Documenta in 1972.

It is the West Coast dimension of hyperrealism that informs both Monory's painting and his novel *Document bleu* (1970). His blue reflections of a violent America, bursting into the unbearable synthetic pinks and yellows of the 'Technicolor' series, were certainly the most significant response to the movement in France. In relation to Monory, Lyotard gives a lingering description of Malcolm Morley's *Race Track* of 1970 (pl. 90), a commentary on apartheid in South Africa, with its red criss-cross erasure and the mechanical, electric and photographic traces of its making which 'contaminate' artistic creativity. (Lyotard appreciated neither the pun of *Race Track*, nor the reference to Malcolm X, or the painstaking facture of the squared-up painting, which had not, as Lyotard presumed, involved slide projection.[56]) This displacement of the discussion – Morley as an alibi – preserves Monory's romanticism in Lyotard's passage on the 'nostalgia of expenditure'. America does not figure here (Lyotard had yet to make his first long visit) but it was explored by both writer and artist in their collaborative work, *Récits tremblants* (1977).

Trembling Narratives
America, 1970–1977

Both Lyotard and Monory experienced 'the dilemma of Americanisation' in post-war Paris, in film, fashion, music, fiction – and the whole problem of the French counterfeit, from gestural expressionism in painting to the fake 'American' novels of Boris Vian and his followers.[57] Yet Monory's first experience of America had been strangely displaced to war-shattered Germany. In the course of his military service, he was attached to the American army in Berlin. He encountered soldiers who were casual and relaxed, he saw doughnuts and heard jazz music in the Red Cross quarters while, outside, scavengers dotted a catastrophic landscapes of ruins. Monory's *American Way of Life* (1968), however, reverts to the myth: it shows a television screen dominated by the conjunction of opposing signs, a smiling woman and a pistol.[58] His superb diptych, *I lived another Life*, painted in 1969 before his first visit, presciently juxtaposes his small self-portrait as a cowboy, linked by plexiglass, and a huge separate canvas showing a sunburst behind clouds in an otherwise empty sky.

 Living in the United States at last provided for Lyotard and Monory the ultimate encounter with difference, generating desire and fear, exultation and profound disquiet. Their experiences epitomised the melancholic 'cool' of the cultural Cold War of the

1970s, a cool to be reflected in America itself after defeat and disillusion in Vietnam. 'Excessive', 'mad' but also more forthright, whether a question of violence, pleasure or money, such was Monory's verdict on America. Europe retrospectively seemed 'camouflaged'.[59] The cut with the past marked a moment of personal crisis for the artist; yet for any Frenchman bound intimately to the revolutionary metre and the Napoleonic code of law, all measure in this coast-to-coast continent seemed to have collapsed. Michel Butor's 1962 text 'L'Appel des Rocheuses' (call of the Rockies), analysed in Lyotard's *Discours, figure*, and Butor's epic poem *Mobile*, an 'Essay in Representing the United States' (also 1962), came to life (Butor had been a professor in New Mexico). *Mobile* used Mallarmé-like arrangements of collaged text to evoke an automobile driving from town to town through landscapes, deserts and time zones, punctuated with giant advertisements, place names and directions.[60] These were recognised as a reality, more than a decade later, by Lyotard: 'Not one State but States. Not one time but times: Atlantic Time, Central Time, Mountain Time, Pacific Time. Not one law but laws'.[61] Monory's *Death Valley no. 10, with Midnight Sun* (1975; pl. 91), the sun moving over the desert in hour-by-hour sections, conveys a sense of this vastness.

For Lyotard, the experience was fundamental in terms of his previously Paris-centred intellectual and political life. His novel of 1974, *Le Mur du Pacifique*, could not be more explicit: 'American presidents are emperors, Washington is Rome, the United States of America are Italy and Europe is their Greece… Visiting professors on campus are mere Greek tutors: liberated slaves, clients, *protégés* of Rome, sponsored with grants by "Amerikapital"'.[62] This narrative was written in the light of his experiences as Visiting Professor at the University of California, San Diego in 1972

91. Monory, *Death Valley no. 10, with Midnight Sun*, 1975

and 1973. It purports to be a manuscript found by chance in the university library. The library itself – labyrinthine, exhaustive, computerised, looking out not onto the city but the sweep of Californian nature and the ocean – offers a new paradigm of postmodern knowledge (like the libraries of Borgès and Sartre). Lyotard uses the detective story genre he admired in Monory's *Document bleu,* an erudite sub-plot and framing devices of

mysterious manuscripts and uncertain authorship. It is, nonetheless, a highly autobiographical text of *dépaysement*, decentering. Driving sequences pass from highways to deserts and ghost towns: 'Through these localisations, a dominable space is dominated like the body of an animal marked up for the butchers'.[63] Roles are delimited to those of pimp, girl and client, while Lyotard's

morbid fantasy extends to see prostitution spreading over the body of 'Kaiser Kapital AmeriKa'. His violent language (with its 'fascist' German Ks) complements the obsession with skin in *Économie libidinale.* He refers to Edward Kienholz's installation *Five Car Stud*, an exposé of Klu Klux Klan racism, shown at Documenta 5 in Kassel in 1972 (pl. 92).[64] His elided references to Nazis, Jews and anti-semitism in this West Coast context are as disturbing as Dürer's knight errant traversing Monory's *Death Valley no. 1* (see pl. 80). Again, Europe invades and haunts America; the Kassel Documenta is discussed in California. Germany's pain and the northern romantic tradition are stranded, uncannily, in the desert.

The unlikely conjunction of realism, hyperrealism and Marcel Duchamp, anticipated with the *Live and let die* 'assassination' painting of 1965, continued. Lyotard's Monory text was dated December 1972. In February and March 1973, two 'Réalismes' numbers of *Chroniques de l'art vivant* appeared. Jean Clair claimed the magazine was advanced in reporting hyperrealism – with Duchamp as its herald. His second article was illustrated with Duchamp's projection-based *Tu'm*, the barn door of *Etant Donné* and Duane Hansen's helmeted biker-sculpture, *The Rocker*.[65] Lyotard's 'Esquisse d'une économique de l'hyperréalisme' (sketch for an economy of hyperrealism), in the February issue, considered Monory's *Claudes* after Audrey Flack and Ralph Goings's *Airstream Caravan*. In both writers' cases the relationship to the pre- and post-photographic apparatus was at stake.

92. Kienholz, *Five Car Stud*, 1969-1972

With Warhol's desire to 'be a machine' as catalyst, Lyotard quoted Lacan on the hysteric. He concluded that the apparatus puts the painter into a hysterical posture: he wants the technology to be his dominating mistress (with her far superior grasp of perspective) and desires to dominate her. 'A worker who wants to be his machine through serving it, is the hysteric' and hyperrealism demonstrates the 'worker–slave' position in the production process, as opposed to the 'capitalist master'.[66]

Lyotard's subsequent engagement with Duchamp in America was marked by a series of lectures on the artist following the definitive Duchamp retrospective in 1973–4, held in Chicago, New York and Philadelphia.[67] Monory saw Lyotard more than once, visiting him in San Diego and attending his lectures in Milwaukee. He, too, created a homage to the American Duchamp with Butor. Another *Boîte-en-valise* was born, the collaborative, blue perspex-encased *U.S.A. 76 Bicentenary Kit* (pl. 93). Inside, accompanying Butor's poems, bicentenary ephemera, popcorn and a squashed Coca-Cola can, was Duchamp's *Wanted $2000 Reward* poster, a rectified ready-made, here stamped *Reproduction Interdite*.[68]

The 'trembling narratives' of *Récits tremblants*, another collaboration between Lyotard and Monory, through its very title introduced the private and the confessional as a counter-dimension to a public and Duchampian year: 1977 saw the publication of Lyotard's Milwaukee lectures as *Les Transformateurs Duchamp* and his contribution to

93. Monory, *U.S.A. 76 Bicentenary Kit*, 1976

the catalogue of the huge Duchamp retrospective which inaugurated the Centre Georges Pompidou in Paris.[69] 'Duchamp' as a posthumous critical construction continued to tease – and to analyse – his analysts; *Récits tremblants*, as a faltering narrative, dominated by the metaphor of the earthquake (a *tremblement de terre* in French), like a dream or a nightmare consciously invoked an absent psychoanalytic interpretation. 'We may say, and Freud himself says, that the unconscious uses all means, including the most crudely fashioned puns, to stage desire', Lyotard wrote elsewhere in 1977.[70] Once again, in *Récits tremblants*, Lyotard's writing was a fictional and autobiographical gloss on *Économie libidinale*, 'my wicked book', he called it, conceived, he said, at a 'seismic' moment of personal crisis.[71]

Monory's *Récits tremblants* photopieces were exhibited by Galerie de Larcos in Paris and published as illustrations to Lyotard's narrative. The cracks and fissures in Monory's paintings there found their objective correlative: the faultlines of earthquakes on the very body of the Californian landscape. Black and white photographs of these landscapes, sometimes from old magazines, were doubled with the same image in Monory blue, then fretted like a jigsaw and presented as images with pieces missing. These equate to the world of Lyotard's hero-narrator who drives through and beyond 'smog city' (*la nébuleuse*, evidently Los Angeles). Narrative scenes suddenly plunge, however, into close-up – into the skin, the nape of the neck, moments of cunnilingus. Erogenous zones and the geographic zones of America seem interchangeable: the High Desert, the Hidden Valley – axes of the landscape or the erotic body, North, South, East or West – the world is in cataclysm or orgasm. Stories shake as the earth moves. Lyotard again uses fiction, a university novel, held hostage to the overwhelming metaphor of Woman as the ultimate unknown country, skin as the ultimate film between internal and external geographies. While the metaphor is never perceived as banal, his female characters remain subordinate to the grand design, his own 'seismic' writing. Moreover, the passionate descriptions again become part of an exchange with *his* artist.

Finally, the narrator reaches a great astronomical observatory. The sublime itself is now measured and transposed with a precision that turns the miracle of light years into an ironic algebra. Incandescent packets of cloud, arranged seemingly by chance, move spontaneously and unpredictably in their own space-time continuums; star rays hit film: they are emanations from celestial bodies that moved light years ago from their positions. Such is the disorder which eclipses our micro-histories, our everyday narratives. This was surely the experience which anticipated Monory's new series of paintings,

'Skies, Nebulae and Galaxies'. As Monory moved towards starlight (for example, the planet Venus sequence in his detective novel *Diamondback*, 1979), so Lyotard moved from dandyism and an American Duchampianism towards the technological and electronic infinitudes of *The Postmodern Condition* and a new aesthetic of the sublime.

The Aesthetic of the Sublime, 1981

Monory's 'Skies, Nebulae and Galaxies' (pl. 94), exhibited at Galerie Maeght in March 1981, were accompanied by a lavish number of *Derrière le miroir*, including Lyotard's text, 'Les Confins d'un dandyisme' ('The Confines of Dandyism'). His participation in this series situates their collaboration within a lineage dating back to 1947. Lyotard followed Foucault and Derrida in the series; but writers and art critics such Eugène Ionesco, Alain Robbe-Grillet and Marcelin Pleynet were also involved, newer voices

94. Monory, *Sky 2*, 1976

replacing the 1940s–60s generation. Just as the painter Rebeyrolle was passed from Sartre to Foucault, Monory was prefaced first by Gilbert Lascault (the 'Opéras Glacés' series in 1976), then Alain Jouffroy wrote on the *Technicolor* works in 1978; Lyotard was thus a latecomer in 1981. The fascination of these collaborations glamourised their promotional value; their range certainly ratifies Lyotard's conception of *l'écriture mâle* (the sculptor Germaine Richier is the only exception to more than three decades of yokings of male brush and pen).[72]

> Lyotard, then, in *Derrière le miroir*, playing freely with the large-format images, states:
>
> > Monory is a spontaneous philosopher. His work is a question, and this question is a commonplace: what is the meaning of life?… The glacier, mountains, nebulae, rising sun, sea, radio telescopes are still treated as in the manner of illustrations, but of what sentence? Is something about to die that is still here, posing in return the question of the meaning of what is alive? Or is it that, with all already dead, meaning is now beyond question?

Going beyond dandyism to its frontiers, he claims 'this complex figure… is an identikit portrait [*portrait-robot*] of postmodernity'. Abruptly, he reverts to desire: 'the flesh of women, cats, children, deserts, murders', to love that is impossible under the reign of technology, impossible for 'astral flesh'. Adorno, Lyotard says, noted that the discourse of the sublime would soon sound hollow. One recognises from *Récits tremblants* the proposition that human star-gazing has now been replaced by analysable computer data, 'the "double" of the visible and invisible sky.'[73] Lyotard notes Monory's inscriptions on some of the canvases, in particular the names of the Nobel Prize-winning Chinese physicists Tsung Dao Lee and Chen Ning Yang, who demonstrated the coiled and twisted nature of space (a perfect metaphysical justification of Lyotard's Moebius strip metaphor in *Économie libidinale*). 'Our lives pass under the reign of desire [*desiderium*] to regret for the stars [*regret des sidera*]'. From inscribing desire on the body, desire is inscribed on the sky in Monory's *Skies no. 39*: 5766 of the most visible stars, a computer–generated astral map, was projected then painted by hand. Monory wrote on the canvas: 'I had hoped for ecstasy – all I received was a supplement of detachment'.[74]

'Les Confins d'un dandyisme' for *Derrière le miroir* was subsumed into the longer text 'L'Esthétique sublime du tueur à gages' ('Sublime Aesthetic of the Contract Killer') completed in December 1981, where the hyperbolic description of a world of ice, night and dying suns functions as a metaphor for the end of our era. 'Dandyism is

a setting sun', Baudelaire had said; the modern age, like Rome or Christendom, is confronting its dissolution. Baudelaire made a conjunction between women's eyes and the empty eyes of the stars; for Lyotard, stars replace Monory's bullet holes, raising his masculine world of the *Kriminalroman* towards the metaphysical. The skies are those of the furthest reaches of dandyism, where the dead star, interiorised, sadistically devours the hero from within; in Freudian terms, melancholy is the work of mourning left incomplete. The text is by no means an encomium: Lyotard is ambiguous, cruel even, to Monory, when he discusses painting as an anachronism, the tasteless realism of the apathetic masses, the painter who has turned his back on artistic and metaphysical research. Yet Lyotard's elaborate attentions to the artist, constantly self-reflexive, prove the strange clairvoyance of Monory's mirror-images. Lyotard is pushed to speak of *l'après-dandyisme*, a prelude to the post-sublime synthesis of the infinite with the finite, where modernism, postmodernism, whole constellations of meanings, affinities, images transmitted, reproduced and altered across terrestrial time become mere figures of experimentation.

Lyotard and Monory on Film

Stars lie on the floor of the studio, fragments of Monory's major mural commission for Saint-Étienne de Rouvray, a painting of constellations over hardboard and mirror (1982; pl. 96).[75] Lyotard, with blue socks and cravat, paces to and fro. Ida the dog, Monory's constant companion, is bewildered. When asked by Lyotard why he wants to make a film, Monory replies disingenuously: 'I prefer painting to everything'. While painting cannot capture the moment, as film does, it can nonetheless travel through imaginary realms, make imaginary collisions, montages. Lyotard draws out the analogy between oil on canvas and the image on the passing film frames. How could film compare with the hours of work inscribed on the face of a Holbein portrait, which renders it a network of contradictions, subject to the scrutiny and interpretations of the spectator? Lyotard invokes the painter's noble aspirations only to be undermined instantly by Monory, who speaks of the infantile, derisory pleasure of the child who paints and daubs: 'The derision comes from the paint itself as a material.' It is derisory – dandyish, of course – to paint the constellations. The conversation turns to God. Death, Monory replies to Lyotard, 'is what gets at me the most... Why did they invent God and all those tall stories?'[76]

Much of the problem of Monory's relationship to painting (and to narrative) involved the exhaustion of the discipline as it encountered film, at a particularly rich moment in French cinema. In addition to the innovative New Wave and rediscoveries of Soviet avant-garde film, this included the popular genre of the crime thriller, a reworking of the Hollywood *film noir. Citizen Kane, Scarface,* the cliché as image and as literally the click of a montage moment or subliminal memory within the image, are reprocessed in Monory's art. Memory itself and Freudian dreamwork operate in a series of flashes, camera stills, fragments. Lyotard himself saw 'Hollywood productions of the thirties' as the exemplary site of 'a kind of somatography', the 'transcribing on and for bodies', extending an analogy from the *mise-en-scène* to the unconscious.[77] Monory's blue evokes the filmic device of the *nuit américaine* night by day – but also the *image fixe*, the sudden device of stopping the film, an abrupt halt of both camera movement and a fictional narrative.[78]

Chris Marker's classic film *La Jetée* (1962) was a crucial influence (pl. 95). It uses a succession of *images fixes*, staccato moments suspended in time to depict a central survivor figure, haunted by images of a woman, a former life, while the present is paused on the very brink of catastrophe.[79] Monory constantly took photographs of the television or cinema screen or made stills from his own films, such as *Ex.* His paintings freeze cinematic moments whose forgotten familiarity is overwhelmed with a sense of the uncanny. Nostalgia plays with a disruptive – or nauseating – kitsch.[80] Monory's

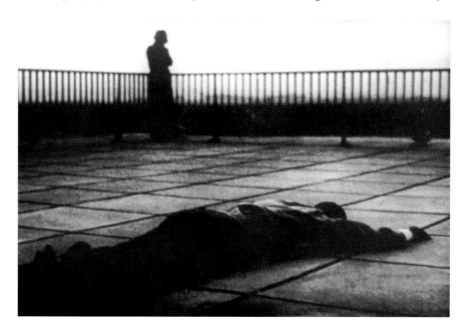

95. Marker, *La Jetée*, 1962

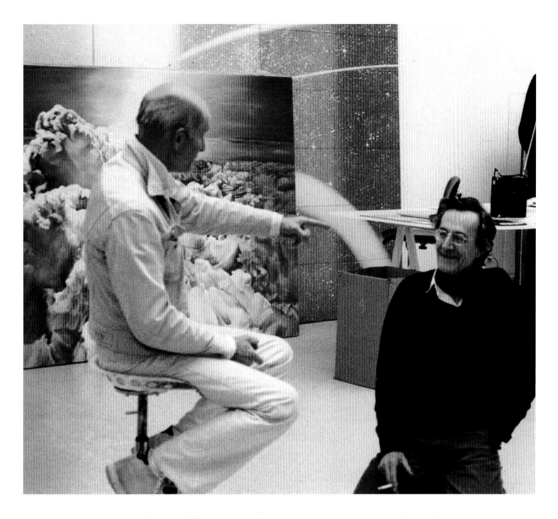

fictional *Document bleu* itself begins with a shooting script; the blue photo-novel *Deux*, shot laboriously in Brighton, London and Ostend in 1972, preceded by a year its remake as the film *Brighton Belle*.[81] In this erotic, lesbian narrative, the influence of Marker is apparent not only in the motif of the natural history museum but in the 'post-catastrophic' sense of movement and life seen through a colour filter, amplified in Monory's film by the screaming crescendo from Richard Strauss's opera *Electra*.

About forty films have been made involving Monory or his work from 1965 onwards. His collaboration with Lyotard came at mid-point, at the moment of an international focus on Lyotard's engagement with cinema.[82] A preliminary experimental session was later followed by *Instantanés et cinéma*, 1982, directed by the Englishman David Carr Brown, with Lyotard as the interviewer in Monory's studio. These precious testimonies to their friendship and frank exchanges were commemorated with a published dialogue:

96. Annick Demeule, Monory and Lyotard, Cachan, 1982

Me: 'In his painting he pays his debt to cinema... the blue filter put over the projector for scenes of love or great anguish: *Phantom of the Louvre*, Annabella running under machine-gun fire at Canton central station. A formless nostalgia emanates from these images.... The painted images come from these glacial burns... I prefer his paintings to his films.'

Him: 'In my films I escape death. In painting you capture, you fix, inscribe, you are alone in the atelier, you bathe in memory... While you are filming you are a dancer, a Japanese calligrapher, you make gestures without memory, you meet images... The sole problem of art, perhaps, is the dance. I escape nostalgia when making a film, even if the film is nostalgic'.[83]

Les Immatériaux: Survivors

Lyotard chose Monory's four-part *Explosion* (1973; pl. 97), which used light-sensitised canvas, as one of the few paintings in the exhibition 'Les Immatériaux', held at the Pompidou Centre in 1985. The huge aircrash and its disappearance, progressing through four canvases represented the ultimate vanishing of events; the greatest of catastrophes, memory-traces, anticipated catastrophes to come (the Centre Pompidou's periodical *Traverses* of November 1977 was devoted to the 'Ville Panique' (Panic-City) and included Michel de Certeau's memorable piece on New York's World Trade Center).[84] Monory's plane as representation dissolves into its virtual image, then blankness.

As a tangible representation of the intangible, a visible trace of the invisible, 'Les Immatériaux', Lyotard's labyrinthine experiment, was, one could argue, an act of hubris – the ultimate *vanitas*. It continues to generate intellectual interest as a postmodern 'container' and catalyst and more than twenty years later has become an object of scholarly investigation.[85] Lyotard was not, perhaps, modernity's Galileo; his *The Postmodern Condition* has become absorbed as a mainstream text of recent history.[86] His philosophical investigations into Kant's sublime were not published until 1991. He continued for the rest of his life to write about art, moving towards Buren's performances and installations, 'a world without painting', subsequently transposing his thoughts on the sublime to Barnett Newman in the mid-1980s; writing on Karel Appel in 1992 and Pierre Skira's pastels as late as 1997.[87] Lyotard's conjugations of Monory and the sublime in 1981 were ambivalent as to the wager they set up together between modern life and its painters: 'the brush paints a world without painting where there will no longer

be a need for testimony.'[88] For the sense of an ending, it is rather to St Augustine that one should turn, whose *Confessions* Lyotard invoked to introduce Monory in his 1981 preface 'Expertise'. Augustine and the mode of the confession, 'the need for testimony', preoccupied Lyotard in his last months.[89] Like Augustine, Lyotard was a libertine, aware of the perils of sentiment. In 1971, Monory had titled a canvas *Illusion is the sentimental form of theory*. The meeting of the artist with the philosopher was a testing of illusion, a testing of theory, a testing of the boundaries of success and failure, separation and recognition. Lyotard concludes: 'In looking at Monory's paintings, we recognise ourselves, we are, or we become, these survivors.[90]

In 2007, Monory joined forces with his friend Fury – an underground 'American-Parisian', the muse of the Bazooka group in the 1970s and a friend of Gilles Deleuze. Based on her photographs of Dubai, he created a four-metre panoramic painting: 'We are in a truck in Dubai; and the wing mirror reflects Fury's image, her face that is never seen in her video paintings.'[91] Another desert, another beautiful woman, blue skies, a horizon and a skull. The obsessive themes of the *roman-photo* – the violence, the women, the blues, the night-time décors of assassination and the assassination of painting – continue. In 2009, new tigers roared.[92]

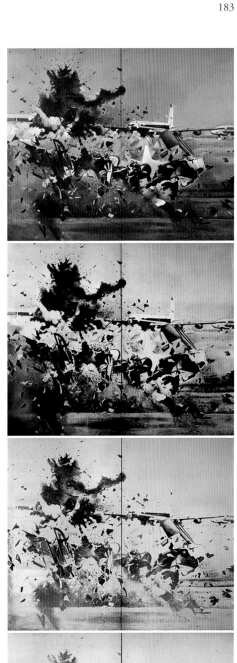

97. Jacques Monory, *Explosion*, 1973

Chapter 6

Derrida, Adami
The Truth in Painting

> Not to pose as a philosopher in front of a painter is to be grateful for the way his work deranges the philosophical instance and the authority the philosopher has always granted himself in his utterances on painting. We must, and I am thinking of Hegel, I am thinking of Heidegger, give a place to painting.
>
> Jacques Derrida with Valerio Adami, 1991[1]

Jacques Derrida was passionately interested in truth, in language and in drawing. *La Vérité en peinture*, a collection of his essays comprising 'Parergon', his celebrated mediation on the frame, '+R' on Adami, 'Cartouches' on Gérard Titus-Carmel and 'Restitutions' on van Gogh (after Heidegger) appeared in 1978.[2] As *The Truth in Painting* (1987), it is well known in the English-speaking world; yet it is impossible to understand without a knowledge of the genesis of the individual texts. The form and format in which these were first published are completely invisible in the 1978 anthology and its translation. These are ruins, mere *aides-mémoire* of the originals. Derrida's entry into the 'scene of writing' and the arena of the public intellectual in Paris can be dated to 1967, the year of the Argenteuil congress and the conflicts around the fine arts encountered by Louis Althusser. In contrast with his fellow *normalien*, Derrida was affiliated with the review *Tel Quel* and its intellectuals Philippe Sollers, Julia Kristeva and Marcelin Pleynet; it was there that he engaged with the works of Antonin Artaud (his writings rather than his drawings) and with Jean Genet, who haunts the text on Adami.

It was not only because of 'elective affinities' but also for strategic reasons, surely, that – like Sartre and Foucault – Derrida wrote a substantial text for *Derrière le miroir* in 1975, participating in the art world centred on Galerie Maeght, and that he was subsequently involved with the new Musée national d'art moderne in the Pompidou Centre, following Lyotard's role in the opening Duchamp show. Derrida worked intensely in collaboration with Titus-Carmel for 'The Pocket-Size Tlingit Coffin' early in 1978,

a major Pompidou exhibition culminating in
a large museum purchase; in the catalogue
his writing is conceived as 'illustration'
and depends for its decorum and length
entirely on the conception and design of that
catalogue.[3] In the same year, the extended
'Restitutions' piece on van Gogh saw Derrida
engaging with the new review *Macula*,
founded in 1976, where a generation of art
historians such as Yve-Alain Bois, exasperated
by France's lack of empiricism and its delay
as regards serious art writing, attempted to
introduce classic art-historical figures and
contemporary voices from America to its
pages: for example, Clement Greenberg on

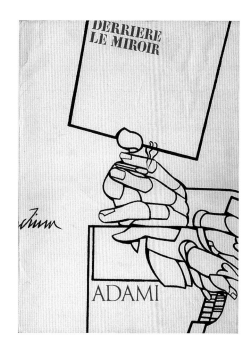

Pollock and, in the case of 'Restitutions', Meyer Shapiro meditating on Heidegger.[4]
Derrida responded to the curators at the Pompidou Centre again in 1979, when he
published a text for the young artist François Loubrieu, who was shown in the 'Ateliers
d'Aujourd'hui' exhibition series. Loubrieu's pen and ink drawings were made to illustrate
Derrida's *Eperons* (spurs). Loubrieu insisted on his mission to illustrate; 'Illustrate, he
says' was the title of Derrida's text, a text finally centred on woman, the problem at the
heart of Nietzsche's writing, and the notion of traces (*Spuren* in German).[5]

Derrida continued to write about art, notably in the context of his major
exhibition of 1990, 'Mémoires d'Aveugle' at the Louvre; it is surprising to discover
his collaboration wth the feminist artist Michèle Katz (2000) and his rich text on the
Algerian philosopher-painter Jean-Michel Atlan, published in 2001.[6] Nevertheless, his
relationship with Valerio Adami is unique. While the conjunctions between philosophers
and artists involved in Narrative Figuration – Bourdieu and Rancillac, Althusser and
Fanti, Foucault, Deleuze and Fromanger, Lyotard and Monory – involved encounters
and friendships that were intense only for certain periods, the friendship between
Derrida and Adami continued up to Derrida's death in October 2004 and continues
to be commemorated posthumously. Derrida's last texts on drawing, published for
Adami's review *Annali* in 2005 and 2006, are barely known; they have escaped the
'Late Derrida' corpus and homages produced in the English-speaking world.

98. Adami, *Derrière le Miroir*, 1975

While Adami's art, as he himself emphasises, is not conventionally 'narrative', one of his first appearances was in the group show 'Un nuovo racconto' at the Studio Scacchi Gracco in Milan (1962); he showed in Paris in 'La Figuration narrative' (1965) and 'Bande dessinée et figuration narrative' (1967). His major retrospective at Gaudibert's ARC in the Musée d'art moderne de la Ville de Paris in 1970 was the catalyst for his relationship with Galerie Maeght which began that year. Experiences in London and New York were crucial for the flavour of his early work, though he maintained strong associations with Italy. The collaboration with Derrida is unusual in that it relates primarily to Adami's graphic work, not painting; a luxury review becomes a veritable site of collision between the orbits of word and image.

Derrida's writing here for Adami, '+R (par-dessus le marché)', or '+R (into the bargain)', was created for a major exhibition of Adami's drawings and watercolours, 'Le Voyage du dessin' at Galerie Maeght that November.[7] It invokes from the start an interrogation of the role of *préfacier* itself: Derrida prefaces while repudiating the preface, thrusting the looking-glass trope *derrière le miroir* – into an abyss of reflections (pl. 98). '+R' reveals Derrida at his most Mallarméan. It was only within the parameters of the *beau livre* that Derrida could fully practise a Mallarméan 'spacing of writing', an *espacement de la littérature*. This principle, at the heart of Mallarmé's revolution in poetics, had provided the epigraph for Derrida's *L'Écriture et la différence* of 1967 (*Writing and Difference*, 1978). Multiple possibilities were offered by the whiteness of the pages in the large *Derrière le miroir* format: games with blank spaces (*blancs*), contrasts between Derrida's handwriting ('reproduced' to his astonishment by the artist) and Adami's characteristic spiky italics, and the drawings the two men created together expressly for this collaboration.

The text of '+R' is an extended exercise, designed with the turning of the pages of the review in mind. Glancing at Derrida's musical references, one recalls (as Derrida must have done) Matisse's reference to writing as a *fond sonore* in *Jazz* (1947), the monumental artist's book of the mid-century. Matisse's handwriting functioned, the artist says in his calligraphed text, as a vibrating sonorous background, a contrapuntal creation whose meaning was supplementary to the impact of his piercingly sharp, coloured cut-outs.[8] (Only a reading of Derrida's text as reproduced in the small-format *La Vérité en peinture* could posit the opposite: 'Derrida's refutation of the idea of illustration seems crucial, all the more so because the drawings function in his text as just another accompaniment'.[9])

Verbally, Derrida married Mallarméan poetics with the etymological pleasures and procedures of Mallarmé's *Les Mots anglais*.[10] To these he added the post-psychoanalytical investigations of an 'antisemantics'.[11] As always, there was also a delirious, wilfully aural turn, inspired by the etymological dictionary *Littré*, proceeding via processes of triangulation, and punning as a psychoanalytic knot.[12] Mallarmé was not the only origin for Derrida's 'spacing of writing'. In 1967, two years before his Mallarméan text 'La Dissemination' appeared in *Critique*, Derrida had been capitvated by the publication in *Tel Quel* of Genet's two (remaining) texts on Rembrandt: *Ce qui est resté d'un Rembrandt déchiré en petits carrés bien reguliers et foutu aux chiottes* (what remains of a Rembrandt torn into small, regular squares and flushed down the pan). These appeared not merely as text and subsidiary text (the classic device of marginalia) but specifically printed side by side as two 'phallic' columns: they mutually complemented/deconstructed each other in their differences.[13] In 1970, Derrida produced 'La Double séance', in which a block of text, Mallarmé's 'Mimique', effectively 'deconstructs' Plato's *Philebus*, on Socrates's reflections on mimesis, truth and representation.[14] This reappeared in *Dissemination* in 1972 while, in the same year, the glorious cut-up text 'Tympan' fronted the cathedral-construction of *Marges de la philosophie*, with its rubric to 'tympanise' the discipline (here Michel Leiris's *Biffures* acts as a poetic/deconstructive margin-column).[15] The beat of the drum – the *tympan* – introduces the phantom sound that reappeared in the Derrida/Adami 'concerto for four hands' in '+R'. A cut-up collage process of composition – a material practice – precedes the vibrating deconstructions of meaning (between columns). *Glas* (a tolling bell, death knell), Derrida's literary masterpiece of 1974, again used this procedure: the 'Hegel' column of text is challenged and decontructed by the 'Genet' column. (Hegel's thought, structured by Family, Trinity, the Judaeo-Christian tradition and the aspiration towards Spirit, is 'undone' by Genet, the orphan, homosexual and criminal, for whom writing was a mortal and erotic 'funeral rite'). Derrida's virtuoso essay on Mallarmé of 1974 stands in between the preliminary version of *Glas* (1973) and the textual architectures of his final text.[16] All had an impact on '+R' and the word-play with Adami. Derrida made no bones about the enrichment, the necessity even, of understanding his cumulative writing practices through a process of cumulative reading.[17]

99. Henri Martin, *Concerto per un quadro di Adami*

The illustrated first version of *Glas*, published in the Derrida special issue of *L'Arc*, first posited a relationship between Genet and Hegel. Here Derrida repeated the twin-column procedures of Genet's 'Rembrandt'. Hegel (Genet's major adversary in the later version of *Glas*) is first introduced, via 'gl':

gl reste gl

tombe comme il faut le caillou dans l'eau – à ne pas prendre encore pour une archiglose (gl rests gl / falls [*tombe*] as should the pebble into the water – not to take yet as an archigloss), where the variants of 'gl' invoking sobs, baby gurgles and an eagle progress to *le nom gluant, glacé, pissant froid d'un impassible teuton, au begaiement notoire* (the gluey, frozen, cold-pissing name of the impassive Teuton [Hegel], notorious for stuttering).[18] In the text on Adami, Derrida pursues the investigation of the 'phonic trait', like 'gl', which precedes the phoneme or word itself, with a focus on 'tr' as in *trait* and the conceit '+R'. The relationship embraces the letter, the proper name, and political narration in painting, he says in the preface to *La Vérité en peinture*.[19]

For *Glas*, published as a book in 1974, Derrida created a verbal pandemonium of styles which competes with James Joyce's *Finnegan's Wake* as much as with Hegel's *Aesthetics*. Unillustrated, this *Glas* respected the decorum of the page, despite columns of text, insertions and changes in font.[20] A gesture towards Mallarmé's conceptual project *Le Livre*, *Glas*'s gigantism must provoke some irony, inasmuch as Mallarmé was the poet of the minimal (his *Igitur* was important for Genet's own, confessional *Fragments*).[21] Yet, as I have argued elsewhere, Derrida tyrannises Genet in *Glas*, suppressing the visuality of Genet's encounter with Rembrandt, his pursuit of the artist across centuries and countries and above all the writer's response to painting, which coincided with his sittings (*séances de pose*) for portraits by Alberto Giacometti.[22]

It was through reading – discovering – *Glas*, that Valerio Adami proposed a collaboration with Derrida to Jacques Dupin, the producer of *Derrière le miroir*. Galerie Maeght's 'Collection Placards' poster series was based on the concept of a 'double signature' by artist and writer. The philosopher and the artist met by chance the day before their official appointment. Their lithographed, double-signed poster which Derrida baptised *Ich* – in an edition of 500 – preceded their collaboration for the number of *Derrière le miroir* which accompanied the exhibition 'Valerio Adami, le voyage du dessin' (see pl. 107). The filiation between *Glas* and Derrida's preface '+R' is clearly stated on the first page: one is in 'the here and now but always drawn into *Glas* by an incredible scene of seduction between Rembrandt and Genet.

With a passage to the act, of course, as one understands seduction in psychoanalysis.'[23] Derrida immediately sexualises his text on Adami: erect columns of text are replaced by Adami's *Study for a Drawing after Glas* (pl. 100), the image of the erect, hooked fish out of water, a 'Christic phallus' according to Derrida, whose play with *Ich* evokes the Greek fish sign *ichthus* for the early Christian church but also the *Ich* ('I' in German or the Hebrew 'Isch') shared, authorially speaking, between the two men – the *chi*-mera of their doubled phantom presences in the work, the constant angling for complements.[24]

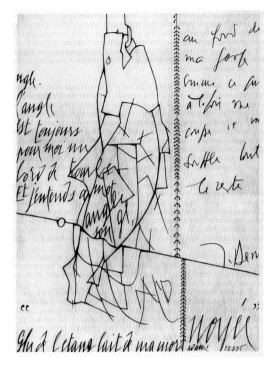

('Kiss me stupid' was inscribed on the Galerie Maeght advertising poster for the 'Voyage du dessin' exhibition). Derrida produces a magnificent piece of fishing writing, with constant *renvois* from references to the enigmatic fish-hooks or fishing flies in Adami's portraits of Sigmund Freud to wider games with the 'net' of language.

Whereas *Glas*, then, had Rembrandt/Genet/Derrida as a major triangulation fighting with Hegel, the Adami text '+R', despite starting with (Genet's) notion of betrayal (*pour trahir Adami*), proposes another: Mallarmé/Benjamin/Derrida. Walter Benjamin and a reference to his essay 'The Author as Producer' (1931) precede the alternative 'incredible scene of seduction' on '+R''s first page of writing. Derrida's refusal of a margin round his text or any pagination, so that the writing overflows pages with no beginning or end (no margins for these margins of philosophy), has a political implication. The sub-title *par-dessus le marché* (into the bargain) means literally 'above the market'. Derrida attempts, textually at least, to position the collaboration between artist and philosopher beyond the frames of gallery, market, critic and, indeed, the prefacer's task. He wants to 'trap' the *travail du préfacier*, which had never been questioned by other collaborators in the *Derrière le miroir* series. Adami's portrait of Walter Benjamin (pl. 101), based on Gisèle Freund's pensive photograph, evokes for Derrida 'The Author as Producer'. As he explains, following Benjamin, subject matter

100. Adami, *Ich*, 1975

alone cannot be revolutionary unless the very apparatus of production itself is seized and shaken, betrayed, drawn out of its element, trapped (like a fish with its bait).[25]

Moreover, the review itself as an object – with Benjamin's name inscribed and depicted in its pages – exemplifies the very principles of mechanical reproduction, of the reproduction of handwriting, printed text, drawing, watercolours, lithographs implying the mirror reversals of images, photographs implying a negative, works reproduced in colour or reduced to monochrome, the maintaining and changing of scale, that is, all the operations which undermine the notion of 'truth to the orginal' as manifested in both the ordinary and the signed, *de luxe* editions of *Derrière le miroir*. Here the analysis of the work of art in the age of mechanical reproduction is put into action; the relationship with Benjamin's invisible texts is also a *mise en abîme*.[26] The centrality of Benjamin as a figure for Adami cemented the affinity between the two men.

Adami + Derrida
The Voyage of Drawing

International success followed Adami's trips, beginning in 1959, to London, where he met Francis Bacon, R. B. Kitaj and Patrick Caulfield, showed at the Institute of Contemporary Arts in 1962 thanks to Roland Penrose and was introduced to Werner Haftmann, who included a painting in 'Aspeckte 1964' at the third Kassel Documenta.

101. Adami, *Walter Benjamin*, 1973

However, it was Adami's work shown after the crucial Paris Salon de la Jeune Peinture of January 1965 in Arturo Schwarz's Milan gallery (in October) that demonstrated his sharp new style. Here, the satire of Enrico Baj met the Pop flatness and black contours of Caulfield (one might also cite analogies with early work by Alberto Magnelli). While the 'everyday' had variously entered the 'Mythologies Quotidiennes' show in Paris in 1964, Adami's 'everyday' had an acerbic, politicised and literary twist. His exhibition title for Schwarz, 'I Massacri Privati' came from W. H. Auden's *In Time of War*: 'Behind each sociable home-loving eye / the private massacres are taking place.' This was quoted in the catalogue along with T. S. Eliot's assertion that disparate experiences, such as falling in love, reading Spinoza, the noise of the typewriter, the smell of cooking, form 'new wholes' in the mind of the poet.[27] For the second show with Schwarz, 'Pictures with Connexions' in 1966, Adami reproduced his photographic sources; for example, he claimed that 'Hodaway's dining set' (from *Time* magazine, 1 April 1966) and the simultaneous reading of Marshall McLuhan's *Understanding Media* are the keys to his painting of an empty dining-room with a four-leafed clover table.[28] In 1968, Adami's sensational series of large-scale works mostly based on his own photographs – *Latrines in Times Square, Chelsea Hotel, Bathroom, The Homosexuals* – were exhibited at the Venice Biennale and afterwards by Alan Solomon at the Institute of Contemporary Art in Boston and the Jewish Museum in New York. (The photographs were presented again in video format at the Grand Palais retrospective of 2008 in Paris, see pl.102).

Adami's black contours were traced from photographs projected by an epidiascope.[29] Comparison with his photographic sources demonstrates not just the techniques of simplification at stake but processes of ellipsis and condensation as understood in psychoanalysis – for Adami's games with metonymy were linked to a powerful eroticism. In the large-format *Chroniques de l'art vivant* of November 1970, Jean Clair suggested a relationship to the Freudian 'primal scene', with Adami's flashbacks recalling

102. Adami, *Urinals, Victoria Station, London*, c.1963

Giacomo Balla-like disjunctions of memory. Atmospheric studio shots increased the sense of tension.[30]

Following the Rebeyrolle number of *Derrière le miroir* with Sartre's preface, Adami's own début in the series contained a text by its *eminence grise*, Jacques Dupin himself. The claustrophobic ambience of paintings such as *The Suicide Game* (1970; pl. 103) were illuminated by Adami's prose poem 'Perfusion' (written in Paris in May 1966), the Prufrock-like fantasies of a technocrat with sexual aberrations playing suicidal games in a shabby hotel-room.[31]

For Adami's show with Maeght in 1973, 'Dimonstrationi', Pierre Gaudibert wrote a preface for the accompanying issue of *Derrière le miroir*, focusing on the political content of the artist's work.[32] Adami's phrase *le voyage du dessin*, the 'journey of drawing,' corresponds, Gaudibert argued, with the political subject matter of people in transit, crossing horizon lines, national boundaries; there is a consonance between the notion of line itself and European history of the nineteenth and twentieth centuries (Derrida amplified this and other ideas in his own text). Gaudibert emphasised Adami's use of montage and his debt to the political films of the Yugoslavian Miklos Jancso: 'Every new horizon explored, which bears his autobiographical obsessions old and new, is a transversal voyage through the cultural and political strata that still determine our present. It is possible to mark out a constellation of the places, people and historic moments, to trace a rudimentary map of the cultural and historical universe inscribed in Adami's works since 1971.'[33] He noted a predominance of the Nazi–Communist axis and the increasing presence of the United States. 'The people, intellectuals or politicians, policemen and clandestines, move over the imaginary map according to the flux and reflux of conflicts, the axes of

103. Adami, *The Suicide Game*, 1970

the routes of exile.'[34] Then he focused on 'the final central figure – the revolutionary intellectual Jew in Central Europe of the 1920s and 1930s, incarnated by Benjamin – a particular but equally tragic destiny.'[35] Here Gaudibert was anticipating Derrida's more refracted writing on Benjamin and frontiers in 1974–5; finally, he referred to Adami's alternative collaboration with a writer, a work on the Third Reich.

In a dialectical debate with the Mallarméan lightness and whiteness of the collaboration between Adami and Derrida one may place the large luxury album *Das Reich/Gelegenheitsgedicht Nr 27, 1877–1945* (The Reich, an Occasional Poem), produced by Maeght in Munich in late 1974 (pl. 104). Here, Adami traced the gold contours of Kaiser Wilhelm's helmet over a dark red cover; gold endpapers embraced a violent, unpunctuated 'masculine' writing by the prominent German poet, Helmut Heissenbüttel: 'Once the ground moved beneath the feet of those walking once there was an air of freedom and the feeling of what nation might mean drowned in blood betrayed and cudgelled down and driven back'.[36] Heissenbüttel's ten lessons on the Reich move from 1890 to 1943, each passage powerfully illustrated by Adami, from Bismark and Wilhelm II to the Spartacist uprising, the Rapallo conference, Hindenberg and the Gestapo's assassination of the anti-Nazi White Rose group. Heissenbüttel concludes: 'for they know very well what they do all over the Reich however the members of the nation still assume that nothing decisive is going to happen at the moment but that overnight for they know very well what they do' – a message for the readers of his time.[37]

Adami has emphasised his philosophical and political affinities with German rather than French culture. The pencil studies for *Das Reich* haunt the other works shown in Adami's 1975 Paris exhibition. For Derrida, too, Benjamin as a figure was paramount. He represented not merely questions of authorship and reproduction but the collision of the German philosophical tradition with the rise of Fascism, the toils of Marxism – which Benjamin encountered through both German and Soviet political models – forced exile and the refracting dimensions of his Jewish messianism. Derrida's perception of the cuts and jumps through time in Adami's drawing technique, occasioned by

104. Adami-Heissenbüttel, *Das Reich*, 1974

these Benjaminian complexities, is remarkably summarised: 'Once again this is the active interpretation of x-rayed fragments, the epic stenography of a European unconscious, the monumental telescoping of an enormous sequence.'[38]

One could argue that Derrida's focus on Benjamin complements the focus by Hubert Damisch within Adami's work on Sigmund Freud (two Freud drawings were shown in the 1975 exhibition).[39] For Derrida's 'exercise in writing' was also defined against his contemporaries' interpretations, against the pieces in Galerie Maeght's 1974 monograph in particular. Damisch's *essai* based on Adami's *S. Freud travelling to London* (1973; pl. 105) opened the book: it was a discursive piece of writing inspired by Freud himself (with Morelli), an art historical debate between line and colour (whence Derrida surely quarried his later notion of the *subjectile*).[40] Derrida's references in his Adami text to a 'concerto for four hands' played by artist and writer – a *concerto a quadri mani* – throws one back again to the 1974 monograph. There Henry Martin described the creation of the recording *Concerto per un quadro di Adami* (concerto for an Adami painting), when technical errors turned Adami's interview about the significations of a painting into a garbled sound-piece (pl. 99). Explicitly renouncing 'art history' and value judgements, Martin recounted the most avant-garde of Adami's experiments. These included the setting up of genuine contests in a boxing ring in front of the painting *Ring* at the Studio Marconi in Milan; 'Laboratorio', Adami's exhibition of photographs as 'painting hypotheses'; his 'mail art' experiment *Send me an Image*, when the public provided him with source material, and the film made with his brother Giancarlo Adami in 1971, *Vacanze nel deserto* ('holiday in the desert', starring the painter Erró; pl. 106).[41]

105. Valerio Adami *Sigmund Freud travelling to London*, 1973

All were conceptual pieces, *hors-cadre* (beyond the frame of painting itself) and certainly *hors-texte* (beyond the text). In contrast, Derrida draws the artist back onto the territory of the textual; he refers to the *Concerto per un quadro di Adami* on the first page of '+R' as a *double gravure (disque et dessin)*. Both the vinyl record and the unique recto/verso drawing *Chi* – the Adami/Derrida collaboration – are engraved, inscribed on back and front.

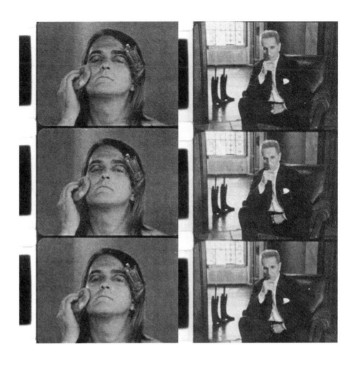

So I turn to another major conceit both within and *hors-texte* of '+R': the double-sidedness of the page, drawing, mirror, plays with the doubled concept of the double-bind. With the already encountered twin columns as a *double-bande*, their erectile nature, punning on *bander* in French (explicit in Genet's 'Rembrandt'), becomes Christic with Adami's fish/Christic phallus drawing. The X – the Greek *chi* in *ichthus* (anagramatically Jesus Christ, Son of God, Saviour) – represents a *chiasmus*, a notion at the heart of Derrida's *La Dissemination*.[42] In '+R' Derrida writes: 'Pronounce *qui* or *khi* expiring, agonising, hawking a little with an extra "r" in the throat, almost *cry*. But one could try several languages and all sexes [for example *she*].'[43] X is another 'phonic trait' like *gl*, like *tr*, where Derrida's raucous delight in sounds and alliteration is utterly lost in translation. The chiasmus, X, not only signals the cross-over between artist and writer but is later linked to an infinitely more cosmological, philosophical notion. Where Lyotard used the Moebius strip as the topological model for his *Économie libidinale*, Derrida points out Adami's use of attributes which symbolise machines, such as the ladder (*échelle*, scale, *escalade*, escalation; see pl. 107a) in the drawing for *Glas*, his wheels, locomotives, slings, or Stalin's 'murderous rifle'. Derrida himself, having illustrated Vitruvian wheels in *Tympan*, turns to Plato's *Timaeus* in '+R': God's creation of the planets takes place through a series of divisions, culminating in

106. Adami, Giancarlo Adami, *Vacanze nel deserto*, 1971

two parts, which he joined to one another at the centre like the letter X, and bent them into a circular form, connecting with themselves and each other at the point opposite to their original meeting point... X, the general intersection of *Glas*, of its beginnings or ends in twisted and spaced out bands, also describes the demiurgic operation in the *Timaeus*.[44]

An X becoming two intersecting spheres passes textually back into hooks, citation marks, fish-hooks, hooks for painting, gallery hooks.

Pourquoi dé-tailler? Pour qui? (Why detail? For whom?), as Derrida says towards the end of his text, which ends, significantly, with the trope of *autobiografia* (he plays throughout with the titles of drawings in the show). Concluding with the epilogue to Benjamin's essay, 'The Work of Art in the Age of Mechanical Reproduction' (1936), where Fascism tends to aestheticise politics and Communism to politicise art, Derrida calls this 'A motto [*légende*] for what I wanted to depict [*dessiner*]: another portrait of Adami, a self-portrait.'[45] *Glas* generated a mirror-image book, *Glassary*, to serve as an exegesis.[46] One could likewise have extended this commentary, but it is all too prosaic when compared to Derrida's brilliant textures, sounds, juxtapositions, combined with the keen sense of the review's design, where Adami's richly coloured full-page lithographs such as *Drawing of a Photo of Ben Shahn* break the monochrome decorum with a clamorous intrusion. Instead, I shall pursue the story beyond these margins, beginning with a postscript and then jumping across decades.

107. Valerio Adami, *Two Studies after Derrida's* Glas, 1975

A later number of *Derrière le miroir*, produced for an exhibition in October 1976, contains Adami's own diary entries describing the aftermath of his 1975 exhibition. There, in 'Les Règles du montage' (the words twice crossed through), Adami notes his visit on 20 December 1975 to Derrida's home in Ris-Orangis and their conversation on desire in *Glas*. After a trip to Italy, he was back in Paris in January:

> 19.1.
>
> Lunch with Jacques Derrida in a restaurant, place Denfert-Rochereau, then all the afternoon together in the rue Danville studio, sitting elbow-to-elbow next to each other to sign 500 'placards'.
>
> He recalls his father.
>
> He concentrates before signing and then it is done with a rapid gesture as though he is not writing.
>
> As for me, I talk about my mother, my writing at the moment resembles hers. When I was a child I spent hours at a time copying out her handwriting.
>
> I reread a text I wrote in '60 for the exhibition 'Possibilita di relazione' I recopy it into a notebook like this one. I note in passing how different my writing was at the time....
>
> 19.2
>
> Derrida asks me if the words written on the painting and superposed over the image have a signification for me, even as regards their phonetic value. Taken aback, I do not answer.
>
> Yes, the phoneme is part of the composition. As an example, the numerous demonstrations offered by advertising posters. The choice of a word can be made for its phonetic definition alone. I would like to develop this form of Lied that I began with the two lithographs on Derrida's texts.[47]

Derrida + Adami, Galerie Lelong, 1991

In June 1991, Adami was interviewed at his Paris show in the luxurious Galerie Lelong in the rue Téhéran.[48] Derrida, the curator Alfred Pacquement, the art historian Marc le Bot and the *philosophes* Christine Buci-Glucksmann and Jean Borreil participated. The encounter was published in the series *Ateliers*, part of the programme of the journal *Rue Descartes*, produced by the Collège de Philosophie, of which Derrida had been a founding father.

Adami's response to Borreil at the outset offers a recapitulation of his aesthetic choices spanning a career of many decades: 'You spoke of neo-classicism, of Mengs, it is this painting that takes me back to my very severe, very disciplined Italian education at the École des Beaux-Arts… Classical art is indissociable from the closed form… You spoke of musicality… You spoke of the portrait… You spoke of heroes… If mythology has faces, bodies, a *mise-en-scène*, it is thanks to painting…'.[49] To Marc le Bot, he replies:

> Painting is above all a memory-system… All my paintings are preceded by drawing. The form of the painting is the result of a long journey made by a line, or as [Giambattista] Vico said, a long journey made by a point… Before beginning to paint, I prepare for three or four weeks four to five hundred different [colour] mixes which are like a piano with an immense *tastiera* [keyboard]. Each colour, each mixture must correspond to a lived emotion… I have never really succeeded in managing oil, invented to lead to sensuality and hence *chiaroscuro*, so I had to revert to a tempera technique, to mental painting. I chose acrylic.[50]

Derrida's substantial contribution remarks on the tension between narration and the interruption of narration in Adami's work, its aphoristic or proverbial function and its secret. He insists on the paradox of a painting 'cut' from the artist which nonetheless retains its autobiographical origins:

> we must think of these two motifs simultaneously, an absolute emancipation from the painted object, and the autobiographical secret, the secret anecdote which it contains… It is in the relationship between the secret and the symbolic that the links must be sought between the autobiographical and the other, the most secret autobiographical narration to others, to the body of all possible readings, to create a pact with the community and with that 'popularity' of which we were speaking.[51]

Recollecting their encounter fifteen years previously, Derrida declares that Adami's secret seemed always to him inviolable: 'You exhibit your drawings beside your paintings, presenting on one side the *ecorché* [flayed figure] of memory and on the other not amnesia but the coloured amnesia of drawing.' Colour is another means of disguising the initial intimate secret. 'How do you experience', he asks, 'this relationship between continuity and interruption, between the enigma and the narration?'[52]

Adami's answer is Mosaic (Derrida later comments on the radical exteriority to any

link with Christianity in his work): 'To write the Tablets of the Law, Moses retreated twice for forty days at a time – when only an afternoon was necessary: one has always wondered what Moses and God had to say to each other. This is how the Kabbalah was born, the complexity around the secret, all those questions born of an enigma.'[53] It is here, confronting the paintings and confronting the secret, that Derrida insists that 'not one of us here is posing as a philosopher. We are not philosophers in general, everyone would recall this no doubt in a different way, and we are certainly not philsophers in front of Adami's painting. Not to pose as a philosopher in front of a painter is to be grateful for the way his work deranges the philosophical instance.'[54] The epigraph at the beginning of my chapter continues this passage, where Derrida measures himself against his great precursors Hegel and Heidegger as he insists on 'giving a place to painting'. By titling his 1978 anthology *La Vérité en peinture* (taking his cue from Cézanne's famous letter to Émile Bernard), Derrida suggested that painting contains a Truth.[55] What he calls in his writing on Adami the 'anamnesis' of colour – or the incision of a line, the voyage of a drawing – goes inevitably beyond the textual. Unquestionably, as an aesthetician, Derrida matched Hegel's teleological vision of successive styles in the *Aesthetics* and Heidegger's mid-twentieth-century investigations of the origins of the work of art, with his notion of *aletheia*, as disclosure and 'truth'.[56] But as opposed to revelation, Derrida is interested in the cut – the work's severance from the artist as it enters the world, and the artist's inviolable secret, to which he returns in his final encounters with Adami.

Adami + Derrida, 2003
Ekphrasis, Drawing, Seeing, Touching

After the many voyages, the many frontiers crossed, it is retrospectively moving that Derrida's first public talk on death should ask 'What, then, is it to cross the ultimate border?' in 1992 (soon after the 'Atelier Valerio Adami' conversation).[57] Derrida and Adami were faithful to each other unto death; two of Derrida's last texts appeared posthumously, published in Adami's journal *Annali*, which is linked to the artist's Fondazione Europea del Disegno. The foundation's inaugural papers, published in 2005, the year after Derrida's death, centred on the theme of *ekphrasis*. They were introduced by his text 'Le dessin par quatre chemins', the four paths of drawing: *dessiner, désigner, signer, enseigner* (drawing, designing, signing and teaching – always

etymologically more pleasing in French). Derrida considers the destiny of the *dessin* in a new institution: '*Expérience* veut dire traversée, transmission, trajectoire, traduction. "Voyage du dessin": dit un jour Adami'('*Experience* means traversal, transmission, trajectory, translation. "The voyage of drawing", as Adami said one day').[58]

In describing the potential agendas of the foundation, Derrida, already a fragile presence, insists on the necessity of a philosophical meditation on drawing, 'notably since the establishment of a tradition which from Plato to Kant, Heidegger and so many others has always sought the path of thought... a reflection on the eidetic figure, on representation, on line, the limit, the trait.'[59] His improvised contribution 'Penser

à ne pas voir' (to think not to see) considered first the relationship of line, language and 'not seeing'. He quotes the metaphysical poet Andrew Marvell with whom he had ended his magisterial exhibition in the Louvre in 1990, 'Mémoires d'aveugle' (memories of the blind): the conceits of 'These weeping eyes, those seeing tears'.[60] The spectre of Nietzsche (who haunts the very island where Adami's foundation is situated) is next evoked and the eyesight that Nietzsche himself linked to his 'life-power' and second sight; thence Derrida moves to the trope of improvisation – to advance blindly, without foresight, without design:

Can one draw without design?... Drawing is the eye and the hand... perception is also a manual grasp, a way of seizing the *Begriff*, the concept... Vision is also apprehension... Vision, eyes seeing, not eyes weeping, is there to warn through anticipation, preconceptualisation, through perception, to see what is coming... but an anticipated event... is not an event... If an event worthy of the name comes from the other, from behind or above, it can open the spaces of theology (the Most High, the Revelation that comes to us from above)... The other is someone who surprises me from behind; from underneath or beside me, but as soon as I see them coming, the surprise is diminished... The moment the trace, the movement or the drawing becomes inventive is the moment the draughtsman becomes blind

in a way, he does not see it coming, he is surprised by the line that he draws, by the passage of the trait, he is blind. It is the great seer, a visionary, who, as he is drawing, if his drawing is an event, is blind...' Perspective – which 'must make itself blind to everything perspective excludes' – is a hierarchised, organised schema of vision which owes as much to blinding as to vision.[61]

The blind spot leads Derrida to thought, to Heidegger's *Was heisst Denken?* (what is called thinking? / what calls for thinking?), to the Logos, *logocentrisme, phonocentrisme* and the phonetic alphabet, its Greek and evangelical affiliations (St John and the *Logos*) and the beginning of writing that signifies a signifier, that represents the 'sounds' of interior thought: 'the first experience of blindness is the word: you do not see what I say'.[62] Writing – on the side of death – is posited against the living present. And the present is posited against 'experience', *Ehrfahrung* – the voyage, the space and time traversed, without design, aim or horizon.

Vision's relationship to the *logos* of Western philosophy bears a relationship, Derrida insists, to Plato's *eidos* – the contour of a visible form – versus *mimesis*, the imitations of poets and artists, *zoographers.* Derrida considers the visual metaphors of philosophy: the 'phenomenon' (*phainesthai*), what shines, what is seen, and 'theory' (*theorein*), to look:

> all the texts from Plato to Husserl, ocular or optical values, shall we say, which I will call *heliocentric*, that is to say values transmitted by light, were at the service of what I shall call a *haptocentrism*, that is to say a figurality privileging touch... Each time the summum of the experience of truth is spoken through the figure of contact and not the figure of vision...[63]

Derrida refers to his work on Jean-Luc Nancy and *Le Toucher* (touch, illustrated with the 'blind' writing and erasures of the artist Simon Hantai); examples are manifold.[64] Finally, he writes, 'when I say *trait* or *espacement* I do not merely designate the visible or space, but another experience of difference.'[65] Thus, yet again in concluding a text linked to Adami, Derrida reverts to the secret: 'what is held back in relationship to visibility, lights, public space – l'*espace des lumières* – the space of reason... In every drawing worthy of the name, in what makes the tracing of the drawing, a movement remains absolutely secret, that is to say *separated* (*scenerer, secretumi*), irreducible to diurnal visibility... The resistance is towards politicisation but like all resistance to politicisation, it is also a force for repoliticisation, a deplacing of politics.'[66]

Derrida
Fear and Trembling – the Shaking Hand, 2004

An image of the invalid Matisse, writing to Aragon about drawing in a moment of respite, began this long improvisation. Derrida spoke for the last time in the summer of 2004, conscious that his death was drawing near; his words were published in the second volume of Adami's *Annali* in 2006, titled 'Comment ne pas trembler?' (how should one not tremble?). The discussion had moved from experience and the visible or felt nature of the *trait* and its secret, to the trembling hand, a physical trembling, fear and trembling – in the face of death – that yet evokes the necessary precision of the artist's hand in creating line. Renée Riese Herbert's text of 1994 on '+R (par-dessus le marché)', placed in *Annali* opposite Adami's portrait drawing *Jacques Derrida* (2003; pl. 108), brings the reader back to that creative moment between Adami and Derrida of 1975.[67] Yet, despite many illuminations, her considerations seem remote from this deeply moving, deeply autobiographical last text.

'How should one not speak?' Derrida had asked twenty years previously in Jerusalem, 'one of the epicentres whose quakings shake the world today'. The quaking of his body as a child, while bombs fell in Algeria in 1942–3 is recalled, with the quaking of his hand now, following chemotherapy – unable to write, to sign. 'I was not trembling with fright but frightened of trembling'.[68] Another *chiasmus* – another brilliant improvisation, from the 'trait traced by a trembling hand, like the *tremolo*...of a voice', or the shaking of poplar leaves (*Zitterpappel*), to a mediation on the necessity of failure and feebleness: 'the thought of trembling is a singular experience of unknowing' and 'the experience of trembling is always the experience of an absolutely exposed, absolutely vulnerable passivity'. 'Trembling makes the autonomy of the self tremble, reinstates it under the law of the other, heterologically... all trembling, literal or metonymic, is a trembling before God.... Or again, God is the name which names that before which one always trembles, whether you know it or not. Or again, God is the name of the ultimately other, who, like any other and as any other, is completely other, makes one tremble... The necessary trembling of the artist's hand who nonetheless has the habit and experience of his art... A secret always *makes* one tremble'. Derrida cites Kierkegaard's *Fear and Trembling* and St Paul's epistle to the Philippians (2:12) where the apostles are asked to work for their salvation with fear and trembling. 'Paul says, and it is one of his "adieux"... work with fear and trembling'. He recalls 'Heidegger

on the subject of death, our death which is always "my death"', and Paul again, 'a still Jewish experience of God hidden, secret, separate absent or mysterious… Paul Ceylan: *Die Welt is fort, ich muss dich tragen*: "The world has departed, I must bear you"… the responsibility of *I must bear you* supposes disappearance, distance, the end of the world' and, Derrida continues, 'to be truly, singularly responsible before the singularity of the other there must be no more world.'[69]

In his 'Dessin par quatre chemins' presentation for the Fondazione Europea del Disegno, Derrida had concluded: 'From one generation to the next, from one country or one continent to the other, elective affinities, invented affinities, will reconstitute what once was called, and is this time around drawing [called], "the *psyché* between friends".'[70] This, then, is philosophy as *autobiografia*, as a self-portrait, a cumulative self-portrait of many voices.[71] Derrida's final adieux in the autumn of 2004 signalled the end of yet another epoch – a final *Glas*.

It is an unfinished story, a story continued, as Adami works through Derrida with other writers, such as Abdelkébir Khatibi or Jean-Luc Nancy in 2007, or participates in the conference 'Derrida's Ghosts' in 2009.[72] It is a story always framed by outside structures, by what Derrida called, in relationship to visibility, the *phanesthai* of the

public space. What he called 'the Institut named Beaubourg' (also a 'morgue') had its role to play in both the concealing and the promotion of Narrative Figuration.[73] Adami's retrospective was organised by the Musée Nationale d'art moderne in 1985.[74] The 2008 group retrospective at the Grand Palais offered a new visibility to this movement that once made its symbolic adieux to the national institution it challenged. To conclude, I shall examine the aptly named exhibition 'Guillotine et Peinture', staged in the Centre Geroges Pompidou's opening year, 1977.[75]

109. Masi, *Derrida*, 2004

Conclusion

In Beaubourg
1977/2007

> The day of the inauguration of the Centre Georges Pompidou, 31 January
> this year, I thought again about that blade, that guillotine blade, the first
> significant element to strike my attention when I saw Topino-Lebrun's
> painting *The Death of Caius-Gracchus*. From the fifth floor, I asked myself
> whether the President of the Republic would open the centre by cutting
> a ribbon with a pair of scissor-blades, thinking that some hundred and
> sixty years earlier, just a few strides away from here on the place des Grèves,
> Topino-Lebrun became a headless corpse by order of another head of State.
>
> Antonio Recalcati, '31 janvier 1801 – 31 janvier 1977'[1]

As President of the Republic, Valéry Giscard d'Estaing presided over the last two
executions by guillotine in France. After immense controversy surrounding the death
of Roger Bontemps in 1972, the capital punishment debate continued around Patrick
Henry's trial in January 1976. The guillotining of Christian Ranucci on 27 July 1976
took place six months before the opening of the Centre Georges Pompidou, whose
name had been hastily changed from Centre Beaubourg with the death of the art-
loving President in 1974 – *pour ne pas guillotiner le projet*: to save the project from
Giscard's chop.[2] The high pomp of the official inauguration preceded the opening in
the contemporary galleries of 'Guillotine et Peinture: Topino-Lebrun et ses Amis' on 15
June. The *couperet* (guillotine blade) performed its last act of decapitation in France on
the neck of a Tunisian man, Hamida Djandoubi, on 10 September 1977.[3]

 In 2007, the Centre Georges Pompidou celebrated its thirtieth anniversary.
History books have retained the opening date of 31 January, the first Marcel Duchamp
retrospective in France and its sequel, 'Paris–New York', running from June to mid-
September, which inaugurated the great series of shows focusing on Paris as a centre of
exchange with other major capitals. Beaubourg's architectural aesthetic, which many
found shocking, emphasised desire and play: the circulation of drives expressed by the

circulation of pipes, conduits and colours on its surface. Its nickname, the *Pompidolium*, expressed its energy as a fuel tank for new projects. The contrast with the persistence of ancient codes and traditions on the conservative right could not have been stronger.

For contemporary art, 1977 was the culmination of a certain story for the painters of Narrative Figuration and the beginning of a new epoch. One could argue that Duchamp, successfully 'assassinated' in 1965, had the last laugh. Two major Parisian exhibitions ran in parallel to 'Duchamp' and 'Paris–New York': 'Mythologies Quotidiennes II' at ARC, from 28 April to 5 June 1977, and 'Guillotine et Peinture', the twin focus of my conclusion.[4]

'Mythologies Quotidiennes II' made deliberate reference both to the twentieth anniversary of Roland Barthes's *Mythologies* of 1957 and the first 'Mythologies' exhibition of 1964, which had marked the beginning of a new era. While the profusion of the 1964 selection had weakened its impact, the repeat performance of 1977 – with many of the same participants, from Bernard Rancillac to Peter Saul – was equally diverse. A second generation of Narrative Figuration painters joined the original grouping, such as Ivan Messac or Giangiacomo Spadari. Gérald Gassiot-Talabot's preface took a critical distance as regards myths of both the left and right: in 1977, Barthes, Duchamp, Sartre and Foucault had themselves become myths, he declared. It was in this context that Gérard Fromanger first showed his series 'Splendours II', including his now celebrated portraits of Sartre and Foucault (see p. 6).

(see p. 6).

110. Antonio Recalcati, *31 January 1801, 1974-75*

The atmosphere was far from neutral, the paintings far more kitsch, more aggressive than a decade previously; yet the sense of change was palpable, in that ARC as an institution within the Musée d'art moderne de la Ville de Paris was widening its agendas. It had a new team with an increasingly international outlook.[5] Jean-Louis Pradel's virulent catalogue text spoke both of the 'exploded globality of the visible' and concluded with an image of the shattering of the mirror of illusion: 'the thousand facets of the broken mirror of Mythologies Quotidiennes write the beginnings of another history'.[6]

The group work *Five Romantic Painters – or Business picks up* was the piece that will be remembered from this enormous show: it performed an act of institutional critique unique among the other figurative paintings. Photographed one by one in the catalogue as surly museum guards, the Malassis (Henri Cueco, Lucien Fleury, Jean-Claude Latil, Michel Parré, Gérard Tisserand) took the doubling of the self, as both museum guard and motif 'within' the painting, to create a *mise en abîme* of the image. Significantly – and as a melancholic political act – they abandoned their previous collective painting ethos: each work was an individual initiative. The confrontation with the State militantly, gloriously orchestrated at the 'Police and culture' Salon in 1969 and in 'Douze ans d'art contemporain' in 1972 here collapsed into a representation of the policing of the work of art by cultural structures. Cueco's flying cobbles of 1968 became white squares echoing the grids of the new conceptual era; Parré's repetitive representations

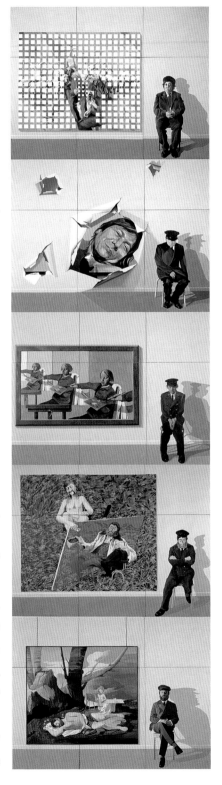

111. The Malassis, *Five Romantic Painters* 1977

of the dejected artist contrasted with Fleury's face which burst through the *cimaise* (the exhibition wall), simultaneously the 'screen' of painting (pl. 111). Besides the political and institutional message – for Foucauldian overtones of surveillance and punishment were all too evident – *Five Romantic Painters* was a reflection upon the vanity of representation itself.[7] The Malassis' cool, self-reflexive irony contrasts with the high pitch of hysteria in the 'Guillotine and Painting' group project.

Despite its Duchampian and internationalist turn, the Musée national d'art moderne could not possibly ignore the art it had collected during the previous decade. Contemporary acquisitions by artists in the orbit of Narrative Figuration painters had been particularly well chosen, rich with the experience of the Centre National

d'Art Contemporain, set up in 1967, which was absorbed into the Beaubourg; the CNAC had had a piloting role for the state purchases of the Fonds National d'Art Contemporain (FNAC) during the decade. Within its broad and adventurous remit the CNAC had held exhibitions such as Rancillac's Maoist 'Le Vent' in 1971, Monory's 'Velvet Jungle' series also in 1971, 'Hyperréalistes Américains, Réalistes Européennes' in 1974 and an Antonio Recalcati exhibition in 1975.[8] State purchases included Erró's *The Background of Jackson Pollock* (exhibited at the Salon de Mai in 1967 and 'Douze ans d'art contemporain' in 1972): it is a delirious recapitulation of canonical modernist pieces as kitsch, dominated by the tormented American with his scaled-down 'drippings' (pl. 112). Adami's *Lenin's Waistcoat,* a crisp take on the 'Lenin fever' of the early 1970s, and Arroyo's diptych *Jean Hélion escaping, en route from Pomerania to Paris* were complemented by Equipo Cronica's *Mayakovsky*, painted in the wake of the nascent Centre Pompidou's superb show 'Maïakovski, 20 ans de travail' of 1975 (pl. 113). Fromanger's *In Huxian, China* (see pl. 74), was perhaps the most audacious purchase, while *Poetry Reader in the Snow*

112. Erró, *The Background of Pollock,* 1966–7 113. Equipo Cronica, *Mayakovsky,* 1976

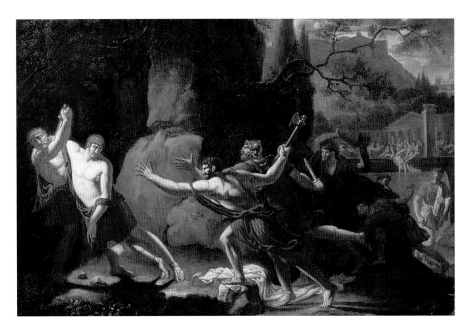

by Fanti, acquired in 1977, countered revolutionary fervour and the pleasures and ironies of appropriation with another Mayakovsky-inspired *vanitas*. Each purchase had a story: proposed, discussed, acquired with public funds, exhibited, consigned to storage, ignored or recently rehabilitated.[9]

As I proposed in my introduction, the encounter of Narrative Figuration with Beaubourg's *Realpolitik* was as instructive in 1977 as today. The travelling exhibition '06 Art 76' sent by the Musée national d'art moderne to America and Norway in 1977, with a catalogue preface by the director Pontus Hulten, exhibited prominent contemporary artists who might have wished for more exposure in Paris that year: Aillaud's figurative zoo paintings, Titus-Carmel's *Tlingit Coffin* series, *Support-Surfaces* work by Claude Viallat with François Rouan's woven strip canvases, Annick and Patrick Poirier's postmodern installations on the theme of Greek ruins and Erró's *Maos*.[10] Hulten, the great intermediary between Stockholm, New York and Paris, had been connected at the outset of his Paris career with Denise René's pioneering Op and kinetic art movements; he promoted Dada, neo-Dada and Nouveau Réalisme and was friends with Rauschenberg, Tinguely and Niki de Saint-Phalle. Yet he retained his anarchist streak and his friendship with a fellow anarchist, the critic and *eminence grise* of the review *Opus International*, Alain Jouffroy. He welcomed Jouffroy as the curator of 'Guillotine et Peinture' into the Centre Pompidou with this major exhibition of large-format works, planned over several years.

114. Topino-Lebrun, *Death of Caius Gracchus*, 1792-97

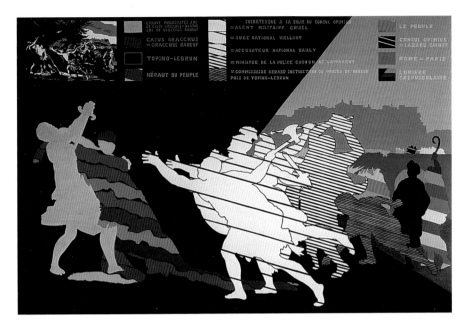

It may be that the show, extending over the summer, was a palliative offered by Hulten, following years of attacks by the Front des Artistes Plasticiens on the Beaubourg project. Perhaps it was a daring gesture defining the institution's independence – or a politically astute *clin d'œil*. Jouffroy claimed: 'Neither Duchamp nor Picabia can serve any longer as alibis to cover operations that are anti-historic, anti-desire'.[11] Despite the contemporary nature of many subjects, revolutionary romanticism dominated these contemporary history paintings. However, this *romantisme révolutionnaire* – the phrase used by Aragon as a counterpart to *réalisme socialiste* in 1935 and in 1949 – made explicit a disturbing discourse of suicide.[12] Narrative Figuration conquered the museum whose state affiliations it had bitterly challenged – yet it was a Pyrrhic victory. The artists Bernard Dufour, Erró, Fromanger, Monory, Recalcati, Vladimir Velickovic and Jean-Paul Chambas were shown in the Musée national d'art moderne's contemporary galleries, huge works in the new Centre Pompidou spaces.[13] The *leitmotif* and inspiration for the show was François Topino-Lebrun's newly restored *Death of Caius Gracchus* (pl. 114). In September 1971, Jouffroy, who had discovered the artist thanks to Aragon, learned that his greatest painting (exhibited at the Paris Salon in 1798) had been folded away and consigned to the cellars of the Palais Longchamp in Marseilles. He first evoked the work and its revolutionary resonances in *Opus International* in 1972, in the very middle of the scandal around 'Douze ans d'art contemporain en France', the official state gesture towards contemporary art from 1960.[14]

115. Fromanger, *Death of Caius Gracchus*, 1975-77

The militant Front des Artistes Plasticiens, spearheaded by Fromanger among others, waged a long campaign against the Beaubourg as a state initiative. They had been galvanised precisely because of the police intervention and the beating up of artists outside the Grand Palais at the opening of 'Douze ans'. The Malassis group took down their painting *The Great Méchoui* (pl. 116) as a sign of protest – a classic *décrochage*. The police confrontation, now part of the Malassis myth, was considered more important than the work itself, by the artists and indeed by their critics (pl. 117). Their epic denunciation of twelve years of right-wing misrule has never exercised its critical function; only a truncated part was shown to the public at the Grand Palais retrospective in 2008.[15]

Born with the Salon de la Jeune Peinture of 1965, hardened by the experiences of the 'Red Room for Vietnam' show of 1968–9 and 'Police and culture' of 1969, the Malassis had been officially founded in 1970. *The Great Méchoui*, a mutton carcass gnawed by a horde of rats, represented the decaying carcass of the state.[16] It was one of a

116. Cueco, Latil, Fleury, Parré, Tisserand, *The Grand Méchoui*, 1972 (detail)

series of canvases that made up an installation of dimensions as vast as Rosenquist's *F-III* and symbolised a twelve-year orgy of consumption and corruption, with the French citizen-sheep as victims. *Push towards the 'New Society', Capital drains away, Housing Construction Scandals, Work, The Consumer Society, In Praise of Profit, Culture, Happiness* followed. *The Great Méchoui* was focused entirely on domestic policy, although the spectre of Algeria haunted the Charonne metro massacre depicted at the outset. Its mural-scale allegory mixed bemedalled political figures with animals (sheep, rats and pigs) with gas masks for the police, evoking not only the fables of Aesop, the *Roman de Renart* or La Fontaine but also contemporary cartoons and a tradition of graphic satire going back to Daumier. Distortion, exaggeration and visual metaphors collided in *The Great Méchoui* while a logic of anamorphosis, a depraved perspective for a depraved society, prevailed.[17] In 1977, Pradel's critical analysis of 'Mythologies Quotidiennes II' for *Opus International* revived the memory of *The Great Méchoui* with an illustration of the panel where the Gaullist Cross of Lorraine served as both extended sheep-pen and Tomb of the Unknown Soldier: sheep rushed into the cross-shaped grave under the Arc de Triomphe, directed by a machine gun.[18]

Jouffroy in 1977 asked whether the fateful years 1796–1800 held the secret of the failure of 1968. Using the neo-classical tropes of revolutionary painting, Topino-Lebrun elided the figure from the Roman Republic, Caius Gracchus, with Gracchus Babeuf who had been guillotined in May 1797. After Caius Gracchus's failed suicide attempt, his slave killed him and then killed himself; Babeuf had also attempted suicide after his death sentence. Topino-Lebrun himself was guillotined not during the Terror of 1794 but under the regime of Napoleon Bonaparte on 31 January 1801. Jouffroy's pursuit of the 'guillotined painter', in conjunction with Philippe Bordes's historical research, led to the restoration of the canvas by the Louvre in conjunction with the Direction des Musées de France. A superb book was published to accompany the Beaubourg show – the culmination of Topino scholarship.[19] Evidently, Jouffroy made the link between the tradition of history painting – from Topino to Géricault's *Raft of the Medusa* and Courbet's *Studio* – to the contemporary and to a continuing history

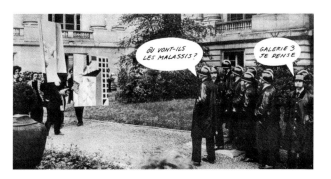

117. The Malassis with police, Grand Palais, 1972,

of anti-revolutionary repression. Recalcati's linking of the two 31 Januaries of 1801 and 1977 in his artist's statement was most explicit: the guillotine – the focus of his allegory of the silenced, headless artist (see pl. 110) – epitomised the abuses of post-Revolutionary Terror, with evident contemporary analogies. The place des Grèves, the site of the first use of the machine in 1792, is now the place de l'Hôtel de Ville – clearly visible from the top of the Centre Pompidou.

'Guillotine et Peinture', a magnificent gesture of protest by the left, was peculiarly self-reflexive. Bernard Dufour evoked the failure of the Commune, the failure of May '68 and continued: 'From the failure of modern art, the failure of libertarianism, the failures of the modern utopia springs an extraordinary stimulation.'[20] In his work, painted in a style close to that of Paul Rebeyrolle, naked bodies twisted in agony with an expressionist pathos. Before any of his contemporaries – for example, Rancillac with *In Memory of Ulrike Meinhof* (1978; see pl. 40) – Dufour brought the Red Army Faction terrorist Holger Meins into history painting, into Topino's circle of death: 'Holger Meins is killed and kills himself inside a network of friends. Caius Gracchus has himself killed by a friend who kills himself at once. Topino-Lebrun, guillotined, painted a picture for his friend Gracchus Babeuf, guillotined'.[21] Fromanger's *Death of Caius Gracchus* made the analogy between the characters in the mythical painting and the colour-coded citizens of the present (see pl. 115). They were strictly identical with the contemporary Parisians in the pendant piece, *Life and Death of the People*. Fromanger's *The Artist's Life* (see pl. 76) – arguably, his most powerful work – showed him in his studio with epidiascope, painting the projected image of prisoners rioting on rooftops. A paradigmatic 'new wave' work in terms of its self-reflexivity as regards process and reproduction, it is exemplary in its dialectics: the secondary, contemplative status of the artist is countered by the gamble he takes with history; the moment of the image, the photo-reportage shot, is prolonged in another medium to create a work, and an alternative, reproducible image – for posterity. Fromanger also brought death into the museum. His *Death of Pierre Overney* (1975) commemorated another notorious assassination, that of the young Maoist killed at the gates of the Renault factory in 1972, whose funeral commanded a crowd of 200,000; his memory lives on today among the French left.[22]

Fromanger's contemporary analogies made a contrast with Monory's incorporation of a mythological painting of mourning: the drowned male body and hysterical woman painted in 1798 by Jean-Joseph Taillasson.[23] Monory's images of images, Taillasson and

Topino painted on suspended guillotine blades, struck though with the black cross 'X' – the 'Ex-' of the past – were uncanny and obscene presences invading a dream-like palm-fringed beach (with television monitor). On the right panel, Monory depicted the corpse of a Cuban revolutionary. Death or the guillotine were everywhere: the hurtling pale body on black ground by the emigré Serbian painter Vladimir Velickovic came to rest as a classic Dead Christ in the manner of Holbein, though bloody and decapitated. Velickovic's artist's statement plays on the death-in-representation of his practice: 'Execution of the image… history as mortal fiction… the guillotine of chairoscuro: condemnation of the palette and the symbolic remains of the wreck of the artist'.[24]

Complementing and corroborating this imagery of lack, Erró's composite, collage-based political extravaganzas once again produced the nausea of excess, as did Jouffroy's quasi-valedictory recapitulation:

> How should we not see that Erró is the sole painter to have dared show Vietnamese combattants in a middle-class American apartment, Mao Tse Tung in front of the Arc de Triomphe, and the Chinese Army in Washington? Who could deny that Fromanger, since 1968 when red started infiltrating his painting like a mental ray of light, is the painter who honoured Overney, the painter of the prisoners rioting on the rooftops, the painter of the daily paroxysms of the streets, and more recently, the most subtle critic of the power of the media: photo, radio, TV? How could we forget that Monory, in his 'Velvet Jungle' series introduced the Vietnam War, and in his 'World Catalogue of Incurable Images', bank strong-rooms, the corridors of American prisons, psychiatric asylums and Nazi concentration camps, when his own meditation, even reverie are highly distanced from the real? How to pass over in silence the painting in which Recalcati prophesied the Mao-Nixon encounter, or leave unacknowledged the one about the burial of the anarchist Pinelli…? When Erró in homage to Topino-Lebrun decides to paint a painting on the assassination of Salvador Allende and a second one on Che, then a third one on Caius himself, projected over the film *2001*, when Fromanger decides to paint a limitless dawn over the corpse of René-Pierre Overney, when Monory decides to put into his triptych a Cuban revolutionary assassinated in the streets of Havana by Battista's police, we could even say that they had decided to rejoin Topino via the traditional way of the celebration of victims and heroes…[25]

The pressure of history confronted the challenge of the future in a period of turmoil. Looking back, on the thirtieth anniversary of the Centre Pompidou in 2007, the historian Jean-François Sirinelli concluded: 'Thus the birth of Beaubourg appeared in a context of deep trouble for the French intelligentsia.... The ideological crisis... was brutal'.[26] The left, 'orphaned', could no longer look to its major political models, the USSR or Communist China; Marxism as a means of interpreting the world was also redundant, he continued, as even Althusser would declare.

The most powerful generation of philosophers produced in France since the eighteenth century found themselves overtaken by globalisation, by the oil crisis, by world recession. Significantly, the review *L'Arc* chose to substitute a Foucault issue planned for 1977 with 'La Crise dans la tête' and put on its cover a Géricault-based 'shipwreck in the head' by the Malassis (pl. 118).[27] The crisis came at the very moment when the celebration of the great thinkers of the 1970s came under attack from the *nouveaux philosophes*, who consigned them to the Marxist *datcha*, where they had been placed, cruelly, as early as 1969 (see my Interlude). The old left was discarded: a new world vision combined with technocratic cynicism shaped the materialist 1980s. Our *philosophes* themselves were engaged in critical and self-reflexive strategies as a result of the 'Reforme Haby', which touched philosophy teaching in schools and the philosophical establishment *per se*.[28] The compendium *Qui a peur de la philosophie?* (who's afraid of philosophy?) was in fact an immense *décélébration* (to use Derrida's term) that crystallised many anxieties and debates in 1977.[29] Lyotard began his *Rudiments païens*, published in the same watershed year, by advocating 'apathy in theory', and quoting Freud: '"I think it its time to interrupt myself."' Ironically anti-academic in tone, he concludes the volume with a reflection on 'theory' as a hybrid, indeed fictional species of writing: 'One might think the moment has come to say *adieu* to the theoretical or critical genre.'[30]

'Guillotine et Peinture' signified farewell to an idea – the idea and ideals of revolution, of history painting – that had survived in France to 1977, and to the idea of painting itself in the era of performance, photography and conceptual art. The painters of the Narrative Figuration movement – many pursuing their careers today – were nevertheless stamped with that revolutionary history, reborn in Lyotard's *désirrévolution*: the energetic mythologies of Erró and Rancillac, the *jouissance rouge* of Cueco, the revolutionary joy of Fromanger, even the more melancholic *jouissance bleu* of Monory or the lost Soviet ideals of Fanti, which Althusser had found so poignant.

The tolling bell which sounded in Derrida's *Glas* (1974) – recalled in his collaboration with Adami – resonated through the era and beyond. Finally, in his writing – as late as 1993 – the question of Marxism appeared as a spectre, a past informing the present like a memory of a death, a mourning whose reverberations profoundly affected the generation whose paintings and whose encounters form the core of this book.[31] As early as 1982, in the new Mitterrand era, Lyotard, thinking of the passion of his Socialisme ou Barbarie days, wrote: 'The history of this Marxist radicalism ought to be thought and written in its own language… to speak of it today would add a useless political imposture to the inevitable betrayal by memory… Nothing else, with the exception of love, seemed to us worth a moment's attention during those years.'[32]

Vous allez trahir, 'you will betray', Alain Jouffroy said to me, adding to Lyotard's 'betrayal by memory' the inevitable betrayal of my account, indeed of any narrative history. Of course, he is right.

118. ARC, *La Crise dans la tête*, 1977

Notes

Preface and Acknowledgements

1 Derrida's collaboration with Titus-Carmel, his Pompidou show and catalogue, *The Pocket-size Tinglit Coffin, illustré de 'Cartouches' de Jacques Derrida,* Centre Georges Pompidou, 1978, was originally destined for inclusion in Chapter 6.

2 In 1996, I published 'Rembrandt, Genet, Derrida', in Joanna Woodall, ed., *Critical Introductions to Art: Portraiture,* Manchester University Press; 'Filles d'Albion: Greer, la Sexualité, le Sexe et les 'Sixties', *Les Sixties en France et l'Angleterre,* Paris, Musée d'Histoire Contemporaine, and 'Réalismes sous le drapeau rouge', *Face à l'histoire,* Paris, Centre Georges Pompidou.

3 See Justin McGuirk, 'La Fuite: Cinema, Fantasy and Memory in the Work of Jacques Monory', and Dina Scoppetone, 'The Salon de Mai in Cuba and the Mural Colectiva, 1967', both MA theses, Courtauld Institute of Art, University of London (hereafter, MA), 1998.

4 See my 'Editor's Introduction' and 'Postmodern Romantics/Romantiques postmodernes', in Jean-François Lyotard, *The Assassination of Experience by Painting – Monory,* ed. Sarah Wilson, London, Black Dog Publishing, 1998, pp. 12–17, 21–81.

5 See my preface, *Gilles Deleuze, Michel Foucault, Gérard Fromanger, Photogenic Painting,* ed. Sarah Wilson, London, Black Dog Publishing, 1999, pp. 13–19; see also Joanna Large, 'All Roads lead to Peking: Joris Ivens and Gérard Fromanger in China, 1974', MA, 2001, and Edward Franckel, 'Karlheinz Stockhausen and Gérard Fromanger: Politics and Reproduction in the Ballet "Hymnen", Amiens, 1970', MA, 2007.

6 See my 'Du pâle criminel: X-crime', in *Monory/Ex-Crime,* Musée d'Angers, 1999, pp. 6–9, 28–9.

7 See my 'Erró, l'extase matérielle', in *Erró: images du siècle,* Paris, Galeries Nationales du Jeu de Paume, 1999, pp. 38–56.

8 See my 'Les Amazones en proverbe', in *Erró,* Paris, Galerie Louis Carré (bilingual), 2004, pp. 5–11.

9 Danielle Kvaran, *Erró Chronology: His Life and Art,* Reykjavik Arts Museum and Edda, 2007.

10 See *Paris, Capital of the Arts, 1900–1968,* London, Royal Academy of Arts; Guggenheim Bilbao; Paris, Librairie Hachette; Cologne, Du Mont Verlag, 2002, pp. 330–43.

11 See my 'Cocktail Rancillac/Rancillac Cocktail', *Bernard Rancillac,* Paris, Éditions Somogy, 2003, pp. 8–49; see also Joanna Boulos, 'Bernard Rancillac: les années politiques', MA, 2000; Joan Lowther, 'The Warhol Effect in France, 1963–1971', MA, 2001.

12 Bernard Rancillac, *Le Regard idéologique,* Paris, Éditions Mariette Guéna and Somogy, 2000.

13 Sarah Wilson, 'The Song of Ruth', in *Ruth Francken,* Hanover, Sprengel Museum (bilingual), 2004; see also Naomi Skelton, 'Ruth Francken: *La coupure et la cohérence*', MA, 2002; Katie Brandon, 'The Death of the Author and the Rebirth of the Book: The *livres d'artiste* of Ruth Francken, Jacques Monory and Annette Messager', MA, 2003.

14 Sarah Wilson, 'Fantasmagorii Fanti', *Sobranie* (Moscow) 3, 2004, pp. 22–5, special number on 'The Megapolis and its Visual Image in Past and Present'.

15 Sarah Wilson, 'Narrative Figuration: *théorie, politique, passions*', in Jean-Luc Chalumeau, Anne Dary and Isabelle Klinka-Ballesteros, *La Nouvelle figuration dans les collections publiques, (1964–1977),* Paris, Éditions Somogy, 2005, pp. 33–9.

16 Gérald Gassiot-Talabot, *Cueco par Cueco*; Itzhak Goldberg, *Marinette Cueco,* Paris, Cercle d'Art, 1995 and 1998.

17 Sarah Wilson, 'Politique et vanitas: Lucien Fleury et les Malassis', *Lucien Fleury 1928–2005,* Dole, Musée des Beaux-Arts, 2007, pp. 10–43.

Introduction

1 See Ch. 4.

2 Pontus Hulten, ed., *06 Art 76: Aillaud, Erró, [Anne and Patrick] Poirier, Rouan, Titus-Carmel, Viallat,* Berkeley, Cal., University Art Museum; Houston, Sarah Campbell Blaffer Gallery; Purchase, New York State University, Neuberger Museum, October 1976–February 1977; then in Montreal and as *Ny Franske Kunst,* Bergens Kunstforening and Oslo, Kunstnernes Hus, April–June 1977; organised by the Association Française d'Action Artistique.

3 Jean-Christophe Amman, *Erró: tableaux chinois,* Lucerne, 1975; the show travelled to Munich, Aachen, Rotterdam, Paris and New York (O. K. Harris Gallery).

4 See Julia F. Andrews, *Painters and Politics in the People's Republic of China, 1949–1979,* Berkeley and London, University of California Press, 1994, pp. 314–42.

5 See Danielle Kvaran, *Erró Chronology: His Life and Art,* Reykavik Art Museum and Edda, 2007, pp. 236–42 and email, 30 June 2009; Erró's Hong Kong trip was 1972 or 1973; his 'Four Cities' series (1972) was painted in oils entirely by the artist.

6 For AES's *Islamic Project* see http://www.aes-group.org/ip3.asp

7 *Premises: Invested Spaces in Visual Arts, Architecture and Design from France, 1958–1998,* New York, Guggenheim Soho, 1998, curated by Bernard Blistène and Alison Gingeras.

8 Zhang Xiaogang's *Bloodline: Three Comrades,* 1994, sold for $2,112,000 at Sotheby's New York in March 2007; in October 2007, Charles Saatchi bought *A Big Family* in the same series for £1.5 million at Christie's, London, and in November 2007, *Tiananmen Square* was sold for $2.3 million at Christie's in Hong Kong; see David Barboza, 'The Rise of Zhang Xiaogang', *ArtzineChina.com,* 2008 (accessed 7 November 2009). See also Jean-Pierre Cabestan, 'Relations between France and China: Towards a Paris-Beijing Axis?', *China: An International Journal,* 4/2, September 2006, pp. 327–40.

9 See contracts awarded to Alstom Transport: internet reports quote a 210–million-euro contract for the Shanghai metro and collaboration with Shanghai Shenton Metro Co. Ltd for the Universal Exhibition line 10 expansion. www.chine-informations.com/actualite/chine-alstom-fournira-voitures-au-metro-de-shanghai 7446.html, 4 September 2007.

10 See Boris Groys, *Total Enlightenment: Moscow Conceptual Art 1960–1990,* Frankfurt, Schirn Kunsthalle, 2008. The trilingual (Russian, French, English) Paris-based review *A-Ya* (1979–86) pursued the story across continents.

11 See Chapter 3. See www.formerwest.org for the continuing international curatorial project.

12 Jean-Paul Améline, ed., *Figuration narrative, Paris 1960–1972*, Paris, Réunion des Musées Nationaux/Centre Georges Pompidou, 2008, with a pioneering 'Chronologie/anthologie, 1960–1972', pp. 33–134. See also *La Figuration narrative au Grand Palais*, Paris, Éditions Beaux-Arts, 2008; *La Figuration narrative*, Paris, Artpress 2, trimestriel 8, 2008; and *La Figuration narrative,* Paris, artabsolumment, 2008, all containing new interviews and critical material.

13 See Bernard Lamarche-Vadel, ed., *Figurations 1960–1973*, Paris, Union Générale des Éditions, 10/18 series, 1973.

14 'Reflection theory' was on the agenda: see György Lukàcs, *Histoire et conscience de classe: essais sur la dialectique marxiste* (Berlin, 1923), Paris, Minuit, 1960; Lukàcs, *La Signification présente du réalisme critique*, Paris, Gallimard, 1960; and Lucien Goldmann, *Lukàcs et Heidegger*, Paris, Mediations, 1973. Apart from the huge contemporary bibliography, the artist Bernard Rancillac's library is symptomatic of reading practices at the time. It contains both Mikel Dufrenne, *Art et politique*, and the anthology *Esthétique et marxisme*, both part of the popular 10/18 series, Paris, Union Générale des Éditions, 1974.

15 See Jean-François Lyotard, *La Condition postmoderne*, Paris, Minuit, 1979, p. 7; *The Postmodern Condition: A Report on Knowledge* (1984), Manchester University Press, 1987, pp. xxiv, xxiii.

16 'Souvent intepreté comme simple émanation d'une culture d'importation, d'une esthétique trouvant son origine dans une culture anglo-saxonne étrangère à la "sensibilité" française', Jacques Beauffet, 'Avant-propos'/'Foreword', in *Bernard Rancillac: Rétrospective 1962–2000*, Musée de l'Hospice Saint Roche d'Issoudun, Musée d'art moderne de Saint-Étienne Métropole, Musée des Beaux-Arts de Dole, 2003, pp. 2–3.

17 'Il y avait aussi cette incroyable fraternité de tous les artistes immigrés à Paris, originaires des pays qui avaient des gouvernements fascistes: Haïti, Espagne, Le Portugal… sans parler des pays de l'Est, avec Christo par exemple', Jan Voss, in 'Rencontre avec les artistes: "Nous étions des barbares"' (interviews), *La Figuration narrative au Grand Palais*, p. 11.

18 See the Korcula summer school schedules and articles in *Praxis: revue philosophique* (international edn), from 1965, and its international advisory board, *Praxis*, first number 1967. See also http://en.wikipedia.org/wiki/Praxis School

19 See Herbert Marcuse, 'there could not be any conference in his field (and how large was his field!) without Goldmann: Korcula, Cerisy, Brussels, Royaumont', in 'Some General Comments on Lucien Goldmann', in Lucien Goldmann, *Cultural Creation in Modern Society*, trans. Bart Grahl and ed. William Mayrl, Oxford, Basil Blackwell, 1977 [1971], p. 127.

20 In 1970, most of Marcuse's texts of 1934–8 were republished in *Culture et société*, trans. Gérard Billy, Daniel Bresson and Jean-Baptiste Grasset, Paris, Minuit, notably 'Réflexions sur le caractère "affirmatif" de la culture' (1937). See Marc Jimenez, *Theodor Adorno: art, idéologie et théorie de l'art*, Paris, Union Générale des Éditions, 10/18, 1973. Adorno's *Théorie esthétique* and *Dialectique de la raison* were published in 1974, *Dialectique négative* (1966), in 1978.

21 See Pierre Gaudibert, 'La Marché de la peinture contemporaine et la crise', *La Pensée*, 123, September–October 1965, pp. 51–77, and Salome Pacon, 'Le Krach de l'art', *Opus International*, 66–7, 1978, special 1968–78 retrospective number, pp. 49–51.

22 'Une certaine autocritique, qui ne sera ni contrition, ni masochisme, nous entraine à voir que le seul renvoi à une manque évidente de moyens financiers, ne suffit pas à expliquer une position de retrait: ni les artistes, ni leurs différentes partenaires ne voyageaient en dehors des frontières et ne sejournaient à l'étranger pour des raisons professionelles pas plus qu'ils ne "savaient les langues" en particulier anglais', Pierre Gaudibert, 'Des années 60', in Henri Cueco and Pierre Gaudibert, *L'Arène de l'art*, Paris, Galilée, 1988, p. 148.

23 'Est-ce la marque de leur origine judéo-chrétienne avec le culte de l'argent vécu comme chose sale?', Gaudibert, 'Du mécénat', ibid., p. 174; see also Jean Baudrillard, *La Société de consommation: ses mythes, ses structures*, Paris, Denoël, 1970 (*The Consumer Society: Myths and Structures*, London, Sage, 1998).

24 'L'isolement de cette génération de rupture, celle des années 1970 à 1975, était sans doute provoqué, sinon souhaité, par les artistes eux-mêmes. Nous étions fréquemment agressifs, et il a fallu l'obstination de quelques-uns conservateurs, journalistes, critiques etc., pour rompre cette solitude', Henri Cueco, 'Des années 60', in *Arène de l'art*, p. 156.

25 'Avec nos radicalisations "théoricistes" nées dans le climat du structuralisme, de *Tel Quel*, des travaux d'Althusser, de Lacan, nous avons contribué à l'embrasement du champ culturel avant et après 1968. En nous joignant à un mouvement extérieure à l'art, en participant à une secousse de l'histoire, nous vivions notre temps', ibid., p. 157.

26 See Louis-Dominique Girard, *La Guerre franco-française,* Paris, André Bonne, 1950; the concept of 'franco-french warfare' has subsequently gained great historical currency.

27 See Stéphane Courtois, Nicolas Werth, Jean-Louis Panné, Andrzej Paczkowski, Karel Bartosek, Jean-Louis Margolin et al., *Le Livre noir du communisme*, Paris, Robert Laffont, 1997 (*The Black Book of Communism*, trans. Jonathan Murphy and Mark Kramer, Cambridge, Mass., Harvard University Press, 1999). For the controversy and further reading see extensive Wikipedia entries in English and French.

28 Sarkozy's vow of 29 May 2007 had immense repercussions: see 'YouTube, Sarkozy 1968'. It was the provincial Musée des Beaux-Arts de Dole (with the École Nationale Supérieure des Beaux-Arts de Paris) which presented the most substantial exhibition, 'Les Affiches de Mai 68', 9 May–31 August 2008.

29 See Richard Mackey and Eugenio Donato, eds., *The Structuralist Controversy: The Languages of Criticism and the Sciences of Man*, Baltimore, Johns Hopkins University Press, 1970. François Cusset, *French Theory: How Foucault, Derrida, Deleuze & Co. Transformed the Intellectual Life of the United States*, trans. Jeff Fort, Minneapolis, University of Minnesota Press, 2008, p. 29, notes the coincidence with the special number of *Yale French Studies* on structuralism and the translation of Lévi-Strauss's *La Pensée sauvage*.

30 Cusset, *French Theory*, pp. 29–32.

31 *French Theory*, 2008, pp. 293, 323.

32 Jean-Clarence Lambert, '1967, l'époque postmoderne est déjà commencée', *Opus International*, 50, May 1974, p. 26.

33 'Chaque rencontre est aléatoire; non seulement dans ses origines (rien ne garantit jamais une rencontre), mais dans ses effets. Autrement dit tout rencontre aurait pu ne pas avoir lieu, mais son possible néant éclaire le sens de son être aléatoire', Louis Althusser, 'Le Courant souterrain du matérialisme de la rencontre' (1982), *Écrits philosophiques et politiques*, vol. 1, ed. François Matheron, Paris, Éditions Stock/IMEC, 1994, p. 566 ('philosophie de la rencontre' p. 561); Eng. edn 'The

Underground Current of the Materialism of the Encounter' (1982), *Philosophy of the Encounter: Later Writings, 1978–1987*, ed. François Matheron and Olivier Corpet, intro. and trans. G. M. Goshgarian, London and New York, Verso, 2006, p. 193 ('philosophy of the encounter' p. 188).

34 'Le catalogue de l'exposition *Courbet* du centenaire, largement répercuté sur les cimaises, évacue délibérément l'aspect politique de l'œuvre et l'engagement de l'artiste', Bernard Rancillac, 'Courbet 1977', *Opus International*, 65, winter 1978, p. 71. Philippe Comte's 'Courbet', ibid., pp. 67–70, mentions T. J. Clark's *Image of the People* (1973).

35 'Les Réalismes et l'histoire de l'art', organised by the Association Histoire et Critique des Arts, 3 and 4 December 1977; see 'Editorial', *Histoire et critique des arts*, 4–5, special number 'Les Réalismes et l'histoire de l'art', Besançon, May 1978, np.

36 Norman Bryson, ed., *Calligram: Essays in New Art History from France*, Cambridge University Press, 1988.

37 See 'The Neo-Avant-Garde' and '1972' in Hal Foster, Rosalind Krauss, Yve-Alain Bois, Benjamin Buchloh, *Art since 1900: Modernism, Antimodernism, Postmodernism*, London, Thames & Hudson, 2004, pp. 31 and 554ff.

38 *Dans l'œil du critique: Bernard Lamarche-Vadel et les artistes*, Musée d'art moderne de la Ville de Paris, 2009.

39 See Sarah Wilson, 'Poststructuralism', *Companion to Contemporary Art since 1945*, ed. Amelia Jones, Oxford, Blackwell, 2005, pp. 424–49.

40 See Sande Cohen and Sylvère Lotringer, eds., *French Theory in America*, London and New York, Routledge, 2001.

41 Rebecca J. De Roo's *The Museum Establishment and Contemporary Art: The Politics of Artistic Display in France after 1968*, Cambridge University Press, 2006. Yet Christian Boltanski's links with Monory were close: a joint show for the Festival d'Automne, Paris, October 1974; a twin appearance with Télémaque in the review *Chorus*, 11/12, 1974, etc.

42 See Clothilde Rouillier, 'Le Centre national d'art contemporain, du service artistique au Musée national d'art moderne, 1965–1983', unpublished, 2004, and CNAC catalogues.

43 *elles@centrepompidou*, ed. Camille Morineau, Paris, Centre Georges Pompidou, 2009, constituted from their collections (see n. 68 below), should be supplemented with Rakhee Balaram, *Femmes Révolutionnaires*: The Politics of Women's Art, Theory and Practice in 1970's France', PhD, University of London, 2009.

44 Catherine Millet contributed a text for *Pierre Klossowski*, ed. Sarah Wilson, London, Whitechapel Art Gallery, and Cologne, Ludwig Museum, 2006–7, prior to the Paris showing and a separate catalogue.

45 See Anne Bony, *Les Années 70*, Paris, Éditions du Regard, 1993, with a French focus yet important for its international comparisons. I refer also to the 'Visual Culture' agenda as understood in Anglo-American university departments.

46 Caroline Bissière and Jean-Paul Blanchet, *Les Années 70: les années mémoire. Archéologie du savoir et de l'être*, Centre d'Art Contemporain, Abbaye Saint-André, Meymac, Corrèze, 1985, was pioneering; the international mix, with Land Art, Arte Povera, Conceptual art and performance in *Les Années 1970: l'art en cause*, Musée d'Art Contemporain, Bordeaux, 2002, cannot convey the particular intensity of Parisian debates.

47 See Adrien Maeght, *Derrière le miroir*, Paris, Maeght, 1983; see also Jean-Marie Drot, ed., *Il Viaggio del dialogo, Le Voyage du dialogue: Adami-Lyotard, Cremonini-Jouffroy, Maselli-Scheffer, Peverelli-Glissant*, Rome, Villa Medicis, Carte Segrete, 1986, and Paul Virilio, *Klasen Virilio: Études d'impact = Impact inspections = Erkundung der Endzeit*, Angers, Expressions Contemporaines, 1999.

48 Yve-Alain Bois, 'Resisting Blackmail', *Painting as Model*, Cambridge, Mass., MIT Press, 1990, p. xvi. In 2004 the École Nationale Supérieure des Beaux-Arts, Paris, hosted the Association Forum de l'Essai sur l'Art's three-day conference, 'L'Essayiste: artiste ou chercheur' (17–19 November), with several distinguished contributions.

49 'l'existence d'une tradition matérialiste presque complètement méconnnue dans l'histoire de la philosophie: le "matérialisme"... *de la pluie, de la déviation, de la rencontre, et de la prise*' (*sic*)... disons pour le moment: un *matérialisme de la rencontre*, donc de l'aléatoire et de la contingence', Althusser, 'Courant souterrain', pp. 539–40; Althusser, *Philosophy of the Encounter*, p. 167.

50 Surely Althusser was inspired by the young Marx's readings of Lucretius and Epicurus for his *Dissertation* of 1841; perhaps he read Francine Markovits, *Marx dans le jardin d'Epicure*, Paris, Minuit, 1974, with her discussions of the *clinamen*, pp. 60–61, 80–81.

51 'En somme un pays atomisé... Il faut *créer les conditions d'une déviation*... il faut une autre rencontre: celle de la fortune et la "virtù" dans le Prince', Althusser, 'Courant souterrain', pp. 544–5.

52 'quand nous naissent conjointement des Hölderlin, des Goethe et des Hegel, quand éclate et triomphe la Révolution française jusqu'au défilé de Napoléon, l'"esprit du monde" sous les fenêtres de Hegel à Iéna... quand explode 1917 en russe', ibid., p. 569; *Philosophy of the Encounter*, p. 196.

53 Adrian Rifkin, 'A Space Between: On Gérard Fromanger, Gilles Deleuze, Michel Foucault and Some Others', in Gilles Deleuze and Michel Foucault, *Photogenic Painting, Gilles Deleuze, Michel Foucault, Gérard Fromanger, Photogenic Painting*, ed. Sarah Wilson, London, Black Dog Publishing, 1999, p. 36.

54 Restany's archives are now at the Archives de la Critique d'Art, Châteaugiron, which he helped to found in 1989. See Michèle C. Cone, 'The Early Career and Formative Years of Pierre Restany', and Romy Golan, 'Restany tous azimuts', in Tom Bishop, ed., *The Florence Gould Lectures*, vol. VI, 2002–4, New York University, 2004, and Richard Leeman, ed., *Le Demi-siècle de Pierre Restany*, ed. Richard Leeman, Paris, Institut national d'histoire de l'art and Éditions des Cendres, 2008.

55 See Jean-Marie Deparis, 'Histoire de l'ARC, 1967–1972', thesis, Paris I–Sorbonne, 1981, for the full range of ARC's activities, and Anabelle Ténèze, *Exposer l'art contemporain à Paris: l'exemple de l'ARC, au Musée d'art moderne de la Ville de Paris (1967–1988)*, 4 vols, Paris, École de Chartes, 2004, http://theses.enc.sorbonne.fr/document143.html

56 Jouffroy's papers are shared between the Archives de l'Art Contemporain, Châteaugiron, and the Institut Mémoire des Éditions Contemporaines, L'Abbaye d'Ardenne, near Caen.

57 Jean Clair, *Art en France: une nouvelle génération*, Paris, Éditions du Chêne, 1972. Gérard Regnier's exhibition 'Mélancolie', a summum of his work on realist painting since 'Les Réalismes entre Révolution et Réaction' (Centre Pompidou, 1981), was held at the Grand Palais in 2005 concurrently

with 'Dada' at the Pompidou. Since the advent of bilingual catalogues, his important work for the Museum of Fine Arts, Montreal, is available in English, unlike much of his pioneering work on Duchamp.

58 *Figurations critiques: 11 artistes des figurations critiques 1965–1975*, E.L.A.C., Lyon, 1992.

59 See Marie Luise Syring, '1960–1980 Critique politique, critique de l'image, contestation, détournement', and Gerald Gassiot-Talabot, 'De la Figuration narrative à la Figuration critique', in *Face à l'histoire: l'artiste moderne devant l'évènement historique, 1933– 1996*, Paris, Éditions du Centre Georges Pompidou, pp. 350–57 and 358–63.

60 Jean-Louis Pradel, *La Figuration narrative*, Paris, Hazan, 2000. The curator Robert Bonacorsi has held many retrospectives of 1970s realists at the Villa Tamaris.

61 Jean-Luc Chalumeau, *La Nouvelle figuration: une histoire, de 1953 à nos jours*, Paris, Éditions Cercle d'Art, 2003.

62 See Ch. 1, n. 15.

63 Raymond Perrot, *De la narrativité en peinture: essai sur la Figuration narrative et sur la figuration en général*, Paris, Éditions l'Harmattan, 2005; Michel Dupré, *Réalisme(s): peinture et politique*, Campagnan, Éditions EC, 2009. The group DDP (François Derivery, Michel Dupré and Raymond Perrot) first showed at the Salon de la Jeune Peinture in 1975. Their commitment to militant painting and an open and critical art history, often with a pedagogical tone, is unique in France and at last entirely available: see www.ddp-art-group.com

64 Serge July, *Gérard Fromanger*, Paris, Éditions Cercle d'Art, 2002; Bernard Ceysson, ed., *Gérard Fromanger 1962–2005*, Musée des Beaux-Arts de Dole, Villa Tamaris, La Seyne-sur-Mer, Éditions Somogy, 2005; Pascale le Thorel, *Jacques Monory*, Paris-Musées, 2006; Sarah Wilson, 'Fromanger, Deleuze, Bacon: o pinto o modelo;, *Gérard Fromanger: a imaginação no poder*, Centro Cultural Banco do Brasil, Brasilia, pp. 20–27.

65 See Daniel Sibony, *Peter Klasen: Nowhere Anywhere, Photographies 1970–2005*, Paris, Maison Européene de la Photographie, Éditions Cercle d'Art, 2005.

66 Josette Rasle, ed., *Hervé Télémaque: du coq à l'âne*, Paris, Musée de la Poste/École Nationale Supérieure des Beaux-Arts, 2005.

67 As precedent, see Irit Rogoff, 'The Aesthetics of Post-History: A German Perspective', in Stephen Melville and Bill Readings, eds., *Vision and Textuality*, Hong Kong, Macmillan, 1995, pp. 121–2. She rebuts the accusation of providing a 'legitimating narrative' for Jorg Immendorf.

68 See e.g. 'elles@centrepompidou', Paris, Centre Georges Pompidou, 25 May–31 December 2009.

69 See Preface, n. 8, and Philippe Dagen, *Nos femmes (Erró, Lebel, Rancillac, Télémaque)*, Athens, Frissiras Museum, 2005.

70 *Ruth Francken*, Paris, Hôtel Drouot, Olivier Doutrebente, 20–21 September 2007, reprints my essay which discusses her long relationship with Jean-François Lyotard, 'The Song of Ruth', in *Ruth Francken*, Sprengel Museum, Hanover, pp. 129–31.

71 Ruth Francken, 'Mirrorical Return (an expression borrowed from Marcel Duchamp)', *Ruth Francken: anti-castrateur, Black Bread, Mirrorical Return*, Neue Galerie, Sammlung Ludwig, Aix-la-Chapelle, 1978, np.

72 'un genre qui est et reste masculin, le genre "essai"… masculin… est un corps qui peut mourir… Les hommes (de l'Occident, au moins) n'aiment pas aimer mais vaincre. Il règne entre eux le mépris et l'ironie pour les choses du corps sensuel, pour les odeurs, le toucher, les sécrétions; ils appellent "artistes" ceux d'entre eux qui y consentent. Mais les artistes sont les femmes', Jean-François Lyotard, 'Écriture mâle', a section of 'Feminité dans la métalangue' ('Eventi 75', *Annuario 76*, Archives of the Venice Biennale, p. 925), *Rudiments païens*, Paris: Union Générale des Éditions, 10/18, 1977, pp. 213, 216, 218, 230.

73 I refer to the Frenchman Serge Guilbault's Promethean title, *How New York stole the Idea of Modern Art: Abstract Expressionism, Freedom and the Cold War*, University of Chicago Press, 1983.

74 'Un vote de l'ONU un jour dénoncera la primauté donnée aux discours théorique comme sexisme mâle, au grand scandale de… nous tous' (one day a United Nations vote will denounce the primacy given to theoretical discourse as male sexism, a great scandal for us all'), Lyotard, *Rudiments païens*, p. 230.

75 Françoise d'Eaubonne, *Féminin et philosophie (une allergie historique)*, Paris, Éditions l'Harmattan, 1997, pp. 10 ff. Her use of Robert Antelme's *L'Espèce humaine* of 1947 and the argument of a concentrationary universe of 'bare life' within this context is especially challenging.

Interlude: *The Datcha*

1 'Louis Althusser, hesitant d'entrer dans la datcha *Triste Miels* de Claude Lévi-Strauss ou sont réunis Jacques Lacan, Michel Foucault et Roland Barthes au moment ou la radio annonce que les ouvriers et les étudiants ont décidé d'abandonner joyeusement leur passé./… Une datcha est une maison de campagne russe./Beaucoup d'intellectuels soviétiques on été consignés pendant l'essentiel de leur vie dans des datchas pour des raisons diverses. Les considérant comme douteux sans les condamner expressément le pouvoir les maintenait – et les maintient encore – à l'écart de la vie publique afin d'éviter qu'ils nuisent en se mêlant de ce qui ne les regarde pas./Une datcha est donc une résidence secondaire qui risque de devenir une résidence principale./Ici aussi, dans le monde "libre", les difficultés de la vie risquent de pousser chacun de nous à se mêler de ce qui ne le regarde pas. C'est pourquoi une publicité intense encourage chacun à passer le maximum de temps dans la calme retraite des champs./Les intellectuels qui ont à la fois plus de temps que les autres et besoin de toujours plus de temps pour mieux réfléchir, se précipitent vers ces résidences secondaires. C'est là, dans le silence et la paix de la méditation, qu'ils courent évidemment le plus grand danger. Ils risquent de s'apercevoir un jour, brusquement, qu'on ne leur a pas demandé leur avis pour passer à l'action et pour se mêler enfin de ce qui nous concerne tous./Personnages:/- Louis Althusser, *philosophe marxiste*./- Claude Lévi-Strauss, *ethonologue*.[sic]/*Professeur au Collège de France. Candidat à l'Académie Française*./- Jacques Lacan, *psychanalyste*./- Michel Foucault, *philosophe. Professeur au Collège de France*/- Roland Barthes, *critique et essayiste. Professeur à l'École Pratique des Hautes Études*', Gilles Aillaud, *Écrits, 1965–1983*, ed. Pierre Buraglio, Valence, Éditions 127, 1987, p. 26, incorrectly ascribed here to the *Bulletin de la Jeune Peinture* 5, 1969. The reason for the abbreviation of this passage (apart from space) in the *Bulletin* is unclear. Aillaud attended Althusser's classes at the École Normale Supérieure, Paris.

2 'une résidence secondaire permanente où, dans un décor particulièrement recherché, la plénitude d'une nature exceptionelle favorise la création des structures', in *Bulletin de la Jeune Peinture* 5, 1969, p. 15. See also Francis Parent and

Raymond Perrot, *Le Salon de la Jeune Peinture: une histoire, 1950–1983*, Montreuil, Éditions JP, 1983, p. 110.

3 Louis Althusser, *Pour Marx*, and *Lire 'le Capital'* (with collaborators), published in September and November 1965 respectively, Paris, Maspéro, and Jacques Bidet, 'La Lecture du *Capital* par Althusser', in *Althusser philosophe*, Paris, PUF, 1997, p. 11.

4 See Maurice Corvez, *Les Structuralistes*, Paris, Aubier-Montaigne, 1969. 'Les linguistes' discussed Michel Foucault, Claude Lévi-Strauss, Jacques Lacan and Louis Althusser.

5 See Vlada Traven, *La Datcha en Russie de 1917 à nos jours*, Paris, Éditions du Sextant, 2005.

6 Chased from the Sainte Anne hospital, Lacan gave his first lecture at the École in January 1964. Althusser there demonstrated his strategy of making new, anti-structuralist allegiances; his own 'Freud et Lacan' appeared in the Communist review *La Nouvelle Critique*, 161–2, December 1964–January 1965 (reprinted as *Positions*, Paris, Éditions Sociales, 1976; trans. in *New Left Review*, 55, May–June 1969, and subsequently). Following his first personal analysis (1950–63), Althusser recommended with René Diatkine in October 1964. He read Lacan's texts scrupulously, long before the publication of the latter's *Écrits* in 1966.

7 See Pierre Vilar et al., *Dialectique marxiste et pensée structuraliste: tables rondes à propos des travaux d'Althusser*, Paris, Les Cahiers du Centre d'Études Socialistes, 1967.

8 Raymond Aron, the adversary of both the Communists and Althusser's 'pseudo-structuralist reading of Marx', was writing as director of studies at the École Pratique des Hautes Études; see *D'une sainte famille à l'autre: essais sur les marxismes imaginaires*, Paris, Gallimard, 1969.

9 'On voit alors mieux pourquoi il ne fut guère apprécié par le groupe de peintres communistes et comment il fallut toute l'autorité morale et organisationelle en particulier d'Aillaud et Arroyo pour qu'il puisse se terminer', Parent and Perrot, *Salon de la Jeune Peinture*, p. 110.

10 See Pierre Bourdieu, *La Noblesse d'état: grandes écoles et esprits de corps*, Paris, Minuit, 1989; published as *The State Nobility: Elite Schools in the Field of Power*, Oxford, Polity Press, 1996, the same year as Niilo Kauppi's analysis (see n. 11 below).

11 Niilo Kauppi, *French Intellectual Nobility: Institutional and Symbolic Transformations in the Post-Sartrian Era*, Albany, State University of New York Press, 1996, a superbly detailed and well argued study. The impact of Ezra Suleiman as precursor deserves fuller acknowledgement: *Politics, Power and Bureaucracy in France: The Administrative Elites*, Princeton University Press, 1974 (*Les Haut fonctionnaires et la politique*, Paris, Seuil, 1976), and *Elites in French Society: The Politics of Survival*, Princeton University Press, 1978 (*Les Elites en France: grands corps et grands écoles*, Paris, Seuil, 1979).

12 See my Conclusion below.

13 Louis Aragon's illustrated series of articles, 'Réflexions sur l'art soviétique', *Les Lettres françaises*, February–April 1952, are partially censored in Louis Aragon, *Écrits sur l'art moderne*, ed. Jean Ristat, Paris, Flammarion, 1981.

14 Conversation with Lucio Fanti, 7 January 2008.

15 Jean-Luc Chalumeau, *Nouvelle figuration*, p. 26, recounts that Biras and Rieti were asked to copy the Duchamp works and that Fromanger gave a hand. Chalumeau offers an extensive illustrated analysis of the other painters involved in the 1965 show, pp. 23–40. For the first retrospective view of the controversy see Gérald Gassiot-Talabot, 'Persistent et signent',

Opus International, 49, March 1974, pp. 97–9, and the texts by the artists included with the article. Ian Fleming's *Live and Let Die* (London, 1954) appeared as *Requins et services secrets* (Paris, Presses Internationales, 1959), as *Vivre et laisser mourir* (Paris, Plon, 1964) and as a film released in France in 1973. See also Jill Carrick, 'The Assassination of Marcel Duchamp: Collectivism and Contestation in 1960s France', *Oxford Art Journal*, 31/1, 2008, pp. 17–24.

16 Michel Foucault was elected to the Collège de France in December 1970; perhaps Aillaud wrote this longer explanation of *Le Datcha* after the 1969 *Bulletin* 5 was published.

17 See catalogue of the 14th Salon de la Jeune Peinture, 1963, with its homage to the 80-year-old critic Georges Besson, and Girod de l'Ain's Bonnard-like still life (illustrated), np.

18 See Sarah Wilson, 'Politique et vanitas: Lucien Fleury et les Malassis', in Anne Dary, ed., *Lucien Fleury 1928–2005*, Musée des Beaux-Arts de Dole, 2007, pp. 10–43.

19 Daniel Anselme, *Une Passion dans le desert*, Paris, Galerie Saint-Germain, January 1965.

20 'La Figuration narrative dans l'art contemporain', 1–29 October 1965; see Jean-Michel Ameline, ed., *Figuration narrative, Paris 1960–1972*, Paris, Réunion des Musées Nationaux and Centre Georges Pompidou, 2008, pp. 91–5.

21 For Duchamp's exchange with Pierre Cabanne (*Entretiens avec Marcel Duchamp*, Paris, Pierre Belfond, 1967, p. 194) see Chalumeau, *Nouvelle figuration*, p. 40.

22 While Recalcati provides the link, he was completely drunk, effacing Wifredo Lam's contribution the night before the vernissage: see Jean-Jacques Lebel, 'La Plaie ouverte', in Laurent Chollet, Enrico Baj et al., *La Grande peinture antifasciste collective*, Paris, Dagorno, 2000, p. 22. Lebel retrieved the work from the Milan police in 1987; it was restored and exhibited in Paris in 'La France en Guerre d'Algérie', Hôtel des Invalides, 1992, and 'Face à l'Histoire', Centre Geroges Pompidou, 1996.

23 Ibid., pp. 42–3, and Maurice Blanchot, *Écrits politiques, 1953–1994,* ed. Eric Hoppenot, Paris, Gallimard, 2008, ch. II, 'La guerre d'Algérie, autour du "Manifeste des 121"' (1960), pp. 45–88.

24 This moment of high symbolism, involving the financing of hundreds of intellectuals, is not mentioned in Pierre Grémion's study of the riposte to Kominform world-wide cultural activity, *L'Intelligence de l'anticommunisme: les congrès pour la liberté de la culture 1950–1975 à Paris*, Paris, Fayard, 1995.

25 For the 'Congresso Cultural de Havana: Reunion de intellectuales de todo el mundo sobre las problemas de Asia, America y America Latina' see Gérald Gassiot-Talabot 'La Havane: peinture et révolution'; Alain Jouffroy, 'Che' Si'; 'Congrès Culturel de la Havane', *Opus International*, 3, October 1967, pp. 14–17, 21–31, 33. Restored, the *Collective Cuban Mural* was shown for the first time abroad in 2008: see *Cuba! Art and History from 1868 to Today*, Montreal, Museum of Fine Art, 2008.

Chapter 1
From Sartre to Althusser

1 'Victimes, bourreaux: le peintre fait notre portrait. Le portrait du siècle en somme. En même temps, l'objet de son art n'est plus l'individu. Ni le typique. C'est la singularité d'une époque et sa réalité. Comment Lapoujade a-t-il réussi, par les exigences même de l'"abstrait", ce que le figuratif n'a jamais pu faire?' Jean-Paul Sartre, untitled, in 'Lapoujade: peintures sur le

thème des *Emeutes, Triptyque sur la torture, Hiroshima*', Paris, Galerie Pierre Domec, 10 March–15 April 1961, np; reprinted as 'Le peintre sans privilèges' in *Situations IV*, Paris, Gallimard, 1964, pp. 364–86.

2 J'ai commencé la préface à ces deux tomes sur *Le Capital*, et je me trouve engagé dans une nouvelle entreprise, ayant découvert qu'il m'était indispensable d'y développer, pour expliquer comment nous avons *lu Le Capital*, toute une *théorie de la lecture*, pour laquelle naturellement j'avais des points d'appui antérieurs (ce que j'avais suggéré dans le papier sur Leonardo [Cremonini]… Ce sera une théorie de la *lecture symptomatique* dans le domaine epistémologique', Louis Althusser, *Lettres à Franca (1961–1973)*, ed. François Matheron and Yann Moulier Boutang, Paris, Éditions Stock/IMEC, 1998, letter of 18 April 1965, p. 611.

3 Pierre Gaudibert, 'Leonardo Cremonini', in Bernard Lamarche-Vadel, ed., *Figurations 1960–1973*, Paris, Union Générale des Éditions, 10/18, 1973, pp. 29–49.

4 Mauricette Berne, ed., *Sartre*, Paris, Bibliothèque Nationale de France and Gallimard, 2005, had no wish to compete with the superbly illustrated numbers of *Obliques*: 'Sartre', 18–19, 1979, and 'Sartre et les arts', 24–5 (Nyons, Éditions Borderie), 1981, both ed. Michel Sicard with 'mirrorical return' portrait covers by Ruth Francken, essential supplements to this chapter. See also Michel Contat's album, *Sartre: 'invention de la liberté*, Paris, Éditions Textuel, 2005.

5 See Sarah Wilson, 'La Bataille des "humbles"? Communistes et catholiques autour de l'art sacré', in Barthélémy Jobert, ed., *Mélanges en l'honneur de Bruno Foucart*, vol. 2, Paris, Éditions Norma, 2008, pp. 3–21, and Walter M. Abbott, ed., *The Documents of Vatican II in a New and Definitive Translation*, New York, Guild Press, 1966.

6 See Sarah Wilson, 'Under the Sign of Sartre' in 'Paris Post War: In Search of the Absolute', *Paris Post War: Art and Existentialism*, London, Tate Gallery, 1992, pp. 25–52.

7 See Alec Mellor, *La Torture: son histoire, son abolition, sa réapparition au XXème siècle*, Paris, Éditions Domat Monchrestien, 1949, and Rita Maran, *Torture: The Role of Ideology in the French-Algerian War*, New York, Praeger, 1989.

8 See Maurice Merleau-Ponty, *Humanisme et terreur: essai sur le problème communiste*, Paris, Gallimard, 1947.

9 Frantz Fanon, *Peau noir, masques blancs*, Paris, Seuil, 1952 (*Black Skin, White Masks*, New York, Grove Press, 1967 and reprints).

10 See Frantz Fanon, 'Racisme et Culture' address to the first Congrès des écrivains et artistes noirs, Paris, September 1956, in *Présence africaine*, 8-9-10, June–November 1956, pp. 122–31.

11 See Michel Contat and Michel Rybalka, *Les Écrits de Sartre: chronologie, bibliographie commentée*, Paris, Gallimard, 1979, p. 313, for the 'Portrait du colonisé', *Les Temps modernes*, 137–8, July–August 1957, pp. 289–93, and reprints including Eng. edns (1965, 1966); pp. 323–32 for the *Sequestrés d'Altona* and ensuing controversies; see also Interlude, n. 23 above, for Blanchot's manifesto.

12 Frantz Fanon, *Les Damnés de la terre*, Paris, Maspéro, 1961; *The Damned*, foreword by Jean-Paul Sartre, *Présence africaine*, 1963, republished as *The Wretched of the Earth*, London, MacGibbon and Kee, 1965; see Contat and Rybalka, *Écrits de Sartre*, pp. 360–61.

13 Inspired by Tintoretto from 1933, his interest rekindled by Jean Vuillemin's 'La Personalité ésthétique du Tintoret', *Les Temps modernes*, 102, May 1954, Sartre published

his first existential analysis of 'Le Sequestré de Venise' in *Les Temps modernes* in 1957; the first part of the MS for 'Saint Marc et son double' may be dated (imprecisely) to 1961; it was published (with critical essays) in *Obliques: Sartre et les arts*, 1981, pp. 171–202.

14 Louis Aragon, 'L'Art et le sentiment nationale' Paris, Éditions Les Lettres Françaises et Tous les Arts, 1951.

15 See Jean Rollin, 'Triomphe du réalisme au Salon d'Automne', *La Patrie*, 9 November 1952, with photograph of Miailhe's painting.

16 See Pascale Froment and Isabelle Rollin-Royer, *Mireille Glodek Miailhe: Œuvres*, Paris, Biro Éditeur, 2007, part II, 'Engagement'.

17 'La classe ouvrière… a déchiré le voile qui separait le monde des arts de ses propres préoccupations', Boris Taslitzky, 'L'Art et les traditions nationales', *La Nouvelle Critique*, 32, January 1952, p. 72.

18 See Frantz Fanon, *L'An V de la révolution algérienne*, Paris, Maspéro, 1960, and Boris Taslitzky, *Algérie 52*, Paris, Éditions Cercle d'Art, 1953, np. The show toured to Bucharest, Budapest and Prague.

19 'reine d'une infinité de possibles: l'*informe*. [Note: Nous devrions dire: l'inconnu, l'inclassé… puisque le forme est le devenir de l'informe]', Robert Lapoujade, *L'Enfer et la mine*, Paris, Galerie Arnaud, October–November 1952, np.

20 'On pouvait voir Robert Lapoujade attablé dans les cafés du quartier latin, et interviewant tantôt Gilles Deleuze, tantôt François Châtelet, Jean-François Lyotard (qui venait de faire paraître un "Que sais-je?" sur ce sujet) et d'autres, dans l'espoir d'une réponse à la question: qu'est-ce que le sens? Fut-il déçu? Pas entièrement, car il a pu s'apercevoir, à l'ombre de la philosophie d'Edmund Husserl, que si les formes, notamment picturales, sont des "moules creux", une ou des significations viennent *immédiatement* se couler en elles', Olivier Revault d'Allonnes, 'Robert Lapoujade, un peintre rêveur et citoyen', *Robert Lapoujade (1921–1993): le provocateur solitaire*, Montauban, Musée Ingres, 1996, pp. 9 and 14. His recollections refer to Lyotard's first publication, *La Phénoménologie*, Paris, 'Que sais-je?', PUF, 1954.

21 'l'informe est partout autour de nous, que le temps tranquillement renouvelle. Les murs, les plafonds, les vieilles portes, les agglomérées, les matériaux les plus divers, les végétaux usés, déssechés, rabotés, fendus, éclatés, la boue, la tache, le sec, l'humide, le sale même, tout cela éparpillé, craquelé, coloré, en mouvement ou statique, nous montre une figure étrange, sa diversité, son insolite et apparemment inutile chaos.' Robert Lapoujade, *Le Mal à voir*, Paris, Le Messager Boiteux de Paris, 1951.

22 Sartre, 'Une idée fondamentale de la phénoménologie de Husserl: L'Intentionalité' in *La Nouvelle revue française*, 304, January 1939, pp. 129–31, reprinted in *Situations* I: Surrealism, Tintoretto, Giacometti, all are here. See Renato Barilli, 'Sartre et ses "Phares"', *Sartre e l'arte, ommagio a J.-P. Sartre*, Rome, Villa Medicis, Edizioni Carte Segrete, 1987, pp. 143–4, 'cet essai fonctionne comme un module de conversion'.

23 See Robert Lapoujade, *Mécanismes de fascination*, Paris, Seuil, 1955, and Maurice Merleau-Ponty, 'Le Doute de Cézanne', *Fontaine*, 47, December 1945, and in *Sens et non-sens*, Paris, Éditions Nagel, 1948.

24 A contemporary of Sartre and Raymond Aron at the École Normale Supérieure, Jean Hyppolite taught Foucault, who ultimately succeeded him at the Collège de France. Lapoujade mixed with other erudite figures from academe and the church

when he gave his paper 'Le Sens et le non-sens dans la peinture abstraite' (note the Merleau-Ponty reference), in Jean Jacquot, ed., *Visages et perspectives de l'art moderne*, preface by Etienne Souriau, Entretiens d'Arras, 20–22 June 1955, Paris, Éditions du Centre National de la Recherche Scientifique, 1956, pp. 45–52.

25 See Hubert Juin, *Seize peintres de la jeune école de Paris*, Paris, Musée de Poche (collection organised by the art critic close to Cobra, Jean-Clarence Lambert). Lapoujade takes his place with semi-abstract contemporaries: Nallard, Moser, Sugai, Corneille, Chelimsky, Gillet, Doucet, Arnal, Alechinsky, Martin Barré, Camille, Bertini, Maryan, Levee and Huguette Arthur-Bertrand.

26 George Howard Bauer, *Sartre and the Artist*, University of Chicago Press, 1969, pp. 129–35, discusses Lapoujade in terms of Sartre's ruminations on Italian painters, with no understanding either of the *informel* as style or discourse, nor of the political context.

27 'Le tableau ne fera rien *voir*. Il laissera l'horreur descendre en lui, mais *seulement s'il est beau*; cela veut dire: s'il est organisé de la manière la plus complexe et la plus riche. La précision des scènes évoquées dépend de la précision du pinceau; qu'on reserre et regroupe ce concert de stries, ces couleurs si belles et pourtant sinistres, c'est la seule manière de faire *épouver* le sens de ce que fait pour Alleg et Djamila leur martyre… Rien n'apparaît sinon, derrière une Beauté radieuse et grâce à elle, un impitoyable Destin que des hommes – nous – ont fait à l'homme', Sartre, 'Lapoujade'.

28 Sartre, 'Saint Genet, comedien et martyr', in Jean Genet, *Œuvres complètes*, vol. 1, Paris, Gallimard, 1952.

29 See Anna Boschetti, *The Intellectual Enterprise: Sartre and Les Temps Modernes*, trans. Richard C. McCleary, Evanston, Il., Northwestern University Press, 1988, p. 142.

30 Sartre, 'Le Fantôme de Staline, *Les Temps modernes*, 129–31 ('La Révolte de la Hongrie'), November 1956–January 1957, pp. 577–697. From November, Sartre publically denounced not only the Soviet invasion but the PCF's direction: 'thirty years of lies and sclerosis' in 'Après Budapest, Sartre parle', *L'Express*, supplement to no. 281, 9 November 1956. See Contat and Rybalka, *Écrits de Sartre*, pp. 304–9, including *The Spectre of Stalin*, trans. Irene Clephane, London, Hamish Hamilton, 1969.

31 'Plus que d'autres, la sphère de la peintures est en effet pour Althusser celle de l'amitié, d'un réseau d'amitiés qu'il ne tient pas à mêler de trop prés à ses fréquentations philosophiques et politiques', François Matheron, ed., in Louis Althusser, *Écrits philosophiques et politiques*, vol. II, Paris, Éditions Stock/IMEC, 1995, p. 32.

32 Francis Mulhern, 'Message in a Bottle: Althusser in Literary Studies', in Gregory Elliott, ed., *Althusser: A Critical Reader*, Oxford, Blackwell, 1994, pp. 161–2.

33 For Poland's 'satellite' position, see Katarzina Murawska-Muthesius, 'Paris from behind the Iron Curtain', in Sarah Wilson, ed., *Paris, Capital of the Arts, 1900–1968*, London, Royal Academy, 2002, pp. 250–61.

34 See Pierre Grémion, *L'Intelligence de l'anticommunisme: les congrès pour la liberté de la culture à Paris, 1950–1975*, Paris, Fayard, 1995.

35 Cremonini showed in New York with the gallerist Catherine Viviano, an associate of Pierre Matisse.

36 See *Cremonini*, Paris, Galerie du Dragon/Galerie Lacloche, 1960; *Cremonini*, text by Pierre Gaudibert, Paris, Galerie du Dragon, 1961, np. The relationship between the

two paradigms of cruelty, the *abattoir* and man-made war, traversed Gaudibert's writing on the artist, culminating in his major 'Leonardo Cremonini' in Lamarche-Vadel, *Figurations 1960–1973*.

37 Interview with Leonardo Cremonini, 8 March 2005. Cremonini himself was not a Communist; his later engagement with the party in 1974, lasting two years, was abruptly halted over a US visa issue.

38 Rubin's change of taste from Cremonini, Giacometti and Matta to Frank Stella was linked to his change of public profile.

39 See n. 2 above.

40 Althusser, 'La Place de la psychanalyse dans les sciences humaines', in Olivier Corpet and François Matheron, eds., *Psychanalyses et sciences humaines*, Paris, Livre de Poche, 1996, pp. 31–3.

41 La Nona (the grandmother) was from the 'aristocracy' of the Milanese working class; her son Mino was a member of the Italian Communist Party (PCI) and the youngest son Tedo composed political songs and music for the theatre. Franca, Mino's wife and the mother of four children, had studied philosophy and was a distinguished translator of many French writers (Pierre Klossowski, Prevert, Genet, Beckett, Merleau-Ponty, Lévi-Strauss, Gérard Genette, Philippe Sollers, Alexis de Tocqueville). She founded Il Teatro Minimo in an abandoned church in the Communist municipality of Forli, where plays by Pirandello, Brecht, Genet, Ionesco and Beckett were performed.

42 'mais pour ça il fallait que je connaisse un peu la peinture moderne, que, inculte que je suis, naturellement j'ignorais… Mais ça *m'interesse*', Althusser, *Lettres à Franca*, letter from Boulogne-sur-Seine, 15 June 1962, p. 181.

43 'un qui représente un homme et une femme qui viennent de faire l'amour, admirable tableau coupé en deux à la Leonardo', ibid., letter of 24 July 1962, p. 195.

44 Franca Madonia, in ibid., letter of 4 August 1962, pp. 202–3.

45 José Pierre, 'A l'étonnement du colibri', *Alvarez Rios*, Paris, La Cour d'Ingres, 1962 (with links to the sculptor Augustin Cardenas and Wifredo Lam, who solicited a short text from Althusser in 1978 via this gallery). See also *Roberto Alvarez-Rios*, Maison de la Mine de Ronchamp, 1982.

46 Althusser met Alvarez-Rios via the latter's brother who trained as a lawyer in France and held a post at UNESCO; the painter and his wife were invited to Althusser's to dine and the relationship continued by correspondence. Interview with Alvarez-Rios, 3 September 2006.

47 'Les toiles bouleversantes d'Alvarez-Rios, jeune peintre de Cuba, nous posent une nouvelle fois *la question du surréalisme*… Trente et un ans. Vingt-sept ans de sa vie à la Havane. Études classiques aux Beaux-Arts. Rêvant de Rembrandt, Cézanne, van Gogh, Picasso. En *1950*, toujours à la Havane, rencontre de *Lam*, dont l'exposition le marque. En *1958* Paris. Rios travaille dans un sous-sol de la Cité universitaire, dans sa chambre (il est marié), sans espace, presque sans lumière', Althusser, 'Devant le surréalisme: Alvares Rios' (*sic*), *Les Lettres françaises*, 954, 29 November–6 December 1962; 'Un jeune peintre cubain devant le surréalisme: Alvarès Rios'(*sic*); and *Écrits philosophiques*, II, pp. 569–70. No ms or typescript exists in the Althusser archives, IMEC, Abbaye de l'Ardenne, France.

48 'ses messes et son latin, sa syntaxe et son vocabulaire', ibid., p. 569.

49 Louis Althusser, 'Lam', in ibid., p. 599: 'du cri muet d'un peuple écrasé par des siècles d'histoire. Dans l'humilité un tel refus d'humiliation, dans la paix la tension d'une telle violence.' The text was writtten at Lam's request for a retrospective at the Maison de la Culture, Nanterre, April 1978 (cancelled), published posthumously for the touring retrospective, Madrid, Paris, Brussels, 1982–3 (see ibid., notes, p. 597).

50 'profondes affinités avec le passé vivant d'un monde, avec la matière d'une vie populaire toute proche… Le discours d'une histoire naissante, qui parle des hommes et de la nature, des esclavages et des maîtres d'une histoire perdu, perverse, dont on voulait à toute force apprivoiser le sens', Althusser, 'Devant le Surréalisme', ibid., p. 571.

51 '*deux façons de parler le même langage*… La naïveté, ou ce qui est tout un, la profondeur de cette peinture, est *aussi* de parler de soi, et de l'avenir de Rios, ce peintre *qui peut être grand*', ibid., p. 572.

52 Michel Ragon on 'Artistes Latino-Américains', Musée d'art moderne de la Ville de Paris, 1965 (unidentified press-cutting in the Alvarez-Rios archives).

53 Cremonini and 'X', 'Artisanat populaire et artisanat colonisé', *Révolution*, November 1963, pp. 76–9 (not included in *Écrits philosophiques*, vol. II. Thanks to Leonardo Cremonini for this information).

54 Althusser, *Lettres à Franca*, p. 51: a dramatic letter of 9 October 1961 refers to a dinner with Gaudibert and tells Claire (his friend, displaced by Franca) to see the Biennale de Paris 'au Trocadéro'. The 'Deuxième Biennale de Paris', Musée d'art moderne de la Ville de Paris, 29 September–5 November 1961, showed works by artists under 35 from more than fifty countries, included Jasper Johns's number paintings, David Hockney's *Cleopatra*, an Arman *poubelle*, Martial Raysse's *Hygiene of Vision* plastic assemblage.

55 Umberto Eco, *Opera aperta*, Milan, Bompiani, 1962.

56 'Segna la nascita di un nuovo sguardo dell'uomo', Pierre Restany, 'Mimo Rotella', *La Biennale di Venezia*, Venice, 20 June–18 October 1964, official catalogue, pp. 109–10.

57 Marco Valsecchi, 'Leonardo Cremonini', in ibid., pp. 111–12.

58 'Comme je me trouvais dans la salle de la Biennale de Venise ou Cremonini exposait d'admirables toiles, deux Français entrèrent, jetèrent un bref regard, et prirent la porte, l'un disant à l'autre: "Sans intérêt: expressionisme!"', Louis Althusser, 'Cremonini peintre de l'abstrait', *Écrits philosophiques*, p. 574. Althusser's first paragraph is excluded from most reprints.

59 Michel Troche, 'Venise découvre après Paris: Cremonini', *Les Lettres françaises*, 25 June 1964; for Moore and Marini see K.-A. Jelenski, 'Les Miroirs de Leonardo Cremonini', *Preuves*, 161, July 1964, p. 80.

60 'dirigisme culturel… un manichéisme sommaire', Michel Troche, 'A propos du caractère spécifique de l'art', *La Nouvelle Critique*, 156–7, June–July 1964, in Troche, *Écrits*, Paris, Éditions du Regard, 1993, pp. 9–22; Troche became Inspecteur Principal des Beaux-Arts au Ministère des Affaires Culturelles in 1973.

61 Compare Troche's later article, 'La Parole à Leonardo Cremonini', *La Nouvelle Critique* 39, January 1970, pp. 37–44.

62 Louis Althusser, 'Leonardo Cremonini', trans. and cut by Richard Heipe, *Tendenzen: Zeitschrift für engagierte Kunst* (Munich), 32, May 1965, p. 60, illustrations pp. 62–4.

63 See Althusser, 'Le Miroir', MS of reading notes, referring to Lacan's 'mirror stage', *Revue française de psychanalyse*, 1949, pp. 449–559. Referred to in Olivier Corpet and François Matheron, eds., *Écrits sur la psychanalyse*, Paris, Éditions Stock/IMEC, 1993, p. 307 (a listing of IMEC archive contents not in the English translation).

64 See Frédérique Matoni, 'Rois-philosophes ou conseillers du Prince?', *Intellectuels communistes: essai sur l'obéissance politique. La Nouvelle Critique (1967–1980)*, Paris, La Découverte, 2005, pp. 59–91 for a discussion of the Althusser–Garaudy confrontation in the framework of Communist publishing politics.

65 Jean-Paul Sartre, *L'Existentialisme est un humanisme*, Paris, Nagel, 1946 (*Existentialism and Humanism*, trans. Philip Mairet, London, Methuen, 1948); Jean Kanapa, *L'Existentialisme n'est pas un humanisme*, Paris, Éditions Sociales, 1947; Emmanuel Mounier, *Introduction aux existentialismes* (1947) was serialised in the Catholic review *Esprit* from October 1946. See also *Pour un nouvel humanisme,* Rencontres Internationales de Genève, Neuchatel, Éditions de la Baconnerie, 1949 (with the theologian Karl Barth, the Marxist Henri Lefebvre and the Orientalist René Grousset); Pierre Bigo, *Marxisme et humanisme*, Paris, PUF, 1953, and Roger Garaudy, *Humanisme marxiste*: cinq essais polémiques, Paris, Éditions Sociales, 1957. Beyond France, see Erich Fromm, ed., *Socialist Humanism: An International Symposium*, New York, Doubleday, 1965, etc. For an extensive argument and bibliography see Robert Geerlande, *Garaudy et Althusser: le débat sur l'humanisme dans le parti communiste français et son enjeu*, Paris, PUF, 1978.

66 Louis Althusser, 'Marxisme et humanisme' (October 1963), *Cahiers de l'Institut des sciences économiques appliqués*, 20, June 1964, pp. 109–33. Althusser's first writing followed the celebrated 'Manege' scandal in Moscow (December 1962) and Khrushchev's hard-line speech against intellectual freedom (8 March 1963). Khrushchev was deposed in October 1964, before *La Nouvelle Critique*'s dossier of March 1965. For an exegesis see Saul Karsz, *Théorie et politique: Louis Althusser*, Paris, Fayard, 1974, pp. 147–63.

67 '"Ma méthode analytique ne part pas de l'homme, mais de la période sociale économiquement donné", Marx, notes sur Wagner, *Le Capital* (1881)', Althusser, 'Marxisme et humanisme', reprinted in *Pour Marx*, Paris, Maspéro, 1965, pp. 225–49.

68 See *La Nouvelle Critique*, 164, March 1965, containing a reprint of Althusser's 'Marxisme et humanisme', pp. 1–21, and in response a reprint of Jorge Semprun, 'L'Humanisme socialiste en question' (*Clarté*, 58, organ of the Union des Etudiants Communistes, January 1965), pp. 22–31, followed by Althusser's 'Note complémentaire sur l'humanisme réel', pp. 32–9.

69 See François Matheron on Michel Verret's dossier on the Choisy Conference sent to Althusser, in 'Louis Althusser et Argenteuil: de la croisée des chemins au chemin de croix', *Annales de la Société des amis de Louis Aragon et Elsa Triolet*, 2, 2000, pp. 169–80, as revised in 2005 http://www.caute.lautre.net/spip.php?article769 ('Aragon et la comité central d'Argenteuil'); see references in Althusser, *Écrits philosophiques*, pp. 523–4.

70 Roger Garaudy, *De l'anathème au dialogue: un marxiste s'adresse au Concile*, Paris, Plon, 1965.

71 See 'Deux lettres sur la connaissance de l'art', *La Nouvelle Critique*, 175, April 1966, pp. 136–7. André Daspré's letter to Althusser focuses on figures who dominated art debates of the 1950s – Picasso, Aragon, Lurçat, Léger, Eluard – raising questions surely long superseded for Althusser, hence the latter's unilluminating reply.

72 Andrei Donatevitch Sinyavsky, 'Qu'est ce que le Réalisme Socialiste?', *Esprit*, February 1959, pp. 335–6; see Pierre Forgues, ed., *L'Affaire Siniavski-Daniel*, Paris, Christian Bourgois, 1967, and Alexander Ginzburg, *Le Livre blanc de l'affaire Siniavski-Daniel,* Paris, La Table Ronde, 1967.

73 Roger Garaudy, *D'un réalisme sans rivages*, Paris, Plon, 1963. Garaudy followed this monograph with *Pour un réalisme du XX^(ème) siècle: dialogue posthume avec Fernand Léger*, Paris, Grasset, 1968 (collaborating with Nadia Léger, and with previously unpublished research).

74 Louis Aragon, preface to Garaudy, *D'un réalisme*, p. 15: 'Question du vocabulaire, question tragique du vocabulaire… Vous pourrez faire du mot *réaliste* une étiquette d'infamie, je n'y renoncerai pas.'

75 *Aragon au défi*, Les Petits Ecrasons, 4, Paris, Éditions Le Terrain Vague, 1966, p. 10. This contains Jean Schuster, 'Allocution au cercle Karl Marx, (Paris) 11 March, 1966'; Aragon, 'A propos d'un procès', *L'Humanité*, 6 February 1966; André Parrinaud, 'Trop tard, Aragon!', *Arts et loisirs*, 23 February 1966, and Edgar Morin, *Les Nouvelles baderies (introduction à une politique de l'homme)*, 1965 (as quoted).

76 'Il y a un humanisme marxiste'. Althusser delegated his speech to Michel Verret and attacks on Garaudy to his disciple Pierre Machery, attacks reciprocated by a three-hour onslaught, interpreted by Althusser as victory.

77 'Il y a dans toute œuvre d'art une part irréductible aux données, et cette part, c'est l'homme même… ce sont des concepts épistémologiquement… *vides*… L'homme, dans l'emploi qu'en fait cette idéologie est… une notion employée pour *masquer la lutte de classes*'. Discussing Althusser's 'antihumanisme théorique', Matheron, 'Louis Althusser et Argenteuil', gives a resumé of Althusser's 'Lettre au Comité Central', which may never have reached its destined recipients.

78 *Cremonini*, Paris, Galerie du Dragon, May–June 1966.

79 'Tout homme est bien dans l'œuvre peinte de Cremonini, justement *parce qu'il n'y est pas*, parce que cette absence est son existence même… C'est à nous, hommes, devant ces tableaux, que cette absence s'adresse, comme un très haut appel', Althusser, 'Cremonini, peintre de l'abstrait', *Écrits philosophiques*, p. 588, alternative ending (b).

80 Ibid., p. 584: 'C'est justement cet antihumanisme radical de l'œuvre de Cremonini qui lui donne un tel pouvoir sur les "hommes" que nous sommes. Nous ne pouvons pas nous reconnaître (idéologiquement) dans ses tableaux… nous pouvons nous *connaître*…. Toute œuvre d'art naît d'un projet à la fois esthétique et idéologique. Quand elle existe, comme œuvre d'art, elle produit, *en tant que d'œuvre d'art*… un effet *idéologique*'. 'Mais… une œuvre d'art peut devenir un *élément* de l'idéologie', p. 585. 'La voie de Cremonini emprunte ainsi celle qu'ont ouverte aux hommes les grands penseurs révolutionnaires, théoriques et politiques, les grands penseurs matérialistes, qui ont compris que la liberté des hommes passait, non par la complaisance de sa *reconnaissance* idéologique mais par la *connaissance* des lois de leur servitude', p. 584. See Althusser's reference to Roger Esteblat's 'Culture et idéologie', *Democratie nouvelle*, 6, June 1966; see also Althusser, 'Cremonini, pittore dell'astratto', *Nuovi argomenti* (Rome), December, 1966.

81 Cremonini spoke of the revolutionary meaning of Velàzquez's *Las Meninas*: 'la grande portée révolutionnaire du tableau… la mort sociale du roi dans le désir de l'œuvre d'art', but confirmed he had not read Foucault at this time. Interview, 8 March 2005.

82 Georges Boudaille, preface, *Exposition d'arts plastiques au XVII^e congrès du parti communiste français'*, dated 'Levallois, 4 janvier 1967'.

83 See Althusser, *Écrits philosophiques*, pp. 435–521, notes 522–32, and *The Humanist Controversy and Other Writings*, London, Verso, 2003.

Chapter 2
Pierre Bourdieu, Bernard Rancillac

1 'Je crois que notre vision est totalement photographique. C'est pourquoi le réalisme picturale ne peut que passer par la photo… Si l'on me demande pourquoi je ne fais pas simplement la photographie, je dirai simplement que je ne suis pas et ne veut pas être photographe, mais peintre. De même le transfer directe et l'aggrandissement sur la toile sensible d'un cliché ne m'intéressent pas… La photo est convaincante, les publicistes l'ont compris. On croit à n'importe quoi du moment qu'une photo en a été prise, de là sa force de persuasion… Volontairement ou non, une photo ment toujours. Il est passionnant de démasquer le menteur. En lui retournant son image, on lui fait dire le contraire; en entrechoquant deux ou trois images qui voisinaient naïvement dans le même magazine, on fait éclater le système', Bernard Rancillac in *Bernard Rancillac*, Musée d'art moderne de Saint-Étienne, 1971, p. 2.

2 'Le regard d'ethnologue compréhensif que j'ai pris sur l'Algérie, j'ai pu le prendre sur moi-même, sur les gens de mon pays, sur mes parents, sur l'accent de mon père, de ma mère… J'ai pris sur des gens très semblables aux Kabyles, des gens avec qui j'ai passé mon enfance, le regard de compréhension obligé qui définit la discipline ethnologique. La pratique de la photographie, d'abord en Algérie, puis en Béarn, a sans doute beaucoup contribué, en l'accompagnant, à cette conversion du regard…', Pierre Bourdieu, *Images d'Algérie: une affinité élective*, Paris, Institut du Monde Arabe/Actes Sud, with Camera Austria, 2003, p. 11.

3 See A. Honneth, H. Kocyba and B. Schwibbs, 'Fieldwork in Philosophy' (interview with Bourdieu, 1985, published Frankfurt, 1986; in *Choses dites*, Paris, Minuit, 1987; *In Other Words*, Oxford, Polity Press, 1990), and Cheleen Mahar, 'Pierre Bourdieu: The Intellectual Project' in Derek Robbins, ed., *Pierre Bourdieu*, London, Thousand Oaks, Cal., New Delhi, Sage Publishers, 2000, vol. 1, pp. 1–27, 32–47.

4 Derek Robbins, *Bourdieu and Culture*, London, Thousand Oaks, Cal., and New Delhi, Sage Publishers, 2000, part 1, 'The Career. I. An insider/outsider Frenchman', pp. 2–7. See also Pierre Bourdieu, *Esquisse pour une auto-analyse*, Paris, Éditions Raisons d'Agir, 2004.

5 See Bourdieu, 'L'Invention de la vie d'artiste', *Actes de la recherche en sciences sociales*, 2, March 1975, pp. 67–75.

6 Jean-Paul Sartre, *L'Idiot de la famille: Gustave Flaubert de 1821 à 1857*, 3 vols, Paris, Gallimard, 1971–2; *The Family Idiot: Gustave Flaubert, 1821–1857*, University of Chicago Press, vol. 1, 1981.

7 See Bourdieu 'Le Point de vue de l'auteur', *Les Règles de l'art: genèse et structure du champ littéraire*, Paris, Seuil, 1992, p. 313, in an annexe which follows his reworking of 'Sartre', *London Review of Books*, 2/22, 20 November 1980, pp. 11–12. Bourdieu's displacement of Sartre has been extensively examined; see Sung-Min Hong, 'La Notion d'habitus définie en tant qu'anti-subjectivisme: Bourdieu et Sartre', *Habitus, Corps, Domination*, Paris, Éditions l'Harmattan, 1999, pp. 3–44.

8 'Rancillac' has a Langue d'Oc derivation meaning 'hard rock'. Yssingeaux is a volcanic outcrop 850 metres above sea-level in the Haute-Loire region.

9 'Mon enfance n'a pas baigné dans l'art... A Yssingeaux dans la maison familiale, les murs sont ornés de peintures (aquarelle) de l'école dite orientaliste, et de paysages habilement traités par mes grands-pères, grands-oncles. Plusieurs générations de bourgeois légèrement (conformément) éclairés qui se livraient à leurs moments perdus aux arts de la bonne société; comédie de salon, musique de chambre, peinture de plein air, terre glaise. Dans le grenier, petites toiles inachevés, boîtes de pastels, chevalet de campagne, comptes rendus de "salons" parisiens', Rancillac in Serge Fauchereau, *Bernard Rancillac*, Paris, Éditions Cercle d'Art, 1991, p. 10.

10 Robbins, *Bourdieu and Culture*, pp. 5–6, points out how the original *Sociologie d'Algérie*, 1958, was largely based on secondary texts: Bourdieu was still unsure how to define his 'field'. Bourdieu continued to publish extensively on the Algerian question.

11 Honneth, Kocyba and Schwibbs, 'Fieldwork in Philosophy', p. 6.

12 Haacke's 'Bernard Aubertin', *Sens plastique*, 28, 1961, appears with Rancillac's 'Aubertin anti-peintre ou la vie en rouge' in *Bernard Aubertin*, Paris, Centre National d'Art Contemporain, 1972, p. 6. Compare Haacke's profiles of museum visitors conducted during 'Directions 3: Eight Artists', Milwaukee Art Center, 1971, with Bourdieu's; see also Pierre Bourdieu and Hans Haacke, *Free Exchange*, Stanford University Press, 1995 (*Libre-échange*, Paris, Seuil/Presses du Réel, 1994).

13 'L'Infini Turbulent', *informel* paintings and graphics by Bertg. Bertholo, Bertini, L. Castro, de Clercq, Danil, Greenham, Marquet, Monjales, Rancillac, Staudacher, Tyszblat, Y. Voss, Paris, Galerie le Soleil dans la Tête, October 1961, Rancillac archives.

14 See *Bernard Rancillac*, Milan, Galleria Civica di Palazzo Todeschini, May–June 1991.

15 Peter Saul lived in Paris in 1958–62. He showed at the Galerie Bretau in February 1963 and simultaneously at the Alan Frumkin Gallery in New York (joint brochure, no list of works). *Mad Ducks* (1962) contained Donald Duck figures and a Mickey Mouse.

16 'Copie de mauvais élève, travail mal léché, cette peinture [tient des marges des cahiers d'écolier dans lesquelles le peintre se souvient d'avoir gribouillé vers ses douze ans]; elle montre son derrière et fait des pieds de nez', Gérald Gassiot-Talabot, 'Rancillac' (at Galerie la Roue and Galerie le Soleil dans la Tête), *Cimaise* 66, November-December 1963, p. 85.

17 Michel Ragon, *Arts*, 9 October 1963, p. 32.

18 See Sarah Wilson, 'From Monuments to Fast Cars: Aspects of Cold War Art, 1948–1957', in Jane Pavitt, ed., *Cold War Modern*, London, Victoria and Albert Museum, 2008, pp. 26–33.

19 See Bourdieu's evolution from *Les Héritiers, les étudiants et la culture*, Paris, Minuit, 1964, to *La Noblesse d'état: grandes écoles et esprit de corps*, Paris, Minuit, 1989 (*The State Nobility: Elite Schools in the Field of Power*, Oxford, Polity Press, 1996).

20 See Luc Boltanski, *Les Cadres: la formation d'un groupe sociale*, Paris, Minuit, 1982 (*The Making of a Class: Cadres in French Society*, Cambridge University Press, 1987), on the import of 'human engineering', 'management practices', 'productivity missions' from the US and their reception.

21 See Jean-Pierre Jeancolas, 'L'Arrangement: Blum-Byrnes à l'épreuve des faits. Les relations (cinématographiques) franco-américaines de 1944 à 1948', *1895*, 13, December 1982, special Blum-Byrnes number.

22 See Richard Kuisel, *Seducing the French: The Dilemma of Americanization*, Berkeley: University of California Press, 1993; Kristin Ross, *Fast Cars, Clean Bodies. Decolonization and the Reordering of French Culture*, Cambridge, Mass., MIT Press, 1995.

23 Honneth, Kocyba and Schwibbs, 'Fieldwork in Philosophy', p. 3.

24 See 'Douze peintres et sculpteurs américains contemporains', April–June 1953; 'L'Art mexicain du précolumbien à nos jours', May–July 1953; 'Cinquante Ans d'art aux États-Unis', 1955; 'Jackson Pollock et la nouvelle peinture américaine' ('The New American Painting'), which also toured major European capitals, arrived in Paris in January 1959 and was solicited by European museums (not CIA-originated).

25 'le puissant impérialisme américain, politique, économique et culturel', 'L'aimable Madame Sonnabend n'a pas débarqué en 1963 à Paris, pour le simple plaisir de voir couler la Seine', Rancillac, 'Marché. Musée. Et la peinture?', *Pour la culture* (organ of the Parti Communiste Français, Fédération du Nord), 20, March–April 1991, p. 6 (an extract from *Art Press*, 154, January 1991, pp. 84–5 [by Catherine Francblin], concerning the exclusion of Narrative Figuration painters from the Pompidou's 'Art & Pub' show), Rancillac archives.

26 See *Paris–New York*, Paris, Centre Georges Pompidou, 1977; Amy J. Dempsey, 'The Friendship of America and France: A New Internationalism, 1961–1964', PhD, University of London, 1999; Eric de Chassey, 'Paris–New York: Rivalry and Denial', in *Paris, Capital of the Arts, 1900–1968*, Royal Academy of Arts, London, 2002, pp. 344–51.

27 See Laure Phélip, 'La Réception des artistes américains à Paris, 1958–1968: Néo-Dadaïsme et Pop Art', Maîtrise, Université Paris I, 2000.

28 See Laurie J. Monahan: 'Cultural Cartography: American Designs at the 1964 Venice Biennale', in Serge Guilbault, ed., *Reconstructing Modernism: Art in New York, Paris and Montreal, 1945–1964*, Cambridge, Mass., MIT Press, pp. 369–416.

29 See e.g. Jean-Robert Arnaud, 'Mise-à-mort dans Venise-la-Rouge', *Cimaise*, 69–70, 1964, pp. 104–22.

30 See Leonard, 'Vers une nouvelle École de Paris'; Michel Ragon, 'On ne sauvera pas l'École de Paris en imitant New York', *Arts*, 8 July 1964; 'Trois peintres leaders de la jeune École de Paris: Télémaque, Rancillac, Arroyo', *Art International*, June 1965, p. 48, all press cuttings, some unsourced, Rancillac archives.

31 See 'Un Groupe 1965', Musée d'art moderne de la Ville de Paris (60 artists), 1965.

32 Thus, Rancillac saw Caulfield's work in London before the 1965 'Saison de la Nouvelle Peinture Anglaise, Patrick Caulfield, Derek Boshier', 4th Biennale de Paris, Musée d'art moderne de la Ville de Paris.

33 Jean Baudrillard, *Le Système des objets*, Paris, Gallimard, 1968 (*The System of Objects*, trans. James Benedict, London, Verso, [1996] 2005).

34 'Antagonismes II, l'Objet', Musée des Arts Décoratifs, Palais du Louvre, Pavillon de Marsan, March 1962.

35 'Pour Raynaud, c'est le pot de fleurs colorié en rouge et accessoirement le petit appareillage électrique, pour Gironella, les boîtes de sardines, pour Niki de Saint-Phalle, les poupées en matière plastique, les vieux tissus, les fleurs artificielles, pour Rancillac la guitare (électrique), pour Atlia, la roue, pour Geissie, la loupe, pour Pistoletto, le miroir, pour Bertholo, le fer électrique, pour Raysse, la serviette-éponge, pour Kalinowski, les cuirs de qualité, pour Arnal, les matelas pneumatique', François Pluchart, 'Mythologies quotidiennes', *Combat*, 8 July 1964, Rancillac archives.

36 'il y eut cette notion de Mythologie quotidienne qui était un retour, en même temps que le Pop Art américain, dans la domain des thèmes très ordinaires, compréhensibles par tout le monde, faisant partie de la vie quotidienne et de la vie de chacun. Ce n'étaient pas des sujets élitistes, littéraires… Ce qui nous a mené à nous préoccuper de la photographie, de la publicité, du cinéma, de la bande dessinée… de la télévision… qui étaient des formes culturelles dites populaires', Rancillac, debate, *Jeune peinture*, March 1982, cited in Fauchereau, *Bernard Rancillac*, p. 48.

37 'une réalité quotidienne de plus en plus complexe et riche qui mêlait les jeux de la cité, les objets sacrés d'une civilisation vouée au culte des biens de consommation, les gestes brutaux fondés sur la ruse, le choc des signaux, des mouvements et des sommations qui traumatisent journellement l'homme moderne', Gérald Gassiot-Talabot, *Mythologies quotidiennes*, Musée d'art moderne de la Ville de Paris, July–October 1964.

38 See *Peter Saul* (Musée de l'Abbaye Sainte-Croix), Paris, Éditions Somogy, 1999.

39 Conversation with Bernard Rancillac, 25 July 2005 (Rancillac's wife was an English teacher).

40 Fauchereau, *Bernard Rancillac*, p. 62, illustrates an extract from Salvator, a cartoon strip published in the French comic *Tarzan* 1948–50 See Thierry Groensteen with Michel Mercier, 'The Dawn of Revolution: Comic Strips and Newspaper Cartoons', in D. A. Mellor and L. Gervereau, eds., *The Sixties, Britain and France: The Utopian Years, 1962–1973*, London, Philip Wilson, 1997, pp. 132–49, and Ann Miller, *Reading Bande Dessinée: Critical Approaches to French-Language Comic Strip*, London, Intellect Books, 2007.

41 'Que le peintre le veuille ou non, ce monde qu'il nous projette est voué au spasmes, à la convulsion, à la panique', Gérald Gassiot-Talabot, 'Rancillac, ou l'insolence', *Les Annales du mois*, June 1965, p. 57.

42 Luc Boltanksi, 'La Constitution du champ de la bande dessinée', *Actes de recherche en sciences sociales*, 1, 1975, pp. 37–59.

43 Rancillac confirmed that he helped hang the show, including *F-III*, in conversation, 6 August 2005. See *F-III* illustrated and Gérald Gassiot-Talabot, in *Bande dessinée et figuration narrative*, Paris, Musée des arts décoratifs, 1967, pp. 248–9.

44 Marcelin Pleynet, 'De la peinture aux États-Unis', appeared in four instalments in *Les Lettres françaises*, 1175–8, March–April, 1967, as the exhibition opened.

45 Pierre Bourdieu, 'Les Musées et leurs publics', *L'Expansion de la recherche scientifique*, 21, December 1964, pp. 26–8; Bourdieu, 'Le Musée et son public', *L'Information d'histoire de l'art*, 3, May–June 1965, pp. 120–22, preceding his *L'Amour de l'art: les musées d'art et leur public*, Paris, Minuit, 1966.

46 Bourdieu, *Les Héritiers*; *Un Art moyen: essai sur les usages sociaux de la photographie*, Paris, Minuit, 1965 (with L. Boltanski, R. Castel and J.-C. Chamboredon).

47 Bourdieu was particularly interested in the Algerian war resistance experiences of Rancillac's wife, Marie, who sided with the National Liberation Front (FLN), thus 'betraying' her *pied noir* community.

48 Baudrillard, *Système des objets*, p. 27.

49 'd'entêtement puéril à vouloir jouer les anarchistes de salon [de vision cynique à l'heure où] le napalm brule le Vietnam', Raoul-Jean Moulin, 'Rancillac: Où es-tu? Où te caches-tu?', *Les Lettres françaises*, 27 May–2 June 1965. The title parodies the 1965 painting *Ou-est tu? Que fais-tu?*, exhibited in May at the Galerie Fels.

50 'pour faire chier tous ceux qui pense que l'art est intemporel', Rancillac in Henri-François Debailleux, 'Rencontre avec l'un des piliers de la figuration narrative', *Libération*, 3 September 2003.

51 Pierre Bourdieu, 'Champ intellectuel et projet créateur', *Les Temps modernes*, 246 (structuralism number), 1966, pp. 865–906 ('Intellectual Field and Creative Project', *Social Science Information*, 8, 1968, pp. 89–119).

52 Max Raphael, *Proudhon, Marx, Picasso*, Paris, Éditions Excelsior, 1933; John Tagg, ed., *Proudhon, Marx, Picasso: Three Studies in the Sociology of Art,* London, Lawrence and Wishart, 1987.

53 Erwin Panofsky, *Architecture gothique et pensée scholastique, précédé de l'abbé Suger de Saint-Denis*, trans. and postface Pierre Bourdieu, Paris, Minuit, 1967. Panofsky's *Essais d'iconologie* were published by Gallimard the same year.

54 'Etrange projet. Un art qui emploie le langage de tous les jours, celui de la bande dessinée, de l'affiche ou de la photographie. Des couleurs franches qui disent franchement ce qu'elles ont à dire, le bleu, le ciel, le vert, l'herbe et le rouge, le sang. Des thèmes aussi familiers que ceux de l'affiche qu'on lit d'un coup d'œil, dans le couloir du métro, et un symbolisme aussi transparent que celui des contes de nourrice ou des mauvais westerns, un revolver, le crime, un loup, le violence. Des intentions qui s'avouent, dénoncer le racisme, l'oppression, la bonne conscience. Bref un art qui veut s'adresser à ceux qui sont les plus démunis devant l'art… Mais cette intention cache une autre qui le contredit. Si *Au mur de Watts* ou *L'horloge indienne* n'exprimaient rien d'autre que la volonté d'aller au peuple avec de bons sentiments, ces œuvres ne feraient pas voir, de façon aussi éclatante, que l'intention populiste est auto-déstructive', Pierre Bourdieu, 'L'Image de l'image', *L'Année 1966*, Paris, Galerie Mommaton, 1967, reprinted in *Art Press*, 133, February 1989, p. 27, after Rancillac's interview with Catherine Millet (pp. 24–6), anticipating his 'Cinémonde' exhibition, Paris, Galerie 1900–2000, October 1989.

55 'L'image de l'image fait voir la bévue qui a rendu possible l'image, bévue des photographiés qui ne voient pas qu'ils sont vus. Mais faisant voir cela, elle fait voir à celui qui la regarde qu'il n'a pas vu l'image dont elle est l'image. Il fait voir la bévue inhérente à la vie quotidienne, au regard distrait qui transforme en "actualité" inactuelle tout ce qu'il saisit', ibid.

56 See Bernard Rancillac, *Le Regard idéologique*, Paris, Éditions Mariette Guéna and Somogy, 2000, pp. 215–16.

57 See e.g. *Democratie Nouvelle*, 7–8, 1966, special number, 'En Marge du festival de Dakar: la culture négro-africaine'.

58 See Jacques Borgé and Nicolas de Rabaudy, 'Un Procès très parisien', *Paris-Match*, 940, 15 April 1967, and Gérald Gassiot-Talabot, 'Arts', *Candide*, 315, and 'Le Diner des têtes de Rancillac', *Arts-Loisirs*, 87, June 1967, p. 30.

59 'L'image de l'image d'un autre lui-même, autre que lui-même', Bourdieu, 'L'Image de l'image'.

60 The *Exposition d'arts plastiques au XVIII^ème congrès du Parti communiste français*, Levallois, 4 January 1967, included Picasso, *Massacre in Corea*; Matta, *The Rosenbergs*; Eduardo Arroyo, *Spain's Worries*; André Fougeron, *Funeral Procession, 13 February*; Jean Dewasne, *Fragment of Empedocles* (geometric abstraction).

61 Gérald Gassiot-Talbot refers to Bourdieu's text in his definitive analysis 'La Figuration narrative', in *Bande dessinée et figuration narrative*, p. 251; it reappears, quoted by Bernard Ceysson, *Bernard Rancillac*, Musée d'Art et d'Industrie de Saint-Étienne, 1971, and in Patrick Elme, *Peinture et politique*, Paris, Maison Mame, 1974, p. 91.

62 See Pierre Cabanne, 'Les Deux Bernard', *Arts et loisirs*, 72, 8–14 February 1967, pp. 32–6, and Jeannine Warnod, 'De l'espace abstrait à l'événement', *Le Figaro*, 9 March 1967, comparing 'L'Année 66' at Galerie Blumenthal with Tàpies's tripartite show 'Devenir de l'Abstraction' at Galerie Stadler.

63 See *Opus International*, 3, October 1967 (including Gérald Gassiot-Talbot, 'La Havane: Peinture et révolution', pp. 14–17, and 'Congres Culturel de la Havane', p. 77).

64 'GUERRE', 'LES RUSSES AUJOURD'HUI', 'NASSER ET LES ISRAELIENS', 'LE DERNIERS JOURS DE SAINT TROPEZ', 'LAVAGE DES CERVEAUX', 'L'ESPION MENSUEL'. See Jean-Clarence Lambert, 'Bris/collage/K: un rêve collectif' (extract with a collage by Rancillac), *Opus International*, 3, October 1967, p. 50; *Un Rêve collectif, précédé de divers activités scéniques. Le principe d'incertitude. Bris/Collage/K,* with four collages by Roman Cieslewicz, Paris, Georges Fall, May 1968.

65 See *Opus International*, 4, December 1967, with 'USA résistance bibliographie', p. 104, and Nelcya Delanoë, *Le Raspail vert: l'American Center à Paris, 1934–1994*, Paris, Seghers, 1994.

66 Cohn-Bendit, a French-German binational of Jewish origin, had opted for German citizenship to dissociate himself from the Algerian War. See Daniel Cohn-Bendit, 'Les Objectifs des 22 marsiens', *Opus International*, 7, 'Violence/Mai 68', pp. 52–3; 'Cohn-Bendit, affiche de l'Atelier populaire des Beaux-Arts, *Quinzaine littéraire*, 16–31 October 1968, and *Les Affiches de mai 68*, Musée des Beaux-Arts de Dole, 2008.

67 'La dernière retombée majeure de mai 68', Fauchereau, *Bernard Rancillac*, p. 110.

68 'À la vue de cette exposition, pensez-vous que l'art puisse avoir un effet libérateur? Parmi les œuvres présentées dans le cadre de cette exposition, y en–a-t-il qui vous semblent belles?', ibid., p. 113 (the artist can no longer locate this questionnaire).

69 Michel Journiac, *24 heures dans la vie d'une femme ordinaire*, Paris and Zurich, Arthur Hubschmidt, 1974 (accompanying an exhibition at Galerie Stadler). See *Michel Journiac*, Musée d'art moderne et contemporain de Strasbourg, 2005.

70 'pour les masses submergées sous les produits culturels à bas prix, l'art est aussi semblablement image de ses images… A travers les affiches, les photos de magazine et de réclames, les filmes, la TV, la "foule solitaire" est renvoyée à son propre fantôme tel qu'il a été conçu, élaboré, fabriqué. Pour qu'en définitive, elle y conforme… le kitsch de proche en proche contamine l'artiste, crée l'artiste "honteux", l'intellectuel "honteux" au service des marchands, employés d'une gigantesque industrie culturelle qui est en passe de tout dévorer l'art compris, sous la masse de ses innombrables produits', Pascal Rossini, 'Le Temps du kitsch', *Chroniques de l'art vivant*, November 1969, pp. 12–13. Gillo Dorflès, *Il Kitsch: antologia del cattivo gusto*, Milan, 1968, was surely known to artists working on the Paris-Milan axis.

71 See Jean Clair on Paris's lateness and the end of Warhol-fever in New York in the Vietnam context: 'La Chute d'un ange', *Chroniques de l'art vivant*, 16, December 1970–January 1971, p. 14.

72 Gilbert Mury, a philosophy professor banned from teaching, was the president of the Amitiés Franco-Albanaises, thanks to which Rancillac went to Albania. For Mury's funeral of 18 May 1975, attended by revolutionaries from all over the world at the Père Lachaise cemetery in Paris, see Rancillac, *Le Regard idéologique*, pp. 143–4.

73 'Qu'un peintre fasse appel à un militant politique pour présenter son œuvre, voilà qui apparaît aujourd'hui comme une démarche scandaleuse. Le Parti "Communiste" Français n'a-t-il pas donné l'exemple de la rupture entre art et politique lorsque, en ce mois de septembre 1971, il a profité de la Fête de l'Humanité pour accrocher aux murs des baraquements de La Courneuve "une exposition aui aurait pu être celle d'un musée national"?…

'… La visite probable de Nixon à Pekin, l'arrivée certaine d'une délégation du gouvernement chinois à Paris, le rapprochement diplomatique entre Tirana et Pékin, d'un côté et Belgrade et Bucarest de l'autre', Gilbert Mury, *Rancillac: le vent*, Paris, Centre National d'Art Contemporain, 1971, np (compare Louis Aragon, 'John Heartfield ou la beauté révolutionnaire', *Pour un réalisme socialiste*, Paris, Denoël et Steele, 1935).

74 The 'Mathelin affair' gave birth to the militant Front des Artistes Plasticiens; see Michel Troche, 'Le F.A.P.', *Opus International*, 36, June 1972, pp. 28–9.

75 See Rancillac on the narrative significance of the installation as a whole, *Régard idéologique*, pp. 218–19.

76 For Mao's pronouncements and related texts see Eric Jannicot, *La Pensée plastique de Zao Wou-ki et la naissance de l'art moderne chinois*, 3e cycle thesis, Université de Paris I–Sorbonne, 1984.

77 See Zhongguo Wuju Tuan, *Red Detachment of Women: A Modern Revolutionary Ballet*, Beijing Foreign Language Press, 1972.

78 See Julia F. Andrews, *Painters and Politics in the People's Republic of China, 1949–1979,* Berkeley and London, University of California Press, 1994.

79 'La photographie n'est pas réaliste mais correspond à une vision moyenne, systématique et conventionelle du monde: "en conférant à la photographie son brevet du réalisme la société ne fait rien que se confirmer elle-même dans la certitude tautologique qu'une image du réel conforme à sa representation de l'objectivité est vraiment objective." [Un art moyen]… L'art de Rancillac se place donc au confluent de l'histoire de l'art et de l'histoire', Ceysson, *Bernard Rancillac*, pp. 4–5.

80 Patrick Elme, 'Le Fleur de lis et le petit livre rouge', *Peinture et politique*, pp. 77–92. Elme put on the first art exhibition from the People's Republic of China in Paris in 1970 (ibid., p. 4).

81 'La première expérience d'improvisation collective traduisant une émotion picturale', *Concert de Jazz*, 27 September 1964, flyer, Rancillac archives.

82 See e.g. 'Bilan discographique de l'année', *Opus International* 4, December 1967, p. 107; Philippe Gras cover and 'Musique noire', *Chroniques de l'art vivant*, 5, November 1969, pp. 27–9; Philippe Gras, 'L'Europe, le "freejazz" et la "pop music"', ibid., 6, 1969, pp. 2–8; 'Cecil Taylor' interview, ibid., 8, February 1970, pp. 26ff; 'Free jazz', ibid., 12, July 1970, 'Special USA', p. 30.

83 Pierre Bourdieu, *La Distinction: critique sociale du jugement*, Paris, Minuit, 1979, p. 15.

84 Holger Meins, Andreas Baader and Jan-Carl Raspe were arrested in 1972. See Robert Storr, ed., *Gerhard Richter, 18 October 1977*, Museum of Modern Art, New York, 2001; and Robert Storr, ed., *Gerhard Richter: Forty Years of Painting*, Museum of Modern Art, New York, 2002.

85 See *Regarding Terror: The RAF-Exhibition*, KunstWerk, Berlin, 2005.

86 The Italian Red Brigade's move to direct terrorist action involving civilian victims was one reason for an end to militancy among the French Maoists in 1973, when the Gauche Prolétarienne was dissolved. See Christophe Bourseiller, *Les Maöistes: la folle histoire des gardes rouges français*, Paris, Plon, 1996.

87 Rancillac in conversation with Francis Colin, *Rancillac*, Ris-Orangis, Salle Robert Desnos, 31 October–3 December 1978, np, cited in Fauchereau, *Bernard Rancillac*, pp. 148–9.

88 'On en arrive à des formes balayées qui tendent au blanc presque pur…Presque blanc sur blanc, il n'y aura plus de couleurs', ibid. See also Rancillac in conversation with Sabine Minne, *Princip actif*, 3, August–September 1989, p. 6.

89 See e.g. Fromanger's *Rebellion, Toul prison* series of 1974. 'Figures d'Enfermement' was held on the prison theme in Lyons at the Espace Lyonnais d'Art Contemporain, bringing together expressionist painters (Bacon, Rebeyrolle) with the Narrative Figuration group; *Le Monde*, 23 January 1980, Rancillac archives.

90 The series was shown in late 1979 in 'Tendances de l'Art en France II: Les Partis Pris de Gassiot-Talabot', ARC, Musée d'art moderne de la Ville de Paris. Rancillac's Meinhof suite was also seen in Grenoble with 'Ernest Pignon-Ernest, 10 ans de travail' and 'Prisons: images d'enfermement' (prisoners's work); see Philippe Merlant, 'À la Maison de la Culture de Grenoble', *Libération*, 26 January 1980.

91 Rancillac, *Le Regard idéologique*, p. 24.

92 Ibid. is an almost daily diary of 1975–9, discussing Paris exhibitions and their reception, reflecting Rancillac's programmatic reading of Marxist critics.

93 'Rancillac, Algérie', Galerie Confluences, Lyon, 2000–1.

94 See Bourdieu, *Images d'Algérie*, together with André Ducret and Franz Schultheis, eds., *Un Photographe de circonstance: Pierre Bourdieu en Algérie*, University of Geneva, 2005; Y. Winkin, 'La Disposition photographique de Pierre Bourdieu', *Le Symbolique et le social: la réceptions international du travail de Pierre Bourdieu*, Colloque de Cerisy (2001), Liège, Université de Liège, 2005. Thanks to Tassadit Yacine for this last reference and her project 'Pierre Bourdieu, esquisses algériennes'. See also 'Bourdieu's Photography and the Field of Visual Anthropology', in Michael Grenfell and Cheryl Hardy, *Art Rules: Pierre Bourdieu and the Visual Arts*, Oxford and New York, Berg, 2007, pp. 140 ff, a guide completely ignorant of the art world of Bourdieu's time.

95 See 'Inventaire des œuvres exposées à Alger en 1964 pour l'Art et la Révolution Algérienne', and 'Pour le Musée d'Art Moderne', two articles after Laurent Gervereau's pioneering essay, 'Des Bruits et des silences: cartographie des représentations de la guerre d'Algérie', *La France en guerre d'Algérie, novembre 1954–juillet 1962*, Paris, Musée d'Histoire Contemporaine de la Bibliothèque de Documentation International Contemporaine, 1992, pp. 178–201; and 'Les Artistes Internationaux et la Révolution Algérienne', Musée national d'art moderne et contemporain d'Alger (MAMA), curated by Anissa Bouayed, 2008.

Chapter 3
Louis Althusser, Lucio Fanti

1 See Boris Groys, 'Moscow Romantic Conceptualism', *A-Ya* (Paris) 1, 1979, pp. 3–11 (Russian/English/French trilingual review that introduced this movement to an international public).

2 It is a pleasure to acknowledge Matthew Beaumont's paper, 'The Marxian Uncanny: Rethinking the Relations between Present and Future', Historical Materialism Annual Conference, School of Oriental and African Studies, University of London, 9 December 2006.

3 Fanti designed façade-sized ceramic murals: see Émile Aillaud, Fabio Rieti, Gilles Aillaud, *La Grande Borne à Grigny: Ville d'Émile Aillaud*, intro. Gérald Gassiot-Talabot and photographs by Eustachy Kossokowski, Paris, Hachette, 1972.

4 Judith Butler, 'Afterword: After Loss, What Then?,' in David L. Eng and David Kazanjian, eds., *Loss, The Politics of Mourning*, Berkeley, University of California Press, 2003, p. 467.

5 I quote Hamlet, whose spirit was resurrected in Jean Starobinski, 'Hamlet and Freud', preface to Ernest Jones, *Hamlet et Œdipe*, Paris, Gallimard, 1967.

6 Walter Benjamin's essays 'Dream Kitsch' (1925) and 'Left Melancholy'(1931), while absolutely specific in their focuses, are provocative to read in conjunction with Fanti's work; as are exegeses such as Max Pensky, *Melancholy Dialectics: Walter Benjamin and the Play of Mourning* (Amherst, University of Massachussetts Press, 1993). Again, one confronts the 'fold of time' between the 1930s and the 1970s. See Walter Benjamin, *Selected Writings*, Cambridge, Mass., and London, Harvard University Press, 2003, vol. 2, pp. 3–5, 423–7.

7 For Giorgio Fanti's Italian Communist Party milieu in Bologna around the journal *Progresso d'Italia* see Marzia Marsili, 'Il Partito comunista italiano negli anni della ricostruzione: un giornale per la sinistra bolognese: "Il Progresso d'Italia" (1946–1951)', PhD, Università degli Studi di Bologna, 1993. For collected art criticism see Giorgio Fanti, *Occhio alla pittura,* Bologna, Gedit Edizione, 2003.

8 See *Lucio Fanti: Mers, Châteaux, Nymphéas*, Paris, Galerie Krief-Raymond, 1980, preface Italo Calvino; *Lucio Fanti*, Paris, Galerie Krief-Raymond and Grenoble, Maison de la Culture (Bicentenaire Stendhal), preface Jorge Semprun, 1983.

9 See Jean Clair, *Art en France: une nouvelle génération*, Paris, Chêne, 1972, pp. 164–5.

10 *Arroyo*, Crane Kalman Gallery, London, 1962 (reviewed by Giorgio Fanti in *Paese sera*).

11 Jean Chesneaux gives a bibliography of works published by both liberal and pro-Vietnamese authors in 'Sens et consequences de la Guerre du Vietnam', *La Pensée,* May–June 1966, 127, pp. 3–33. *La Pensée* continued its Vietnamese rubric; the Association d'Amitié Franco-Vietnamienne was extremely active.

12 Kristin Ross, *May '68 and its Afterlives*, Chicago and London, University of Chicago Press, 2002, pp. 80–81.

13 See '"Police and culture": notes préliminaires pour la prochaine manifestation de la Jeune Peinture', *Bulletin de la Jeune Peinture,* 4, May 1969, pp. 2–6; 'Police and culture', *Bulletin de la Jeune Peinture*, 5, June 1969, pp. 11–16, to accompany this 20th Salon de la Jeune Peinture, Salle du Quai de New York, Musée d'art moderne de la Ville de Paris, 28 June–16 July. Buraglio was a member of the Parti Communiste Marxiste-Léniniste de France (PCMLF).

14 See e.g. *La Nouvelle Critique*, 13, 'Dossier Vietnam', 15 June 1968.

15 The painter Gérard Tisserand describes the committee's mixed base: communists, *por-chinois*, 'anars', marxists-leninists and *mal-assis* and the political difficulties posed by their militancy including the loss of two million francs from Gaudibert's budget (*Politique-hébdo*, November 1970) in Francis Parent and Raymond Perrot, *Le Salon de la Jeune Peinture: une histoire, 1950–1983*, Montreuil, Salon de la Jeune Peinture, 1983, p. 93 (part of an extensive discussion of the 'Red Room'show).

16 The 'Red room'show also toured to the Alstom Factory, Belfort; Perrouges; Bourge-en-Bresse (exit of the Berliet factory); Long-le Saulnier (Maison des Jeunes); Besançon (Maison des Jeunes et de la Culture); see *Bulletin de la Jeune Peinture* 5, June 1969, p. 10.

17 Michel Troche's anonymous 'Eléments d'étude sur le réalisme socialiste', *Bulletin de la Jeune Peinture*, 3, March 1969, pp. 4–7, and ibid., 4, May 1969, pp. 11–13, carried no reference to France's own Stalinist adventure in literature or the fine arts: the PCF after 1968 was the enemy. Mao Zedong's (Tse Tung) *Causerie sur l'art et la littérature* was discussed at the 'Red Room' debate and slideshow; see 'La Salle en rouge, en mars, à l'école de Beaux-Arts de Versailles', ibid., p. 10.

18 '1. Entrer dans la lutte avec tous les moyens dont vous disposez (Ho Chi Minh) / 2. Modifier peu à peu le rapport des forces, faire que de faibles nous devenions forts et que de fort l'ennemi devienne faible, Giap, Général en Chef de l'Armée Populaire de la RDV', *Salle rouge pour le Vietnam,* 17 January–23 February, 1969, np.

19 The French had refused to industrialise the country before 1954; see Pierre Brocheux, 'The Economy of War as a Prelude to a "Socialist Economy": The Case of the Vietnamese Resistance against the French, 1945–1954' in Gisèle Bousquet and Pierre Brocheux, eds., *Viet Nam Exposé: French Scholarship on Twentieth-Century Vietnamese Society*, Ann Arbor, University of Michigan Press, 2002, pp. 313–30.

20 The photograph is of the capture of the helicopter pilot William A. Robinson, by this time in the Hanoi prison system (he was released in 1973). The *Courrier de Vietnam* caption proclaims 3151 planes shot down by 13 September 1968.

21 See Yann Moulier Boutang, 'L'Interdit biographique et l'autorisation de l'œuvre', in G. Albiac et al., *Lire Althusser aujourd'hui,* Paris, Éditions l'Harmattan, 1997, p. 84: Althusser seized the taped interview on the pretext of correcting certain details and never returned it to the interviewer, Ulla Culioli.

22 The subject matter was apparently a true story involving Tisserand's cousin. For a longer analysis of the Malassis's works see Sarah Wilson, 'Politique et vanitas: Lucien Fleury et les Malassis', *Lucien Fleury 1928–2005*, Musée des Beaux-Arts, Dole, pp. 10–43. For the *guerre franco-française* see Introduction, n. 26 above.

23 'psychologisme, paternalisme – le Progrès, l'Université, l'Homme… profondement idéaliste', in Parent and Perrot, *Salon de la Jeune Peinture*, pp. 106–7 and 115, n. 37.

24 Pierre Gaudibert*, Action culturelle: intégration et/ou subversion*, Paris, Casterman, 1972, p. 52, also noting Althusser's 'Idéologie et appareils idéologiques d'état' (April 1970), *La Pensée*, 151, June 1970.

25 Paul Nizan, *Les Chiens de garde*, Paris, Maspéro, 1960 (*The Watchdogs: Philosophers and the Established Order*, New York, Monthly Review Press, 1972).

26 See Parent and Perrot, *Salon de la Jeune Peinture*, pp. 112, 109.

27 Anti-ORTF posters made in May 1968 were shown in 'Les Murs ont la parole', Maison Elsa Triolet-Louis Aragon, Saint-Arnoult en Yvelines, 5 April–15 June 2008.

28 'au moment ou la radio annonce que les ouvriers et les étudiants ont décidé d'abandonner joyeusement leur passé', *The Datcha*, inscription.

29 See *Opus International*, 16, March 1970, produced in Italy by Gillo Dorflès and Tommaso Trini, including Enrico Crispolti, 'Petit dossier de la Figuration nouvelle en Italie' and special numbers of *Opus, Chroniques de l'art vivant* and *Tendenzen* etc.

30 See 'Vladimir Ilitch Lénine, 1870–1924', Paris, Grand Palais, May–June 1970.

31 Althusser, *Lénine et la philosophie*, Paris, Maspéro, 1969 (*Lenin and Philosophy and Other Essays,* New York and London, Monthly Review Press, 1971).

32 E.g. Georges Plekhanov, *Les Questions fondamentales du marxisme: le matérialisme militant*, Paris, Éditions Sociales, 1974; Alexander Bogdanov, *La Science, l'art et la classe ouvrière*, ed. and trans. Blanche Grinbaum, Paris, Maspéro, 1977; Vsevolod Meyerhold, *Écrits sur le théâtre*, Lausanne, L'Âge d'Homme, 1973; *Maïakovski: poèmes*, trans. C. David, C. Frioux and C. Prokhoroff, Paris, Le Champ du Possible (1973), 1977.

33 Jean Fréville (pseudonym), *Sur la littérature et l'art: Karl Marx, Friedrich Engels*, and *Sur la littérature et l'art: V. I. Lénine, J. Staline*, Paris, Éditions Sociales Internationales, 1936 and 1937; *Lénine à Paris*, 1968, and *La nuit finit à Tours: naissance du Parti communiste française*, 1970, with the same Party editor.

34 See the 1930s Musée du Soir activist, Paul-Adolphe Löffler's *Chronique de l'AEAR: le mouvement littéraire progressiste en France (1930–1939)*, Rodez, Éditions Subervie, 1971; the history of the German association ASSO in the 1930s was chronicled in 1970 in *Tendenzen*. See also Marcel Martinet, *Culture prolétarienne* (1935), Paris, Maspéro, 1976, Agone, 2004.

35 'Kunst und Politik', Karlsruhe, Badischer Kunstverein, curated by Georg Bussmann, June–September 1970; see also Gérald Gassiot-Talabot, 'Karslruhe, art et politique', *Opus International*, 19, 20 (double number), October 1970, pp. 163–4.

36 Bernd Bücking, 'Karl Marx und die Kinder von Coca-Cola', *Tendenzen*, 66, May–June 1970, pp. 45–52.

37 Marcuse, retranslated by Johann Tinquist and Lin Denwald into German from a talk given at the School of Visual Arts, New York, in 1967, in *Kunst und Politik*, Kunstverein Karlsruhe, 1970, np.

38 'En tête de la colonne des sportifs sont les meilleurs de Kiev qui ont été champions des pays' (caption translated from Ukranian), *Kiev, 1654–1954*, Kiev, 1954; Fanti's procession has been significantly thinned. The sanatorium photograph is also in this book, of which Fanti had two copies – one cut up, one remaining intact.

39 Althusser, *Philosophie et philosophie spontanée des savants*, (lectures October–November 1967), Paris, Maspéro, 1974, p. 17.

40 'Ce microcosme de *soviétisme*, fondée comme lui sur les inégalités sociales, la hiérarchisation des privilèges. Une mobilisation quasi militaire, le mensonge d'un jargon stéréotypé.

Artek – ce mirage qui m'avait trompé, avait aussi ancré en moi le besoin passionné d'un monde fraternel', Paul Thorez, *Les Enfants modèles*, Paris, Lieu Commun, 1982, p. 191. (He was writing in disillusionment after the Soviet invasion of Prague and then Afghanistan).

41 See Rosalind E. Krauss, 'Reinventing "Photography", and Paul Virilio 'Photo Finish', in *The Promise of Photography*, Munich, Prestel, 1998, pp. 33, 23 ('the end… of plastic [graphic] arts', *sic*).

42 Lenin as *Denkmal*, a commemorative monument; Lenin as *Mahnmal*, a monument which acts as a warning.

43 See Starobinski in Jones, *Hamlet et Œdipe*.

44 Jean-Paul Sartre, 'Le Fantôme de Staline', *Les Temps modernes*, 129–31, November 1956–January 1957; Althusser, 'we need more light on Marx so that the phantom of Hegel can return into the night', *Pour Marx*. For Derrida's *Spectres de Marx* see Conclusion, n. 31 below.

45 'une délicatesse cruelle… Ciels étranges, vastes comme le regret, ouverts comme l'esperance, tenace comme des souvenirs', Gérald Gassiot-Talabot, *Fanti*, Rome, Galleria Il Fante di Spade, 1972, np.

46 Gérald Gassiot-Talabot, 'Un Malaise généralisé'; Pierre Gaudibert, 'Réflexions politiques sur une exposition contestée'; Michel Troche, 'Le F.A.P.'; and Jean Jourdheuil, 'Fanti, à la recherche de temps perdu', *Opus International*, 36, June 1972, pp. 20–21, 23–4, 28–9, 49–51.

47 Gaudibert's exhibitions for the pioneer ARC were not even listed in Suzanne Pagé and Juliet Laffon, eds., *ARC 1973–1983*, Musée d'art moderne de la Ville de Paris, 1983; he went on to work in Grenoble and became a distinguished Africanist, the director of the Musée des Arts Africains et Océaniens, Paris.

48 Eduardo Arroyo, 'Cartes postales', *Rebelote* 1, February 1973, np.

49 *Première rencontre: Fanti, Mehes, Sandorfi*, ARC 2, Musée d'art moderne de la Ville de Paris, 3 April–1 May 1973, np.

50 Ibid. Carole Nagar on Sandorfi (np) and Lazlo Méhes (30 March 1983) in *ARC 1973–1983*, pp. 26–7 ('la nouvelle peinture réaliste européene… dévélopée parallèlement à l'hyperréalisme américaine… et transmettant les doutes européens').

51 Gérald Gassiot-Talabot, [untitled], *Première rencontre*.

52 See Michel [Pierre] Buraglio, 'A. comme Aillaud, F. comme Fanti, S. comme Schlosser', *Aillaud, Schlosser, Fanti*, Rennes, Maison de la Culture, 1973; also *Chambas, Esteban, Fanti, Eve Gramatzki, Le Boul'ch*, Galerie du Luxembourg, with a catalogue prefaced by Patrick Le Nouëne, 4 December 1973 (apparently cancelled), and *Images Imaginaires*, Galerie AARP, January 1974 (catalogue prefaced by Le Nouëne).

53 Louis Althusser, *Réponse à John Lewis*, Paris, Maspéro, 1973, first published as 'Reply to John Lewis (Self-Criticism)', *Marxism Today*, October and November 1972.

54 Michelle Lois, 'Pour Althusser: réponse à Joe Metzger', *Rebelote*, 4, February 1974, pp. 1–3.

55 Solzhenitsyn's *Archipeli Gulag*, first published in Russian by the Instytut Literacki, Le Mesnil-le-Roi, 1973, and Paris, Seuil, vols. 1 and 2, 1974, produced a huge literature. See Véronique Hallereau, 'La Médiatisation d'Alexandre Soljénitsyne à la télévision française de 1974 à 1994', maîtrise, Université de Paris I–Panthéon–Sorbonne, 1999, http://vhallereau.free.fr/index.htm, and notably Claude Lefort, *Un Homme en trop: essai*

sur l'archipel du goulag de Soljénitsyne, and André Glucksmann, *La Cuisinière et le mangeur d'hommes: essai sur les rapports entre l'état, le marxisme et les camps de concentration*, both Paris, Seuil, 1975. See also Pierre Rigoulot, *Les Paupières lourdes: les français face au goulag: aveuglement et indignation*, Paris, Éditions Universitaires, 1991.

56 See David Rousset, *Pour la vérité sur les camps concentrationnaire*, Paris, Éditions du Pavois, 1951, and Rousset with Paul Barton, *L'Institution concentrationnaire en Russie, 1930–1957*, Paris, Plon, 1957.

57 From 4 to 12 August 1949 there was discussion in *Pravda* of the plenary session of the Lenin Academy of Agronomic Science, where Lysenko demonstrated the inheritance of acquired characteristics. See Francis Cohen, Jean Desanti, Raymond Guyot, Gérard Vassails, *Science bourgeoise et science prolétarienne*, Paris, La Nouvelle Critique, 1950.

58 'Je veux seulement prendre occasion de ce livre et de son sujet pour énoncer quelques rappels, qui crèvent les yeux et la mémoire… comme *impuissants de rendre compte, en marxistes de leur propre histoire* – surtout quand ils la ratent… Manifestement les dirigeants soviétiques se sont refusés, *et se refusent toujours*, à affronter l'analyse marxiste de cette gigantesque erreur, enterrée, après ses millions de victimes, dans le silence d'État', Louis Althusser, preface in Dominique Lecourt, *Lysenko: histoire réelle d'une "science prolétarienne"*, Paris, Maspéro, 1976, pp. 9–10, 14–15 (my translation; see also *Proletarian Science? The Case of Lysenko*, London, New Left Books, 1977, pp.7–8, 11).

59 'non seulement l'individu Staline, comme tel, mais la structure et la confusion du parti et de l'État soviétiques, la "théorie" et les pratiques imposées par Staline pendant quarante ans, non seulement à l'U.R.S.S., mais aux partis communistes du monde entier… Oui, il y a eu l'Armée rouge, les Partisans et Stalingrad, inoubliables. Mais il y a eu aussi les procès, les massacres et les camps. Et il y a ce qui dure', Louis Althusser, in *22ᵉᵐᵉ Congrès*, Paris, Maspéro, 1977, pp. 30–31 (rev. version); translated in *New Left Review*, 1/104, July–August 1977, pp. 3–22.

60 Time, history, Mayakovsy and Lenin as *revenant* are treated magisterially in Dragan Kujundzic, *The Returns of History: Russian Nietzscheans After Modernity*, Albany, State University of New York Press, 1997; see 'Interval', 'Mayakovsky and the Ventriloquism of History' and 'Russian Formalism and the Birth of the Mausoleum', pp. 73–82, 110ff.

61 Marie-Laure Antelme, ed., *Maïakovski: 20 ans de travail*, 18 November 1975–5 January 1976; this exhibited the panels from Mayakovsky's own exhibition 'Twenty Years of Work'.

62 'La Peinture Russe Contemporaine', Paris, Palais des Congrès, 2–21 November 1976 (450 works by 58 artists); 'Adieu à la Russie: Lidia Masterkova', Galerie Dina Vierny, 25 January–25 February 1977; Vierny, permitted to visit the USSR in 1967–74 (she held 'Avant-Garde Russe, Moscou' in May–June 1973), used the occasion to denounce the 'bulldozer' exhibition scandal of September 1974, entailing the internment of two artists in psychiatric asylums and the co-option of several others into the army.

63 See André Breton, 'La Barque d'amour s'est brisée contre la vie courante', *Le Surréalisme au service de la révolution*, 1, 1930, pp. 16 ff.

64 '60 ans de peinture soviétique', Paris, Grand Palais, 29 July–12 September 1977, curated by Gaston Diehl with Vadime Elisseeff from the Musée Cernuschi. Jean Cassou's first showing of Russian and Soviet painting organised at the Musée

national d'art moderne in 1960 is saluted in the catalogue preface. See also *L'URSS et la France: les grandes moments d'une tradition, 50e anniversaire des relations diplomatiques franco-soviétiques*, Paris, Grand Palais, December 1974–February 1975; *L'Affiche soviétique, 1970–1974*, Centre Beaubourg with the Association France-URSS, 10 October 1974–5 January 1975.

65 See Bernadette Dufrêne, 'Art et médiatisation: le cas des grandes expositions inaugurales de Centre Georges Pompidou (Paris–New York, Paris–Berlin, Paris–Moscou)', doctoral thesis, Université Stendhal – Grenoble III, 1998. The idea began with an ICOM visit to the Tretyakov stores in 1974 (p. 213) and the first official moves came in late 1977.

66 For the polemic around 'Paris–Moscou', and a political pulse-taking involving Russian emigrés such as Andrei Sinyavsky and Igor Golomstock, see Gilles Deleuze, ed., *Recherches*, 39, special number 'Culture et pouvoir communiste: l'autre face de Paris–Moscou', October 1979.

67 'Lucio Fanti est un peintre qui "annonce la couleur". Quand on lui demande ce qu'il peint, il répond (et d'ailleurs il suffit de regarder ses toiles): "l'Union Soviétique." Pas moins. Et si on lui demande pourquoi, il répond par sa propre vie: il a été élévé par des parents communistes dans la ferveur de l'URSS, qu'il connut à quinze ans, tout un été dans un camp de pionniers, où commence à se forger cet "homme nouveau", dont l'idéologie soviétique a besoin de croire qu'il existe. Pour être quitte à l'idée qu'elle se fait du socialisme, et pour bien tenir en main les enseignants et leurs pupilles… Un bon hégelien dirait: "Lucio Fanti peint la conscience de soi de l'Union soviétique". Un marxiste dirait: "Lucio Fanti peint l'idéologie officielle de l'URSS: le type d'identité dont l'Union soviétique a besoin de se doter pour assurer l'unité officielle de ses 'citoyens' et de ses 'peuples'." / Et si on demande: mais comment donc faire pour *peindre une idéologie*? Lucio Fanti répond en peignant des photographies soviétiques officielles composées par des photographes attentifs à leurs devoirs idéologiques… l'idéologie soviétique… "existe" aussi dans ces images, dans le traitement du "sujet", dans le symbolisme des personnages, dans le cadrage, le type de paysage, dans les statues, les statues, les statues, qui peuplent les jardins, dans les statues et les tableaux qui habitent les demeures', Louis Althusser, preface (untitled) in *Lucio Fanti*, Paris, Galerie Krieff-Raymond, 21 April–22 May 1977. See also 'Sur Lucio Fanti (mars 1977)' *Écrits philosophiques et politiques*, ed. François Matheron, Paris, Éditions Stock/IMEC, 1995, vol. II, pp. 591–4, with notes on the typescript version, p. 595, precisely concerning the memory of Mayakovsky's verse versus the 'established conventions regarding his suicide' (*dont la seule mémoire de quelques vers ébranle les conventions établis sur son suicide*). *Lecteur de poésie dans la neige*, 1977, was purchased by the Musée national d'art moderne, after this show.

68 'une image chargée d'idéologie ne se donne jamais à voir comme de l'idéologie en image. Il faut la travailler pour produire en elle cette minuscule distance intérieure, qui la déséquilibre, l'identifie et la dénonce. Lucio Fanti pratique ce décalage implacable dans le silence de procédés variés: soit l'insistance sur l'insolite du non-insolite, soit le deuil ou la violence de la couleur, soit l'étrangeté de quelques papiers volant au ras d'une immense plaine accablée d'une ciel d'orage, ou d'hommes qui, sur la neige, lisent, et des feuilles s'échappent de leurs livres, soit même l'absence, témoins ces gigantesques pylônes de l'électrification du communisme à qui manquent seulement les Soviets! Mais les arbres d'un bois ont pris la place des hommes', ibid.

69 The 'Textes de crise' in Althusser's *Écrits philosophiques*, vol. II, open with 'Une question posée par Louis Althusser', a spoof piece written as a 'public question' addressed to Marcel

Cornu, the editor of *La Pensée*, pp. 345–56, probably never sent, which occasioned much laughter with Dominique Lecourt ('Notice', p. 344). (It is excluded from *Philosophy of the Encounter: Later Writings, 1978–1987*, ed. François Matheron and Olivier Corpet, trans. and intro. G. M. Goshgarian, London and New York, Verso, 2006.) Matheron refers to Althusser's extensive reading of Derrida over a long period (p. 20), which surely involved the latter's reflections on Artaud, language and *la folie*.

70 *Les faits* is dated 1976, a 76–page corrected typescript, written for publication in Regis Debray's revue *Ça ira* of which only the pilot issue (January 1976) appeared; see Althusser, *L'Avenir dure longtemps, suivi par Les Faits*, ed. Olivier Corpet and Yann Moulier-Boutang, Paris, Éditions Stock/IMEC, 1992, p. v. A humorous parody designed to preface *Etre marxiste en philosophie* (published as 'Une conversation philosophique', *Digraphe*, 66, December 1993, pp. 55–62), dated July 1976, is one of many versions in the IMEC archives. The archives contain photographs of Althusser's audience with Pius XI (May 1946) and with Général de Gaulle (1959, Bal de Lens, *France Soir*) not mentioned by his detractors.

71 'Mais alors, l'Union soviétique n'est qu'un détour? Oui dirait L. Fanti… les clichés des photographs cadrant-composant au 1/1000 de seconde les clichés idéologiques, ou certaine poésie même trouve à glisser sa platitude L. Fanti dirait: l'URSS m'est un détour nécessaire, pour parler de nous, de moi…. "Je ne quitterai jamais ce pays, incomparable pour comprendre car les choses s'y voient à nu, le vrai comme vrai, le faux comme faux, et chaque mot y porte à conséquence. Interdit de jouer avec les images." L. Fanti le sait, qui "joue" avec les clichés, non pour s'en jouer mais les faire voir à nu. Il n'y a que les rois nus qui regnent', unpaginated catalogue (*Écrits philosophiques*, II, pp. 591–5, which changes 'L.' to 'Lucio' throughout).

72 See Althusser, *L'Avenir dure longtemps*, p. 182: '("car là au moins on y voit les choses à nu, et sans fard")' (*The Future Lasts a Long Time*, London, Chatto and Windus, 1993, p. 190: 'because here at least you see things as they really are, not dressed up'). See also *Dialektik, Staat, Recht: Internationaler Hegel-Kongress*, Berlin, Akademie-Verlag, 1976; and Alexander Zinoviev, *Ziyayushchie Vysoty*, Lausanne, Éditions l'Âge d'Homme, 1976 (*The Yawning Heights*, London, Bodley Head, 1978, and New York, Random House, 1979).

73 'Mais le Grand-Duc est tout nu, s'écria l'enfant', Hans Christian Andersen, epigraph to Simon Leys, *Les Habits neufs du president Mao: chronique de la 'révolution culturelle'*, Paris, Bibliothèque Asiatique, Éditions Champ Libre, October 1971.

74 Irène Fenoglio, *Une Auto-graphie du tragique: les manuscrits de* Les Faits *et de* L'Avenir dure longtemps *de Louis Althusser*, Louvain-La-Neuve, Bruylant-Academia, 2007, rehearses all the paradoxes of 'autobiography' versus exhaustive textual analysis.

75 See Guido Fanti and Giancarlo Ferri, *Cronache dell'Emilia Rossa: l'impossibile riformismo del PCI*, Bologna, Pendragon, 2001. Elected as the mayor of Bologna in 1966, Fanti became the first president of Emilia Romagna in 1970. See also Antonio Negri, *Books for Burning: Between Civil War and Democracy in 1970s Italy*, London, Verso, 2005.

76 The Belgrade Conference of June 1977 succeeded the Helsinki Summit Conference on Security and Cooperation in Europe, where human rights had featured. In 1977, demonstrations and vigils were held in sympathy with the hunger strikes organised in Soviet camps and jails (Perm, Moldovia, Vladimir) to coincide with the talks: the situation was much debated at Venice in November.

77 Manifestos and articles with quotations and sources are detailed in the catalogue *Identité italienne: l'art en Italie depuis 1959*, ed. Germano Celant, Paris, Musée national d'art moderne, Centre Georges Pompidou, 1981, pp. 544–55, a superb gloss on Fanti's Italian context.

78 See Maria-Kristiina Soomre, ed., *Archives in Translation: Biennale of Dissent 77*, Kumu Art Museum, Tallinn, Estonia, 2007, and Alessandra Agostinelli, 'Collezionisti italiani alla Biennale del dissenso', graduating thesis, Venice, Università Ca'Foscari, 2008, for an extensive bibliography.

79 See *La Nuova arte sovietica: una prospettiva non ufficiale*, ed. Enrico Crispolti and Gabriella Moncada, La Biennale di Venezia, Marsilio Editori, November 1977.

80 See *5 pittori sovietici*, texts by Renato Guttoso, Alberto Moravia, Yu Osmolovski, Rome, Galleria Il Gabbiano, December 1972, an exchange exhibition with Moscow, Gallery of the Union of Artists, 1974, with Perioro Guccione, Fabio Rieti, Lorenzo Tornabuoni.

81 See n. 1 above. An impossibly complex relationship among authenticity, absurdity and dialectical inversion in a society with no market is adumbrated by Boris Groys, *Total Enlightenment: Moscow Conceptual Art, 1960–1990*, Frankfurt, Schirn Kunsthalle, and Madrid, Fundación Juan March, Ostfildern, Hatje Cantz, 2008.

82 See Louis Althusser, 'Finalmente qualcosa divitale si libera dalla crisi e nella crisi del marxismo', *Il Manifesto*, 16 November 1977, reprinted in 'Potere e opposizione nelle società post-rivoluzionarie: una discussione nella sinistra', *Manifesto quaderno*, 8, Rome, Alfani Edittore, June 1978; and 'Enfin le crise du marxisme', in *Il Manfesto*, reprinted in *Pouvoir et opposition dans les sociétés postrévolutionnaires*, Paris, Seuil, 1978, pp. 242–53 ('The Crisis of Marxism, *Marxism Today*, July 1978, pp. 215–20, 227, and *Power and Opposition in Post-Revolutionary Societies*, London, Ink Links, 1979, pp. 225–37. 'Enfin la crise du marxisme' was reworked and extended as 'Marx dans ses limites' in 1978; see *Écrits philosophiques et politiques*, vol. I, ed. François Matheron, Paris, Stock/IMEC, 1994, pp. 359–512 and nn. pp. 513–24.

83 'J'ai, combien de fois, pensé à ton mot, combien de fois: "je reste, car c'est ici qu'on voit le fond des choses, à nu"', Althusser, letter to Merab Mamardashvili, Fonds Althusser, IMEC, Abbaye d'Ardenne; *Écrits philosophiques*, I, p. 525 (see *Multitudes*, http://multitudes.samizdat.net/spip.php?article1146). My translation (see also *Philosophy of the Encounter*, p. 2).

84 Giorgio Fanti, 'Al "punto zero" della teoria', *Paese Sera*, 6 May 1978. 'Althusser… corrigea encore le texte au marbre sul les instigations pressantes de son ami Giorgio Fanti'. See also Yann Moulier Boutang, 'L'Interdit biographique et l'autorisation de l'œuvre', in *Lire Althusser aujourd'hui*, pp. 83–4.

85 Reproduced constantly, unauthored, undated – notably on the cover of *Philosophy of the Encounter* – this photograph was taken by Jacques Pavlovksy working for Sygma, a commissioned reportage of 19 May 1978, one of four shots (165283–004). The second (002), which shows Althusser reading a datable copy of *L'Humanité*, is also in the IMEC archives. Conversation with Jacques Pavlovsky, 25 August 2008.

86 See Althusser, 'Marx dans ses limites', *Écrits philosophiques*, II, pp. 357–512, notice pp. 343–4; nn. pp. 513–24; 'Marx in his limits', *Philosophy of the Encounter*, pp. 7–162. Fanti's motif of flying papers derives, he insists, from the nineteenth-century engraver Paul Gavarni.

87 'Le silence d'Althusser: est-il comparable à ceux d'Hölderlin, de Nietzsche, d'Artaud, ces "absences d'œuvre" qui fascinaient Foucault?', Etienne Balibar, 'Tais-toi encore, Althusser!' written for the 70th birthday Althusser number of *KultuRRevolution*, 20, October 1988 (reprinted in *Les Temps modernes*, 509, December 1988, and in Etienne Balibar, ed., *Écrits pour Althusser*, Paris, Éditions de la Découverte, 1991, p. 60. Extensive press dossiers concerning the murder and the autobiography are held by IMEC.

88 'En tuant sa femme le 16 november 1980, Louis Althusser cesse définitivement d'être un sujet politico-philosophique', François Matheron, 'Presentation', *Écrits philosophiques*, I, p. 12; the principle involves the organisation of the texts in the two volumes of Althusser's writings and those excluded as 'documents cliniques' (p. 20). Despite the economy and finesse of the discussions, I profoundly disagree with the concept of a break and the unproblematised use of the world *folie* ('un prodigieux témoignage de folie') to frame Althusser's autobiographies in the preface to *L'Avenir dure longtemps*, pp. viii, ix.

89 François Matheron, 'La Récurrence du vide chez Louis Althusser', in *Lire Althusser aujourd'hui*, pp. 23–47; see also Moulier Boutang's highly pertinent 'L'Interdit biographique, ibid., pp. 75–112, and Gregory Elliott, 'Analysis Terminated, Analysis Interminable', in Elliott, ed., *Louis Althusser: A Critical Reader*, Oxford, Blackwell, 1994, pp. 177–202.

90 'Il avançait dans son récit avec soulagement et c'était comme une zone de lumière qu'il laissait derrière lui', Althusser, 'Chronique d'un prisonnier (extrait)', 1940, in *Journal de captivité, Stalag XA/1940–1945: carnets, correspondances, textes*, ed. Olivier Corpet and Yann Moulier Boutang, Paris, Stock/IMEC, 1992, p. 13.

91 'Le souffle coupé d'un poète est encore un poème, qui dit pourquoi il acceptait de vivre. Les écrits s'envolent, les paroles durent et le temps passé les rend plus dure que le métal. Lénine, Maïakovski: leurs statues… sont comme des fantômes, surgissant d'une surprenante légerté de la brume d'hiver, abandonnées, dans le deuil des arbres nus. Quelques mots d'un mort, bien mort, toujours vivant dans ce qu'il dénonçait', Althusser, 'Lucio Fanti', 1977, in *Écrits philosophiques*, II, p. 593.

92 For his theatre productions see 'Lucio Fanti: tout sauf la peinture', *Le Petit Chaillioux*, Fresnes, La Maison d'Art Contemporain Chaillioux, October 2002.

Chapter 4 Deleuze, Foucault, Guattari, Fromanger

1 '"Qu'est-ce que peindre aujourd'hui?" Que peut alors signifier une telle pratique, après l'effondrement des systèmes de représentation qui supportaient les subjectivités individuelles et collectives jusqu'au grand balayage d'images mass-médiatiques et à la grande déterritorialisation des codages et surcodages traditionnels qu'a connus notre époque?, C'est cette question que Fromanger a pris partie de peindre', Félix Guattari, 'Fromanger, la nuit, le jour', *Eighty Magazine*, August 1984, *Eighty Magazine*, 1984, in *Fromanger*, Tokyo, Fuji Television Gallery, np, reprinted in Guattari, *Les Années d'hiver, 1980–1985*, Paris, Bernard Barrault, 1986, p. 250.

2 John R. Searle's *Speech Acts* (1969) appeared as *Les Actes de langage: essai de philosophie du langage*, Paris, Hermann, 1972.

3 The watershed 'New Spirit in Painting', London, Royal Academy of Arts, 1981, was complemented in France by the first 'figuration libre' show, 'Finir en Beauté', curated by Bernard Lamarche-Vadel (editor of *Figurations*, 1960–73), rue Fondary, Paris, in June 1981.

4 'ce gigantesque carnaval qui a su se rendre incontournable à mesure qu'il parvenait à répondre, même par les voies les plus débilitantes, à un authentique désir de reterritorialisation subjective', Guattari, 'Fromanger', p. 250.

5 Guattari's own 'Glossary' of this critical language in English was written for his *Molecular Revolution, Psychiatry and Politics*, trans. Rosemary Sheed, London, Peregrine, 1984, pp. 288–90.

6 Tunix was held 28–31 January 1978 in West Berlin. See J. Gehret, ed., *Gegenkultur heute: Die alternativbewegung von Woodstock bis Tunix*, Amsterdam, Azid Presse, 1979; Jens Gehret, ed., *Gegenkultur: Von Woodstock bis Tunix, von 1969 bis 1981*, Asslar, BarGis, 1985.

7 'Mais ici, la topique triangulaire de l'a-signifiant, du signficatif et de l'énonciation perd ses droits et, avec elle, celle du Ça, du Moi et du Surmoi', Guattari, 'Fromanger', p. 257 ('narcissim*e*, joyeusement assumé', p. 254).

8 'Celui qui peint, l'"actant" qui se trouve être ce peintre-là, a été entraîné dans une irréversible déterritorialisation des corps et des codes, opérant aussi bien en deça qu'au-delà des délimitations personnologique. L'originalité de cette transformation telle que l'a pilotée Fromanger, c'est qu'elle n'about-il pas à une décomposition, comme dans la lignée Soutine-Bacon ou à une désexualisation, comme dans celle des formalistes américains. On assiste, au contraire, à une recomposition corporelle et à la refondation d'une énonciation picturale', ibid., p. 256.

9 Harry Jancovici, a former student of Deleuze, who after teaching philosophy ran a gallery, then worked for Éditions de la Différence, commissioned this text in his series 'La vue, le texte'. It was based on Deleuze's seminars at the Université de Vincennes for the year 1979–80. The Galerie Harry Jancovici, showing young artists, ran from 1974 to 1976.

10 See Sarah Wilson, ed., *Photogenic Painting: Gilles Deleuze, Michel Foucault, Gérard Fromanger*, intro. Adrian Rifkin, London, Black Dog Publishing, 1999, for the republication of both texts, trans. Daffyd Roberts; 'Photogenic Painting' was first translated by Pierre A. Walker for *Critical Texts*, 6/3, 1989, pp. 1–12.

11 The twelve *Souffles* were named after towns where there had been workers' protests (Caen, Flins, Sochaux, etc); after student revolutions (Paris, Rome, Berlin, Warsaw); and after women (Florence, Chantal, Isabelle, Elisabeth); performances took place outside the Alésia church, 12 October 1968. See Serge July, *Gérard Fromanger,* Paris, Éditions Cercle d'Art, 2002, p. 34.

12 'Son atelier achevait de flamber et tout son travail n'était plus que cendres mouillées', Jacques Prévert, 'Gérard Fromanger' in '5 Peintres et un sculpteur', *Derrière le miroir*, 150, Paris, Galerie Maeght, March–April 1965.

13 The painter Pierre Buraglio confirmed his refusal for the Salon of *Les Pétrifiées;* they were shown at Galerie Jean Taffaray.

14 See *Un Acteur de son temps: Gérard Philipe*, Paris, Bibliothèque Nationale de France, 2003. The green *Prince de Homburg* (Gérard Depardieu collection) reached a record 61,000 euros at auction in 2002: see 'Consécration pour le Pop français', *Le Journal des Arts*, 143, 2002, in Jean-Luc Chalumeau, *La Nouvelle figuration: une histoire de 1953 à nos jours*, Paris, Éditions Cercle d'Art, 2003, p. 8.

15 Arroyo's studio in the Villa des Ternes, where Recalcati stayed for two years, was near Fromanger's in the rue Bayen, 17th arrondissement.

16 July, *Fromanger*, pp. 41–2. See also 'L'Atelier populaire de l'ex-École des Beaux-Arts: entretien avec Gérard Fromanger, in Laurent Gervereau, ed., *Mai 68: les mouvements étudiants en France et dans le monde*, Paris, Bibliothèque de Documentation Internationale Contemporaine, 1988, pp. 184–91.

17 July, *Fromanger*, p. 43.

18 Ibid., p. 44.

19 See 'Le Peinture qui bouge', 3–11 November 1970, programme in the *Bulletin de la Jeune Peinture*, 6, November 1970, p. 11. Fromanger's second collaboration with Godard, *Partie de campagne*, a 40–minute video, was probably shown at ARC. Note also Pierre Clementi's *Les Souffles de Gérard Fromanger* (16 mm, 30 mins) and Isabelle Pon's 12–minute Super 8 film *Souffles*, both shot in 1968. Both versions of *Red* were shown in Fromanger's presence in London, Tate Modern, 2 May 2008 as the finale of a 'May '68' series.

20 *Films de peintres (Boltanski, Erró, Fromanger, Ipostéguy, Martial Raysse)*, ARC, Musée d'art moderne de la Ville de Paris, 1970; see also Alfred Pacquement's two nine-screen film installations, 'Précurseurs et principales tendances de l'art contemporains' and 'Parallèles étrangers (1960–1972)', in 'Les Films d'artistes', *Douze ans d'art contemporain*, Paris, Grand Palais, 1972, pp. 89–93.

21 See 'Stockhausen *Hymnen*', *Ballet théâtre contemporain*, 1, October 1970, Amiens, Centre Choréographique Nationale, Maison de la Culture. The first performances were given before officials from Dortmund with whom Amiens was twinned; seasons in Grenoble and Marseilles were followed by performances in Paris, Portugal, Spain and Italy, then a two–month tour of South America. The repertoire given here reveals inspiring combinations: e.g. Stravinsky with Sonia Delaunay, Xenakis with Prassinos, Boulez with Borès, Edgar Varèse with Léon Zack. See also Edward Frankel, 'Karlheinz Stockhausen and Gérard Fromanger: Politics and Reproduction in the Ballet *Hymnen*, Amiens, 1970', MA, Courtauld Institute of Art, University of London, 2007.

22 Fromanger's *Le Rouge* album of lithographs was first shown in the Biennale de la Gravure, Paris, 1969, and finally at the Galerie Baba, Paris, 1970.

23 For the capitalist urban environment of signs, see Benjamin Buchloh, 'Villeglé, from Fragment to Detail' (*October*, Spring 1991), *Neo-Avant-garde and Culture Industry*, Cambridge, Mass., and London, MIT Press, 2000, pp. 443–60.

24 See Elie Kagan and Patrick Rotman, *Le Reporteur engagé: treize ans d'instantanés,* Paris, Métailié, 1989, and Elie Kagan and Jean-Luc Einaudi, *17 octobre 1961*, Arles, Actes sud-Bibliothèque de Documentation Internationale Contemporaine, 2001.

25 See July, *Fromanger*, p. 54: 'Elie Kagan n'etait d'ailleurs pas un artiste mais un enregistreur qui n'interferait pas dans le choix fait par le peintre de la quotidienneté la plus banale'; he proceeds to quote Foucault's reference to 'photos de hasard'. The concept of the photograph as a mere *document de travail* prevailed until Rancillac's court casebrought by Alain Saulnier heralded a change (see Chapter 2 above).

26 See Jacques Prévert and Alain Jouffroy, *Fromanger: Boulevard des Italiens*, Paris, Éditions Georges Fall, 1971.

27 The Biennale de Paris conceptual art section was curated by Nathalie Aubergé, Catherine Millet and Alfred Pacquement; Daniel Abadie, Jean Clair and Pierre Léonard worked on hyperrealism. Both Pacquement and Clair were involved at the time with the controversial 'Douze ans d'art contemporain' for the Grand Palais, 1972.

28 Jean Clair, 'Hyperréalisme, 7ᵉᵐᵉ Biennale de Paris', *Chroniques de l'art vivant*, 24, October 1971, pp. 30–31, with Aragon photograph.

29 Another anecdote recounted many times (Fromanger demonstrated an admirable rigour, bearing in mind Aragon's status and power at *Les Lettres françaises*). Henri Avron, *Le Gauchisme*, Paris, PUF, Que sais-je? series (1974), 1977, explained the multiplicity of tendencies subsumed under *gauchisme*, and the genesis of the term, in Lenin's *'Leftism': An Infantile Malady of Communism*.

30 Lindner exhibited at the Galerie Claude Bernard in 1965, in Rome with Il Fante di Spade in 1966 and, after marrying a Frenchwoman, set up a large studio in Paris in 1971; he entertained the Narrative Figuration artists in Paris and New York prior to his major 1974 touring retrospective. See Eduardo Arroyo, 'L'Ami Richard', in *Richard Lindner*, Paris, Musée de la Vie Romantique, 2005, pp. 39–40.

31 *Documenta 5* in Kassel, 1972, was the first to have an artistic director and themes.

32 Lindner's painting is reproduced as *Garçon à la machine*, frontispiece, in Gilles Deleuze and Félix Guattari, *Capitalisme et schizophrénie: 1, L'Anti-Œdipe*, Paris, Minuit, 1972 (*Anti-Oedipus: Capitalism and Schizophrenia*, trans. Robert Hurley, Mark Seem and Helen R. Lane [New York, 1977], London, Athlone Press, 1984).

33 See 'Introduction to Schizanalysis', ibid., pp. 369–70 (Holy Family) and p. 132 (Turner); with James Williams, 'Deleuze on J. M. W. Turner: Catastrophism in Philosophy', in Keith Ansell Pearson, ed., *Deleuze and Philosophy: The Difference Engineer*, London, Routledge, 1997, pp. 233–46.

34 Deleuze, 'Appréciation', *La Quinzaine littéraire*, 140, 11–15 May 1972, p. 19, in *L'Île deserte et autres textes: textes et entretiens, 1953–1974*, ed. David Lapoujade, Paris, Minuit, 2002, pp. 299–300.

35 Deleuze's wife Fanny, starting a job with Karl Flinker, witnessed Fromanger's shabby treatment by the eminent gallerist who had taken his *agrégation* examination with her husband (Flinker retracted the offer of an important exhibition). Foucault's text 'Les Rayons noirs' for Constantin Byzantios's '30 Dessins' at Flinker (15 January 1974) was published in *Le Nouvel observateur*, 483, 1 February 1974, reprinted in *Dits et écrits*, vol. II, 1976–88, ed. François Ewald and Daniel Defert, Paris, Gallimard, 1994, pp. 518–21, 'Sur D. Byzantios' (*sic*).

36 'catégories empiriques… [qui] peuvent néanmoins se servir d'outils conceptuels pour dégager des notions abstraites et les enchaîner en propositions', Claude Lévi-Strauss, *Le Cru et le cuit*, Paris, Plon, 1964, p. 9 (*The Raw and the Cooked*, London, Jonathan Cape, 1970, p. 1). Fromanger confirmed Deleuze's analogy, conversation with the artist, 27 March 2009.

37 See Félix Guattari, *The Anti-Oedipus Papers*, trans. Kélina Gotman, ed. Stephane Nadaud, New York Semiotext(e), 2006, esp. pp. 69–72, on the joint brainstorming sessions. Deleuze controlled the final text.

38 Again, repeated in several different interviews by the artist. On this technique of brainstorming *à deux* and subsequent quoting and editing see François Dosse, *Gilles Deleuze et Félix Guattari: biographie croisée,* Paris, La Découverte, 2007, pp. 19–21.

39 'Vous introduisez le désir dans l'infra-structure ou ce qui revient au même, vous introduisez la catégorie de production dans le désir', Deleuze, letter to Pierre Klossowski, 21 April 1971, Bibliothèque Littéraire Jacques Doucet, Paris; Deleuze's letters to Klossowski traverse the period of evolution of *L'Anti-Œdipe*.

40 'Le modèle du peintre, c'est la marchandise. Toutes sortes de marchandise: vestimentaires, balnéaires, nuptiales, érotiques, alimentaires. Le peintre est toujour présent, silhouette noire: il a l'air de regarder. Le peintre et l'amour, le peintre et la mort, le peintre et la nourriture, le peintre et l'auto: mais d'un modèle à l'autre, tout est mesuré à l'unique modèle. Marchandise qui circule avec le peintre. Les tableaux, chacun construit sur une couleur dominante, forment une série. On peut faire comme si la série s'ouvrait sur le tableau *Rouge de Cadmium*, et se fermait sur le *Vert Véronèse*, représentant le même tableau, mais cette fois exposé chez le marchand, le peintre et son tableau devenus eux-mêmes marchandises. Ou bien on peut imaginer d'autres débuts et d'autres fins', Gilles Deleuze, 'Le Froid et le chaud', Paris, Galerie 9, 1972; in Wilson, *Deleuze, Foucault, Fromanger*, p. 63.

41 'le vert n'est pas espérance; ni le jaune tristesse, ni le rouge, gaieté. Rien que du chaud ou du froid, du chaud et du froid. Du matériel dans l'art: Fromanger peint, c'est-à-dire fait fonctionner le tableau. Tableau-machine d'un artiste mécanicien. L'artiste mécanicien d'une civilisation: fait-il fonctionner le tableau?', ibid, pp. 63–4.

42 Bernard Ceysson refers to Pliny the Elder's story of the lovesick daughter of Butades of Sicyon, who traced the countour of her lover, in Bernard Ceysson, ed., *Gérard Fromanger 1962–2005*, Paris, Somogy, 2005, rev. 2008, p. 16.

43 Fromanger repeated the anecdote at the '1968' study day, London, Tate Modern, 2 May 2008.

44 'Le peintre peint *dans le noir*, pendant des heures. Son activité nocturne révèle une vérité éternelle de la peinture: que jamais le peintre n'a peint sur la surface blanche de la toile pour reproduire un objet fonctionnant comme modèle, mais qu'il a toujours peint sur une image, un simulacre, une ombre de l'objet, pour produire une toile dont le fonctionnement même renverse le rapport du modele et de la copie, et qui fait précisément qu'il n'y a plus de copie *ni de modèle*', Deleuze, 'Le Peintre et le modèle', in Wilson, *Deleuze, Foucault, Fromanger*, p. 65

45 'C'est une erreur de croire que le peintre est devant une surface blanche. La croyance figurative découle de cette erreur: en effet, si le peintre était devant une surface blanche, il pourrait reproduire un objet extérieur fonctionnant comme modèle. Mais il n'est pas ainsi. Le peintre a beaucoup de choses dans la tête, ou autour de lui, ou dans l'atelier. Or, tout ce qu'il y a dans la tête ou autour de lui est déjà dans la toile, à titre d'images, actuelles ou virtuelles. Si bien que le peintre n'a pas à remplir une surface blanche, il aurait plutôt à vider, désencombrer, nettoyer. Il ne peint donc pas pour reproduire sur la toile un objet fonctionnant comme modèle, il peint sur les images qui sont déjà là, pour produire une toile dont le fonctionnement va renverser les rapports du modèle et de la copie', Gilles Deleuze, *Francis Bacon: logique de la sensation*, Paris, Éditions de la Différence, 1981, ch. XI, p. 57 (*Francis Bacon: The Logic of Sensation*, trans. Daniel W. Smith, London and New York, Continuum, 2003, p. 86). Harry Jancovici took Deleuze's text to Bacon in London for a final perusal, to discuss the lithographs inserted in the collector's edition and to procure photographs from Marlborough Fine Art, Bacon's gallery. Deleuze met Bacon at the celebratory post-publication dinner in Paris and received Bacon's compliments.

46 The Deleuzian mindset is central to the contemporary popular philosopher Michel Onfray's reflections in 'Gérard Fromanger, un portrait du portrait', in *Gérard Fromanger: peintres, poètes, philosophes et amis*, Argentan (Normandy), Médiathèque, 2006.

47 '[Comment] le tableau fonctionne… chaude ou froide à son tour, elle peut chauffer ou refroidir la dominante…

en noir, comme un double potentiel s'actualisant aussi bien dans un sens et dans l'autre, ou qui peut "filer" vers le bleu froid comme vers le chaud violet... Bref le peintre noir a dans le tableau deux fonctions, suivant deux circuits: lourde silhouette immobile paranoïaque qui fixe le marchandise autant qu'il est fixé par elle; mais aussi ombre schizo mobile, en perpétuel déplacement par rapport à soi-même, parcourant toute l'échelle du froid et du chaud, pour s'échauffer le froid et refroidir le chaud, voyage incessant sur place', Deleuze, 'Le Peintre et le modèle', pp. 66–7, 70–71.

48 The connection with *L'Image-temps Cinéma 2* (in fact not published until 1985) was made by Fromanger at Tate Modern, 2 May 2008. Deleuze made notes not during but straight after seeing films.

49 'Il ne s'agit pas d'appliquer la philosophie au cinéma, mais on allait tout droit de la philsophie au cinéma. Et inversement aussi, on allait tout droit du cinéma à la philosophie', Gilles Deleuze, 'Le Cerveau, c'est l'écran', *Cahiers du cinéma*, 380, February 1986, pp. 25–32, in David Lapoujade, ed., *Deux régimes de fous: textes et entretiens, 1975–1995*, Paris, Minuit, 2003, pp. 263–4.

50 'la machine capitaliste civilisée', Deleuze and Guattari, *L'Anti-Œdipe*, pp. 263 ff (*Anti-Oedipus: Capitalism and Schizophrenia*, ch. 3, pt 9, 'The Civilised Capitalist Machine', pp. 222 ff).

51 Conversation with Gérard Fromanger, nd.

52 See Marshall McLuhan, *Understanding Media: The Extensions of Man*, New York, McGraw Hill, 1964 (*Pour comprendre les médias: les prolongements technologiques de l'homme*, trans. Jean Paré, Paris, Seuil, 1968); G. E. Stearn ed., *McLuhan Hot and Cool*, New York, Dial, 1967 (*Pour ou contre McLuhan*, trans. G. Durond and P.-Y. Pétillon, Paris, Seuil, 1969).

53 Marshall McLuhan, Quentin Fiore, *War and Peace in the Global Village*, New York: Bantam, 1968 (*Guerre et paix dans la village planétaire*, Paris, Robert Laffont, 1970).

54 See *Chroniques de l'art vivant*, 36 and 37, 1: 'Hyperréalisme', 2: 'Réalismes', February and March 1973, ed. Jean Clair with contributions by Lyotard et al.

55 See Salvador Dalì, preface to Linda Chase, *L'Hyperréalisme américain*, Paris: Filipacchi, 1973.

56 Alain Jouffroy, *Les Visionneurs*, Brussels, Galerie Espace, and Basel, Galerie 15, 1973.

57 Exhibitions held in 1972: *Réalisme*, Brussels, Palais des Beaux-Arts; *Relativerend Réalisme*, Eindhoven, Van Abbemuseum; in 1973, *Photorealism*, London, Serpentine Gallery; *Realists*, Essen, Folkwang Museum; *Mit Kamera, Pinsel und Spritzpistole*, Recklinghausen, Kunsthalle; *Ekstrem Realism*, Humlebaek, Louisiana Museum; *Hyperréalisme*, Brussels, Galerie Isy Brachot. In publishing see Udo Kulterman, *New Realism*, London, Matthews Miller Dunbar, 1972 (*Hyperréalisme*, Paris, Chêne, 1972); Daniel Abadie, *L'Hyperréalisme américain*, Paris, Fernand Hazan, 1975. Similar titles appeared in England, Belgium, Germany and Italy. The final American/European juxtaposition, taking a Duchampian title, 'Copie Conforme?', showed John de Andrea and Chuck Close with Jean-Olivier Hucleux, Paris, Centre Georges Pompidou, 1979.

58 Fromanger specifically recalled work by Gérard Gasiorowski in the show. *Nous n'avions rien à faire avec ça... Pourquoi mélanger?* (We had nothing to do with all that. Why mix them up?). Conversation with Fromanger, 7 September 2006.

59 Linda Chase, 'L'Hyperréalisme américain', *Hyperréalistes américains-Réalistes européens*, Paris, CNAC, Établissement Beaubourg, 1974, p. 8.

60 *Francis Bacon*, Paris, Grand Palais, 1971, intro. Michel Leiris.

61 Jean-Paul Sartre 'Coexistences', *Derrière le miroir*, 187, 1970, reproduced in *Rebeyrolle: peintures 1968–1978*, Paris, Maeght Éditeur, 1978, with texts by Michel Troche, Carlos Francqui, Jean-Paul Sartre, Michel Foucault, Samir Amin, José Angel Valenté, pp. 27–33

62 See Philippe Artières, Laurent Quéro, and Michelle Zancarini-Fournel, eds., *Le Groupe d'information sur les prisons: archives d'une lutte, 1970–1972*, Paris, IMEC, 2003.

63 Michel Foucault, 'La Prison partout', *Combat*, 8335, 5 May 1971, p. 1, reprinted in Foucault, *Dits et écrits*, vol. I, 1954–1975, ed. François Ewald and Daniel Defert, Paris, Gallimard, 1994, p. 1061.

64 Rebeyrolle (d. 2005) enjoyed no less than five numbers of *Derrière le miroir*: no. 163 prefaced by Claude Roy in 1967; no. 177, 'Les Guerillos', preface by Carlos Franqui (the exiled editor of Cuba's *Revolución* and organiser of the 1967 Salon de Mayo) in 1969; Sartre's number of 1970; no. 202, 'Les Prisonniers' with Foucault's 'La Force de fuir' and Ricardo Porro's 'Portrait de la crise' in March 1973; no. 219, 'Natures mortes et pouvoir', 1976, again prefaced by Carlos Franqui. Rebeyrolle is constantly exhibited in France, including contemporary shows (eg, 'La Force de l'Art', Paris, Grand Palais, 2006); see www.espace-rebeyrolle.com

65 For interest after Wilson, *Deleuze, Foucault, Fromanger* (1999) see Sarah Wilson, 'De la Bar aux Folies-Bergères au prison de Toul: Michel Foucault et la peinture', Colloque Michel Foucault, Cérisy-la-Salle, June 2001; 'Michel Foucault et les Arts: Problèmes d'une Généalogie des Arts', Zentrum für Kunst und Medientechnologie, Karlsruhe, 19–22 September 2002; Michel Foucault, *La Peinture de Manet, suivi de Michel Foucault: un regard*, ed. Maryvonne Saison, Paris, Seuil, 2004; p. Gente, ed., *Foucault und die Künste*, Frankfurt, Suhrkamp, 2004; Matthew Barr, 'Michel Foucault and Visual Art, 1954–1984', PhD, University of London, 2006–7, with extensive bibliography, and Barr, ed., *Manet and the Object of Painting*, preface by Nicolas Bourriaud, London, Tate Publishing, 2009.

66 See Barr, 'Michel Foucault', ch. 1, 'Art and the Asylum', pp. 36–107, for Foucault's relationship with precursors such as Merleau-Ponty and Georges Canguilhem, and in terms of arguments about the 'veracity' of claims regarding both art and 'madness' (*la folie*).

67 Michel Foucault, afterword to Gustave Flaubert, in *Die Versuchung des Heiligen Antonius* (Frankfurt, 1964), pp. 217–51, reprinted in *Cahiers de la compagnie Madeleine Renaud–Jean-Louis Barrault*, 59, Marc, 1967, pp. 7–30, and in *Dits et écrits*, I, pp. 326–7; trans. in Michel Foucault, *Aesthetics, Method and Epistemology*, ed. J. D. Faubion, London, Allen Lane, 1998, pp. 103–22, cited p. 107. Thanks to Matthew Barr for this reference.

68 See Didier Erebon, *Michel Foucault*, Paris, Flammarion, 1989, pp. 182–3.

69 Michel Foucault, 'La Prose du monde', *Diogène*, 53, January–March 1966, pp. 20–41, reprinted in *Dits et écrits* I, pp. 507–25; see 'Les Suivantes', *Les Mots et les choses: une archéologies des sciences humaines*, Paris, Gallimard, 1966, p. 19. See also Barr, 'Michel Foucault', pp. 111–20.

70 The relationship of the Velázquez piece to the literary structures of the *mise en abîme* is interesting here; see Foucault's *Raymond Roussel,* 1963, and the *nouveau roman.*

71 'Ce qui me plaît justement dans la peinture, c'est qu'on est vraiment obligé de regarder. Alors, là, c'est mon repos. C'est l'une des rares choses sur laquelle j'écrive avec plaisir et sans me battre avec qui que ce soit. Je crois n'avoir aucun rapport tactique ou stratégique avec la peinture', Michel Foucault, 'A quoi rêvent les philosophes' (with E. Lossowski), *L'Imprévu*, 2, 28 January 1975, p. 13, reprinted in *Dits et écrits*, vol. II, 1976–1988, p. 706.

72 Michel de Certeau, 'Le Rire de Michel Foucault', *Histoire et psychanalyse entre science et fiction*, Paris, Gallimard, 1987, p. 55, quoted in Stefano Catucci, 'La Pensée picturale', in Philippe Artières, ed., *Michel Foucault, la littérature et les arts*, Paris, Kimé, 2004, p. 131.

73 See Michel Foucault, 'Ceci n'est pas une pipe', *Les Cahiers du chemin*, 2, 15 January 1968, pp. 79–105, reprinted in *Dits et écrits* I, pp. 663–78; and 'Klee, Kandinski, Magritte', *Ceci n'est pas une pipe*, Paris, Fata Morgana, 1973, pp. 39–45 (*This Is Not A Pipe*, trans. J. Harkness, Berkeley, University of California Press, 1983. Foucault's acknowledgements are incomplete: see Patrick Waldberg, *René Magritte*, Brussels, André de Rache, 1965; René Passeron, *Magritte*, Paris, Filipacchi, 1970 (before the Fata Morgana edition). See also Passeron, *L'Œuvre picturale et les fonctions d'apparence*, Paris, Vrin, 1962, and Barr, 'Michel Foucault', pp. 126–8.

74 Magritte to Foucault, 4 June 1966, in *Ceci n'est pas une pipe*, 1973, pp. 86–8.

75 Incorrectly cited as *Le Noir et la surface* in Erebon, *Michel Foucault*, p. 202.

76 'Je ne suis pas historien de l'art' in 'Les Mots et les images', *Le Nouvel observateur*, 154, 25 October 1967, pp. 49–50, reprinted in *Dits et écrits* I, p. 648.

77 See Jean Genet, *Rembrandt*, Paris, Gallimard, 1995, and Sarah Wilson, 'Rembrandt, Genet, Derrida', in Joanna Woodall, ed., *Portraiture: Facing the Subject*, Manchester University Press, 1996, pp. 203–16.

78 Catucci, in Artières, *Michel Foucault*, p. 143, n. 10, notes that the late Hervé Guibert recounted his presence at the moment of the destruction of the manuscript in his novel *L'Ami qui ne m'a pas sauvé la vie*, Paris, Gallimard, 1990. See Maryvonne Saison in Foucault, *Peinture de Manet*, p. 11, and Molly Nesbitt, http://2nd.moscowbiennale.ru/en/light in buffalo/ for *Light in Buffalo* (forthcoming).

79 Foucault set up a course relating to a 4th-year complementary certificate; his teaching was taken over by H. Ben Halma, who described his slide lectures; see Rachida Triki, 'Foucault en Tunisie', in Foucault, *Peinture de Manet*, p. 57.

80 Pierre Francastel, *Peinture et societé: naissance et destruction d'un espace plastique. De la renaissance au cubisme*, Paris, Gallimard, 1965; possibly also relevant were Francastel's *La Figure et le lieu: l'ordre visuel du Quattrocento*, Paris, Gallimard, 1967, and *Études de sociologie de l'art*, Paris, Denoël-Gonthier, 1970, and John White's *The Birth and Rebirth of Pictorial Space*, London, Faber and Faber, 1957.

81 Rachida Triki, 'Une Expérience politique décisive', in Foucault, *Peinture de Manet*, p. 61.

82 Michel Foucault, 'L'homme est-il mort ?', conversation with Claude Bonnefoy, *Arts et loisirs*, 38, 15–21 June 1966, pp. 8–9, reprinted in *Dits et écrits*, I, pp. 568–72.

83 In 1974, with the proceeds from the reissue of *Folie et déraison*, Foucault said that he realised his life's dream of buying a Tobey – then the hyperrealists arrived, Foucault, 'A quoi rêvent les philosophes', *Dits et écrits*, II, p. 706. Interviewed on 28 January about the artist who interested him most, Foucault did not mention Fromanger; his preface was thus conceived in early February.

84 Ibid., p. 707. 'Le courant passait, corporellement, sexuellement. Tout à coup sautait aux yeux l'incroyable jansénisme que la peinture nous avait imposé pendant des dizaines et des dizaines d'années'. See also Raymond Charmet, *Clovis Trouille*, Paris, Filipacchi, 1972; Aleska Celebonovic, *Peinture kitsch ou réalisme bourgeois: l'art pompier dans le monde*, Paris, Seghers, 1974.

85 Erebon, *Michel Foucault*, p. 218.

86 Ibid., pp. 219–21.

87 Simon Leys, *Les Habits neufs du president Mao: chronique de la 'révolution culturelle'*, Paris, Champ Libre, 1971 (English edn 1977), based on official texts, Red guard press reports, 'self-criticisms' and trial extracts, considered an over-rhetorical and inadequate response to available primary material by Hon Yung Lee, *The American Historical Review*, 84/1, February 1979, pp. 229–30. See François Marmor, *Le Maoïsme: philosophie et politique*, Paris, PUF, Que sais-je? series, 1976, with bibliography; Christophe Bourseiller, *La Folle histoire des gardes rouges français*, Paris, Plon, 1996; and, symptomatically, Guy Sorman, 'Mao ou l'étrange fascination française pour le sado-marxisme', *Le Figaro*, 8 September 2006.

88 Julia Kristeva, *Des Chinoises*, Paris, Éditions des Femmes, 1974; Marcelin Pleynet, *Le Voyage en Chine*, Paris, Hachette, 1980; Philippe Sollers 'Pourquoi j'étais chinois', *Tel Quel* 88, Summer 1981, pp. 13ff; see Ieme van der Pole, *Une Révolution de la pensée: maoïsme et feminisime à travers* Tel Quel, Les Temps Modernes, *et* l'Esprit, Amsterdam, Rodopi, 1992.

89 See Joanna Large, 'All Roads lead to Peking: Joris Ivens and Gérard Fromanger in China', 1974, MA thesis, Courtauld Institute of Art, University of London, 2001, involving extensive work in the Ivens archive. This trip is omitted by François Hourmant, *Au pays de l'avenir radieux: voyages des intellectuels français en URSS à Cuba et en Chine populaire*, Paris, Aubier, 2000.

90 Fromanger's 'Tout est allumé' exhibiton was held at the same Galerie Jeanne Bucher, Paris, in 1973 (well known for its École de Paris artists Dubuffet, de Stael, Vieira de Silva). The Sinophile Bibliothèque Asiatique was situated on 6 rue des Beaux Arts, just opposite Galerie 9 and at an angle with rue de Seine where the gallery is situated.

91 Foucault, 'Prison partout', *Dits et écrits* I, p. 1061.

92 *Paysans et peintres amateurs à Hu Xian, province du Shan-Xi, Chine Populaire, le 20 juin, 1974*, and 'Servir le peuple', *Le Désir est partout*, Paris, Galerie Jeanne Bucher, 27 February–29 March 1975, np.

93 'Un Peintre en Chine', France-Culture, in *Gérard Fromanger 1963/1983*, Caen, 29 Janaury–6 March 1983, Paris, Éditions Opus International, p. 90, with the best early bibliography.

94 'Est-ce que cela veut dire qu'en fait il y a maintenant un régime de répression tel qu'ils n'ont plus le droit à cette expression libre, spontanée, sauvage de la révolution culturelle?', Michel Foucault, 'Sur la seconde révolution chinoise', with Karol and a journalist, *Libération*, 157, 31 January 1974, and 158, 1 February 1974, reprinted in *Dits et écrits* I, pp. 513, 516. K. S. Karol, *La Deuxième révolution culturelle*, Paris, Robert Laffont, 1973, preceded the Gang of Four's campaign, launched on 25 January.

95 Foucault on the question of pictorial depth in Manet's *Le Balcon*: 'Manet est là particulièrement vicieux et méchant', *Peinture de Manet*, p. 21.

96 See Gisèle Freund, *Photographie et société*, 1974, throroughly updated from the 1st edn, *La Photographie en France au dix-neuvième siècle*, Paris, La Maison des Amis des Livres, 1936, crucial for Walter Benjamin.

97 'Ce qu'avait fait Reijlander pour la *Madone* de Raphaël. Ce que faisaient Julia Margaret Cameron pour le Perrugin, Richard Pollack pour Peter de Hoogh, Paul Richier pour Böcklin, Fred Boissonas pour Rembrandt, and Lejaren à Hiller pour toutes les *Dépositions de croix* du monde', Michel Foucault, 'La Peinture photogénique', *Le Désir est partout*, np (my translation).

98 'Désir de l'image partout et par tous les moyens, plaisir de l'image', Foucault, ibid.

99 Alphonse Bertillon, *Instructions sur la photographie judiciaire*, 1890.

100 Réné Backmann and Claude Angeli, *Les Polices de la nouvelle société*, Paris, Maspéro, 1971; Christian Phéline, 'L'Image accusatrice', *Cahiers de la photographie*, Paris, ACCP, 1985.

101 'Des détenus révoltés sur un toit: une photo de presse partout reproduite. Mais qui donc a vu ce qui s'y passe? Quel commentaire a jamais délivré l'événement unique et multiple qui circule en elle? En jetant un semis de taches multicolores, dont l'emplacement et les valeurs sont calculés non par rapport à la toile, Fromanger tire de la photo d'innombrables fêtes', Foucault, 'Peinture photogénique'.

102 For the protest of 18 January 1972, see Erebon, *Michel Foucault*, pp. 246–7.

103 'Ce qu'il cherche? Non pas tellement ce qui avait pu se passer au moment ou le photo a été prise; mais l'événement qui a lieu, et qui continue sans cesse d'avoir lieu sur l'image, du fait même de l'image… Créer par le court-circuit photocouleur; non pas l'identité truquée de l'ancienne photo-peinture, mais un foyer pour des myriades d'images en jaillissement', Foucault, 'La Peinture photogénique'.

104 'Deux tableaux terminent l'exposition d'aujourd'hui. Deux foyers de désir. A Versailles, lustres, lumière, éclat, déguisement, reflet, glace; en ce haut-lieu où les formes devaient être ritualisés dans la somptuosité du pouvoir, tout se décompose en éclat même du faste et l'image libère un envol de couleurs. Feux d'artifices royaux, Haendel tombe en pluie; Bar aux Folies-Royales, le mirroir de Manet éclate; Prince travesti, le courtisan est une courtisane. Le plus grand poète du monde officiel. Et les images reglées de l'étiquette fuient au galop ne laissant derrière elles que l'événement de leur passage, la calvacade des couleurs parties ailleurs./À l'autre bout des steppes, à Hu Xian, le paysan-peintre-amateur s'applique. Ni miroir ni lustre. Sa fenêtre n'ouvre sur aucune paysage, mais sur quatres à-plats de couleur, qui se transposent, dans la lumière où il baigne. De la Cour à la discipline, du plus grand poète du monde au sept cent millionème amateur docile, s'échappe une mulititude d'images et c'est le court-circuit de la peinture', ibid.

105 Co-author of the Electric manifesto in 1971, by the age of 26 in 1975 Michel Bulteau had published *Poème A (Effraction-Laque*, 1972), *Les Cristaux de folie suivi de Watcris88mots* (1973), *Sang de satin* (1973), *Ester-Mouth, Slit, Hypodermique et L'Angle lit* (1974), *Coquillage rétroviseur* (1975). He left for New York to join Warhol and the beat poets in 1976.

106 'Images du Peuple Chinois', ARC, Musée d'art moderne de la Ville de Paris, 20 March–27 April 1975, curated by Jean-Louis Boissier, who recalls that the Chinese painter Zao Wou-Ki was an initiator and go-between for 'Peintres Paysans de Houhsien', Biennale de Paris, September–November 1975 (http://www.archives.biennaledeparis.org/fr/1975/artistes/invites_speciaux.htm). See Françoise Eliet, 'Travail des peintres, ouvriers et paysans: le pinceau comme arme de combat', *Art Press*, 20, September–October 1975, p. 10, and Boissier's doctoral thesis, 'La Question de l'héritage dans les arts plastiques en Chine, 1973–1979', Université de Paris VIII–Sorbonne, 1979.

107 *Hymnen*, Ballet de Lorraine, with choreography by Didier Deschamps and Lia Rodrigues; see Marie-Christine Vernay, 'Stockhausen reprend ses couleurs', *Libération*, 8 June 2007, p. 24; 'Gérard Fromanger, dessinateur', including Fromanger's designs for the 1970 performance, was held simultaneously at the Musée des Beaux-Arts, Nancy. Mme Marianne Mathieu is preparing a catalogue raisonné of Fromanger's work.

Chapter 5 Lyotard, Monory

1 Bill Readings, *Introducing Lyotard: Art and Politics*, Routledge, London and New York, 1991, p. xviii; see also his 'Postmodernity and Narrative', ibid., reprinted in Victor E. Taylor and Gregg Lambert, eds, *Jean-François Lyotard: Critical Evaluations in Cultural Theory*, 3 vols., Oxford, Routledge, 2006, vol. 1, pp. 208–40 (Monory, p. 209).

2 Wolfgang Welch and Christine Preis, eds, *Aesthetik im Widerstreit: Interventionen zum Werk von Jean-François Lyotard*, Weinheim, Acta Humaniora, 1991; Amaris Isabel Pena Aguado, *Aesthetik des Erhabenen: Burke, Kant, Adorno, Lyotard*, and Alexandra Stäheli, *Materie und Melancholie: Die Postmoderne zwischen Adorno, Lyotard und dem 'pictorial turn'*, both Vienna, Passagen Verlag, 1994 and 2004 respectively. Lynda Stone, 'Exploring "Lyotard's Women": The Unpresentable, Ambivalence and Feminist Possibility' (2000), in Taylor and Lambert, *Lyotard*, vol. 3, pp. 326–43, egregiously ignores Lyotard's engagement with the artist Ruth Francken.

3 Antonia Wunderlich, *Der Philosoph im Museum: Die Austellulng 'Les Immatériaux' von Jean-François Lyotard*, Berlin, Transcript, 2008; Francesca Gallo, *Les Immatériaux: un percorso di Jean-François Lyotard nell'arte contemporanea*, Rome, Aracne, 2008. Tate Modern's conference in London, 'Landmark Exhibitions, Contemporary Art Shows since 1968', 10–11 October, 2008, had a major emphasis on 'Les Immatériaux'.

4 'Les toiles de Cueco sont des assassinats… Cueco "voit rouge"… rouge de la jouissance', Corinne Lyotard and Catherine Masson, 'Une Peinture ambivalente', in Bernard Lamarche-Vadel, ed., *Figurations 1960–1973*, Paris, Union Générale des Éditions, 10/18, 1973, pp. 240, 269, 272.

5 'Le dandyisme est un soleil couchant; comme l'astre qui décline, il est superbe, sans chaleur et plein de mélancolie', Charles Baudelaire, 'Le Peintre de la vie moderne' (*Le Figaro*, 1863), *Œuvres complètes*, vol. 2, Paris, Gallimard, 1976, p. 712 ('The Painter of Modern Life', *Selected Writings on Art and Artists*, trans. p. E. Charvet, Cambridge University Press, 1972, pp. 421–2 (Baudelaire refers to Constantin Guys).

6 'l'espace-temps romantique de la nostalgie', Pierre Gaudibert, 'Jungle de velours/Velvet Jungle', in Pierre Gaudibert and Alain Jouffroy, *Monory*, Paris, Georges Fall, 1972, p. 8.

7 See Pierre Tilman, *Monory*, Paris, Frédéric Loeb, 1992. This contains a catalogue raisonné from 1952 to June 1991, with photographs of destroyed and remaining early works.

8 For the Moebius strip, see Jacques Lacan, 'Il n'est pas sans l'avoir' (9 January 1963), 'Le Seminaire X', *L'Angoisse*, Paris, Seuil, 2004, pp. 101–17.

9 See Jean-François Lyotard, 'Nés en 1925', *Les Temps modernes*, 32, 1948.

10 Jean Clair, *Art en France: une nouvelle génération*, Paris: Éditions du Chêne, 1972. This reworks a passage from 'Jacques Monory/Dreamtigers', *Chroniques de l'art vivant*, 21, June 1971.

11 Conversation with Jean-François Lyotard, 26 January 1997.

12 Lyotard mentions his *fâcheuse absence de talent* to Philippe Lançon, quoted in the latter's obituary article: 'Philosophe, une de ses vocations', *Libération*, 22 April 1998, p. 37.

13 'L'althusserisme n'a donc été que le double d'un ancien cauchemar, rencontré en cours de dérive', Jean-François Lyotard, 'Préface', *Dérive à partir de Marx et Freud*, Paris, Union Générale des Éditions, 10/18, 1973, p. 11. 'Désirévolution', pp. 30ff, was written *dans la braise de juillet 68* to accompany collages by Bruno Lemenuel. (Several pieces on art are omitted from *Dérive*, rev. edn, Paris, Galilée, 1994.)

14 'Le désir qui donne forme et soutien aux institutions s'articule en dispositifs qui sont des investissements énergétiques sur le corps, sur le langage, sur la terre et sur la ville, sur la différences des sexes et des âges etc. Le kapitalisme est l'un de ces dispositifs', Lyotard, *Dérive*, p. 16.

15 Works such as Pierre Janet, *De l'Angoisse et l'extase*, Paris, Alcan, 1926, important for the younger Lyotard, and P. Kauffmann, *L'Expérience émotionnelle de l'espace*, Paris, Vrin, 1967, modified his readings of classic texts such as Pierre Francastel, *Peinture et societé*, Paris, Gallimard, 1965.

16 Lyotard, 'Espace plastique et espace politique', on revolutionary posters, *Revue de l'esthétique*, 23/3–4, December 1970, summarised his participation in Louis Marin's seminars on Utopia, in the Faculté de Lettres, 1968–9, where his own seminar 'Rétournement à partir de Marx et Freud' was held in 1969–70, in relationship with Mikel Dufrenne's seminar on the Imaginary; see *Dérive*, pp. 276–316, and *Dérive*, 1994, pp. 139–61.

17 'L'œil écoute… la réflexion s'installe au carrefour de deux expériences, parler et voir', Jean-François Lyotard, *Discours, figure*, Paris, Klincksieck, 1971, p. 9 (from Paul Claudel, *Art poétique*, Paris, Mercure de France, 1941, pp. 50–51) and p. 27; Lyotard had evidently read Anton Ehrenzweig, *The Psycho-analysis of Artistic Vision and Hearing: An Introduction to a Theory of Unconscious Perception*, London, Routledge and Kegan Paul, 1953.

18 Henri Focillon, *Vie des formes*, Paris, Librarie Ernest Leroux, 1934 (*The Life of Forms in Art*, New York, Wittenborn, Schulz, 1948, and London, Zone Books, [c. 1989]).

19 André Malraux, *Le Musée imaginaire: psychologie de l'art*, Geneva, Skira, 1947, and subsequent reprints; Eng. edn *The Voices of Silence*, New York, Doubleday, 1953. Malraux, appointed the Minister of Culture in 1958 and associated with de Gaulle and the right, is significantly omitted in the *Discours, figure* bibliography, reappearing in Lyotard's final homages, *Signé Malraux*, Paris, Grasset, 1996, and *La Chambre sourde: l'antiesthétique de Malraux*, Paris, Galilée, 1998.

20 Maurice Merleau-Ponty, 'Le Doute de Cézanne' (December 1945), *Sens et non-sens*, Paris, Nagel, 1948, Eng. edn 'Cézanne's Doubt', *Sense and Non-Sense*, trans. Herbert L. Dreyfus and Patricia Allen Dreyfus, Evanston, Ill., Northwestern University Press, 1964, pp. 9–25.

21 Jean-François Lyotard, *La Phénoménologie*, Paris: PUF, 1954, and 'Freud selon Cézanne' (December 1971), extract from 'Psychanalyse et peinture', *Encyclopaedia Universalis*, Paris, vol. 13, 1980, pp. 745–50, reprinted in *Des Dispositifs pulsionnels* (1973), Paris, Gallimard, 1994, pp. 71–89.

22 See the extensive international bibliography footnoted in 'Principales tendances actuelles de l'étude psychanalytique des expressions artistiques et littéraires' (July 1969, linked to a UNESCO iniative directed by Mikel Dufrenne) in *Dérives*, pp. 53–77, and 1994, pp. 117–37.

23 Lyotard quotes Kandinsky on blue from the *Bauhaus* catalogue, Musée d'art moderne de la Ville de Paris, April 1969, p. 52, in *Discours, figure*, p. 84.

24 'vrai anti-art', Lyotard on the barricades in 'Notes sur la fonction critique de l'œuvre', *Revue d'esthétique*, 23/3–4, December 1970, results of a discussion with Pierre Gaudibert on art, ideology, and phantasy for the seminar 'L'Art et le Société' at the Maison des Lettres, in *Dérive*, 1973, p. 246 (not in 1994 edn).

25 Jean-François Lyotard, 'A Memorial of Marxism: For Pierre Souyri'(*Esprit*, Janaury 1982), *Peregrination*s: *Law, Form, Event*, New York, Columbia University Press, 1988, pp. 45–75 (*Pérégrinations*, Paris, Galilée, 1990, pp. 94–131). Lyotard described his loss at the end of his friendship with Pierre-François Souyri, the Maoist historian and theoretician and comrade of Socialisme et Barbarie days.

26 'Les courants les plus modernes, abstraits américains, pop et "hyperréalistes", en peinture et en sculpture, musiques pauvres et concrètes (celles de Cage avant tout), chorégraphie libres (celles de Cunningham), théâtres d'intensité (existent-ils?), placent la pensée critique, la dialectique négative devant un défi considérable: ils produisent des œuvres affirmatives et non critiques', Lyotard, 'Dérives'(preface, October 1972), *Dérive*, p. 20.

27 Jean-François Lyotard, 'Adorno come diavolo', previously unpublished text of August 1972, *Des Dispositifs pulsionnels*, pp. 99–113.

28 Herbert Marcuse, *Eros and Civilization: A Philosophical Enquiry into Freud* (Boston, Beacon Press, 1955), New York, Vintage Books, 1961, preface, pp. ix–x (*Eros et civilisation*, Paris, Minuit, 1963).

29 See Marc Jimenez, 'Situations. Sur la reception de la théorie critique. Contradictions et incoherence: les années 60–70 en France', *Adorno et la modernité: vers une ésthétique négative*, Paris (1983), Klincksieck, 1986, pp. 35–47.

30 See above, note 20 of the introduction.

31 Professor Andrew Feenberg, the renowned expert on Marcuse and a witness to this period, has written: 'Lyotard certainly knew Marcuse but they did not do a course together in La Jolla or participate in a conference together there. I have a feeling he admired Marcuse as a kind of historical survival… But I don't think Lyotard accepted Marcuse's basic position, which he regarded as internal to a bourgeois cultural world postmodernity had surpassed. There seems to have been a kind of franco-german allergy at work', email to me, 26 October 2006.

32 'Le philosophe et le politique (celui que vous lirez ici) auraient aimé se contenter après Adorno de se servir des arts comme des matrices formelles de renversement, il faudra qu'ils aient un œil et une oreille, une bouche et une main pour la position nouvelle, qui est la fin de la critique', Lyotard, *Dérive*, p. 21.

33 See Sarah Wilson, ed., *Pierre Klossowski*, London, Whitechapel Art Gallery, and Ostfildern, Hatje Cantz, 2006 (*Pierre Klossowski: tableaux vivants*, Paris, Gallimard and Centre Pompidou, 2007).

34 Pierre Klossowski, 'Don Juan selon Kierkegaard' *Acéphale*, 3–4, July 1937, pp. 27–32.

35 Pierre Klossowski, *La Monnaie vivante,* Paris, Filipacchi, 1970.

36 Jean-François Lyotard, 'L'Acinéma', *Revue d'esthétique*, July 1973, offprint dedicated to Pierre Klossowski: 'le vrai destinataire de ces lignes, leur inspirateur... Urbino, 20.7.73', Paris, Bibliothèque Littéraire Jacques Doucet, in *Des Dispositifs pulsionnels*, pp. 99–113; Eng. edn, 'Acinéma', *Wide Angle* (Manchester), 2/3, 1978, pp. 53–9.

37 Klossowski's combination of Sade with Nietzsche is crucial. Lyotard repeats from 'L'Acinéma' his theory of the immobile or mobile art spectator in his passage on the 'Economy of the Figurative or Abstract[art]', *Libidinal Economy*, London, Athlone Press, 1993, pp. 240–45 (*Économie libidinale*, Paris, Minuit, 1974).

38 Jean-François Lyotard, 'Par delà la réprésentation', preface to Anton Ehrenzweig, *L'Ordre caché de l'art*, Paris, Gallimard, 1974, pp. 9–24, an extensive treatment.

39 Jean-François Lyotard, 'Cadeau d'organes', an unpublished introduction to texts by Bernard Lamarche-Vadel with ink drawings by Michel Tessier of July 1969, appears in Lyotard, *Dérive*, pp. 47–52 (Jimenez, *Art, idéologie, théorie* appeared in the same series 'S').

40 Conversation with Jacques Monory, 12 August 1998.

41 'Contribution des tableaux de Jacques Monory à l'intelligence de l'économie libidinale du capitalisme dans son rapport avec le dispositif pictural et inversement' (p. 154),'Libidinal economy of the dandy'Lyotard, *Figurations 1960–1973*, Paris, 10/18, U.G.É., 1973, p. 154.

42 Lyotard, 'Preface', *Dispositifs pulsionnels*, 1994, p. 13. This states baldly, 'Baudelaire et Marx nommait Prostitution cette condition capitaliste.'

43 Jacques Monory and Franck Venaille, *Deux*, photo-roman (text by Franck Venaille), Paris, Chorus Poucet, 1973.

44 For the exchange of females, anguish and the phallus see Lacan, *L'Angoisse*, pp. 105–6; Lacan sent lecture typescripts to his daughter Judith, the basis for her husband Jacques-Alain Miller's editing (see notice, p. 391). She was later a militant Maoist at Vincennes, when Lyotard was teaching. *Libidinal Economy* was written with no published Lacanian 'text' to acknowledge as a specific debt other than the *Écrits*, 1966.

45 'Female trouble' is a *renvoi* on my part to Abigail Solomon Godeau's *Male Trouble*, the work of Judith Butler and the corpus of *écriture féminine* and its exegetes. See Rakhee Balaram, 'Femmes Révolutionnaires: Women and Art in 1970s France', PhD, University of London, 2009.

46 Notably by Jean Clair, 'Dürer, *Le Dessinateur du modèle feminin*, (1525)', in *Marcel Duchamp*, catalogue raisonné, Paris, CNAC, Centre Georges Pompidou, 1977, vol. 2, no. 241, p. 175.

47 'L'œil existe à l'état sauvage', André Breton, *Le Surréalisme et la peinture*, Paris, Gallimard, 1965, a constant reference.

48 'étrangement somptueux', Alain Jouffroy, *Beaux-Arts*, 5–11 October 1955.

49 For Magritte's *La Reconnaissance infinie*, 1953, see Lyotard, *Discours, figure*, pl. 17 and commentary p. 412.

50 'l'érotisation de la durée... la sensualité de la facture... l'usage des marques métriques pour l'accroître l'intensité de la jouissance-mort', Jean-François Lyotard, 'Contribution des tableaux de Jacques Monory', in Lamarche-Vadel, *Figurations, 1960–1973*, pp. 154–238; as 'Économie libidinale du dandy' in Lyotard, *L'Assassinat de l'expérience par la peinture – Monory*, Talence, Le Castor Astral, 1984 (*The Assassination of Experience by Painting – Monory*, ed. Sarah Wilson, bilingual, London, Black Dog Publishing, 1998, pp. 155, 156).

51 Stanislas Rodanski, *La Victoire à l'ombre des ailes*, Paris, Le Soleil Noir, 1975. The book of stories written in the 1950s was included in Monory's eponymous *livre-objet*. Monory discussed his debt to Rodanski, in conversation, 12 August 1998.

52 'des clients de cinéma, des téléspectateurs, toute l'humanité moyenne qui dans le métro du matin, la café de la gare, le ciné du samedi, quand elle ne travaille pas en somme, parcourt des illustrés', Jean-François Lyotard, 'L'Esthétique sublime du tueur à gages' (1981), in *L'Assassinat* and Wilson, *Assassination*, p. 218.

53 Monory, 'Caspar David Friedrich', *Chorus*, 11–12, 1974; Jean-Christophe Bailly and Jacques Monory, *Hommage à Caspar David Friedrich*, Paris, Christian Bourgois, 1977. This followed Bailly's *La Légende dispersée* of 1976 on German romanticism; see *Hommage à Caspar David Friedrich, no. 1*, 1975, with its Auschwitz landscape.

54 Pierre Gaudibert, *Monory*, p. 8.

55 De Quincey's text was used as a chapter title and motif in Jean-Paul Sartre, *Saint Genet Comedien et Martyr*, vol. 1 of Jean Genet, *Œuvres complètes*, Paris, Gallimard, 1952.

56 Malcolm Morley exhibited at Documenta 5, Kassel, and in Paris in 'Grands Maîtres Hyperréalistes Américains', Galerie des 4 Mouvements; 'Art Conceptuel et Hyperréaliste: Collection Ludwig, Neue Galerie, Aix-La Chapelle', ARC, Musée d'art moderne de la Ville de Paris, 1973 (including *Race Track*) and 'Hyperréalistes Américains – Réalistes Européens', CNAC, where he was joined by Monory.

57 Richard Kuisel, *Seducing the French: The Dilemma of Americanization*, Berkeley, University of California Press, 1993; Kristin Ross, *Fast Cars, Clean Bodies: Decolonization and the Reordering of French Culture*, Cambridge, Mass., MIT Press, 1995.

58 Raymond Ruyer, *Eloge de la société de consommation*, Paris, Calmann-Lévy, 1969.

59 Monory speaking in André Labarthe, *Le Cinéma de Jacques Monory*, television programme, *Cinéma, cinémas*, 3, Paris, Antenne 2, 1982.

60 See Michel Butor, 'L'Appel des rocheuses', photographs by Ansel Adams and Edward Weston, *Réalités*, 197, June 1962, pp. 76–83, reprinted as pls. 20–21 in facsimile, in Lyotard, *Discours, figure*, with Lyotard's analysis of this and 'Les Montagnes rocheuses', pp. 360–75. See also Michel Butor, *Mobil: étude pour une représentation des États-Unis*, Paris, Gallimard, 1962; echoed in Jean-François Lyotard, *Le Mur du Pacifique*, Paris, Galilée, 1979, p. 38.

61 'Pas un État, des États. Pas un temps, des temps: Atlantic Time, Central Time, Mountain Time, Pacific Time. Pas une loi, des lois', Lyotard, in Michel Vachey, *Toil, précéde d'un avertissement et de le mur du Pacifique de Jean-François Lyotard*, Paris, Christian Bourgois, 1975, and Jean-François Lyotard,

Pacific Wall, Venice, Cal., Lapis Press, 1990. The 'Pacific' Wall ironically mimics the wartime Atlantic Wall.

62 'Les présidents américains sont des empereurs, Washington est Rome, les États-Unis d'Amérique sont l'Italie, l'Europe est leur Grèce… Les visiting professeurs européens sur les campus sont les précepteurs grecs: esclaves affranchis, clients, protégés de Rome, stipendiés de l'Amerikapital soucieux de ses bordures', ibid., pp. 19–20.

63 'Par ces localisations est signalé un espace dominé dominable comme le corps d'une bête pour la boucherie', ibid., p. 33.

64 Jean-François Lyotard, 'L'Histoire kienholz' (*sic*), ibid., pp. 21–30.

65 Jean Clair, 'L'Adorable leurre', *Chroniques de l'art vivant*, 36, 'Hyperréalisme' 1, February 1973, pp. 4–5, and 'L'Adorable leurre (fin)', *Chroniques de l'art vivant*, 37, 'Réalismes', 2 March 1973, pp. 4–5.

66 'Un travailleur qui veut être sa machine à force de s'y asservir, c'est l'hystérique… En peignant des photos, mais *fortes*, l'hyperréalisme montre comment le désir s'agence dans le procès de production, quand on s'y place non pas au lieu du *maître* capitaliste bureaucratique, mais au lieu de l'*esclave* travailleur', Jean-François Lyotard, 'Esquisse d'une économie de l'hyperréalisme', *Chroniques de l'art vivant*, 36, February 1973, p. 12.

67 Jean-François Lyotard, 'Machinations', New York, Columbia University, December 1974; 'Parois', February 1975; 'Incongruences', August 1976; 'Charnières' and 'Duchamp as a Transformer', Milwaukee, September and November 1976; *Les Transformateurs Duchamp*, Paris, Galilée, 1977; see *Duchamp TRANS/formers*, Venice, Cal., Lapis Press, 1990.

68 Michel Butor, 'Reproduction interdite', *Critique*, 334, March 1975, pp. 269–83; offprint enclosed in Butor with Jacques Monory, *U.S.A. 76 bicentenaire kit*, Paris, Club Français du Livre, 1976. See also *Michel Butor: écriture nomade*, Paris, Bibliothèque National de France, 2007.

69 Lyotard, *Les Transformateurs Duchamp,* and *Duchamp, TRANS/formers*; 'Inventaire du dernier nu', in *Marcel Duchamp*, vol. 2 'Approches critiques', Paris, Centre Georges Pompidou, 1977.

70 'Il faut dire, et Freud lui-même le dit, que l'inconscient utilise tous les moyens, y compris les jeux de mots les plus grossiers pour mettre en scène le désir', Lyotard, 'The Unconscious as Mise-en-scène', *Performance in Postmodern Culture*, ed. Michel Benamou and Charles Caramello, Madison, Wis., Coda Press, 1977, p. 89.

71 'ce livre méchant' [écrit à la suite d'] un séisme que [son] âme avait enduré', Lyotard, *Pérégrinations*, pp. 32, 35.

72 Gilbert Lascault, 'Monory: opéras glacés', *Derrière le miroir*, 217, 1976, pp. 7–30; Alain Jouffroy, 'Une certaine exigence traverse le douleur et le rire', 'Monory, technicolor', *Derrière le miroir*, 277, January 1978, pp. 2–3, 6–8.

73 'Monory est un philosophe spontané. Son œuvre est une question, cette question est la plus commune: quel est le sens de la vie? Quant aux images, mont glacé, nebuleuse, soleil levant, mer, radiotélescopes, elles sont traités à la manière d'illustrations, mais de quelle phrase? Est-ce quelque chose va mourir, encore ici, posant en retour la question du sens de ce qui vit? Ou bien est-ce que, tout étant déjà mort, le sens ne fait plus question?… Monory mène son dandysme (populaire) jusqu'au bout, là où il n'est plus dandy… cette figure complexe est un portrait-robot de la postmodernité… La chair des femmes, des félins, des déserts, des enfants, des meurtres… la volupté était interdit,

déconsiderée… de même pour la chair astral dans les *Ciels* [le double du ciel visible et invisible]', Jean-François Lyotard, 'Les Confins d'un dandysme', *Derrière le miroir*, no. 244, March 1981, p. 7.

74 'Notre vie passe sous le régime du *desiderium* qui est le regret des *sidera*… J'avais espéré l'extase. Je n'ai eu qu'un supplément de détachement', ibid., repeated in Lyotard, 'L'Esthétique sublime du tueur à gages', in Wilson, *Assassination*, p. 195.

75 Monory's mural commission for the medecine and pharmacy faculty of the U.F.R. Madrillet, Saint-Étienne de Rouvray, attached to the University of Rouen, was installed in 1982 but has now probably been destroyed.

76 'C'est dans la matière même de la peinture qu'il y a de la dérision…', 'La mort?' [Lyotard], 'Oui, c'est ce qui m'emmerde le plus… Pourquoi ils ont inventé Dieu et tous ces salades?' Monory, 'Instantanés et cinéma', video, 16 mm, 35 mins, by David Carr-Brown and Jean-François Lyotard, Paris, Serdav-CNRS/Camera, labelled 'atelier de Cachan, 1982'. Lyotard was also involved with short films on the artists Degottex and René Guiffrey.

77 Lyotard, 'The Unconscious as *Mise-en-scène*', *Performance*, p. 88.

78 Gaudibert, *Monory*, p. 27, comments on the device as used by Vsevolod Pudovkin and Alexander Dovzhenko in the Soviet avant-garde film *Arsenal*, 1924.

79 See Chris Marker, *La Jetée,* Argos Films, 1962; Marker, *La Jetée: Ciné-roman*, bilingual, New York, Zone Books, 1993; Sarah Cooper, *Chris Marker*, Manchester University Press, 2008.

80 Gillo Dorfles, *Il Kitsch: antologia del cattivo gusto*, Milan, Gabriele Mazzotta Editore, 1968; trans. *Le Kitsch: un catalogue raisonné du mauvais goût*, Paris, Complexe, 1978.

81 Monory and Venaille, *Deux*; Monory, *Brighton Belle*, 1973, 16mm short colour film.

82 Claudine Eizkyman and Guy Fihman, 'L'Œil de Lyotard: de l'Acinéma au postmoderne', in Jean-Paul Olive and Claude Amey, eds., *A partir de Jean-François Lyotard*, Paris, L'Harmattan, 2000, pp. 120–47. The *séminaire-atelier* 'L'Acinéma', held during the Lyotard conference at Cerisy-la-Salle in 1982, involved artists' films and interaction with artists including Michael Snow and Peter Kubleka. The authors participated in Lyotard's *Dérives* seminar in late 1968, and organised the L'Acinéma conference, Paris, INHA, 2–3 March, 2010.

83 '*Moi*: Dans sa peinture il paye sa dette au cinéma… l'écran bleu que le projectionniste met devant l'objectif pour les scènes d'amour et de grande inquiétude. *Le Fantôme du Louvre*, Annabella courant sous la mitraille à travers les voies de la gare de triage de Canton. Une nostalgie sans forme émane de ces images… ces images peintes viennent de ces brûlures glaciales… Je préfère ses tableaux à ses films. / *Lui*: Dans mes films, j'échappe à la mort. En peignant, on capte, on fixe, on inscrit, on est seul dans l'atelier, on est baigné de mémoire. Au tournage, tu es un danseur, un calligraphe japonais, tu fais des gestes sans mémoire, tu rencontre des images. Le seul problème de l'art, c'est peut-être la danse. J'échappe à la nostalgie en faisant le film, même si le film est nostalgique', Jean-François Lyotard, Jacques Monory and Martine Aflalo, 'Le Peintre et la caméra' (December 1981, np), with Jean-Christophe Bailly, 'Monory et le cinéma', *Les Peintres cinéastes*, Paris, Ministère des relations extérieures, 1982.

84 Michel de Certeau, 'Pratiques d'espaces: la ville métaphorique', *Traverses*, 9, 'Ville Panique', November 1977, pp. 4–9.

85 *Les Immatériaux*, ed. Jean-François Lyotard and Thierry Chaput, Paris, Centre Georges Pompidou, 1985; see n. 3 above for new bibliography; see also Anthony Hudek, '*Museum Tremens* or the Mausoleum without Walls: Working through *Les Immatériaux* at the Centre Pompidou in 1985', MA, Courtauld Institute of Art, University of London, 2001; Hudek, 'From Over- to Sub-Exposure: The Amamnesis of *Les Immatériaux*', *Tate Papers* 12, 2009.

86 See Alexandre Koyré, *Études galiléennes*, Paris, Hermann, 1966. This crucial reference for parts of *Discours, figure* may be seen as a point of genesis for Lyotard's writing on stars.

87 See texts on art and aesthetics anthologised in Wilson, *Monory; Assassination*, and Jean-François Lyotard, *L'Inhumain*, Paris, Galilée, 1988 (*The Inhuman*, trans. G. Bennington and R. Bowlby, Cambridge, Polity Press, 1991. See also his *Leçons sur l'analytique du sublime*, Paris, Galilée, 1991; 'Parce que la couleur est un cas de la poussière', *Pastels de Pierre Skira*, Paris, Galerie Patrice Trigano, 1997; and *Jean-Luc Parant: les yeux, les boules, les boules, les yeux*, Paris, Réunion des Musées Nationaux, 1999.

88 'Mais le pinceau peint un monde sans peinture, où il n'y aura plus besoin de témoignage', Lyotard, 'L'Esthétique sublime', in Wilson, *Assassination*, pp. 229–30.

89 Pierre Courcelle, *Les Confessions de Saint Augustin dans la tradition littéraire: antécédents et posterité*, Paris, Études Augustiniennes, 1963, signalled new scholarship in this area. Lyotard's last seminars at Emory University, Atlanta, Ga., were on writing as confession in texts by Saint Augustin, Jean-Jacques Rousseau, Franz Kafka and Georges Bataille; see Jean-François Lyotard, *La Confession d'Augustin*, Paris, Galilée, 1998.

90 'En regardant les tableaux de Monory, nous nous reconnaissons, nous sommes ou nous devenons ces survivants', Lyotard, in Wilson, *Assassination*, p. 219.

91 *Monory/Fury/Dubai Project*, Paris, Galerie 208, 2007, bilingual, np.

92 See *Monory: roman-photo*, Maison Européene de la Photographie, 2008, brochure, Paris, Robert Delpire and Gazette de l'Hôtel Drouot, 2008; *Jacques Monory: Tigre*, Saint-Paul de Vence, Fondation Marguerite et Aimé Maeght, 2009. See also Pascale le Thorel, *Monory*, Paris-Musées, 2006, and www.jacquesmonory.com. Mme Paule Monory is preparing a catalogue raisonné.

Chapter 6 Derrida, Adami

1 'Ne pas se poser comme philosophe à un peintre, c'est lui être reconaissant de déranger par son travail l'instance philsophique et l'autorité qu'il s'est toujours attribuée dans ses énonces sur la peinture. Il fallait, je pense à Hegel, je pense à Heidegger, assigner une place à la peinture', Jacques Derrida, in 'L'Atelier de Valerio Adami: le tableau est avant tout un système de mémoire', ed. Armelle Auris, *Rue Descartes*, 4, 1992, p. 160.

2 Jacques Derrida, *La Vérité en peinture*, Paris, Flammarion, 1978 (*The Truth in Painting*, ed. and trans. G. Bennington and I. McCleod, University of Chicago Press, 1987).

3 *Gérard Titus-Carmel: The Pocket Size Tlingit Coffin et les 61 premiers dessins qui s'ensuivrent, illustré par Cartouches de Jacques Derrida*, 1 March–10 April 1978, Paris, Musée national d'art moderne, Centre Georges Pompidou; *Gérard Titus-Carmel, 61 dessins juillet 1976/octobre 1977 annotés par Gilbert Lascault*, Paris, Maeght Éditeur, published simultaneously, contains the

general apparatus the Pompidou catalogue lacks, while Gerard Titus-Carmel, 'The Pocket-size Tlingit Coffin (or: of lassitude considered as a surgical instrument)', *12 gravures sur the pocket-size Tlingit coffin*, Paris, Baudouin Lebon–SMI, 1976, pp. 39–43, gave the artist's own gloss.

4 Jacques Derrida, 'Restitutions de la vérité en pointure', *Macula*, 3/4, 1978, 'Martin Heidegger et les souliers de van Gogh', pp. 11–37.

5 Jacques Derrida, 'Illustrer dit-il', in François Loubrieu, *Ateliers aujourd'hui* 17, 12 September–22 October 1979, Paris, Musée national d'art moderne, Centre Georges Pompidou, 1979 (see http://www.jacquesderrida.com.ar/frances/derrida illustrer.htm).

6 *Le Shibboleth pour Paul Celan de Jacques Derrida: lithographies et monotypes de Michèle Katz*, La Marelle, Paris, 2000; Jacques Derrida, 'De la couleur à la lettre', in *Atlan, Grand Format*, Paris, Gallimard, 2001.

7 'Valerio Adami: Le Voyage du Dessin' Paris, Galerie Maeght, November 1975, and Valerio Adami and Jacques Derrida, '+R (par-dessus le marché)', *Derrière le miroir*, 214, May 1975 (notices by Jacques Dupin).

8 Henri Matisse, *Jazz*, Paris, Tériade, 1947. Matisse's centenary exhibition was held at the Grand Palais in 1970.

9 Renée Riese Hubert, 'Derrida, Dupin, Adami: "Il faut être plusieurs pour écrire"', *Annale della Fondazione Europea del Disegno* (Fondation Adami), 2006/2, p. 51 (extract, from Yale French Studies, *Boundaries: Writing and Drawing*, 84, 1994, pp. 242–64).

10 'La Dissemination', a huge Mallarmé-centred text, includes Derrida's own mimicking of 'Un coup de dès' (*Critique*, 261/2, 1969) in *La Dissemination*, Paris, Seuil, 1972, pp. 356–7 (*Dissemination*, trans. B. Johnson, University of Chicago Press, 1981, and London, Continuum, 2004, pp. 352–3). See also e.g. Mallarmé on truth: 'true, *vrai* truth et troth *vérité* / to (be)troth, *fiancer*. / to trow, *croire* comme vrai. / truism, *verité evidente*. / to trust, *se confier à*. / truce, *trève sur parole*', *Les Mots anglais*, 1877, in *Œuvres complètes*, ed. Bertrand Michel, Paris, Gallimard, 2003, vol. 2, p. 1003.

11 See Jacques Derrida, 'Fors: les mots anglés de Nicolas Abraham and Maria Torok', preface to Abraham and Torok, *Le Verbier de l'Homme aux Loups*, Paris, Aubier/Flammarion, 1976, pp. 11, 48, etc. for an 'antisemantics' and *anasémie*.

12 Jacques Derrida in Freddy Trellez and Bruno Mazzoldi, 'The Pocket-Size Interview with Jacques Derrida [1978–80]', discusses his relationship with *Littré*, the indispensable etymological dictionary, in T. J. Mitchell and Arnold I. Davidson, eds., 'The Late Derrida', *Critical Inquiry*, 33/2, Winter 2007, pp. 367–8.

13 Jean Genet, 'Ce qui est resté', *Tel Quel* 29, Spring 1967, pp. 3–11, republished in *Œuvres complètes*, Paris, Gallimard, vol. 4, 1979, pp. 21–31.

14 See Jacques Derrida, 'The Double Session', *Dissemination*, pp. 227–316. 'La Double séance', I and II, *Tel Quel*, 41 and 42, 1970, reprinted in *La Dissemination*, pp. 201–318. Plato's text from *Philebus* (into which Derrida inserts Mallarmé's 'Mimique' as a block) specifically introduces the painter of visual images after the notional 'writer' who 'fills up the book of the brain'. 'Mimique' introduces as well as the jump in time, space and culture, movement, dance, the trope of murder: the one-man mime show of a Pierrot tickling his wife's feet to the death; finally Derrida realises that the short scene refers to another, absent text: an invisible palimpsest.

15 Jacques Derrida, 'Tympan', *Marges de la philosophie*, Paris, Minuit, 1972, pp. i–xxv (*Margins of Philosophy*, trans. A. Bass, University of Chicago Press, 1982, pp. x–xxix). *Tympaniser* is to criticise, ridicule publically (archaic). Like its spatialised precursors, 'Tympan' could not have been composed without experimental cut-up and pasted page designs.

16 Derrida, 'Mallarmé', *Tableau de la littérature française: de Madame de Staël à Rimbaud*, Paris, Gallimard, 1974, pp. 368–79. See Robert Cohn, *L'Œuvre de Mallarmé: un coup de dés*, Paris, Librairie des Lettres, 1951. Jacques Scherer's *Le 'Livre' de Mallarmé*, Paris, 1957, concerned the poet's *Œuvre* or *Livre*, the apex of his life's work, involving discussion of the imagery of the tomb, box and block that were crucial for Derrida. Cohn, *Mallarmé's Masterwork* (1966), preceded Derrida's 'Le Double séance'.

17 'It is clear that when I wrote "Cartouches", in a way, even though this text is, to a certain degree, readable by someone who has not read some other texts – Genet, Freud, even *Glas*, and so on – nevertheless this text is more readable for someone who has been able to accumulate its implicit references. And so the writing strategy is modified according to the pace of the accumulation', Derrida in Trellez and Mazzoldi, 'Pocket-Size Interview', p. 373.

18 Jacques Derrida, 'Glas', *L'Arc,* 54, special Jacques Derrida number, 1973, p. 14. The novelist and writer Catherine Clément was responsible for the layout of Derrida's text in this issue.

19 Jacques Derrida, 'Avertissement', *La Vérité en peinture*, p. 3.

20 'Glas' was illustrated with a branch of 'genet', the golden flowering broom of Morvan (see Genet's *Notre-Dame des Fleurs*) and an image of the guillotine, the engine of death, which cut the heads off Genet's pin-ups, just as the easel/guillotine slices up the body in portraiture.

21 In Stéphane Mallarmé, *Igitur ou la folie* (c. 1867–70), Paris, Gallimard, 1925, conventional narrative (absent) has to be 'reconstituted' by the reader. *Igitur* contained the first ideas for Mallarmé's masterpiece, 'Un Coup de dés' (1897, A Throw of the Dice), which exemplified his revolutionary 'orchestral' or 'stellar' disposition of words across a double page.

22 See Sarah Wilson, 'Rembrandt, Genet, Derrida', in Joanna Woodall, ed., *Critical Introductions to Art: Portraiture*, Manchester University Press, 1996, pp. 203–16. Derrida read this at draft stage and met and corresponded with me.

23 'ici maintenant, mais depuis toujours entraînées dans *Glas* par un incroyable scène de séduction entre Rembrandt et Genet. Avec passage à l'acte, bien sur comme on entend la séduction dans la psychanalyse', Derrida, '+R (par-dessus le marché)', reprinted in *La Vérité en peinture*, p. 172 (see *The Truth in Painting*, p. 152 for Geoffrey Bennington's alternative translation).

24 See also Geoffrey Hartman, 'Homage to *Glas*', *Critical Inquiry*, Winter 2007, pp. 350–51, on this moment with Adami. He refers us also to the palindromic *ici* (here) and the 'IC' as Immaculate Conception with a possible link to Breton in *Glas*, which permits a *glissage* to Artaud. While he was a friend of Paule Thévenin, whether Derrida knew much of the corpus of Artaud's graphic work in the mid-1970s seems to me improbable; I question the decorum of Hartman's progression here, from Adami to Artaud.

25 'il n'approvisionne un appareil de production sans transformer le structure même de l'appareil, sans le tordre, le trahir, l'attirer hors de son élément. Après avoir piégé, avant d'un mauvais coup pris au mot ou au mors', Derrida, '+R'.

26 Benjamin's 'The Work of Art in the Age of Mechanical Reproduction' had been translated by Klossowski in 1936 (*Zeitschrift für Sozialforschung*); the 1939 translation by Maurice de Gandillac was published in *Œuvres choisis*, Paris, Julliard, 1959, and revised in *Poésie et révolution,* 2, Paris, Denoël, 1971.

27 'I Massacri Privati', Milan, Galleria Arturo Schwarz, 1966.

28 Valerio Adami, *Salotto svedese con tavolo quadrifoglio*, 1965.

29 See Valerio Adami, *Les Règles du montage*, Paris, Carnets, Plon, 1989, p. 82.

30 Jean Clair, 'Mémoire et métonymie chez Valerio Adami', *Chroniques de l'art vivant*, November 1970, pp. 16–17, where in the rubric 'Rencontres' he evokes the Alberto Magnelli retrospective at the Musée Cantini and the strange confluence between Adami and the Magnelli of 1914–15.

31 See Valerio Adami, 'Perfusion' (1966), in *Derrière le miroir*, 188, November 1970, pp. 13, 16.

32 See Pierre Gaudibert, 'Le Travail de l'image', and Valerio Adami 'Dimonstrationi', *Derrière le miroir*, 206, November 1973, pp. 3–19.

33 'Ce qui caractérise tout ce que ce nouvel horizon exploré, qui charrie d'anciennes et de nouvelles obsessions autobiographiques, est un voyage transversal à travers des strates culturelles et politiques qui déterminent encore notre présent. Il est possible de dresser une constellation des lieux, de personnages et de moments historiques, de tracer une cartographie sommaire de l'univers culturel et historique inscrit dans l'ensemble des œuvres d'Adami depuis 1971', Gaudibert, 'Travail de l'image', p. 17.

34 'Les personnages, intellectuels ou politiques, policiers et clandestins, se déplacent sur la carte imaginaire selon les flux et les reflux des conflits, les axes des routes d'exil', ibid.

35 'On arrive finalement à une figure centrale… celle de l'intellectuel juif révolutionnaire, d'Europe centrale, dans les années 20 et 30, dont la personnalité de Benjamin offre une incarnation distincte, un destin particulier, mais également tragique', ibid., p. 19.

36 Valerio Adami and Helmut Heissenbuttel, *Das Reich/Gelegenheitsgedicht Nr 27, 1877–1945*, Munich, Studio Bruckmann with Galerie Maeght, 1974 (in English and German), p. 3.

37 Ibid., p. 10.

38 'C'est encore une fois l'interprétation active de fragments radiographié, la sténographie épique d'un inconscient européen, le télescopage monumental d'une enorme séquence', Derrida, '+R', in *La Vérité en peinture*, p. 200 (*The Truth in Painting*, p. 175).

39 See *Valerio Adami: le voyage du dessin*, no. 28, *Dr Sigmund Freud*, 29.8.72, pencil, 48 x 36 cm, and no. 32, *Sigmund Freud in viaggio verso Londra*, 12.3.73, pencil, 48 x 36 cm, both lent from private collections.

40 Hubert Damisch, 'S. Freud en voyage vers Londres', in Damisch and Henry Martin, *Valerio Adami*, Paris, Éditions Maeght, 1974, pp. 7–45 (in which Walter Benjamin's portrait along with Isaac Babel and Buffalo Bill joins the photographs, drawings and Freud memorabilia). Damisch's loose, facsimile typescript, 'La stratégie du dessin', inserted in the catalogue *Adami/Dr Sigm. Freud*, Centre d'Arts Plastiques Contemporains de Bordeaux, 1976, refers to Pierre Lavallée, *Les Techniques du dessin* (Paris, 1949, a reference excluded from reprints), and explains *subjectile* in its Renaissance context, a notion famously re-appropriated by Derrida on Artaud.

41 Henry Martin, 'A+D+A+M+I' part II, 'Concerto per un quadro di Adami', in Damisch and Martin, *Valerio Adami*, pp. 84–9.

42 Derrida discussing the preface as *semen*: 'Selon le X (le chiasme) (qu'on pourra toujours considérer, hâtivement, comme le dessein thematique de la disssemination)', *La Dissemination*, p. 52.

43 'Prononcez *qui* ou *khi,* en expirant, ralant ou raclant un peu, avec un *r* en plus au travers de la gorge, presque *cri.* Mais on peut essayer plusieurs langues et tous les sexes (par exemple *she*)', Derrida, '+R', in *La Vérité en peinture*, p. 189; my translation is preferred to that in *The Truth in Painting*, p. 165. (The parenthesis around '*she*' does not appear in *Derrière le miroir*).

44 'X, l'intersection générale de *Glas*, de ses commencements ou fins en bande tordues et écartées, décrit aussi l'opération demiurgique dans le *Timée*: "La systase ainsi obtenue, d'un bout à l'autre il la fendit en deux d'une schize dans le sens de la longueur; ces deux bandes, il les fixa l'une sur l'autre par le milieu en forme de X; puis il les ploya pour former de chacune une cercle et réunit entre elles toutes les extremités à l'opposé du point de croisement"', Derrida, ibid., p. 12. See Plato, 'Timaeus', *The Collected Dialogues of Plato including the Letters*, ed. Edith Hamilton and Huntington Cairns, Princeton, Princeton University Press, (1961) 1973, p. 1166.

45 'Legende pour ce que j'aurais voulu dessiner: un autre portrait d'Adami, un autoportrait', Derrida, ibid.

46 See John P. Leavey, Jr., *Glassary*, Lincoln, University of Nebraska Press, 1986.

47 '19.1. /... Déjeuner avec Jacques Derrida dans un restaurant, place Denfert-Rochereau, puis tout l'après-midi ensemble dans un atelier de la rue Danville, assis coude à coude pour la signature des 500 placards. / Il évoque son père. / Il se concentre avant de signer et puis c'est un geste rapide comme s'il n'écrivait pas. / Moi, je parle de ma mère, mon écriture à présent ressemble à la sienne. Quand j'étais enfant je passais des heures entières à recopier son écriture./ Je relis un texte que j'avais écrit en 60 pour l'exposition "Pos sibilità di relazione". Je la recopie dans un cahier comme celui-ci. Je note en passant combien mon écriture était alors différente. /... 19.2 / Derrida me demande si les mots écrits sur le tableau et superposés à l'image ont pour moi une signification, même dans leur valeur phonétique. Pris de court, je ne réponds pas. / Oui, le phonème fait partie de la composition. Citons pour exemple les nombreuses démonstrations que nous offrent les affiches publicitaires. Le choix d'un mot peut être fait pour sa seule définition phonétique. Je voudrais développer cette forme de lied que j'ai commencée avec les deux lithos sur des textes de Derrida', Valerio Adami, 'Les Règles du montage', *Derrière le miroir*, 222, October, 1976, pp. 3, 9, 15.

48 For Adami's exhibition see Octavio Paz, 'Valerio Adami', preface, in *Repères: cahiers d'art contemporain*, 77, Paris, Galerie Lelong, 1991.

49 'Tu as parlé de néoclassicisme, de Mengs, c'est effectivement la peinture à laquelle me réfère mon éducation italienne, très sévère, très disciplinée à l'École des beaux-arts... L'art classique est indissociable de la forme close... Tu as parlé de musicalité... Tu as parlé du portrait... Tu as parlé de héros... Et si la mythologie a des visages, des corps, des mises en scène, c'est à la peinture qu'elle le doit', Adami, in 'L'Atelier de Valerio Adami', p. 146.

50 'Le tableau est avant tout un système de mémoire... Tous mes tableaux sont precédés d'un dessin. La forme du tableau est le résultat d'un long voyage de la ligne, ou plutôt, comme le disait Vico, d'un long voyage du point... avant de commencer à peindre, je prépare, durant trois à quatre semaines quatre cents à cinq cents mélanges différentes qui constituent comme un piano pourvu d'un immense *tastiera*. Chaque couleur, chaque mélange doit correspondre à une émotion vécue... Je n'ai jamais vraiment réussi à manier l'huile, inventée pour amener la sensualité et donc le clair-obscur, et j'ai du revenir à la technique de la tempera, à une peinture mentale. J'ai choisi l'acrylique', Adami, in ibid., pp. 148 and 149.

51 'Il faut penser ces deux motifs simultanément, celui d'une émancipation absolue de la chose peinte, et selui du secret autobiographique, anecdotique, du secret qu'elle garde... C'est dans le rapport du secret et du symbolique qu'il faut chercher les liens entre l'autobiographique et autrui, ce qui rattache la narration autobiographique la plus secrète aux autres, à l'ensemble des lectures possibles, crée un pacte avec la communauté et avec cette "popularité" dont on parlait', Derrida, in ibid., pp. 152–3.

52 'Tu exposes tes dessins, à côté des tableaux, présentant d'un côté comme l'écorché de la mémoire, et de l'autre non pas l'anamnèse mais l'amnésie colorée du dessin. Le travail de la couleur est encore une manière de sceller le secret... Comment ressens-tu ce rapport de continuité et d'interruption entre l'énigme et la narration?' Derrida, in ibid., pp. 153 and 154.

53 'Pour écrire les Tables de la Loi, alors qu'une après-midi est nécéssaire, Moïse s'est retiré deux fois quarante jours, et on s'est toujours demandé ce que Moïse et Dieu avaient bien pu se dire. De là serait née la Kabbalah, de cette complexité autour du secret, de toutes ces questions nées d'une enigme', Adami, in ibid., p. 154.

54 '[qu']aucun d'entre nous ici ne se pose comme philosophe. Nous ne sommes pas des philosophes en général, chacun le rappelerait sans doute de manière différente, et nous ne sommes certainement pas des philosophes devant la peinture d'Adami. Ne pas se poser comme philosophe...', Derrida, in ibid., p. 160; see n. 1 above.

55 Derrida expatiates on Cézanne's letter (via Hubert Damisch) in his preface 'Passe-partout', *La Vérité en peinture*, pp. 6–8.

56 See Martin Heidegger, 'Der Ursprung des Kunstwerkes', *Holzwege*, Frankfurt, 1950 ('The Origin of the Work of Art', 1955–6, in *Heidegger: Basic Writings*, ed. D. F. Krell, 1978, which was the subtext to Sartre's essay on Giacometti for *Derrière le miroir*, 65, May 1954).

57 Derrida gave the talks 'Apories: Mourir – s'attendre aux limites de la vérité' at the Cerisy-la-Salle conference *Passage des frontières (autour de Jacques Derrida)*, June 1992, Paris, Galilée, 1993; see 'Dying – awaiting (one another at) the "limits of truth"', *Aporias*, Stanford, University Press, 1993.

58 Jacques Derrida, 'Le Dessin par quatre chemins', in Amelia Valtolina, ed., *Annali della Fondazione europea del disegno*, 2005/1, Milan, Bruno Mondadori, pp. 4–5.

59 '(Je serai tenté pour ma part d'insister en particulier sur la nécessité d'une méditation philosophique du dessin, notamment depuis une tradition qui, de Platon à Kant, Heidegger et tant d'autres, a toujours cherché la voie de la pensée, comme de son enseignement, dans une réflexion sur la figure eidétique, la représentation, la ligne, la limite, le trait)', ibid., p. 5.

60 Jacques Derrida, *Mémoires d'aveugle: l'autoportrait et autres ruines*, curated with Françoise Viatte, Paris, Réunion des Musées Nationaux, 1990, pp. 113 and 129 (*Memoirs of the Blind: The Self-Portrait and Other Ruins*, trans. P.-A. Brault and M. Naas, University of Chicago Press, 1993).

61 '[Nietzsche a habité ces lieux, cette île. Son spectre hante ces lieux]… Est-ce qu'on peut dessiner sans dessein?… Le dessin, c'est l'œil *et* la main… la perception est aussi une prise manuelle, une façon de saisir, le *Begriff*, le concept.… [Donc] la vue est aussi l'appréhension… Mais la vue, les yeux voyants et non pas les yeux pleurants, sont là pour prévenir, par anticipation, par préconceptualisation, par perception: pour voir venir ce qui vient… [L'aveugle avance avec apprehension]… Donc la vision est aussi appréhension.… Un événement qu'on anticipe… n'est pas un événement… Qu'un événement digne de ce nom vienne de l'autre derrière ou de dessus, ça peut ouvrir les espaces de la théologie (du Très Haut, la Révélation qui nous vient d'en haut)… L'autre, c'est quelqu'un qui me surprend par derrière; par dessous ou sur le côté, mais dès que je le vois venir, la surprise est amortie… le moment ou le trace, le mouvement ou le dessin invente, ou il s'invente, c'est un moment où le dessinateur est aveugle en quelque sorte, où il ne voit pas, où il ne voit pas venir, il est supris par le trait même qu'il fraie, par le frayage du trait il est aveugle. C'est un grand voyeur, voir un visionnaire qui, en tant qu'il dessine si son dessin fait événement, est aveugle.… La Perspective doit se rendre aveugle à tout ce qui est exclu de la perspective', Derrida, 'Penser à ne pas voir', ed. Simone Regazzoni, in *Annali*, [p. 51], pp. 52–5, 57.

62 'La première expérience que nous faisons de la cécité c'est la parole; vous ne voyez pas ce que je dis', Derrida, ibid., p. 62.

63 'Dans tous les textes, de Platon à Husserl, les valeurs disons oculaires ou optiques, les valeurs qu'on appelle ailleurs héliocentriques, c'est-à-dire les valeurs transies de lumière, étaient au service de ce que j'appelle un *haptocentrisme*, c'est-à-dire une figuralité privilégiant le toucher, le contact – ou le tact… Chaque fois le summum de l'expérience de la vérité se disait dans la figure du contact et non pas dans le figure de la vision', Derrida, ibid., p. 67.

64 Jacques Derrida, 'On the Work of Jean-Luc Nancy', in P. Kamuf ed., *Paragraph: A Journal of Modern Critical Theory*, 16/2, July 1993, elaborated as *Le Toucher: Jean-Luc Nancy*, Paris, Galilée, 2000.

65 'Quand je dis *trait* ou *espacement*, je ne désigne pas seulement du visible ou de l'espace, mais une autre expérience de la différence', Derrida, *Le Toucher*, p. 71.

66 'Il y a donc là une expérience du secret, c'est-à-dire de ce qui se tient en retrait par rapport à la visibilité, par rapport aux lumières, par rapport à l'espace public même.… Dans tout dessin digne de ce nom, dans ce qui fait le tracement d'un dessin, un mouvement reste absolument secret, c'est-à-dire *séparé (secernere, secretum)*, irréductible à la visibilité diurne… Cela résiste à la politicisation mais, comme toute résistance à une politicisation, c'est aussi naturellement une force de repoliticisation, un déplacement du politique', Derrida, ibid., p. 72.

67 Riese Hubert, 'Derrida, Dupin, Adami', pp. 33–54.

68 'Comment ne pas trembler?… "Comment ne pas parler?"… Il y a vingt ans à Jerusalem qui reste un des épicentres des séismes qui secouent tout le monde aujourd'hui… Je ne tremblais pas de peur, mais j'avais peur de trembler', Jacques Derrida, 'Comment ne pas trembler?' (speech ed. S. Regazzoni), *Annali della Fondazione*, 2006/2, pp. 91–2.

69 'trait tracé d'une main tremblante, du *tremolo* … de la voix… La pensée du tremblement est une expérience singulière du non-savoir… L'expérience du tremblement est toujours l'expérience d'une passivité absolue, absolument exposée, absolument vulnerable… Trembler fait trembler l'autonomie du je, il l'installe sous la loi de l'autre, hétérologiquement… eh bien tout tremblement, de façon littérale ou métonymique, tremble devant Dieu. Ou encore, Dieu est le nom du tout autre qui, comme tout autre, et comme tout autre fait trembler… Le nécessaire tremblement du main de l'artiste qui a pourtant l'habitude et l'expérience de son art… Un secret *fait* toujours trembler.… Paul dit, et c'est l'un de ces "adieux"… travaillez avec crainte et tremblement [*cum metu et timore*]… Heidegger sur le sujet de la mort, de notre mort, de ce qui est toujours "ma mort"… Paul… une expérience encore juive du Dieu caché, secret, séparé absent ou mystérieux… Paul Ceylan: *Die Welt is fort, ich muss dich tragen*: "Le monde est parti, je dois te porter"… la responsabilité de *je dois te porter* suppose la disparition, l'éloignement, la fin du monde.… Pour être vraiment, singulièrement responsable devant la singularité de l'autre, il faut qu'il n'y ait plus de monde', Derrida, ibid., pp. 91–103. The celebrated writer of *créolité*, Edouard Glissant, contributed 'La Pensée du tremblement' and his talk was followed by 'Fragments d'une discussion: Jacques Derrida, Edouard Glissant', adding a polyphony which my edited extracts of a morning's debates cannot convey (pp. 81–90, 105–12). Derrida's book of elegies to his departed friends, *Chaque fois unique le fin du monde*, Paris, Galilée, 2003, is overwhelmingly present in all senses. He died on 9 October 2004, after this summer conference with Adami in Italy.

70 'D'une géneration à l'autre, d'un pays ou d'un continent à l'autre, des affinités électives et inventives reconstitueraient ce qu'on appelait jadis, mais cette fois autour du dessin, "la psyche entre amis"', Derrida, 'Le Dessin par quatre chemins', p. 5.

71 See Joseph G. Kronick, 'Philsophy as Autobiography: The Confessions of Jacques Derrida', *Modern Language Notes*, 113, 2000, pp. 997–1018, for an extended treatment of this theme.

72 Valerio Adami, in *Rue Descartes* 48, 2005/2, pp. 62–3; Adami's illustrations for Jean-Luc Nancy, 'Sur un portrait de Valerio Adami', in *A plus d'un titre: Jacques Derrida*, Paris, Galilée, 2007; Adami's illustrations for Abdelkébir Khatibi, *Jacques Derrida en effet*, Paris, Al Manar, 2007; 'Derrida's Ghosts: Five Years after his Death', 7–10 October 2009, Naples, www.iisfit/derridas_ghosts.htm.

74 Derrida, in *Gérard Titus-Carmel: The Pocket Size Tlingit Coffin*, '6 décembre 1977', pp. 13–14.

74 While Fromanger's 'Tout est allumé' series was exhibited at the Centre Pompidou in 1980, Adami followed Claude Viallat, Bernard Pages, Pierre Buraglio, François Rouan, Christian Boltanski and Raymond Mason in the 'Collections Contemporains' exhibition series. Derrida's '+R' was reprinted with texts by Hubert Damisch, Jean-François Lyotard et al. in *Valerio Adami*, Paris, Centre Georges Pompidou, 1985.

75 The guillotine story continues – chez Adami. See Philippe Bonnefis, 'Sur quelques propriétés insoupçonnées des triangles rectangles', *Annali della Fondazione Europea del Disegno*, 2007/3, pp. 83–103.

Conclusion

1 'Le jour de l'inauguration du Centre Georges Pompidou, le 31 janvier de cette année, je repensais à cette lame, à ce couperet qui avait été le premier élément significatif à frapper mon esprit lorsque j'avais vu le tableau de Topino-Lebrun, *Le Mort de Caius Gracchus*. Je me demandais depuis

le cinquième étage, si le président de la République inaugurait le Centre en coupant un ruban avec les lames d'une paire de ciseaux, en pensant que quelque cent-seize ans plus tôt, exactement à deux pas de là, en place de Grève, sur l'ordre d'un autre chef d'État, Topino-Lebrun était devenu un corps sans tête', Antonio Recalcati, in Alain Jouffroy, ed., *Guillotine et peinture: Topino-Lebrun et ses amis*, Paris, Chêne, 1977, p. 92.

2 'Pour ne pas guillotiner le projet', Germain Viatte, the former director of the Musée national d'art moderne, an active curator at CNAC, then the Beaubourg, conversation with the author, 19 September 2008. President Georges Pompidou died on 2 April 1974; Giscard was elected with full powers on 19 May.

3 Robert Badinter's campaign of 9 years to end guillotining (abolished under François Mitterand in October 1981) is detailed in his *L'Abolition*, Paris, Fayard, 2000.

4 The Centre Georges Pompidou opened on 31 January 1977; 'Marcel Duchamp', 2 February–2 May; 'Paris-New York', 1 June–19 September; 'Guillotine et Peinture: Topino-Lebrun et ses Amis' opened on 15 June and toured to Marseilles, Centre de la Vieille Charité, in January 1978.

5 See Suzanne Pagé and Juliet Laffon, eds., *ARC 1973–1983,* Musée d'art moderne de la Ville de Paris, 1983.

6 'De la globalité irrémédiablement éclatée du visible, les milles facettes du miroir brisée des Mythologies Quotidiennes écrivent l'incipit d'une autre histoire', Jean-Louis Pradel, *Mythologies quotidiennes II*, Musée d'art moderne de la Ville de Paris, 1978, np.

7 See *La Coopérative des Malassis* (Montreuil, Galerie Municipale M. T. Douet, Centre des Expositions), Paris, Éditions Pierre Jean Oswald, 1977; Daniel Mongeau, ed., *La Coopérative des Malassis: enjeux d'un collectif d'artistes*, Service Municipale de la Culture de Bagnolet, 1999; Emily Chabert, 'La Coopérative des Malassis: les enjeux d'un art politique', mémoire de maîtrise, Université de Paris IV–Sorbonne, 2004.

8 See Clothilde Roullier, 'Le Centre national d'art contemporain: du service artistique au Musée national d'art moderne, 1965–1983', Paris, Service des Archives du MNAM, Centre Georges Pompidou, 2004.

9 *La Figuration Nouvelle dans les collections publiques* (Musée des Beaux-Arts, Orléans, and Musée des Beaux-Arts de Dole), Paris, Somogy, 2005, includes selected early purchases by the FNAC and the MNAM.

10 See Intro., n. 2 above.

11 'Ni Duchamp, ni Picabia ne peuvent plus servir d'alibis pour couvrir des opérations anti-historiques, anti-désir', Alain Jouffroy, 'Pour une nouvelle peinture d'histoire: introduction aux amis de Topino', in Jouffroy, *Guillotine et peinture*, p. 49.

12 Louis Aragon, *Pour un réalisme socialiste*, Paris, Denoël et Steele, pp. 85–6.

13 Jouffroy's selection may be compared with the exhibition for whose catalogue he wrote the preface, Galerie 15, Basel, 1973, in which Erró, Fromanger and Monory showed with Peter Klasen and Peter Stämpfli.

14 See Alain Jouffroy, 'La Peinture française au Louvre: promenade et conversation avec Martial Raysse', *Opus International*, 36, April 1972, pp. 30–32; Jouffroy, 'A la Recherche des douze poignards de Topino-Lebrun', *Collective Change*, 15 'Police Fiction', 1973, pp. 61–89, illustrated by Fromanger.

15 See e.g. Pierre Gaudibert, 'Réflexions politiques sur une exposition contestée', *Opus International*, June 1972, pp. 22–5, and Jean-Louis Pradel, in *Coopérative des Malassis*, 1977, which revel in images of the police and the Malassis outside the show. A slide presentation took place at Galerie 3 on 26–8 June 1972; film of the event was shown at the Grand Palais in 2008.

16 Arab in origin, the word *méchoui* recalls the festive roasting of a whole mutton.

17 See Michel Ragon, preface, *Opus International*, 31–2, special number *Dessin d'humour et contestation*, January 1972, np, and Jurgis Baltrusaitis, preface, in *Anamorphoses: chasse à travers les collections du musée*, Paris, Musée des Arts Décoratifs, 27 February–9 May 1976.

18 *Le Grand Méchoui* (detail) in Jean-Louis Pradel, 'Mythologies Quotidiennes 2', *Opus International*, 63, May 1977, p. 39.

19 See Philippe Bordes's historical analysis, 'Intentions politique et peinture: la cas de la mort de Caius Gracchus' in *Guillotine et Peinture*, pp. 26–45, with chronology and documents. *La mort de Caius Gracchus*, 387 x 615 cm, Marseille, Musée de Longchamp, is reproduced in the book with Jacqueline Hyde's photograph (May 1977) prior to its X-raying and restoration by the Musée du Louvre.

20 'Mais de l'échec de l'art moderne, de l'échec du libertarisme, échecs de l'Utopie moderne, jaillit un extraordinaire stimulation', Bernard Dufour, in ibid., p. 65.

21 'Holger Meins est tué et se tue à l'intérieur d'un réseau d'amis. Caius Gracchus se fait tuer par son ami, qui se tue aussitôt. Topino-Lebrun, guillotiné, peint un tableau pour son ami Gracchus Babeuf, guillotiné', ibid. The 'multicanvas' *Holger Meins*, 1975 (276 x 505 cm) was accompanied by *Kawasaki à travers l'histoire,* 1976 (162 x 130 cm).

22 See Morgan Sportès, *Ils ont tués Pierre Overney*, Paris, Grasset, 2008, and the song by Dominique Grance, *1968–2008, N'effacez-pas nos traces!*, AMOC (recording company), 2008.

23 Jean-Joseph Taillasson exhibited the works Monory cites at the Salon of 1798 with Topino's masterpiece. Seven succesive stages of Monory's sequence (part of the final triptych) are illustrated in *Guillotine et peinture*, pp. 88–9.

24 '1– Exécutions de l'image; 2– Approche physique de l'Histoire comme fiction mortelle . . . 4– Guillotine du clair-obscur: condemnation de la palette et restes symboliques des épaves d'artiste', Vladimir Velickovic, in ibid., p. 100.

25 'Comment ne pas voir qu'Erró est le seul peintre à avoir osé montré des combattants vietnamiens dans les appartements de la *middle-class* américaine, Mao-Tsé-toung devant l'Arc de triomphe et l'armée chinoise à Washington? Comment nier que Fromanger depuis qu'en 1968 la couleur rouge s'est infiltrée dans sa peinture comme une lumière mentale, est le peintre qui a rendu hommage à Overney, le peintre des prisonniers en révolte sur les toits, le peintre du paroxysme quotidien dans la rue, et plus récemment, le critique les plus subtil du pouvoir des media: photo, radio, TV? Comment oublier que Monory, dans sa série *Velvet Jungle*, a introduit la guerre de Vietnam, et dans son *Catalogue mondial des images incurables*, les chambres forts des banques, les couloirs de prisons américaines, les asiles psychiatriques et les camps de concentration nazis, alors même sa méditation, sa rêverie, sont les plus distanciées à l'égard du réel? Comment passer sous silence le tableau ou Recalcati a prophétisé la rencontre Mao-Nixon, comment méconnaitre celui qu'il a consacré à l'enterrement de l'anarchiste Pinelli . . . ?

Quand Erró en hommage à Topino-Lebrun, décide de peindre un tableau sur l'assasinat de Salvador Allende, et un second sur le "Che", puis un troisième sur Caius lui-même, projeté sur le film *2001*, quand Fromanger décide de peindre une aurore illimité de couleurs autour du cadavre de René-Pierre Overney, quand Monory décide de faire figurer dans son tryptique un révolutionnaire cubain assassiné dans les rues de La Havane par la police de Battista, on pourrait même déduire qu'ils cherchent à rejoindre Topino par la voie traditionelle de la célébration des victimes et des héros. [Mais on aura tort]', Jouffroy, in ibid., pp. 55–6.

26 'Ainsi la naissance de Beaubourg intervient-elle dans un contexte de trouble profonde de l'intelligentsia française… La crise idéologique… est brutale…. [He quotes Jean-Claude Guillebaud's 1978 term, *années orphelines*]. Cette gauche… se retrouve brusquement privée de ses grands modèles de référence (URSS, puis Chine Communiste)… et de l'une de ses grilles de l'explication du monde, le marxisme', Jean-François Sirinelli, 'L'Institutionalisation de la culture en question', in Bernadette Dufrêne, ed., *Centre Pompidou: trente ans d'histoire*, Paris, Éditions du Centre Pompidou, 2007, p. 46. See also Dufrêne, *La Création de Beaubourg*, Presses Universitaires de Grenoble, 2000.

27 Géricault's *Raft of the Medusa* was the leitmotif for the huge Malassis commission, for the Grand Place commercial centre, Grenoble (1975), which was already problematic, as I have argued in 'Politique et vanitas: Lucien Fleury et les Malassis', in Anne Dary, ed., *Lucien Fleury 1928–2005* (Musée des Beaux-Arts, Dole), Dole, Association des Amis du Jura, 2007, pp. 10–43.

28 See the numbers of *L'Arc* on Deleuze (1972); on Aragon and Derrida (1973); on Barthes and Lacan (1974); on Lyotard, Le Roy Ladurie and Yves Bonnefoy (1976); a Winnicot number in 1977 precedes *La Crise dans la tête*.

29 *Qui a peur de la philosophie?*, Paris, Flammarion, 1977, a compendium produced by the Group de Recherches sur l'Enseignement Philosophique, founded in 1974 by Jacques Derrida; see Christopher I. Fynsk, 'A Deceleration of Philosophy', *Diacritics* 8/), 1978, pp. 80–90, reprinted in Victor E. Taylor and Gregg Lambert, eds., *Jean-François Lyotard: Critical Evauations in Cultural Theory*, vol. 2, London, Routledge, 2006, pp. 142–57. His critique of the 'failure to appreciate the socio-political aspects of deconstruction… an exclusion of the political questions raised by this philosophy' already taking place in the United States is particularly relevant (p. 151).

30 'Je crois qu'il est temps de m'interrompre', Jean-François Lyotard, 'Apathie dans la théorie', significantly retitled and modified from 'De l'apathie théorique', *Critique*, 333, February 1975, reprinted in *Rudiments païens, genre dissertatif*, Paris, Union Générale des Éditions, 10/18, 1977, p. 9; in conclusion: 'On pourrait croire que le moment est venue de dire adieu au genre théorique ou critique' opens 'Dissertation sur une inconvenance' (the *dissertation finale*, written specifically to end the book published in late 1977), p. 233 (my translations). While *la théorie* is indeed reifed as such (pp. 237, 240) there are constant slippages among *la genre théorique-critique* (p. 233), *l'art des philosophes, l'art théorique* etc, and Lyotard paid attention to Bruno Latour's demolishing analysis (with Paolo Fabbri), 'La Rhétorique de la science, pouvoir et devoir dans un article de science exacte', *Actes de recherche en sciences sociales*, 13, March 1977, pp. 81–95 (misquoted reference in Lyotard, 'Apathie', p. 31).

31 I refer to the immense lateness of Derrida's celebrated *Spectres de Marx: l'état de la dette, le travail du deuil et la nouvelle internationale*, Paris, Gallimard, 1993 (*Specters of Marx: The State of the Debt, the Work of Mourning and the New International*, New York and London, Routledge, 1994).

32 'L'histoire de ce radicalisme marxiste devrait être pensée et écrite dans sa propre langue… Rien d'autre, à part aimer, ne nous avait paru valoir un instant de distraction pendant ces années', Jean-François Lyotard, 'Mémorial pour un marxisme: à Pierre Souryri', *Esprit*, January 1982, reprinted in *Pérégrinations: loi, forme, événement*, Paris, Galilée, 1990, pp. 95–6 ('A Memorial of Marxism: For Pierre Souyri,' *Peregrinations: Law, Form, Event*, New York, Columbia University Press, 1988, p. 47).

119. Lucio Fanti, 1969

Select Bibliography

General

Abadie, Daniel, *L'Hyperréalisme américain* (Paris: Fernand Hazan, 1975)

Adorno, Theodor, *Théorie esthétique*, trans. Marc Jimenez [1970] (Paris: Klincksieck, 1974)

—, and Max Horkheimer, *Dialectique de la raison: fragments philosophiques* (Amsterdam, 1947), trans. E. Kaufholz in collaboration with M. Horkheimer (Paris: Gallimard, 1974; New York, 1994)

Agostinelli, Alessandra, *Collezionisti italiani alla Biennale del dissenso*, thesis, Venice, Università Ca'Foscari, 2008

Althusser, Louis, 22ème Congrès, (Paris: Maspéro, 1977); '22nd Congress', *New Left Review*, 1/104, July–August 1977, pp. 3–22

—, *Althusser: A Critical Reader,* ed. Gregory Elliott (Oxford: Blackwell, 1994

—, *L'Avenir dure longtemps, suivi par Les Faits*, ed. Olivier Corpet and Yann Moulier-Boutang (Paris: Éditions Stock/IMEC, 1992); *The Future Lasts a Long Time,* trans. Richard Veasey (London: Chatto and Windus, 1993)

—, *Écrits philosophiques et politiques*, vol. 1, ed. François Matheron (Paris: Éditions Stock/IMEC, 1994)

—, *Écrits philosophiques et politiques*, vol. II, ed. François Matheron (Paris: Éditions Stock/IMEC, 1995)

—, 'Freud et Lacan', *La Nouvelle Critique*, 161–2, December 1964–January 1965; Eng. edn in *New Left Review*, 55, May-June 1969

—, *The Humanist Controversy and Other Writings* (London: Verso, 2003)

—, *Journal de captivité, Stalag XA/1940–1945: Carnets, Correspondances, Textes*, ed. Olivier Corpet and Yann Moulier Boutang (Paris: Éditions Stock/IMEC, 1992)

—, *Lénine et la philosophie* (Paris: Maspéro, 1969); *Lenin and Philosophy and Other Essays* (New York and London: Monthly Review Press, 1971)

—, Letter to Merab Marmardashvili, 1978, trans. Mithcell Abidor, Louis Althusser internet archive

—, *Lettres à Franca (1961–1973)*, ed. François Matheron and Yann Moulier Boutang (Paris: Stock/IMEC, 1998)

—, *Lire 'le Capital'*, with collaborators (Paris: Maspéro, 1965); *Reading 'Capital'*, trans. Ben Brewster (London: NLB, 1970)

—, *Philosophie et philosophie spontanée des savants*, (Paris: Maspéro, 1974)

—, *Philosophy of the Encounter: Later Writings, 1978–1987*, ed. François Matheron and Olivier Corpet, intro. and trans. G. M. Goshgarian (London and New York: Verso, 2006)

—, 'La Place de la psychanalyse dans les sciences humaines', in Olivier Corpet and François Matheron, eds., *Psychanalyses et sciences humaines* (Paris: Livre de Poche, 1996), pp. 31–3

—, *Pour Marx* (Paris: Maspéro, 1965); *For Marx*, trans. Ben Brewster (London: Allen Lane, 1969)

—, preface to Dominique Lecourt, *Lyssenko: histoire réelle d'une 'science prolétarienne'* (Paris: Maspéro, 1976)

—, *Réponse à John Lewis*, (Paris: Maspéro, 1973); 'Reply to John Lewis (Self-Criticism)', *Marxism Today*, October and November 1972.

Améline, Jean Michel, ed., *Figuration narrative: Paris 1960–1972* (Paris: Réunion des Musées Nationaux/Centre Georges Pompidou, 2008)

—, and Harry Bellet, eds., *Face à l'histoire: l'artiste moderne devant l'événement historique, 1933–1996* (Paris: Centre Georges Pompidou, 1996)

Andrews, Julia, *Painters and Politics in the People's Republic of China, 1949–1979* (Berkeley and London: University of California Press, 1994)

Ansell-Pearson, Keith, ed., *Deleuze and Philosophy: The Difference Engineer* (London: Routledge, 1997)

Antonioli, Manola, Frédéric Astier and Olivier Fressard, eds., *Gilles Deleuze et Félix Guattari: une rencontre dans l'après Mai 68* (Paris: L'Harmattan, 2009)

Aragon, Louis, 'L'Art et le sentiment nationale' (Paris: Éditions Les Lettres Françaises et Tous les Arts, 1951)

—, *Écrits sur l'art moderne*, ed. Jean Ristat (Paris: Flammarion, 1981)

—, *Pour un réalisme socialiste* (Paris: Denoël et Steele, 1935)

Aron, Raymond, *D'une sainte famille à l'autre: essais sur les marxismes imaginaires* (Paris: Gallimard, 1969)

Artières, Philippe, ed., *Michel Foucault: la littérature et les arts* (Paris: Kimé, 2004)

—, Laurent Quéro and Michelle Zancarini-Fournel, eds., *Le Groupe d'information sur les prisons: archives d'une lutte, 1970–1972* (Paris: IMEC, 2003)

Avron, Henri, *Le gauchisme* (Paris: PUF, 1968)

Badinter, Robert, *L'Abolition* (Paris: Fayard, 2000)

Backmann René and Claude Angeli, *La Police dans la Nouvelle Societé* (Paris: Mitspéro, 1971)

Baj, Enrico, Laurent Chollet, et al, *La Grande peinture antifasciste collective* (Paris: Éditions Dagorno, 2000)

Balaram, Rakhee, 'Femmes Révolutionnaires: The Politics of Women's Art, Theory and Practice in 1970's France', PhD, University of London, 2009

Balibar, Etienne, ed., *Écrits pour Althusser* (Paris: Éditions de la Découverte, 1991)

Baltrusaitis, Jurgis, ed., *Anamorphoses: chasse à travers les collections du musée* (Paris: Musée des Arts Décoratifs, 1976)

Barr, Matthew, 'Michel Foucault and Visual Art, 1954–1984', PhD, University of London, 2006–7

Baudelaire, Charles, 'Le Peintre de la vie moderne' (*Le Figaro*, 1863), *Œuvres complètes*, vol. 2 (Paris: Gallimard, 1976), p. 712; 'The Painter of Modern Life', *Selected Writings on Art and Artists*, trans. p. E. Charvet (Cambridge University Press, 1972)

Baudrillard, Jean, *La Societé de consommation: ses mythes, ses structures* (Paris: Denoël, 1970, 2nd edn 1974); *The Consumer Society: Myths and Structures* (London: Sage, 1998)

—, *Le Système des objets* (Paris: Gallimard, 1968); *The System of Objects*, trans. James Benedict (London and New York: Verso, 1996; London: Verso, 2005)

Bauer, George Howard, *Sartre and the Artist* (University of Chicago Press, 1969)

Benjamin, Walter, *Selected Writings*, trans. Rodney Livingstone et al, ed. Marcus Bulloch and Michael W. Jennings, 4 vols (Cambridge and London: Harvard University Press), 1996-2003

Berne, Mauricette, ed., *Sartre* (Paris: Biblothèque Nationale de France and Gallimard, 2005)

Bigo, p. *Marxisme et humanisme* (Paris: PUF, 1953)

Bissière, Caroline, and Jean-Paul Blanchet, *Les Années 70: les années mémoire. Archéologie du savoir et de l'être* (Meymac, Corrèze: Centre d'Art Contemporain, Abbaye Saint-André, 1985)

Blanchot, Maurice, *Écrits politiques, 1953–1994*, ed. Eric Hoppenot (Paris: Gallimard, 2008), ch. 2, 'La Guerre d'Algérie, autour du "Manifeste des 121"' (1960), pp. 45–88

Blistène, Bernard, and Alison Gingeras, eds., *Premises: Invested Spaces in Visual Arts, Architecture and Design from France, 1958–1998* (New York: Guggenheim Soho, 1998)

Bogdanov, Alexander, *La Science, l'art et la classe ouvrière,* trans. and ed. Blanche Grinbaum (Paris: Maspéro, 1977)

Bois, Yve-Alain, *Painting as Model* (Cambridge, Mass: MIT Press, 1990)

Boissier, Jean-Louis ed., *Images du Peuple Chinois*, (Paris: Musée d'Art Moderne de la Ville de Paris, 1975)

Boltanski, Luc, *Les Cadres: la formation d'un groupe sociale* (Paris: Minuit, 1982); *The Making of a Class: Cadres in French Society* (Cambridge University Press, 1987)

—, 'La Constitution du champ de la bande dessinée', *Actes de recherche en sciences sociales*, 1, 1975, pp. 37–59

Bony, Anne, *Les Années 70* (Paris: Éditions du Regard, 1993)

Boschetti, Anna, *The Intellectual Enterprise: Sartre and Les Temps Modernes*, trans. Richard C. McLeary (Evanston, Il.: Northwestern University Press, 1988)

Bouayed, Anissa ed., *Les Artistes Internationaux et la Révolution Algérienne*, (Algiers: Musée national d'art moderne et contemporain d'Alger, 2008)

Boudaille, Georges ed., *Exposition d'arts plastiques au XVII^ème congrès du Parti communiste français,* (Paris: Parti Communiste Français, 1967)

Bourdieu, Pierre, *L'Amour de l'art, les musées d'art et leur public* (Paris: Minuit, 1966); *The Love of Art*, trans. C. Beattie and N. Merriman (Cambridge: Polity, 1990)

—, *Un Art moyen: essai sur les usages sociaux de la photographie* (Paris: Minuit, 1965); *Photography: a middle-brow art*, trans. S. Whiteside (Cambridge: Polity, 1990)

—, 'Champ intellectuel et projet créateur', *Les Temps modernes*, 246 (structuralism number), 1966, pp. 865–906; 'Intellectual Field and Creative Project', *Social Science Information*, 8, 1968, pp. 89–119

—, *La Distinction: critique sociale du jugement* (Paris: Minuit, 1979); *Distinction*, trans. R. Nice, Cambridge, Mass: Harvard University Press, 1984

—, *Esquisse pour une auto-analyse* (Paris: Éditions Raisons d'Agir, 2004); *Sketch for a self-analysis*, trans. R. Nice (Cambridge: Polity, 2007)

—, *Les Héritiers, les étudiants et la culture*, with L. Boltanski, R. Castel and J.-C. Chamboredon (Paris: Minuit, 1964); *The Inheritors*, trans. R. Nice, Chicago: University of Chicago Press, 1979)

—, 'L'Image de l'image', *L'Année 1966* (Paris: Galerie Mommaton, 1967), reprinted in *Art Press*, 133, February 1989, p. 27

—, *Images d'Algérie: une affinité élective* (Paris: Institut du Monde Arabe/Actes Sud, with Camera Austria, 2003)

—, 'L'Invention de la vie d'artiste', *Actes de la recherche en sciences sociales*, 2, March 1975, pp. 67–75

—, *La Noblesse d'État: grandes écoles et esprits de corps* (Paris: Minuit, 1989); *The State Nobility: Elite Schools in the Field of Power* (Oxford: Polity Press, 1996)

—, 'Le Point de vue de l'auteur', *Les Règles de l'art: genèse et structure du champ littéraire* (Paris: Seuil, 1992)

—, with Hans Haacke, *Free Exchange* (Stanford University Press, 1995)

Bourseiller, Christophe, *Les Maoïstes: la folle histoire des gardes rouges français* (Paris: Plon, 1996)

Brocheux, Pierre, 'The Economy of War as a Prelude to a "Socialist Economy": The Case of the Vietnamese Resistance against the French, 1945–1954', in Gisèle Bousquet and Pierre Brocheux, eds., *Viet Nam Exposé: French Scholarship on Twentieth-Century Vietnamese Society* (Ann Arbor: University of Michigan Press, 2002), pp. 313–30

Bryson, Norman, ed., *Calligram: Essays in New Art History from France* (Cambridge University Press, 1988)

Buchloh, Benjamin, *Neo-Avant-garde and Culture Industry* (Cambridge, Mass., and London: MIT Press, 2000)

Bücking, Bernd, 'Karl Marx und die Kinder von Coca-Cola', *Tendenzen*, 66, May-June 1970, pp. 45–52

Bulletin de la Jeune Peinture, 1969-1972

Bussmann, Georg, ed., *Kunst und Politik* (Karlsruhe: Badischer Kunstverein, 1970)

Butler, Judith, 'Afterword: After Loss, What Then?,' in David L. Eng and David Kazanjian, eds., *Loss: The Politics of Mourning* (Berkeley: University of California Press, 2003)

Butor, Michel, *Mobile: étude pour une représentation des États-unis*, (Paris: Gallimard, 1962)

Cabestan, Jean-Pierre, 'Relations between France and China: Towards a Paris-Beijing Axis?', *China: An International Journal*, 4/2, September 2006 (on line)

Calvi, Fabrizio, *Italie 77: le 'Mouvement', les intellectuels* (Paris: Seuil 1977)

Carr, David, *Time, Narrative and History* (Bloomington: Indiana University Press, 1986)

Carrick, Jill, 'The Assassination of Marcel Duchamp: Collectivism and Contestation in 1960s France', *Oxford Art Journal*, 31/1, 2008, pp. 17–24

Certeau, Michel de, *Histoire et psychanalyse entre science et fiction* (Paris: Gallimard, 1987)

—, 'Pratiques d'espaces: la ville métaphorique', *Traverses*, 9, 'Ville Panique', November 1977, pp. 4–9

Chalumeau, Jean-Luc, *La Nouvelle figuration: une histoire, de 1953 à nos jours* (Paris: Éditions Cercle d'Art, 2003)

—, Anne Dary and Isabelle Klinka-Ballesteros eds., *La Nouvelle figuration dans les collections publiques (1964–1977)* (Paris: Éditions Somogy, 2005)

Charmet, Raymond, *Clovis Trouille* (Paris: Filipacchi, 1972)

Chase, Linda, 'L'Hyperréalisme américain', *Hyperréalistes américains-Réalistes européens* (Paris: CNAC, Établissement Beaubourg, 1974)

Chassey, Eric de, 'Paris–New York: Rivalry and Denial', in Sarah Wilson, ed., *Paris, Capital of the Arts, 1900–1968* (London: Royal Academy of Arts, 2002), pp. 344–51

Clair, Jean, *Art en France: une nouvelle génération* (Paris: Éditions du Chêne, 1972)

—, 'La Chute d'un ange', *Chroniques de l'art vivant*, 16, December 1970–January 1971, p. 14

—, 'Hyperréalisme, 7^ème Biennale de Paris', *Chroniques de l'art vivant*, 24, October 1971

—, *L'œuvre de Marcel Duchamp catalogue raisonné* vol. II; *Abécédaire/ approches critiques*, vol. III (Paris: Centre Georges Pompidou, 1977)

—, ed., *Les Réalismes entre révolution et réaction, 1919–1939* (Paris: Centre Georges Pompidou, 1980)

Cohn, Robert, *L'Œuvre de Mallarmé: un coup de dés* (Paris: Librarie des Lettres, 1951)

Cone, Michèle C., 'The Early Career and Formative Years of Pierre Restany', in Tom Bishop, ed., *The Florence Gould Lectures*, vol. 6, 2002–4 (New York University, 2004)

Contat, Michel, *Sartre: l'invention de la liberté* (Paris: Les Éditions Textuels, 2005)

—, and Michel Rybalka, eds., *Les Écrits de Sartre: Chronologie, bibliographie commentée* (Paris: Gallimard, 1979); *The Writings of Jean-Paul Sartre*, Volume 1: *A Bibliographical Life*, trans. Richard C. McCleary (Evanston, Il: Northwestern University Press, 1974)

Corvez, Maurice, *Les Structuralistes* (Paris: Aubier-Montaigne, 1969)

Couperie, Pierre, et al., *Bande dessinée et figuration narrative* (Paris: Musée des Arts Décoratifs, 1967)

Courtois, Stéphane, et al., *Le Livre noir du communisme* (Paris: Robert Laffont, 1997); *The Black Book of Communism*, trans. Jonathan Murphy and Mark Kramer (Cambridge, Mass: Harvard University Press, 1999)

Cuba! Art and History from 1868 to Today (Montreal: Museum of Fine Art, 2008)

Cueco, Henri, and Pierre Gaudibert, *L'Arène de l'art* (Paris: Galilée, 1988)

Cusset, François, *French Theory: Foucault, Derrida, Deleuze et cie et la mutation de la vie intellectuelle aux États-unis* (Paris: Éditions La Découverte, 2003); *French Theory: How Foucault, Derrida, Deleuze, & Co, Transformed the Intellectual Life of*

the United States, trans. Jeff Fort (Minneapolis: University of Minnesota Press, 2008)

Dary, Anne, ed., La Nouvelle figuration dans les collections publiques (1964–1977) (Paris: Éditions Somogy, 2005)

Decron, Benoît ed., Peter Saul (Musée de l'Abbaye Sainte-Croix) Paris, Éditions Somogy, 1999

Delanoë, Nelcya, Le Raspail vert: l'American Center à Paris, 1934–1994 (Paris: Seghers, 1994)

Deleuze, Gilles, Francis Bacon: logique de la sensation (Paris: Éditions de la Différence, 1981); Francis Bacon: The Logic of Sensation, trans. Daniel W. Smith (London and New York: Continuum, 2003)

—, Deux régimes de fous: textes et entretiens, 1975–1995, ed. David Lapoujade (Paris: Minuit, 2003)

—, Différence et répétition (Paris: PUF, 1968)

—, L'Île deserte et autres textes: textes et entretiens, 1953–1974, ed. David Lapoujade (Paris: Minuit, 2002)

—, and Félix Guattari, Capitalisme et schizophrénie, vol. 1, L'Anti-Œdipe (Paris: Minuit, 1972); Anti-Oedipus: Capitalism and Schizophrenia, trans. Robert Hurley, Mark Seem and Helen R. Lane (New York: Viking, 1977; London: Athlone Press, 1984)

Dempsey, Amy J., 'The Friendship of America and France: A New Internationalism, 1961–1964', PhD, University of London, 1999

Deparis, Jean-Marie, 'Histoire de l'ARC, 1967–1972', thesis, Université de Paris I–Sorbonne, 1981

Derivery, François, L'Exposition 72/72 (Campagnan: Éditions EC, 2001)

De Roo, Rebecca J., The Museum Establishment and Contemporary Art: The Politics of Artistic Display in France after 1968 (Cambridge University Press, 2006)

Derrida, Jacques, Aporias (Stanford University Press, 1993)

—, Archive Fever: A Freudian impression, trans. Eric Prenowitz (University of Chicago Press, 1996)

—, Chaque fois unique le fin du monde (Paris: Galilée, 2003)

—, 'Comment ne pas trembler', ed. S. Regazzoni, Annali della Fondazione europea del disegno, 2006/2 (Milan: Bruno Mondadori), pp. 91–103

—, 'De la couleur à la lettre', Atlan Grand Format (Paris: Gallimard, 2001)

—, 'Le Dessin par quatre chemins', Annali della Fondazione europea del disegno, 2005/1 (Milan: Bruno Mondadori), pp. 4–5

—, La Dissemination (Paris: Seuil, 1972); Dissemination, trans. Barbara Johnson (University of Chicago Press, 1981; London: Continuum, 2004)

—, 'Fors: les mots anglés de Nicolas Abraham and Maria Torok' (preface), in Abraham and Torok, eds., Le Verbier de l'homme aux loups (Paris: Aubier/Flammarion, 1976)

—, Gérard Titus-Carmel. The Pocket Size Tlingit Coffin et les 61 premiers dessins qui s'ensuivrent' illustré par Cartouches de Jacques Derrida, (Paris: Centre Georges Pompidou, 1978)

—, 'Glas', L'Arc, 54, special Jacques Derrida number, 1973

—, Glas (Paris: Galilée, 1974); Glas trans. John P. Leavey Jr. and Richard Rand, (Lincoln and London: University of Nebraska Press, 1986)

—, 'Illustrer, dit-il' Ateliers d'aujourd'hui 17, François Loubrieu (Paris: Centre Georges Pompidou, 1979)

—, Marges de la philosophie (Paris: Minuit, 1972); Margins of Philosophy, trans. A. Bass (University of Chicago Press, 1982)

—, 'Mallarmé', Tableau de la littérature française: de Madame de Staël à Rimbaud (Paris: Gallimard, 1974), pp. 368–79

—, Mémoires d'aveugle: l'autoportrait et autres ruines (Paris: Réunion des Musées Nationaux, 1990); Memoirs of the Blind: The Self-Portrait and Other Ruins, trans. Pascale-Anne Brault and Michael Naas (Chicago: University of Chicago Press, 1993)

—, 'The Pocket-Size interview with Jacques Derrida', ed. Freddy Trellez and Bruno Mazzoldi (1978–80), in T. J. Mitchell and Arnold I. Davidson, eds., Critical Inquiry, 'The Late Derrida', Winter, 2007, 33/2, pp. 367–8

—, 'Restitutions de la verité en pointure' (in 'Martin Heidegger et les souliers de Van Gogh', Macula 3/4 (1978), pp. 11-37

—, Le Schibboleth pour Paul Ceylan de Jacques Derrida, lithographies et monotypes de Michèle Katz (Paris: La Marelle, 2000)

—, Spectres de Marx: l'état de la dette, le travail du deuil et la nouvelle internationale (Paris: Gallimard, 1993); Specters of Marx: The State of the Debt, the Work of Mourning and the New International, trans. Peggy Kamuf (New York and London: Routledge, 1994)

—, Le Toucher: Jean-Luc Nancy (Paris: Galilée, 2000)

—, La Verité en peinture (Paris: Flammarion, 1978); The Truth in Painting, ed. Geoffrey Bennington and Ian McCleod (University of Chicago Press, 1987)

Donato, Eugenio, and Richard Mackey, eds., The Structuralist Controversy: The Languages of Criticism and the Sciences of Man (Baltimore: Johns Hopkins University Press, 1970)

Dosse, François, Gilles Deleuze et Félix Guattari: biographie croisée (Paris: La Découverte, 2007)

Drot, Jean-Marie, ed., Il Viaggio del dialogo, Le Voyage du dialogue: Adami-Lyotard, Cremonini-Jouffroy, Maselli-Scheffer, Peverelli-Glissant (Rome: Villa Medicis, Carte Segrete, 1986)

Ducret, André, and Franz Schultheis, eds., Un Photographe de circonstance: Pierre Bourdieu en Algérie (University of Geneva, 2005)

Dufrêne, Bernadette, 'Art et médiatisation: le cas des grandes expositions inaugurales de Centre Georges Pompidou (Paris-New York, Paris-Berlin, Paris-Moscou)', thesis, Université Stendhal-Grenoble III, 1998

—, ed., Centre Pompidou: trente ans d'histoire (Paris: Éditions du Centre Georges Pompidou, 2007)

Dufrenne, Mikel, Art et politique (Paris: Union Générale des Éditions, 10/18, 1974)

Dupré, Michel, Réalisme(s): peinture et politique (Campagnan: Éditions EC, 2009)

d'Eaubonne, Françoise, Féminin et philosophie (une allergie historique) (Paris: L'Harmattan, 1997)

Eco, Umberto, Opera aperta (Milan: Bompiani, 1962)

Ehrenzweig, Anton, The Psychoanalysis of artistic vision and hearing, (London: Routledge and Kegan Paul, 1953)

Eizkyman, Claudine, and Guy Fihman, 'L'Œil de Lyotard: de l'Acinéma au Postmoderne', in Jean-Paul Olive and Claude Amey, eds., A partir de Jean-François Lyotard (Paris: L'Harmattan, 2000), pp. 120–47

Elliott, Gregory, Althusser: The Detour of Theory, (London: Verso, 2006)

Elme, Patrick, Peinture et politique (Paris: Maison Mame, 1974)

Erebon, Didier, Michel Foucault (Paris: Flammarion, 1989)

Fanon, Franz, L'An V de la révolution algérienne (Paris: Maspero, 1960)

—, Les Damnés de la terre (Paris: Maspéro, 1961); The Wretched of the Earth (London: MacGibbon and Kee, 1965)

—, Peau noir, masques blancs (Paris: Seuil, 1952); Black Skin, White Masks, trans. Charles Lam Markmann(New York: Grove Press, 1967)

—, 'Racisme et culture', Présence africaine, 8-9-10, June-November 1956, pp. 122-131

Fanti, Giorgio, Occhio alla pittura (Bologna: Gedit Edizione, 2003)

Fanti, Guido, and Giancarlo Ferri, Cronache dell'Emilia Rossa: l'impossibile riformismo del PCI (Bologna: Pendragon, 2001)

Fenoglio, Irène, Une Auto-graphie du tragique: les manuscrits de Les Faits et de L'Avenir dure longtemps de Louis Althusser (Louvain-La-Neuve: Bruylant-Academia, 2007)

Figurations critiques: 11 artistes des figurations critiques 1965–1975 (Lyons: E.L.A.C., 1992)

La Figuration narrative (Paris: Artpress 2, trimestriel 8, 2008)

La Figuration narrative (Paris: artabsolumment, 2008)

La Figuration narrative au Grand Palais (Paris: Beaux-Arts Éditions, 2008)

Focillon, Henri, *Vie des formes* (Paris: Librarie Ernest Leroux, 1934); *The Life of Forms in Art*, trans. C. B. Hogan and George Kubler (New York: Wittenborn, Schulz, 1948; London: Zone Books, c. 1989)

Forgues, Pierre, ed., *L'Affaire Siniavski-Daniel* (Paris: Christian Bourgois, 1967)

Foster, Hal, Rosalind Krauss, Yve-Alain Bois, Benjamin Buchloh, *Art Since 1900: Modernism, Antimodernism, Postmodernism* (London: Thames & Hudson, 2004)

Foucault, Michel, *Aesthetics: Method and Epistemology*, ed. James D. Faubion (London: Allen Lane, 1998)

—, *Ceci n'est pas une pipe* (Paris: Fata Morgana, 1973); *This Is Not A Pipe*, trans. J. Harkness (Berkeley: University of California Press, 1983)

—, *Dits et écrits*, I: 1954–1975; *Dits et écrits*, II: 1976–1988, ed. François Ewald and Daniel Defert (Paris: Gallimard, 1994)

—, *Les Mots et les choses: une archéologie des sciences humaines* (Paris: Gallimard, 1966). *The Order of Things*, trans. A. M. Sheridan Smith (New York: Vintage, 1994)

—, *La Peinture de Manet, suivi de Michel Foucault: un regard*, ed. Maryvonne Saison (Paris: Seuil, 2004); *Manet and the Object of Painting*, ed. and trans. Matthew Barr, intro. Nicholas Bourriaud (London: Tate Publishing, 2009)

Francastel, Pierre, *Peinture et société: naissance et destruction d'un espace plastique. De la renaissance au cubisme* (Paris: Gallimard, 1965)

Fréchuret, Maurice, *Les années 1970: l'art en cause* (Paris: Réunion des Musées Nationaux, 2002)

Fréville, Jean, ed., *Lénine à Paris* (Paris: Éditions Sociales Internationales, 1968)

—, *La Nuit finit à Tours: naissance du Parti communiste française* (Paris: Éditions Sociales Internationales, 1970)

—, *Sur la littérature et l'art: Karl Marx, Friedrich Engels* (Paris: Éditions Sociales Internationales, 1936)

—, *Sur la littérature et l'art: V. I. Lénine, J. Staline* (Paris: Éditions Sociales Internationales, 1937)

Froment, Pascale, and Isabelle Rollin-Royer, *Mireille Glodek Miailhe: œuvres* (Paris: Biro Éditeur, 2007)

Fromm, Erich, ed., *Socialist Humanism,* international symposium (New York: Doubleday, 1965)

Gallo, Francesco, *Les Immatériaux: un percorso di Jean-François Lyotard nell'arte contemporanea* (Rome: Aracne, 2008)

Garaudy, Roger, *De l'anathème au dialogue: un marxiste s'adresse au Concile* (Paris: Plon, 1965)

—, *Humanisme marxiste: cinq essais polémique* (Paris: Éditions Sociales, 1957)

—, *D'un réalisme sans rivages* (Paris: Plon, 1963)

—, *Pour un réalisme du XXᵉᵐᵉ siecle: dialogue posthume avec Fernand Léger* (Paris: Grasset, 1968)

Gassiot-Talabot, Gérald, *La Figuration narrative* (Nîmes: Éditions Jacqueline Chambon, 2003)

—, 'La Havane: peinture et révolution', *Opus International*, 3, October 1967

—, 'Karslruhe, art et politique', *Opus International*, 19/20, double number, October 1970, pp. 163-4

—, *Mythologies quotidiennes* (Paris: Musée d'Art Moderne de La Ville de Paris, 1964)

—, 'Persistent et signent', *Opus International*, 49, March 1974, pp. 97–9

—, and Jean-Louis Pradel, *Mythologies quotidiennes 2* (Paris: Musée national d'art moderne, 1977)

Gaudibert, Pierre, *Action culturelle: intégration et/ou subversion* (Paris: Casterman, 1972)

—, 'La Marché de la peinture contemporaine et la crise', *La Pensée*, 123, September-October 1965, pp. 51–77

Geerlande, Robert, *Garaudy et Althusser: le débat sur l'humanisme dans le Parti communiste français et son enjeu* (Paris: PUF, 1978)

Gehret, J., ed., *Gegenkultur heute: Die alternativbewegung von Woodstock bis Tunix* (Amsterdam: Azid Presse, 1979)

—, *Gegenkultur: Von Woodstock bis Tunix, von 1969 bis 1981* (Asslar: BarGis, 1985)

Genet, Jean, 'Ce qui est resté . . .', *Tel Quel* 29, Spring 1967, in *Œuvres complètes*, vol. 4 (Paris: Gallimard, 1979), pp. 21-31

Genosko, Gary, ed., *Deleuze and Guattari: Critical Assessments of Leading Philosophers*, 2 vols (London, Routledge, 2001)

Gente, P., ed., *Foucault und die Künste* (Frankfurt: Suhrkamp, 2004)

Gervereau, Laurent ed., *La France en guerre d'Algérie, novembre 1954 – juillet 1962* (Paris: Éditions Bibliothèque de Documentation Internationale Contemporaine, 1992)

—, ed., *Mai 68: les mouvements étudiants en France et dans le monde* (Paris: Bibliothèque de Documentation Internationale Contemporaine, 1988)

—, ed., *Les Sixties en France et l'Angleterre* (Paris: Musée d'Histoire Contemporaine, 1996)

Ginzburg, Alexander, *Le Livre blanc de l'Affaire Siniavski-Daniel* (Paris: La Table Ronde, 1967)

Girard, Louis-Dominique, *La Guerre franco-français* (Paris: André Bonne, 1950)

Glucksmann, André, *La Cuisinière et le mangeur d'hommes: essai sur les rapports entre l'état, le marxisme et le camps de concentration* (Paris: Seuil, 1975)

Golan, Romy, 'Restany tous azimuts', in Tom Bishop, ed., *The Florence Gould Lectures*, vol. 6 (New York University, 2004)

Goldmann, Lucien, *Cultural Creation in Modern Society*, trans. Bart Grahl, ed. William Mayrl (Oxford: Basil Blackwell, 1977)

—, *Lukàcs et Heidegger* (Paris: Médiations, 1973)

Grémion, Pierre, *L'Intelligence de l'anticommunisme: les congrès pour la liberté de la culture à Paris, 1950–1975* (Paris: Fayard, 1995)

Grenfell, Michael, and Cheryl Hardy, *Art Rules: Pierre Bourdieu and the Visual Arts* (Oxford and New York: Berg, 2007)

GREPH (Group de Recherches sur l'Enseignement Philosophique), *Qui a peur de la philosophie?* (Paris: Flammarion, 1977)

Gribaudo, Ezio, *Mural Cuba colectiva 1967. Salon de Mai*, preface by Alain Jouffroy (Turin: Edizioni d'Arte Fratelli Pozzo, 1970)

Groensteen, Thierry, with Michel Mercier, 'The Dawn of Revolution: Comic Strips and Newspaper Cartoons', in D. A. Mellor and L. Gervereau, eds., *The Sixties, Britain and France: The Utopian Years, 1962–1973* (London: Philip Wilson, 1997), pp. 132–49

Groys, Boris, 'Moscow Romantic Conceptualism', *A-Ya* (Paris), 1, 1979, p. 3

—, *Total Enlightenment: Moscow Conceptual Art 1960–1990* (Ostfildern: Hatje Cantz, 2008)

Guattari, Félix, *The Anti-Oedipus Papers*, trans. Kélina Gotman, ed. Stephane Nadaud (New York: Semiotext(e), 2006)

—, *Molecular Revolution, Psychiatry and Politics*, trans. Rosemary Sheed, (London: Peregrine, 1984)

Guilbault, Serge, *How New York Stole the Idea of Modern Art: Abstract Expressionism, Freedom and the Cold War* (Chicago and London: University of Chicago Press, 1983)

Heidegger, Martin, 'Der Ursprung des Kunstwerkes', *Holzwege* (Frankfurt), 1950; 'The Origin of the Work of Art' (1955–6) in *Heidegger: Basic Writings*, ed. D. F. Krel (London: Routledge and Kegan Paul, 1978)

Hergott, Fabrice, ed., *Dans l'œil du critique: Bernard Lamarche-Vadel et les artistes* (Musée d'Art Moderne de la Ville de Paris, 2009)

Hourmant, François, *Au pays de l'avenir radieux: voyages des intellectuels français en URSS à Cuba et en Chine populaire* (Paris: Aubier, 2000)

Hudek, Anthony, '*Museum Tremens* or the Mausoleum without Walls: Working through *Les Immatériaux* at the Centre Pompidou in 1985', MA thesis, Courtauld Institute, University of London, 2001

—, 'From over-to Sub-Exposure: The Anamnesis of *Les Immatériaux*', *Tate Papers*, 12, 2009 (online)

Hulten, Pontus, ed., *06 Art 76, Aillaud, Erró, Poirier, Rouan, Titus-Carmel, Viallat* (Berkeley, Cal: University Art Museum, 1976)

—, ed., *Ny Franske Kunst* (Paris: Association Française d'Action Artistique, 1977)

—, ed., *Paris–New York* (Paris: Centre Georges Pompidou, 1977)

—, ed., *L'œuvre de Marcel Duchamp*, 4 vols., (Paris: Centre Georges Pompidou, 1977)

Jannicot, Eric, 'La Pensée plastique de Zao Wou-ki et la naissance de l'art moderne chinois', 3e cycle thesis, Université de Paris I–Sorbonne, 1984

Jimenez, Marc, *Theodor Adorno: art, idéologie et théorie de l'art*, (Paris: Union Générale des Éditions, 10/18, 1973)

—, *Adorno et la modernité: vers une ésthétique négative* (1983; Paris: Klincksieck, 1986)

Jouffroy, Alain, 'À la recherche des douze poignards de Topino-Lebrun', *Collectif Change*, 15, 'Police Fiction', 1973, pp. 61-89

—, ed., *Guillotine et peinture: Topino-Lebrun et ses amis* (Paris: Éditions du Chêne, 1977)

—, *Une Nouvelle peinture d'histoire* (Paris: CNAC, 1974)

—, 'La Peinture française au Louvre: promenade et conversation avec Martial Raysse', *Opus International*, 36, April 1972

—, *Les Visionneurs*, Brussels, Galerie Espace, and Basel, Galerie 15, 1973

Kagan, Elie, and Patrick Rotman, *Le Reporteur engagé: treize ans d'instantanés* (Paris: Métailié, 1989)

—, and Jean-Luc Einaudi, *17 octobre 1961* (Arles: Actes sud-BDIC, 2001)

Kanapa, Jean, *L'Existentialisme n'est pas un humanisme* (Paris: Éditions Sociales, 1947)

Karsz, Saul, *Théorie et politique: Louis Althusser* (Paris: Fayard, 1974)

Kauppi, Niilo, *French Intellectual Nobility: Institutional and Symbolic Transformations in the Post-Sartrian Era* (Albany: State University of New York Press, 1996)

Khatibi, Abdelkébir *Jacques Derrida en effet* ([Neuilly-sur-Seine] Paris: Al Manar, 2007

Kristeva, Julia, *Des chinoises* (Paris: Éditions des Femmes, 1974)

Kronick, Joseph G., 'Philosophy as Autobiography: The Confessions of Jacques Derrida', *Modern Language Notes*, 115, 5, 2000, pp. 997-1018

Kuisel, Richard, *Seducing the French: The Dilemma of Americanization* (Berkeley: University of California Press, 1993)

Kujundzic, Dragan, *The Returns of History: Russian Nietzscheans After Modernity* (Albany: State University of New York Press, 1997)

Kulterman, Udo, *Hyperréalisme*, (Paris: Chêne, 1972); *New Realism* (London: Matthews Miller Dunbar, 1972)

Lamarche-Vadel, Bernard, ed., *Figurations 1960–1973* (Paris: Union Générale des Éditions, 1973)

Lambert, Gregg, and Victor E. Taylor, eds., *Jean-François Lyotard: Critical Evaluations in Cultural Theory*, vol. 1, *Aesthetics* (London: Routledge, 2006)

Lambert, Jean-Clarence, 'Bris/collage/K: un rêve collectif' (extract with a collage by Rancillac), *Opus International*, 3, October 1967, p. 50

—, '1967, l'époque postmoderne est déjà commencée', *Opus International*, 50, May 1974, p. 26

Lefort, Claude, *Un Homme en trop: essai sur l'archipel du goulag de Soljénitsyne* (Paris: Seuil, 1975)

Leiris, Michel, intro., *Francis Bacon* (Paris: Grand Palais, 1971)

Leavey, John P., Jr., *Glassary* (Lincoln: University of Nebraska Press, 1986)

Leeman, Richard, ed., *Le Demi-siècle de Pierre Restany* (Paris: Institut National d'Histoire de l'Art and Éditions des Cendres, 2008)

Lenain, Thierry, ed., *L'Image: Deleuze, Foucault, Lyotard* (Paris: Vrin, 2003)

Lévi-Strauss, Claude, *Le Cru et le cuit* (Paris: Plon, 1964); *The Raw and the Cooked* trans. John and Doreen Weightman, (London: Jonathan Cape, 1970)

Leys, Simon, *Les Habits neufs du président Mao: chronique de la 'révolution culturelle'* (Paris: Champ Libre, 1971) *The Chairman's New Clothes: Mao and the Cultural Revolution* (New York: Random House, 1977)

Lois, Michelle,'Pour Althusser: réponse à Joe Metzger', *Rebelote*, 4, February 1974, pp. 1–3

Lotringer, Sylvère, ed., *Italy: Autonomia – Post-political Politics'* (New York: Semiotext(e), 2007)

—, and Sande Cohen, eds., *French Theory in America* (London and New York: Routledge, 2001)

Lukàcs, György, *Histoire et conscience de class: essais sur la dialectique marxiste* (Berlin, 1923; Paris: Minuit, 1960)

— *La signification présente du réalisme critique* (Paris: Gallimard, 1960)

Lyotard, Jean-François, 'Acinéma', *Revue d'esthétique,* July, 1973; *Wide Angle* 2/3 (Manchester), 1978, pp.53-9

—, *L'Assassinat de l'expérience par la peinture, Monory* (Talence: Le Castor Astral, 1984); *The Assassination of Experience by Painting, Monory*, ed. Sarah Wilson, trans. Rachel Bowlby and Jeanne Bouniort, (London: Black Dog Publishing, 1998)

—, *La Chambre sourde: l'antiesthétique de Malraux* (Paris: Galilée, 1998); *Soundproof Room, Malraux's Anti-Aesthetics*, trans. D. Harvey, (Stanford CA: Standford University Press, 2001)

—, *La Condition postmoderne* (Paris: Minuit, 1979); *The Postmodern Condition: A Report on Knowledge*, trans. Geoff Bennington and Brian Massumi (1984; Manchester University Press, 1987)

—, *La Confession d'Augustin* (Paris: Galilée, 1998); *The Confessions of Augustine*, trans. Richard Beardsworth (Stanford: Stanford University Press, 2000)

—, *Dérive à partir de Marx et Freud* (Paris: Union Générale des Éditions, 10/18, 1973)

—, *Discours, figure* (Paris: Klincksieck, 1971); *Discourse-Figure*, trans. Anthony Hudek and Mary Lydon (Minneapolis: University of Minnesota Press, 2010)

—, *Économie libidinale* (Paris: Minuit, 1974); *Libidinal Economy*, trans. I. Hamilton Grant, (London: Athlone Press, 1993)

—, 'Esquisse d'une économique de l'hyperréalisme', *Chroniques de l'art vivant*, 36, February 1973, p. 12

—, 'Freud selon Cézanne', *Des Dispositifs pulsionnels* (1973; Paris: Gallimard, 1994), pp. 71–89

—, *L'Inhumain* (Paris: Galilée, 1988); *The Inhuman*, trans. Geoff Bennington and Rachel Bowlby (Cambridge: Polity Press, 1991)

—, *Leçons sur l'analytique du sublime* (Paris: Galilée, 1991)

—, 'Notes sur la fonction critique de l'œuvre', *Revue d'esthétique*, 23/3–4, December 1970

—, *Le Mur du Pacifique* (Paris: Galilée, 1979); *Pacific Wall*, trans. Bruce Boone (Venice, Cal: Lapis Press, 1990)

—, 'Par delà la répresentation', preface to Anton Ehrenzweig, *L'Ordre caché de l'art* (Paris: Gallimard, 1974), pp. 9–24

—, 'Parce que la couleur est un cas de la poussière', *Pastels de Pierre Skira* (Paris: Galerie Patrice Trigano, 1997)

—, *Pérégrinations: loi, forme, événement* (Paris: Galilée, 1990); *Peregrinations: Law, Form, Event*, trans. Cecile Lindsay (New York: Columbia University Press, 1988)

—, *La Phénoménologie* (Paris: PUF, 1954)

—, *Rudiments païens, genre dissertatif* (Paris, Union Générale des Éditions, 10/18, 1977)

—, *Signé Malraux* (Paris: Grasset, 1996); *Signed Malraux*, trans. R. Harvey (Minnesota: University of Minnesota Press, 1999)

—, *Les Transformateurs Duchamp* (Paris: Galilée, 1977); *Duchamp's TRANS/formers* trans. Ian McLeod, (Venice, CA: Lapis Press, 1990)

—, 'The Unconscious as Mise-en-scène', trans. Joseph Maier, *Performance in Postmodern Culture*, ed. Michel Benamou and Charles Caramello (Madison, Wis: Coda Press, 1977) pp.87-98

—, and Thierry Chaput, eds., *Les Immatériaux* (Paris: Centre Georges Pompidou, 1985)

Mackey, Richard, and Eugenio Donato, eds., *The Structuralist Controversy: The Languages of Criticism and the Sciences of Man* (Baltimore: Johns Hopkins University Press, 1970)

McLuhan, Marshall, *Understanding Media: The Extensions of Man*; (New York: McGraw Hill, 1964); *Pour comprendre les médias: les prolongements technologiques de l'homme*, trans. J. Paré, (Paris: Seuil, 1968)

—, Quentin Fiore, *War and Peace in the Global Village* (New York: Bantam, 1968); *Guerre et paix dans le village planétaire* (Paris: Robert Laffont, 1970)

Maeght, Adrien, *Derrière le miroir* (Paris: Éditions Maeght, 1983)

Malraux, André, *Le Musée imaginaire: psychologie de l'art* (Geneva: Skira, 1947; *The Voices of Silence*, trans. Stuart Gilbert (New York: Doubleday, 1953)

Marcuse, Herbert, *Eros and Civilization: A Philosophical Enquiry into Freud* (Boston: Beacon Press, 1955; New York: Vintage Books, 1961); *Eros et civilisation Contribution à Freud*, trans. J. G. Nény et B. Fraenkel (Paris: Minuit, 1963)

—, *Culture et société*, trans. Gérard Billy, Daniel Bresson and Jean-Baptiste Grasset (Paris: Minuit, 1970)

Martinet, Marcel, *Culture prolétarienne* (Paris: 1935, Maspero, 1976)

Markovits, Francine, *Marx dans le jardin d'Epicure* (Paris: Minuit, 1974)

Marmor, François, *Le Maoïsme: philosophie et politique* (Paris: PUF, 1976)

Marsili, Marzia, 'Il Partito comunista italiano negli anni della ricostruzione: un giornale per la sinistra bolognese: "Il Progresso d'Italia": (1946–1951)', PhD., Università degli Studi di Bologna, 1993

Matheron, François, 'Louis Althusser et Argenteuil: de la croisée des chemins au chemin de croix', *Annales de la Société des amis de Louis Aragon et Elsa Triolet*, 2, 2000, pp.169–80 (online)

Mathey, François et al., eds., *72/72: Douze ans d'art contemporain en France, 1960–1972* (Paris: Éditions des Musées Nationaux, 1972)

Mellor, Alec, *La torture: son histoire, son abolition, sa réapparition au XXème siècle* (Paris: Éditions Domat Monchrestien, 1949)

Melville, Stephen and Bill Readings eds., *Vision and Textuality* (Hong Kong: Macmillan, 1995)

Merleau-Ponty, Maurice, 'La Doute de Cézanne', *Fontaine*, 47, December 1945, reprinted in *Sens et non-sens* (Paris: Éditions Nagel, 1948); 'Cézanne's Doubt', *Sense and Non-Sense*, trans. Herbert L. Dreyfus and Patricia Allen Dreyfus (Evanston, Il: Northwestern University Press, 1964), pp. 9–25

—, *Humanisme et terreur: essai sur le problème communiste* (Paris: Gallimard, 1947)

Miller, Ann, *Reading Bande Dessinée: Critical Approaches to French-language Comic Strip* (London: Intellect Books, 2007)

Monahan, Laurie J., 'Cultural Cartography: American Designs at the 1964 Venice Biennale', in Serge Guilbault, ed., *Reconstructing Modernism: Art in New York, Paris and Montreal, 1945–1964* (Cambridge, Mass: MIT Press) pp. 369–416

Morineau, Camille, ed., *elles@centrepompidou* (Paris: Éditions du Centre Georges Pompidou, 2009)

Moulier-Boutang, Yann, *Louis Althusser: une biographie*, vol. 1, 1918–1956 (Paris: Grasset, 1992); vol. 2, 1945–1956, (Paris: Librarie Générale Française, 2002)

Murawska-Muthesius, Katarzina, 'Paris from behind the Iron Curtain', in Sarah Wilson, ed., *Paris, Capital of the Arts, 1900–1968* (London: Royal Academy of Arts, 2002), pp. 250–61

Negri, Antonio, *Books for Burning: Between Civil War and Democracy in 1970s Italy* (London: Verso, 2005)

Nizan, Paul, *Les Chiens de garde* (Paris: Maspéro, 1960); *The Watchdogs: Philosophers and the Established Order (*New York: Monthly Review Press, 1972)

Le Nouëne, Patrick, ed., *Peter Saul* (Musée de l'Abbaye Sainte-Croix; Paris: Éditions Somogy, 1999)

Pacon, Salome, 'Le Krach de l'art', *Opus International,* 66–7, 1978, special 1968–78 retrospective number, pp. 49–51

Pagé, Suzanne, and Juliet Laffon, eds., *ARC 1973–1983* (Musée d'art moderne de la Ville de Paris, 1983)

Panofsky, Erwin, *Architecture gothique et pensée scholastique, précédé de l'abbé Suger de Saint-Denis*, trans. and postface Pierre Bourdieu (Paris: Minuit, 1967)

Parent, Francis, and Raymond Perrot, *Le Salon de la jeune peinture: une histoire, 1950–1983* (Montreuil: Édition JP, 1983)

Parent, Raymond, *Le Collectif antifasciste, 1974–1977* (Campagnan: Éditions EC, 2001)

Passeron, René, *Magritte* (Paris: Filipacchi, 1970)

—, *L'Œuvre picturale et les fonctions d'apparence* (Paris: Vrin, 1962)

Pensky, Max, *Melancholy Dialectics: Walter Benjamin and the Play of Mourning* (Amherst: University of Massachussets Press, 1993)

Perrot, Raymond, *De la narrativité en peinture: essai sur la figuration narrative et sur la figuration en général* (Paris: Éditions L'Harmattan, 2005)

Pheline, Christian, 'L'Image accusatrice', *Cahiers de la photographie* (Paris: ACCP, 1985)

Phélip, Laure, 'La Réception des artistes américains à Paris, 1958–1968: néo-dadaïsme et Pop Art', maître, Université de Paris I, 2000

Plato, *The Collected dialogues of Plato including the letters*, ed. Edith Harris and Huntington Cairns, (Princeton: Princeton University Press, 1973)

Plekhanov, Georges, *Les Questions fondamentales du marxisme: le matérialisme militant* (Paris: Édition Sociales, 1974)

Pleynet, Marcelin, *Le Voyage en Chine* (Paris: Hachette, 1980)

Pole, Ieme van der, *Une Révolution de la pensée: maoïsme et feminisme à travers Tel Quel, Les Temps Modernes, et* l'Esprit (Amsterdam: Rodopi, 1992)

Pradel, Jean-Louis, ed., *La Figuration narrative* (Paris: Hazan, 2000)

Preis, Christine, and Wolfgang Welch, eds., *Aesthetik im Widerstreit: Interventionen sum Werk von Jean-François Lyotard* (Weinheim: Acta Humaniora, 1991)

Raphael, Max, *Proudhon, Marx, Picasso* (Paris: Éditions Excelsior, 1933)

Raymond, Pierre, ed., *Althusser philosophe* (Paris: PUF, 1997)

Readings, Bill, *Introducing Lyotard: Art and Politics* (Routledge: London and New York, 1991)

Reed-Danahay, Deborah E., ed., *Auto/Ethnography: Rewriting the Self and the Social* (Oxford and New York: Berg, 1997)

Revault d'Allones, Olivier, et al, *Esthétique et marxisme* (Paris: Union Générale des Éditions, 1974)

Rigoulot, Pierre, *Les Paupières lourdes: les français face au goulag: aveuglement et indignation* (Paris: Éditions Universitaires, 1991)

Robbins, Derek, ed., *Bourdieu and Culture* (London and Thousand Oaks, Cal: Sage Publishers, 2000)

Ross, Kristin, *Fast Cars, Clean Bodies: Decolonization and the Reordering of French Culture* (Cambridge, Mass: MIT Press, 1995)

—, *May '68 and its Afterlives* (Chicago and London: University of Chicago Press, 2002)

Rouillier, Clothilde, 'Le Centre national d'art contemporain: du service artistique au Musée national d'art moderne, 1965–1983', unpublished, Paris, Service des Archives du MNAM, Centre Georges Pompidou, 2004

Rousset, David, *Pour la vérité sur les camps concentrationnaire* (Paris: Éditions du Pavois, 1951)

—, and Paul Barton, *L'Institution concentrationnaire en Russie, 1930–1957* (Paris: Plon, 1957)

Sabau, Luminita, ed., *The Promise of Photography*, with essays by Rosalind Krauss and Paul Virilio (Munich: DG Bank Art Collection and Prestel, 1998)

Sartre, Jean-Paul, 'Coexistences', *Derrière le miroir*, 187, 1970, reproduced in *Rebeyrolle: peintures 1968–1978* (Paris: Maeght Éditeur, 1978)

—, *Essays in Aesthetics*, trans. and ed. Wade Baskin (London: Peter Owen, 1964)

—, *L'Existentialisme est un humanisme* (Paris: Nagel, 1946); *Existentialism and Humanism*, trans. Philip Mairet (London: Methuen, 1948)

—, 'Le Fantôme de Staline', *Les Temps modernes*, 129–31, 'La Révolte de la Hongrie', November 1956–January 1957, pp. 577–697; *The Spectre of Stalin*, trans. Irene Clephane (London: Hamish Hamilton, 1969)

—, 'Saint Genet: comédien et martyr', in Jean Genet, *Œuvres complètes*, vol. 1 (Paris: Gallimard, 1952)

—, *Situations IV* (Paris: Gallimard, 1964)

Scopettone, Dina, 'Le Salon de Mai in Cuba, 1967', MA thesis, Courtauld Institute of Art, University of London, 1998

Sicard, Michel, ed., *Obliques*, 18–19, Sartre special number (Nyons: Éditions Borderie, 1979)

– *Obliques*, 24–25, 'Sartre et les arts', special number (Nyons: Éditions Borderie, 1981)

Sollers, Philippe, 'Pourquoi j'ai été chinois', *Tel Quel*, 88, Summer 1981, pp. 11–35

Soomre, Maria-Kristina ed., *Archives in Translation: Biennale of Dissent '77* (Tallin: Kumu Art Museum, 2007)

Sorman, Guy, 'Mao, ou l'étrange fascination pour le sado-marxisme', *Le Figaro*, 8 September 2006 (online)

Sportés, Morgan, *Ils ont tué Pierre Overney* (Paris: Grasset, 2008)

Stäheli, Alexandra, *Materie und Melancholie: Die Postmoderne zwischen Adorno, Lyotard und dem pictorial turn* (Vienna: Passagen Verlag, 2004)

Starobinski, Jean, 'Hamlet and Freud', preface to Ernest Jones, *Hamlet et Œdipe* (Paris: Gallimard, 1967)

Stearn, Gerald E. ed., *McLuhan hot and cool* (New York: Dial Press, 1967); *Pour ou contre McLuhan*, trans. G, Durand and P.-Y. Pétillon (Paris: Seuil, 1969)

Stone, Lynda, 'Exploring "Lyotard's Women": The Unpresentable, Ambivalence and Feminist Possibility', in Victor E. Taylor and Gregg Lambert, eds., *Jean-François Lyotard: Critical Evaluations in Cultural Theory* (London: Routledge, 2006), vol. 3, pp. 326–43

Storr, Robert, ed., *Gerhard Richter, 18 October 1977* (New York: Museum of Modern Art, 2001)

—, *Gerhard Richter: Forty Years of Painting* (New York: Museum of Modern Art, 2002)

Suleiman, Ezra, *Politics, Power and Bureaucracy in France: The Administrative Elites* (Princeton University Press, 1974); *Les haut fonctionnaires et la politique* (Paris: Seuil, 1976)

—, *Elites in French Society: The Politics of Survival* (Princeton University Press,1978); *Les Élites en France: grands corps et grands écoles* (Paris: Seuil, 1979)

Taslitzky, Boris, *Algérie '52* (Paris: Cercle d'Art, 1953)

—, 'L'Art et les traditions nationales', *La Nouvelle Critique*, 32, January, 1952

Ténèze, Anabelle, *Exposer l'art contemporain à Paris: l'exemple de l'ARC, au Musée d'art moderne de la Ville de Paris (1967–1988)*, 4 vols (Paris: École de Chartes, 2004)

Thorez, Paul, *Les Enfants modèles* (Paris: Lieu Commun, 1982)

Traven, Vlada, *La Datcha en Russie de 1917 à nos jours* (Paris: Éditions du Sextant, 2005)

Troche, Michel, *Écrits* (Paris: Éditions du Regard, 1993)

—, 'Le F.A.P.', *Opus International*, 36, June 1972, pp. 28–9

Tronche, Anne, *L'Art actuel en France: du cinétisme à l'hyperréalisme* (Paris: Balland, 1973)

Vachey, Michel *Toil, précédé d'un avertissement et de le mur de pacifique de Jean-François Lyotard* (Paris: Christian Bourgois, 1975)

Vilar, Pierre, et al, *Dialectique marxiste et pensée structuraliste: tables rondes à propos des travaux d'Althusser* (Paris: Les Cahiers du Centre d'Études Socialistes, 1967)

Waldberg, Patrick, *René Magritte* (Brussels: André de Rache, 1965)

Wilson, Sarah, 'La Bataille des "humbles"? Communistes et catholiques autour de l'art sacré', in Barthélémy Jobert, ed., *Mélanges en l'honneur de Bruno Foucart*, vol. 2, (Paris: Éditions Norma, 2008)

—,'Filles d'Albion: Greer, la Sexualité, le Sexe et les 'Sixties', *Les Sixties en France et l'Angleterre* (Paris: Musée d'Histoire Contemporaine, 1996); 'Daughters of Albion: Greer, Sex and the Sixties', *Les Sixties: Great Britain-France, 1962-1973, The Utopian Years* (London: Philip Wilson, 1997) pp. 75–85

—,'From Monuments to Fast Cars: Aspects of Cold War Art, 1948–1957', in Jane Pavitt, ed., *Cold War Modern* (London: Victoria and Albert Museum, 2008,) pp. 26–33

—, 'Paris Post War: In Search of the Absolute', *Paris Post War: Art and Existentialism, 1945–1955*, ed. Frances Morris, (London: Tate Gallery, 1993), pp. 25–52

—, 'Politique et vanitas: Lucien Fleury et les Malassis', *Lucien Fleury 1928–2005* (Dole: Musée des Beaux-Arts, 2007) pp. 10–43

—, 'Poststructuralism', in Amelia Jones, ed., *Companion to Contemporary Art since 1945* (Oxford: Blackwell, 2005), pp. 424–49

—, 'Réalismes sous le drapeau rouge', *Face à l'histoire* (Paris: Centre Georges Pompidou, 1996), pp. 244–251

—, 'Rembrandt, Genet, Derrida', in Joanna Woodall, ed., *Critical Introductions to Art: Portraiture* (Manchester University Press, 1996), pp. 203–16

—, ed., *Pierre Klossowski* (London: Whitechapel Art Gallery, and Ostfildern: Hatje Cantz, 2006)

—, ed., *Paris, Capital of the Arts, 1900–1968* (London: Royal Academy of Arts, 2002)

Welch, Wolfgang and Christine Preis eds., *Aesthetik im Widerstreit: Interventionen zum werk Jean-François Lyotard* (Wernheim: Acta Humaniora, 1991)

Winkin, Y., 'La Disposition photographique de Pierre Bourdieu', *Le Symbolique et le social: la réceptions international du travail de Pierre Bourdieu,* Colloque de Cerisy (2001; Université de Liège, 2005)

Wunderlich, Antonia, *Der Philosoph im Museum: Die Austellung 'Les Immatériaux con Jean-François Lyotard'*, (Berlin: Transcript, 2008)

Zinoviev, Alexander, *Ziyayushchie Vysoty* (Lausanne: Éditions de l'Âge d'Homme, 1976); *The Yawning Heights* (London: Bodley Head, 1978; New York: Random House, 1979)

Artists

Adami, Valerio

Adami (Milan: Galleria Arturo Schwarz, 1965, 1966,1969)

Adami, (Paris: Musée d'Art Moderne de la Ville de Paris, 1970)

Adami, IVAM Centre Julio González (Valencia: IVAM, 1990)

Adami, Valerio, 'À la mémoire d'une amitié, pour Jacques Derrida'. *Rue Descartes* 48, 2005/2 special number 'Salut à Jacques Derrida', pp. 62-3

—, *Les Règles du montage* (Paris: Carnets, Plon, 1989)

Clair, Jean, 'Mémoire et métonymie chez Valerio Adami', *Chroniques de l'art vivant,* November 1970, pp. 16–17

Damisch, Hubert, and Henry Martin, *Adami* (Paris: Maeght Éditeur, 1974)

—, 'La stratégie du dessin', *Adami/Dr Sigm. Freud* (Bordeaux: Centre d'Arts Plastiques Contemporains, 1976)

Derrida, Jacques (et al.), 'L'Atelier de Valerio Adami: le tableau est avant tout un système de mémoire', ed. Armelle Auris, *Rue Descartes*, 4, 1992

—, 'Penser à ne pas voir', *Annali della Fondazione europea del disegno*, 2005/1 (Milan: Bruno Mondadori), pp.49-74

—, '+R (par-dessus le marché)', *Derrière le miroir*, 214, May 1975 'Adami, Le voyage du dessin'

Gaudibert, Pierre, 'Le travail de l'image', *Derrière le miroir*, 206, 1973, 'Adami', pp. 3-19

Hartman, Geoffrey, 'Hommage to Glas', *Critical Inquiry*, Winter 2007, pp. 344-361

Heissenbuttel, Helmut, Valerio Adami, *Das Reich, Gelegenheitsgedicht Nr 27, 1877–1945* (Munich: Studio Bruckmann, and Paris: Galerie Maeght, 1974)

Lyotard, Jean François, *Que Peindre? Adami, Arakawa, Buren* (Paris: Éditions de la Différence, 1987)

—, ed., 'Adami: peintures récentes', *Repères*, 6 (Paris: Galerie Maeght, 1983)

121. Guido Cegnani, Valerio Adami

Nancy, Jean-Luc, 'Sur un portrait de Valerio Adami', *Portrait à plus d'un titre* (Paris: Gallimard, 2007)

Pacquement, Alfred, ed., *Adami* (Paris: Centre Georges Pompidou, 1985)

Riese Hubert, Renée, 'Derrida, Dupin, Adami: "Il faut être plusieurs pour écrire"', *Annali della Fondazione europea del disegno* 2006/2, (Milan: Bruno Mondadori), pp. 33-54

Antonio Tabucchi and Vassili Vassilikos, *Adami: A Retrospective* (Athens: Vlassis Frissira Museum of Contemporary European Art, 2004)

Aillaud, Gilles

Aillaud, Gilles, *Écrits, 1965–1983* (Valence: Éditions 127/E.R.B.A., 1987)

Bailly, Jean-Christophe, *Gilles Aillaud* (Marseille: André Dimanche, 2005)

Gilles Aillaud: peintures (Grenoble: Musée de la Culture, 1984)

Gilles Aillaud (Paris, Musée d'Art Moderne de la Ville de Paris, 1971)

Ottinger, Didier, ed., *Gilles Aillaud: la jungle des villes* (Arles: Actes Sud, 2001)

Schefer, Jean Louis, *Gilles Aillaud: dans le vif du sujet* (Paris: Hazan, 1987)

Alvarez-Rios, Roberto

Althusser, Louis, 'Devant le surréalisme: Alvares Rios' (sic), *Les Lettres françaises*, 954, 29 November-6 December, 1962

—, 'Un jeune peintre cubain devant le surréalisme: Alvarès Rios'(sic), *Écrits Philosophiques et politiques* II, ed. François Matheron, (Paris: Stock/IMEC, 1995, pp. 569-570)

Pierre, José, 'À l'étonnement du colibri', *Alvarez Rios* (Paris: La cour d'Ingres, 1962)

Roberto Alvarez-Rios, (Ronchamp: Maison de la Mine de Ronchamp, 1982)

Arroyo, Eduardo

30 Jahre danach/30 ans après, ARC, Musée d'Art Moderne de la Ville de Paris (Frankfurt: Frankfurter Kunstverein, 1971)

Arroyo, Eduardo, *Minutes pour un testament. Mémoires* (Paris: Grasset, 2010)

Arroyo (London: Crane Kalman Gallery, 1962)

Arroyo, Musée national d'art moderne, (Paris: Centre Georges Pompidou, 1982)

Astier, Pierre, *Arroyo* (Paris: Flammarion, 1982)

Di Rocca, Fabienne, ed., *Eduardo Arroyo: obra gráfica*, (Valencia: IVAM Centre Julio González, 1989)

Ragon, Michel, 'Trois peintres leaders de la jeune École de Paris: Télémaque, Rancillac, Arroyo', *Art International*, June 1965, p. 48

Ybarra, Lucía, ed., *Eduardo Arroyo* (Madrid: Museo Nacional Reina Sofía, 1998)

Cremonini, Leonardo

Althusser, Louis, 'Cremonini, pittore dell'astratto', *Nuovi argomenti* (Rome), December, 1966

—, 'Artisanat populaire et artisanat colonisé', *Révolution*, November, 1963, pp. 76-79

—, 'Cremonini, peintre de l'abstrait', *Écrits Philosophiques* II, François Matheron ed., (Paris, Stock/IMEC, 1995), pp

—, 'Cremonini, pittore dell'astratto, *Nuovi argomenti* (Rome), December, 1966

—, 'Leonardo Cremonini', trans. and cut by Richard Heipe, *Tendenzen: Zeitschrift für engagierte Kunst* (Munich), 32, May 1965, pp.60-64

Arensi, Flavio and Alberto Buffi eds., *Cremonini. Drawings and Watercolours*, Turin, Allemandi, 2010

Butor, Michel, Pierre Emmanuel, *Cremonini 1958-1961, minéral, végétal, animal* (Paris: Seuil, 1996)

Cremonini, Galerie du Dragon, 1961, text by Pierre Gaudibert

Debray, Regis, *Cremonini, éléments, aquarelles et petits formats, 1951-1993* (Geneva: Albert Skira, 1995)

Gaudibert, Pierre,'Leonardo Cremonini', in Bernard Lamarche-Vadel ed., *Figurations 1960-1973*, (Paris: UGÉ 1973), pp. 29-49

Jelenski, K. A., 'Les Miroirs de Leonardo Cremonini', *Preuves*, 161, July 1964

Leonardo Cremonini, antologica retrospettiva 2003-1953, Accademia di Belle Arti (Bologna: L'artiere, 2004)

Troche, Michel, 'La parole à Leonardo Cremonini', La Nouvelle Critique 39, January 1970, pp. 37-44

Valsecchi, Marco, 'Leonardo Cremonini' La biennale di Venezia (Venice: 1964) pp. 109-110 20 June – 18 October

Cueco, Henri

Henri Cueco, Les Hommes Rouges, (Paris: Musée d'Art Moderne de la Ville de Paris, 1970)

Henri Cueco (Paris: École Nationale Supérieure de Beaux-Arts, 1993)

Henri Cueco: entre vénération et blasphème (Paris: Éditions Somogy, 2005)

Gassiot-Talabot, Gérald ed., *Cueco par Cueco* (Paris: Éditions Cercle d'Art, 1995)

Lyotard, Corinne and Catherine Masson, 'Une peinture ambivalente', Bernard Lamarche-Vadel ed., *Figurations 1960–1973*, (Paris: Union Générale des Éditions 1973), pp. 239–297

Mondzain, Marie-José, *Cueco, dessins*, (Paris: Cercle d'Art, 1997)

Equipo Crónica (Manolo Valdés, Rafael Solbes)

Dalmace, Michèle, ed., *Equipo Crónica, catalogue raisonné* (Valence: IVAM, 2001)

Fernández, Valeriano Bozal, ed., *Equipo Crónica: series: Los viajes, crónica de transición* (Madrid: Ministerio de Cultura, 1981)

Llorens, Tomás, ed., *Equipo Crónica, 1965–1981* (Madrid: Ministerio de Cultura, 1989)

Pagé, Suzanne, ed., *Equipo Crónica* (Paris: Musée d'art moderne de la Ville de Paris, 1974)

Erró

Abadie, Daniel, *Erró: rétrospective*. (Paris: Galerie Nationale du Jeu de Paume, 1999), with a text by Sarah Wilson 'Erró, l'extase matérielle', pp. 38–56

Amman, Jean-Christophe, *Erró: tableaux chinois* (Lucerne: Kunstmuseum,1975)

Augé, Marc, *Erró: peintre mythique* (Paris: Le Lit du Vent, 1994)

Briend, Christian ed., *Erró. 50 ans de collages* (Paris: Centre Georges Pompidou, 2010)

Brownstone, Gilbert, *Erró* (Paris: Georges Fall, 1972)

Erró, 1944-1974: catalogo generale (Milan/Paris Le Chêne, 1976)

Erró: 1974–1986: catalogue général (Paris: Hazan, 1986)

Erró (Paris: Galerie Louis Carré, 2004, bilingual)

Kvaran, Danielle, *Erró Chronology: His Life and Art*, trans. David Ames Curtis (Reykjavik Art Museum and Edda, 2007)

Lambert, Jean-Clarence, *Stalinade: une tragédie-bouffe* (Paris: Édition Somogy, 1997)

Neyer, Hans Joachim, *Erró: Political Painting*, Orangerie Herrenhausen, Hannover (Ostfildern: Hatje Cantz, 1996)

Nos Femmes, curated by Philippe Dagen (*Erró, Lebel, Rancillac, Télémaque*), (Athens: Frissiras Museum, 2005)

Sargeant, Philippe, *Erró où le langage infini* (Paris: Christian Bourgois, 1979)

Fanti, Lucio

Aillaud, Schlosser, Fanti (Rennes: Musée de la Culture, 1973)

Chambas, Esteban, Fanti, Eve Grammatziki, Le Boul'ch (Paris: Galerie du Luxembourg, 1973)

Lucio Fanti, preface by Louis Althusser, (Paris: Galerie Krief-Raymond, 1977)

Lucio Fanti, preface by Jorge Semprun (Paris: Galerie Krief-Raymond, and Grenoble: Maison de la Culture, 1983)

Lucio Fanti: Mers, Châteaux, Nymphéas, preface by Italo Calvino (Paris: Galerie Krief-Raymond, 1980)

'Lucio Fanti: tout sauf la peinture', *Le Petit Chaillioux* (Fresnes: La Maison d'Art Contemporain-Chaillioux, 2002)

Gassiot-Talabot, Gérald, *Fanti* (Rome: Galleria Il Fante di Spade, 1972)

Jourdheuil, Jean, 'Fanti, à la recherche de temps perdu', *Opus International*, 36, June 1972, pp. 20–21, 23–4, 28–9, 49–51

Première rencontre: Fanti, Mehes, Sandorfi, (Paris: Musée d'Art Moderne de la Ville de Paris, 1973)

Wilson, Sarah, 'Fantasmagorii Fanti', *Sobranie* (Moscow, in Russian), 3, 2004, pp. 22–5

Francken, Ruth

Brandon, Katie, 'The Death of the Author and the Rebirth of the Book: The livres d'artiste of Ruth Francken, Jacques Monory and Annette Messager', MA, Courtauld Institute of Art, University of London, 2003

Doutrebente, Olivier, ed., *Ruth Francken* (Paris: Hôtel Drouot, 2007)

Ruth Francken, Anti-castrateur, Black Bread, Mirrorical Return (Aix-la-Chapelle: Neue Galerie Sammlung Ludwig, 1978)

Kempel, Ulrich, ed., *Ruth Francken*, bilingual (Hannover: Sprengel Museum, 2004) woth a text by Sarah Wilson, 'The Song of Ruth'

Skelton, Naomi, 'Ruth Francken: *la coupure et la cohérence*', MA, Courtauld Institute of Art, University of London, 2002

Fromanger, Gérard

Ceysson, Bernard, ed., *Gérard Fromanger 1962–2005*, Musée des Beaux Arts de Dole, Villa Tamaris, La Seyne-sur-Mer (Paris: Éditions Somogy, 2005, 2008)

Frankel, Edward, 'Karlheinz Stockhausen and Gerard Fromanger: Politics and Reproduction in the Ballet *Hymnen*, Amiens, 1970', MA thesis, Courtauld Institute of Art, University of London, 2007

Fromanger: le désir est partout, with text 'La peinture photogenique' by Michel Foucault (Paris: Galerie Jeanne Bucher, 1975); 'Photogenic Painting', trans. Pierre A. Walker, *Critical Texts*, 6/3, 1989, pp. 1–12

Gérard Fromanger, dessinateur, (Nancy: Musée de Beaux-Arts) 2007

Gérard Fromanger: tout est allumé [1980] (Paris: Centre Georges Pompidou, 1979)

Guattari, Félix, 'Fromanger, la nuit/le jour', *Eighty Magazine*, August 1984, reprinted in Félix Guattari, *Les Années d'hiver, 1980–1985* (Paris: Bernard Barrault, 1986), p. 250

Jouffroy, Alain, and Jacques Prévert, *Fromanger: Boulevard des Italiens* (Paris: Éditions Georges Fall, 1971)

July, Serge, *Gérard Fromanger* (Paris: Éditions Cercle d'Art, 2002)

Large, Joanna, 'All Roads lead to Peking: Joris Ivens and Gérard Fromanger in China, 1974', MA, Courtauld Institute of Art, University of London, 2001

Onfray, Michel, *Gérard Fromanger: peintres, poètes, philosophes et amis* (Argentan (Normandy): Médiathèque, 2006)

Prévert, Jacques, and Alain Jouffroy, *Fromanger, Boulevard des Italiens* (Paris: Georges Fall, 1971)
Wilson, Sarah, ed., *Gilles Deleuze, Michel Foucault, Gérard Fromanger, Photogenic Painting*, intro. Adrian Rifkin (London: Black Dog Publishing, 1999)
—, 'Fromanger, Deleuze, Bacon: o pintor o modelo', *Gérard Fromanger: A Imaginação no Poder* (Brasilia: Centro Cultural Banco do Brasil, 2009), pp. 20–27

Klasen, Peter

Sibony, Daniel, *Peter Klasen: Nowhere Anywhere, Photographies 1970–2005* (Paris: Cercle d'Art, 2005)
Virilio, Paul, *Klasen: Études d'impact = Impact inspections = Erkundung der Endzeit* (Angers: Expressions Contemporaines, 1999)

Lapoujade, Robert

Lapoujade, Robert, *Le mal à voir* (Paris: Le Messager Boiteux de Paris, 1951)
—, *L'Enfer et la mine* (Paris: Galerie Arnaud, 1952)
—, *Mécanismes de fascination* (Paris: Seuil, 1955)
Revault d'Allones, Olivier, 'Robert Lapoujade, un peintre rêveur et citoyen', *Robert Lapoujade (1921–1993): le provocateur solitaire* (Montauban: Musée Ingres, 1996)
Sartre, Jean-Paul, 'Lapoujade: peintures sur le thème des *Emeutes, Triptyque sur la torture, Hiroshima*' (Paris: Galerie Pierre Domec 1961; reprinted in *Situations IV*, Paris: Gallimard, 1964)
Vigne, Georges, ed., *Robert Lapoujade (1921–1993): le provocateur solitaire* (Montauban: Musée Ingres, 1996)

Monory, Jacques

Bailly, Jean-Christophe, *Monory* (Paris: Maeght Éditeur, 1979)
Brandon, Katie, 'The Death of the Author and the Rebirth of the Book: The *livres d'artiste* of Ruth Francken, Jacques Monory and Annette Messager', MA, Courtauld Institute of Art, University of London, 2003
Gaudibert, Pierre, and Alain Jouffroy, *Monory* (Paris: Georges Fall, 1972)
Jacques Monory: Tigre (Saint Paul de Vence: Fondation Marguerite et Aimé Maeght, 2009)
Jouffroy, Alain, 'Monory, technicolor', *Derrière le miroir*, 277, January 1978, pp. 2–3, 6–8
Lascault, Gilbert, 'Monory: opéras glacés', *Derrière le miroir*, 217, 1976
Lyotard, Jean-François, 'Les Confins d'un dandysme', *Derrière le miroir*, 244, March 1981, p. 7
—, *L'Assassinat de l'expérience par la peinture* (Talence: Le Castor Astral, 1984); —, *The Assassination of Experience by Painting – Monory*, ed. Sarah Wilson (London: Black Dog Publishing, 1998)
—, Jacques Monory and Martine Aflalo, 'Le Peintre et la camera' (December 1981), *Les Peintres Cinéastes*, (Paris, Ministere des Relations Extérieures, 1982) np
McGuirk, Justin 'La Fuite: Cinema, Fantasy and Memory in the Work of Jacques Monory', MA, Courtauld Institute of Art, University of London, 1998
Monory/Fury/Dubai project (Paris: Galerie 208, 2007)
Monory, Jacques, and Franck Venaille, *Deux*, photo-novel (Paris: Chorus, 1973)
Le Nouëne, Patrick, ed., *Monory, ex-crime*, with a text by Sarah Wilson, 'Du pâle criminel: X-crime' (Angers: Musée d'Angers, 1999)
Thorel, Pascale le, *Monory* (Paris-Musées, 2006)
Tilman, Pierre, *Monory* (Paris: Frédéric Loeb, 1992)

Rancillac, Bernard

Boulos, Joanna, 'Bernard Rancillac: les années politiques', MA, Courtauld Institute of Art, University of London, 2000
Bourdieu, Pierre, *L'année 66* (Paris: Galerie Mommaton, 1966)
Cabanne, Pierre, 'Les Deux Bernard', *Arts et loisirs*, 72, February 1967, pp. 32–6
Ceysson, Bernard, ed., *Bernard Rancillac* (Saint-Étienne: Musée d'Art Moderne, 1971)
Cinémonde, (Paris: Galerie 1900–2000)
Fauchereau, Serge, *Bernard Rancillac* (Paris: Éditions Cercle d'Art, 1991)
Ferrier, Jean-Louis, *Rancillac/Jazz*, (Paris: Éditions du Cercle d'Art, 1997)
Gassiot-Talabot, Gérald, 'Arts', *Candide*, 315, and 'Le Diner des têtes de Rancillac', *Arts-Loisirs*, 87, June 1967, p. 30
—, 'Rancillac, ou l'insolence', *Les Annales du mois*, June 1965, p. 57
—, Bernard Rancillac: *Série Walt Disney*, Galerie Mathias Fels, Paris, France
Lévèque, Jean-Jacques, and Raoul-Jean Moulin, *Rancillac* (Paris: Galerie La Roue, 1963)
Mury, Gilbert, *Rancillac: le vent* (Paris: Centre National d'Art Contemporain, 1971)
Rancillac, Algérie, (Lyons: Galerie confluences, 2000)
Rancillac, Bernard, 'Aubertin anti-peintre ou la vie en rouge', in Bernard Aubertin (Paris: CNAC, 1972)
—, 'Courbet 1977', *Opus International*, 65, Winter 1978, p. 71
—, *Peindre à l'acrylique* (Paris, Éditions Bordas, 1987)
—, *Le Regard idéologique* (Paris: Éditions Mariette Guéna and Somogy, 2000)
—, *Voir et comprendre la peinture*, (Paris, Éditions Bordas, 1992)
Bernard Rancillac (Malakoff: Maison des Arts, 2003)
Bernard Rancillac: rétrospective 1962–2000, with text by Sarah Wilson, 'Cocktail Rancillac/Rancillac Cocktail' (Paris: Somogy, 2003)

120. Hans Haacke, Bernard Rancillac, 1961

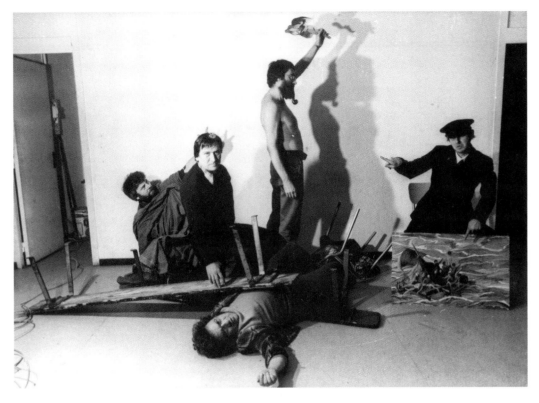

Recalcati, Antonio

Antonio Recalcati, Cinque momenti deal '60 al '06' (Rome: Accademia Nazionale di San Luca, 2007

Bonaccorsi, Robert ed., Antonio Recalcati, 1958-1999, (La Seyne sur mer: Villa Tamaris, 1999)

Bourgois, Christian, and Alain Jouffroy, *Les Empreintes de Recalcati: 1960–1962* (Paris: Christian Bourgois, 1975)

Chalumeau, Jean-Luc, and Beatrice Buscaroli Fabbri, *Antonio Recalcati: la passione della libertà* (Verona: Aurora, 2004)

Rieti, Fabio

Crevier, Richard ed., *Fabio Rieti, peintures, textes et errances* (Paris, Herscher, 1992)

Gassiot-Talabot, Gérald, Alain Devy, *La Grande Borne à Grigny, ville d'Emile Aillaud* (Paris: Hachette, 1972)

Perioro Guccione, Fabio Rieti, Lorenzo Tornabuoni, (Moscow: Gallery of the Union of Artists, 1974)

Télémaque, Hervé

Livingstone, Marco, *Hervé Télémaque: des modes et travaux, 1959–1999* (Perrigny: Centre d'Art de Tanly, 1999)

Hervé Télémaque (Musée d'art moderne de la Ville de Paris, 1976)

Lamarche-Vadel, Bernard, 'Un point de suspension' in Lamarche-Vadel ed., *Figurations 1960-1973*, (Paris: Union Générale des Éditions 1973), pp. 49-71

Rasle, Josette, ed., *Hervé Télémaque: du coq à l'âne* Musée de la Poste, (Paris: ENSBA, 2005)

Télémaque (Valencia: IVAM, Centre Julio González, 1998)

Tronche, Anne, *Hervé Télémaque* (Paris: Flammarion, 2003)

La Coopérative des Malassis

(Henri Cueco, Lucien Fleury, Jean-Claude Latil, Michel Parré, Gérard Tisserand)

Chabert, Emily, 'La Coopérative des Malassis: les enjeux d'un art politique', mémoire de maîtrise, Université de Paris IV–Sorbonne, 2004

Clair, Jean, 'Petites notes sur la peinture de Michel Parré'. *Michel Parré*, Galerie Marquet, 1974

Dary, Anne, ed., *Lucien Fleury 1928–2005* (Dole: Association des Amis du Jura, 2007) with a text by Sarah Wilson

Gaudibert, Pierre, *Cueco, Parré*, (Paris: Musée d'art moderne de la Ville de Paris, 1970)

—, 'Réflexions politiques sur une exposition contestée', *Opus International*, June 1972, pp. 22–5

Le Blanc, Alain, *Gérard Tisserand*, (Angoulême: 1995)

Mongeau, Daniel, ed., *La Coopérative des Malassis: enjeux d'un collectif d'artistes* (Marie de Bagnolet, 1999)

Parré, Michel avec Jacques Vallet, *Peinture injure* (Paris: Carte Blanche, 1999)

Pradel, Jean-Louis, *La Coopérative des Malassis* (Paris: Éditions P. J. Oswald, 1977)

Qui tue? L'affaire Gabrielle Russier (Alleaume, Cueco, Latil, Mikaeloff, Parré, Tisserand) (Paris: Musée d'art moderne de la Ville de Paris, 1970)

122. The Malassis: Raft of the Medusa (courtesy Henri Cueco)

Plates

Jacket

Henri Cueco: *Five Romantic Painters of the Malassis Period – or Business picks up*, 1977. Acrylic on canvas, 300 x 390 cm (one of six). © Musée des Beaux-Arts de Dole, Photo: Jean-Loup Mathieu

Frontispiece

André Morain: 'Mythologies Qutodiennes', exhibition dinner, Le Train bleu, Paris, 1964. From left to right: Samuel Buri, Jean Tinguely, Jacques Monory, Hervé Télémaque, Marie-Claude Dane, Gérald Gassiot-Talabot, Peter Foldes, Bernard Rancillac, Antonio Berni, Attila, Cheval Bertrand, Edmund Alleyn. Seated: Peter Klasen, Klauss Geissler, Niki de Saint Phalle, Jan Voss. © André Morain

p6 Gérard Fromanger: *Michel* (Michel Foucault) 'Splendours II' series, 1976. Oil on canvas, 130 x 97 cm, artist's collection. © Gérard Fromanger

Preface and Acknowledgements

1 Henri Cueco, *Barricade, Vietnam 68*, 1968. Housepaint on canvas, 200 x 200 cm, artist's collection. © Henry Cueco

2 Erró, *Mao at San Marco*, 1974. Oil on canvas, 97 x 77 cm. Musée nationale d'art moderne, Centre Georges Pompidou, Paris. © Erró

3 AES (Tatiana Arzamasova, Lev Evzovitch, Evgeny Syvatsky), *Beaubourg*, 1996, digital collage. From the series 'Witnesses of the Future. Islamic Project' (1996–2003). Courtesy of the artists and the Triumph Gallery, Moscow, © AES

4 Ruth Francken, *Lyotard 'Mirrorical Return'* series: (two details) Drawing on photographic fragments, collage, pencil, coloured pen and diamond dust on several layers of cardboard, 1982–84. Triptych, 65 x 400 cm. Musée d'art moderne et contemporain de Strasbourg. Courtesy Emmanuelle Delaye. Photo: Musées de la Ville de Strasbourg

Interlude: *The Datcha*

5 Gilles Aillaud, Francis Biras, Lucio Fanti, Fabio Rieti, *The Datcha*. (conception: Eduardo Arroyo) Oil on canvas, 200x 400 cm. Private collection

6 André Fougeron, *Atlantic Civilisation,* 1953. Oil on canvas, 380 x 559 x 70 m, Tate, London. © Tate, London 2009. The estate of André Fougeron

7 James Rosenquist, *F-III*, 1964–65. Multipanel room installation: oil on canvas and aluminium. Panels, 10 x 86 feet (304.8 x 2621.3 cm) overall. The Museum of Modern Art, New York, Gift of Mr. and Mrs. Alex L. Hillman and Lillie P. Bliss Bequest (both by exchange), 1996. © James Rosenquist/ DACS, London/VAGA, New York 2010

8 Eduardo Arroyo, Gilles Aillaud, Antonio Recalcati, *Live and Let Die: or the Tragic End of Marcel Duchamp*, 1965. Oil on canvas, series of eight paintings, 162 x 114 cm, 162 x 130 cm. Museo nacional, centro de arte Reina Sofía, Madrid. © ADAGP, Paris and DACS, London 2010. Photo: Archivo Fotografico Museo Nacional Centro de Arte Reina Sofía, Madrid.

9 Ian Fleming, *Vivre et laisser Mourir,* Paris, Plon, 1964. Cover

10 Edouardo Arroyo, *Six lettuces, a knife and three peelings,* 1965. Oil on canvas, 200 x 200 cm. Galerie di Meo, Paris. © ADAGP, Paris and DACS, London 2010

11 Antonio Recalcati, Erró, Jean-Jacques Lebel, Enrico Baj, Crippa, Dova*, The Great Antifascist Collective Painting,* 1960. Oil on canvas, 400 x 500 cm. Private collection, courtesy Jean-Jacques Lebel

12 Catalogue cover: 24ᵉᵐᵉ Salon de Mai, Paris, 1968, with *Collective Cuban Mural,* Havana, 1967 (Original, oil on canvas, six panels, 501 x 1,083 cm. Museo Nacionale de Bellas Artes, Havana Cuba)

Chapter 1
From Sartre to Althusser

13 Cremonini, *La Torture,* 1961. Oil on canvas, 130 x 81 cm, artist's collection © Leonardo Cremonini

14 Mireille Miailhe, *Barefoot in the snow, Algeria,* 1952. Crayon on paper, 70 x 47 cm. Artist's collection

15 Boris Taslitzky, *Women of Oran,* 1952. Oil on canvas, 114 x 147 cm. Private collection. © Private collector. Photo: Isabelle Rollin-Royer

16 Robert Lapoujade, *The Riot,* 1961. Print, 26 x 45.5 cm, Musée nationale d'art moderne, Centre Georges Pompidou, Paris © Collection Centre Pompidou Distribution RMN / Philippe Migeat

17 Robert Lapoujade, *Torture Triptych,* 1961. Oil on canvas, 196 x 342 cm. Private collection

18 Leonardo Cremonini, Articulations *and disarticulations*, 1959–60. Oil on canvas, 130 x 195 cm. Artist's collection © Leonardo Cremonini

19 Roberto Alvarez-Rios, *The Universal Dove of Peace, Paris, 1960.* Oil on canvas, 130 x 197 cm. 1961. Artist's collection © Roberto Alvarez-Rios

20 Roberto Alvarez-Rios outside the Maison de Cuba, 1960 Photograph, artist's collection

21 Roberto Alvarez-Rios, *Human beings, Wars, Invasions etc. Enough!,* 1965 Oil on canvas, 200 x 127 cm, artist's collection. © Roberto Alvarez-Rios

22 Mimmo Rotella, *Tender is the Night,* 1963. Torn poster. Courtesy of the Fondazione Mimmo Rotella, Italy © DACS 2010

23 Leonardo Cremonini, *Night Train,* 1963. oil on canvas, 117 x 73 cm. Private collection. © Leonardo Cremonini

Chapter 2
Pierre Bourdieu, Bernard Rancillac

24 Bernard Rancillac, *The Dark Room* 1961. Installation with objects and materials (destroyed). © Bernard Rancillac

25 Bernard Rancillac, *Mickey's return,* 1964. Oil on canvas, 300 x 250 cm. Musée d'art contemporain du Val-de-Marne, Vitry, Conseil général du Val-de-Marne. © Bernard Rancillac

26 Patrick Caulfield, *Greece Expiring on the Ruins of Missolonghi (after Delacroix)*, 1963. Oil on board, 152.4 x 121.9 cm, Tate Britain. © Tate, London 2009. The Estate of Patrick Caulfield. All rights reserved, DACS 2010

27 Bernard Rancillac, *Private Diary of a Kick,* 1965. Oil on canvas, 146 x 211 cm. Private collection. © Bernard Rancillac

28 Andy Warhol, *Saturday's Popeye,* Synthetic polymer paint on canvas, 108 x 99 cm. Aachen, Ludwig Forum für Internationale Kunst, Collection Ludwig. © The Andy Warhol Foundation for the Visual Arts / Artists Rights Society (ARS), New York / DACS, London 2010. Photo: The Andy Warhol Foundation, Inc. / Art Resource, NY

29 Bernard Rancillac, *Ideal Homes*, 1965. Comic character transfers on page of *Paris-Match*), 34 x 26 cm, Galerie Krief, Paris © Bernard Rancillac

30 Bernard Rancillac, *At last, a silhouette slimmed to the waist*, 1966. Acrylic on canvas, 195 x 130 cm. Musée de Grenoble. © Bernard Rancillac

31 Bernard Rancillac, *Dinner-party of the head-hunters*, 1966. Vinyl on wood, 170 x 150 cm. Three panels open. Collection Jean Boghici, Rio de Janeiro. © Bernard Rancillac

32 Bernard Rancillac, decor for *Bris/Collage/K,* 1967. © Bernard Rancillac

33 Bernard Rancillac, *Malcolm X*, 1968. Silkscreen print on plexiglas, 2 panels, 160 x 120 cm. Musée Cantini, Marseille. © Bernard Rancillac

34 Bernard Rancillac, *Nous sommes tous des juifs et des allemands,* 1968. Silkscreen print on paper (Atelier Populaire des Beaux-Arts poster). © Bernard Rancillac

35 Bernard Rancillac, *Sailor boy,* 1969, defaced photograph, 100 x 73 cm, artist's collection. © Bernard Rancillac

43 Bernard Rancillac, *Pornography censured by eroticism,* 1969. Photograph on paper retouched with acrylic paint, objects added in 1984, 146 x 97 cm, artist's collection © Bernard Rancillac

37 Bernard Rancillac, *Kennedy, Johnson, Nixon and Lieutenant Calley on the road to My-Lai,* 1971. Acrylic on canvas, 195 x 200 cm. Musée de Villeneuve-d'Ascq. © Bernard Rancillac

38 Bernard Rancillac, *The Red Detachment of Women*, 1971. Acrylic on canvas, diptych 240 x 390 cm. Berardo Collection, Lisbon. © Bernard Rancillac

39 Bernard Rancillac, *BB King*, 1972. Acrylic on canvas, 195 x 130 cm. Collection Robert Crégut. © Bernard Rancillac

40 Bernard Rancillac, *In memory of Ulrike Meinhof,* 1978. Acrylic on canvas, 204 x 283 cm. Musée des Beaux-Arts, Orléans. © Bernard Rancillac

41 Gerhard Richter, *October 18,1977, Cell,* 1988. MOMA, NY. Oil on canvas, 201 x 140 cm. The Sidney and Harriet Janis Collection, gift of Philip Johnson, and acquired through the Lillie P. Bliss Bequest (all by exchange) – Enid A. Haupt Fund – Nina Gordon Bunshaft Bequest Fund – and gift of Emily Rauh Pulitzer. 1969. 1995. m. © 2009. Digital image, The Museum of Modern Art, New York / Scala, Florence

42 Pierre Bourdieu, *Untitled,* nd., R1, Archive Pierre Bourdieu, Images from Algeria, 1958 – 1961. © Pierre Bourdieu / Fondation Pierre Bourdieu, St. Gallen. Courtesy Camera Austria, Graz

43 Bernard Rancillac, *Bar-codes, Algeria*, 1999. Acrylic on canvas with slide projection, 165 x 250 cm, private collection © Bernard Rancillac

Chapter 3
Louis Althusser, Lucio Fanti

44 Lucio Fanti, *Soviet Garden*, 1972, oil on canvas, 162 x 130 artist's collection © Lucio Fanti

45 Pierre Buraglio, *Camouflage Mondrian*, 1968. Camouflage material and paint on canvas, 200 x 180 cm. Collection N. et G. Blanckeart, France. Photo: J. L. Losy © Pierre Buraglio

46 *La salle rouge pour le Vietnam,* catalogue, 1969: Pierre Buraglio, Louie Cane, Zipora Bodek, Francis Biras, Henri Cueco, Maxime Darnaud

47 Fabio Rieti, *Courrier de Vietnam* (16 September 1968). *Salle rouge pour le Vietnam,* 1969

48 a. Lucio Fanti, *Vietnamese Family*, 1969. Oil on canvas, 200 x 200 cm, collection of the artist. © Lucio Fanti

b. Gilles Aillaud, *The Battle for Rice*, 1968. Oil on canvas, 200 x 200 cm. Private collection © ADAGP, Paris and DACS, London 2009

49 Jean-Claude Latil, Michel Parré, Claude Rutault, Gérard Tisserand, *Story of a poor peasant,* 1969, acrylic on canvas, eight panels, each 200 x 200, Musée des Beaux-Arts, Dôle © the artists, photograph courtesy of Henri Cueco

50 Henri Cueco, Marinette Cueco, Lucien Fleury, Gérard Schlosser, Edgard Naccache, Schnee, *School book, Class book*, 1969, Musée des Beaux-Arts, Dôle. © the artists, photograph courtesy of Henri Cueco

51 Isaac Brodzki, *Vladimir Lenin at Smolny*, 1930. Oil on canvas, 190 x 287 cm. The State Tretyakov Gallery, Moscow. © The State Tretyakov Gallery, Moscow

52 Lucio Fanti, *Grandchildren of the Revolution*, 1969, oil on canvas,180 x 143 artist's collection © Lucio Fanti

53 Lucio Fanti, *Statue*, 1969, oil on canvas, 130 x 162, destroyed after damage © Lucio Fanti

54 Interior, Kiev Museum of Russian Art from *Kiev, 1654–1954*, (Kiev: 1954), Lucio Fanti collection

55 Lucio Fanti, *Lenin's armchair at Smolny, 1917,* 1975. 81 x 100 private collection, Milan. © Lucio Fanti

56 Lucio Fanti, a. *Anaït Anian, candidate in agricultural sciences admires the new species of tomato she has obtained*, 1971–2, oil on canvas, 100 x 81, private collection, Paris. © Lucio Fanti b. *Kukuruza (maize)*, 1971, oil on canvas, 162 x 130 private collection, Paris © Lucio Fanti

57 Lucio Fanti, a. *Useless Poems I,* 'My poem flies like a telegram' (Mayakovsky), 1976, oil on canvas, 81 x 100, Jean Labib, Paris b. Lucio Fanti, *Useless Poems III, Young man in a state of nostalgia,* 1977, oil on canvas, 81 x 100, private collection, Paris © Lucio Fanti (a, b)

58 Lucio Fanti, *Forgotten Books. Lenin in Siberia*, 1978, 162 x 130, oil on canvas. Ville de Montrouge, Paris © Lucio Fanti

59 Erik Bulatov, *Red Horizon*, 1971–2. Oil on canvas, 150 x 180 cm, oil on canvas, private collection, Paris. © E. and N. Bulatov

60 Jacques Pavlovsky, *Althusser*, Sygma reportage, 19 May 1978 © Photograph Jacques Pavlovsky / Sygma / Corbis

61 Lucio Fanti, *Electrification plus the sentiment of nature*, 1977, oil on canvas, 162 x 130 cm private collection, Milan, © Lucio Fanti

Chapter 4 Deleuze, Foucault, Guattari, Fromanger

62 Gérard Fromanger, *Bubble* ('Souffle' *series*) May-June, 1968. Translucent altuglas, chrome, cast iron, 220 x 240 x 150 cm. © Gérard Fromanger

63 Gérard Fromanger, *Self-portrait with Test-Tube*, 1963–4, ('Petrified' series) oil on canvas, 116 x 73 cm, Private collection. © Gérard Fromanger

64 Gérard Fromanger, *My picture is dripping,* 1966. Primer and acrylic paint on wood, 220 x 150 cm. Private collection. © Gérard Fromanger

65 Philippe Vermèse, Atelier des Beaux-Arts, Paris, 1968. © Philippe Vermèse

66 Gérard Fromanger, *Red (a-b)*, 1970. Lithographs each 60 x 89 cm, artist's collection. © Gérard Fromanger
c. John Heartfield, *Platz! dem Arbeiter*, 1924. First Almanac of the Malik-Verlag. Archiv der Akademie der Künste, Berlin. © The Heartfield Community of Heirs/VG Bild-Kunst, Bonn and DACS, London 2010. Photo: Akademie der Künste, Berlin

67 Gérard Fromanger, *Break the Ice, Red, Half past twelve, Everything most go!*('Boulevard des Italiens' series), oil on canvas, all 100 x 100 cm, 1971. (Jean Coulon, Eric and Odile Finck Beccafico and private collections) © Gérard Fromanger

68 Richard Lindner, *Boy with machine,* 1954. Oil on canvas, 122 x 72 cm, private collection. Courtesy Anouk Papadiamandis, Paris. © Anouk Papadiamandis

69 Fromanger, *Light Cadmium Red, Bayeux violet, Egyptian violet, Veronese Green,* ('The Painter and the model' series), 1972. Oil on canvas, 150 x 200 cm. (Collection Martine et Michel Brossard, Paris, Private collection Paris, Musée de la Ville de Paris, Private collection Paris,) © Gérard Fromanger

70 Richard Estes, *Cafeteria,* 1972. Oil on canvas, 100 x 120 cm. © Richard Estes, courtesy Marlborough Gallery, New York. Photo: akg-images, London / Archives CDA

71 Noel Mahaffey, *St. Louis, Missouri*. Acrylic on canvas, 152 x 182. Private collection

72 Jean-Luc Godard, *La Chinoise*, 1967. © J.-L. Godard. Photo: BFI Stills Collection, London

73 Édouard Manet, *A Bar at the Folies-Bergère,* 1882. Oil on canvas, 96 x 130 cm. Courtauld Gallery, London. © The Samuel Courtauld Trust, Courtauld Gallery, London

74 Gérard Fromanger, *In Huxian, China,* 1974. Oil on canvas, 195 x 130 cm ('Desire is everywhere' series), Musée national d'art moderne, Centre Georges Pompidou, Paris. © Gérard Fromanger

75 Oscar Gustav Rejlander, *Two ways of life,* 1857. Composite photograph, National Media Museum, Bradford. © National Media Museum / Science & Society Picture Library

76 Gérard Fromanger, *The Artist's Life,* ('Topino-Lebrun' series), 1972–75. Oil on canvas, 200 x 300, artist's collection. © Gérard Fromanger

77 Gérard Fromanger, *Portrait of Michel Bulteau, at the Versailles Opera.* 1974. Oil on canvas, 195 x 130 cm ('Desire is everywhere' series). Beuymans von Beunigen Museum, Rotterdam. © Gérard Fromanger

78 Gérard Fromanger, *In Huxian, Portrait of Liu-Chi Tei, amateur peasant-painter*, 1974. Oil on canvas, 195 x 130 cm, ('Desire is everywhere' series). © Gérard Fromanger

Chapter 5 Lyotard, Monory

79 Jacques Monory, *For all that we See or Seem is a Dream within a Dream,* 1967. Oil on canvas, 125 x 172 cm. Musée Cantini, Marseilles. © Jacques Monory

80 Jacques Monory, *Death Valley no. 1,* 1974. Oil on light-sensitive canvas. 170 x 490 cm. Private collection. © Jacques Monory

81 Édouard Manet, *Portrait d'Emile Zola*, 1868. Oil on canvas, 146 x 114 cm, Musée d'Orsay, Paris © RMN (Musée d'Orsay) /Hervé Lawandowski

82 Jacques Monory, *Toxic no 1, Melancholy,* 1982. Oil on canvas, 150 x 230 cm. Musée d'Art moderne de Fukuoka, Japon. © Jacques Monory

83 Pierre Zucca, illustration, from Klossowski, *La Monnaie vivante*, 1970. © Sylvie Zucca

84 Jacques Monory, *Dreamtiger* 5, 1972. Oil in canvas, 195 x 228 cm. Private collection. © Jacques Monory

85 Jacques Monory, *Photo of Claude,* 1972 © Jacques Monory

86 Albrecht Dürer, *Draughtsman Making a Perspective Drawing of a Woman,* illustration from 'Unterweysung der Messung mit dem Zirckel und Richtscheyt', first publication 1525, this woodprint 1538. Meder 271. British Museum, London. © Trustees of the British Museum

87 Jacques Monory, a. *Claude,* 1972. Oil on canvas, 114 x 162 cm. Private collection. © Jacques Monory

b. *Claude,* 1972. Oil on light-sensitive canvas, 81 x 160 cm. Private collection. © Jacques Monory

88 Jacques Monory, *Ex,* film stills 1968. © Jacques Monory

89 Jacques Monory, *Murder* 10/2, 1968. Oil on canvas, mirror with gunshot holes, 162 x 425 cm. Musée nationale d'art moderne, Centre Georges Pompidou, Paris. © Jacques Monory

90 Malcolm Morley, *Race Track,* 1970. Liquitex on canvas, 170.2 x 220.3 cm. Ludwig Museum, Budapest. © Malcolm Morley and Sperone Westwater, NY. Photo: Jozsef Rosta

91 Jacques Monory, *Death Valley no. 10, with Midnight Sun,* 1975. 170 x 450 cm. Musée d'art contemporain de Nimes, Fondation Lintas. © Jacques Monory

92 Edward Kienholz, *Five Car Stud,* 1969–1972. Mixed media installation, dimensions variable. Kawamura Memorial Museum of Art, Sakura, Japan. © Kienholz Estate. Courtesy of L.A. Louver, Venice, California.

93 Jacques Monory, *U.S.A. 76 Bicentenary Kit,* 1976. Perspex boxes, lithographs, Michel Butor poems, souvenirs, 31.5 x 42.5 x 12, *livre-objet*, Paris, Lebaud, 1976. © Jacques Monory

123. Selby, Erró nude, 2005

Index

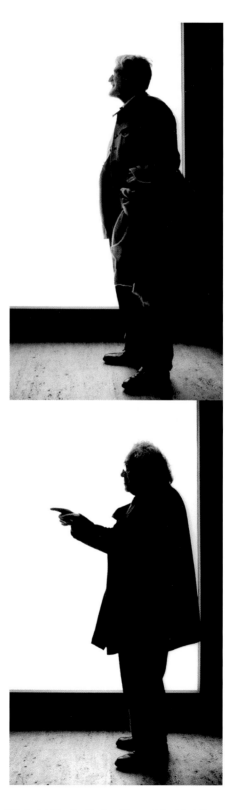

124. André Morain, *Shadows Monory Adami Erró Cueco*,
'Figuration Narrative' exhibition, Grand Palais, Paris, 2008.
Composition Adrien Sina

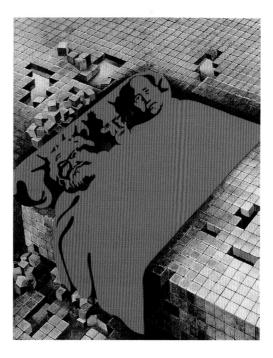

125. Cueco, *Marx, Freud, Mao*, 1969

Yale University Press
New Haven and London
2010